Disciplines in Art Education: Contexts of Understanding
General Series Editor, Ralph A. Smith

Books in the Series

Art Education: A Critical Necessity
Albert William Levi and Ralph A. Smith

Art History and Education
Stephen Addiss and Mary Erickson

Aesthetics and Education
Michael J. Parsons and H. Gene Blocker

Art Making and Education
Maurice Brown and Diana Korzenik

Art Criticism and Education
Theodore F. Wolff and George Geahigan

Art Criticism and Education

ART CRITICISM
AND
EDUCATION

*Theodore F. Wolff and
George Geahigan*

UNIVERSITY OF ILLINOIS PRESS
Urbana and Chicago

© 1997 by the Board of Trustees of the University of Illinois
Manufactured in the United States of America
1 2 3 4 5 C P 5 4 3 2 1

This book is printed on acid-free paper.

This volume and the others in the series Disciplines in Art Education: Contexts of Understanding are made possible by a grant from the Getty Center for Education in the Arts. The J. Paul Getty Trust retains all publishing rights to the individual essays in the series. The views expressed in the volumes are those of the authors and not necessarily those of the J. Paul Getty Trust.

The following articles by Theodore F. Wolff appeared in the *Christian Science Monitor* and are reprinted with permission of The Christian Science Publishing Society. All rights reserved: "Art by Computer"; "Artistic Creations That Push against Their Showcase"; "Bringing Down the Curtain on Modernism"; "Kollwitz Gave Modern Form to Humanity's Most Essential Questions"; "Love in Art"; "Making and Marketing Art Superstars"; "Modern Art's Father Figure"; "More Than Superb—Alive"; "Putting It on the Line"; "Swimming against the Contemporary Tide"; "Undoing Stereotypes"; and "With a Special Lens."

Library of Congress Cataloging-in-Publication Data
Wolff, Theodore F.
Art criticism and education / Theodore F. Wolff
and George Geahigan.
p. cm. — (Disciplines in art education)
Includes bibliographical references and index.
ISBN 0-252-06614-6 (pbk. : acid-free paper). —
ISBN 0-252-02314-5 (cloth : acid-free paper)
1. Art criticism. I. Geahigan, George.
II. Title. III. Series.
N7476.W63 1997
701'.18—dc20 96-35655
CIP

Contents

General Series Preface

Since the early 1980s, the Getty Center for Education in the Arts, which is an operating entity of the J. Paul Getty Trust, has been committed to improving the quality of aesthetic learning in our nation's schools and museums. According to the organizing idea of the center's educational policy, teaching about the visual arts can be rendered more effective through the incorporation of concepts and activities from a number of interrelated disciplines, namely, artistic creation, art history, art criticism, and aesthetics.

The resultant discipline-based approach to art education does not, however, mandate that these four disciplines be taught separately; rather, the disciplines are to provide justifications, subject matter, and methods as well as exemplify attitudes that are relevant to the cultivation of percipience in matters of art. They offer different analytical contexts to aid our understanding and aesthetic enjoyment, contexts such as the making of unique objects of visual interest (artistic creation), the apprehension of works of art under the aspects of time, tradition, and style (art history), the reasoned judgment of artistic merit (art criticism), and the critical analysis of basic aesthetic concepts and puzzling issues (aesthetics). Discipline-based art education thus assumes that our ability to engage works of art intelligently requires not only our having attempted to produce artwork and gained some awareness of the mysteries and difficulties of artistic creation in the process, but also our having acquired familiarity with art's history, its principles of judgment, and its conundrums. All are prerequisite to building a sense of art in the young, which is the overarching objective of aesthetic learning.

Although no consensus exists on precisely how the various components of aesthetic learning should be orchestrated in order to accomplish the goals of discipline-based art education, progress toward these objectives will require that those charged with designing art education programs bring an adequate understanding of the four disciplines to bear on their work. It is toward generating such needed understanding that a five-volume series was conceived as part of

the Getty Center's publication program. To narrow the distance sep-
arating the disciplines from classroom teaching, each book following
the introductory volume has been coauthored by a scholar or practi-
tioner in one of the disciplines (an artist, an art historian, an art crit-
ic, and a philosopher of art) and an educational specialist with an
interest or competence in a given art discipline. The introductory
volume provides a philosophical rationale for the idea of discipline-
based art education. It is hoped that the series, which is intended
primarily for art teachers in elementary and secondary education, for
those who prepare these teachers, and for museum educators, will
make a significant contribution to the literature of art education.

Ralph A. Smith
General Series Editor

General Editor's Introduction

In *Art Criticism and Education* two writers with different backgrounds and professional commitments convey essentially the same message. The message is that art criticism should be sympathetic, open-minded inquiry into works of art for the sake of the greater aesthetic understanding and self-realization that such inquiry can provide. Both writers emphasize that it is only through the cultivation of personal awareness that the young can learn to appreciate the special ways in which making and perceiving art contribute to a richer and more fulfilling life.

Although critical inquiry—a concept George Geahigan explores systematically—is not uniquely instantiated in art criticism understood as a discipline, it becomes critical for discipline-based art education in its association with art criticism. It can, in fact, be held that critical inquiry is its key integrating activity, a contention that begins to make sense when one reflects on how art critics go about their work. Art-critical thought is infused not only with a good understanding of the history of art—the record of the accomplishments and failures of artistic endeavors—but also with a knowledge of the special problems and puzzles that the interpretation of art poses. Critical inquiry as a way of unlocking the import of artworks can be brought to bear on any work, past and present. Criticism is thus a wide-ranging discipline that not only concerns itself with contemporary art but also with the art of any historical period. The excursions Wolff and Geahigan make into the art of the past and modern periods should not cause dismay, for a careful reader will realize that they have not strayed into doing art history or aesthetics but are maintaining their focus on art criticism.

So far as further similarities between the writers are concerned, one need only compare the ways in which Wolff would involve the young in discussions of the work of Jackson Pollock and James Turrell and how Geahigan would encourage them to look at the work of Manet and Frida Kahlo. Both writers, moreover, stress that the young should read professional art criticism and write critical commentaries. Such

writing contributes to a better understanding of art and the develop-
ment of academic skills and general intelligence. Finally, both writ-
ers forego technical language and abstract theory in setting out their
ideas. Wolff and Geahigan write clearly and simply but not simplis-
tically. Using these common features of the outlooks and dispositions
of the writers readers can better understand the content of each set
of chapters.

Theodore Wolff, the author of the first set of chapters, studied art
and art history at the University of Wisconsin. He worked as a painter
in San Francisco and New York and served as a certified appraiser for
estates, collections, and museums before accepting employment in
1980 as an art critic for *The Christian Science Monitor*. For his efforts
he has received a number of awards, including the National Head-
liners Award for "Consistently Outstanding Special Columns—Art"
(1982). Wolff has also been the critic-in-residence of several colleges
and universities and involved in curriculum projects and seminars
sponsored by the Getty Center for Education in the Arts. His most
recent publications are *The Many Masks of Modern Art* (1989) and
Morris Graves: Flower Paintings (1994). He has recently returned to his
first love, painting, but continues to work as a critic and writer.

Wolff defines art criticism as the assessment of an artwork's qual-
ity and significance. Such an assessment is grounded in clearly estab-
lished and identified criteria and replete with an explanation of how
critics arrive at their conclusions. Such an emphasis on the applica-
tion of standards toward critical verdicts has led many, teachers in-
cluded, to think of art criticism as a sternly judgmental and hence
somewhat forbidding undertaking. Wolff wants to dispel this impres-
sion because it would be inappropriate for the use of art criticism in
the classroom, where criticism's more supportive, generous-spirited
side should predominate.

Wolff sets himself the goal of bridging the perceived gap between
art critics and art teachers and convincing the latter not only of their
ability to become adept at teaching art criticism in a meaningful way
but also of the vital importance of their doing so in order to achieve
important art-educational objectives. He acquits himself of this task
of persuasion by remaining true to his promise "to be informal in
approach, personal in voice, and as nonjudgmental as appropriate and
possible in my conclusions." The result are chapters that provide art
teachers with many valuable insights into the discipline of art criti-
cism and a wealth of sensible advice on how to make it accessible to
students.

As taught within the framework of discipline-based art education,

art criticism should contribute to the larger aims of that approach. Among these aims Wolff mentions the heightening of students' awareness of the life-enhancing qualities and significance of art, the cultivating of aesthetic sensibility, and, quite generally, the helping of young people to fulfill themselves through art. But there are other important art-educational aims that art criticism serves. It also concentrates on the individual work of art and strives to make students more comfortable and competent in their aesthetic encounters. Moreover, through extended exposure to art criticism students develop their own criteria of judgment, which will be especially helpful not only as they estimate the artwork of others but also as they measure progress in their artistic endeavors. Wolff further emphasizes the importance of art criticism in providing access to the art of today, but, as his own writing reveals, the work of art critics is not confined exclusively to talking about contemporary art.

Criticism that teachers should find useful is likely to exhibit the attributes of sound judgment. It is apt to turn out to be a mixture of several art-critical approaches—diaristic, formalist, and contextual—and may lean strongly toward one of these. Such criticism will maintain a good working relationship between reason, intuition, and sensitivity, yet it may also be fallible. Assessments often change with the years as new theories and concepts replace earlier ones. But neither the role accorded to intuition and sensitivity nor criticism's ultimate fallibility absolve the critic from the requirement to produce, and the teacher from the requirement to use, responsible criticism. Such criticism, in Wolff's opinion, tries very hard to be objective. It gathers and carefully considers the widest range of evidence about an artwork, bases its conclusions on standards, and explains how they were arrived at: "I will always maintain that the critic's most important word is `because.'" Nothing, Wolff insists, can qualify as art criticism without well-substantiated justification. What is more, helping the young to make and justify aesthetic judgments is a convenient way to help them gain familiarity with judgment in general.

George Geahigan, the author of part 2 of this book, received a bachelor of fine arts degree from the Philadelphia College of Art, a master of arts from the University of Illinois, and a Ph.D. from The Ohio State University. He taught in public schools in Connecticut and universities in North Carolina, Wyoming, and Ohio before accepting a position at Purdue University, where he teaches courses in art and design. He has received numerous awards, among them an achievement award from the Philadelphia College of Art, an excellence award for dissertation research, and an Indiana Outstanding Art Educator

of the Year Award. He has contributed numerous articles to periodicals and chapters on art criticism and the history and philosophy of art education to several books. In particular, his extensive work in analyzing the concept of criticism qualifies him to address the task of teaching art criticism to young people.

One of the strengths of Geahigan's contribution to a discussion of art criticism is the seamless connection between his theoretical position and his recommendations to art educators; once the former are understood, the latter follow logically. As an educator, Geahigan subscribes to the view that schooling properly addresses several dimensions of a developing personality. Because one of these dimensions is the aesthetic, the first part of a school's mandate to introduce the young to art as a form of life is thus established. The second part derives from the fact that socialization alone, for reasons Geahigan explains, is no longer sufficient to effect such an introduction; formal schooling must therefore intervene. The specific measures that Geahigan believes would be likely to secure this initiation into the world of art evolve from his conception of the visual work of art.

According to Geahigan, an artwork's most salient feature is its having been created by an artist intending to convey meaning. Artists proceed on the assumption that they share a common stock of knowledge and concerns with their audience, and viewers approach a work of art with the supposition that its meaning is comprehensible. Both sets of assumptions can be expected to mesh, however, only if viewers come properly equipped for interpreting the artist's meaning. It is the requirement to prepare percipients' minds that assigns such a vital role to art criticism and the teaching of it.

The notions of meaning, understanding, and artistic intentions are of pivotal importance in Geahigan's approach. He devotes an illuminating discussion to the topic of the artist's intended meaning and demonstrates how it can be recovered in many instances. This meaning is supplemented by other, unintended kinds—general principles, cultural and epochal trends, and ideas—that can be inferred from biographical, historical, and social contexts as well as from the more strictly aesthetic understandings viewers may garner from a work's perceptual features. Clearly, Geahigan sets the work of art at the center of a rather wide field of relevance and adopts a generous, comprehensive view of art.

For Geahigan, art criticism is a form of inquiry. The term *inquiry* is apt, for it connotes active investigation, curiosity about the thing examined, and a quest: in the case of scrutinizing works of art, a quest for meaning, enlightenment, and personal significance. The last item,

personal significance, marks one of the three proximate goals Geahigan has set for critical inquiry, the other two being intentional understanding and aesthetic understanding. These three goals, outcomes of critical inquiry, in turn depend on the prior attainment of three kinds of objectives: (1) knowledge objectives (background information in the form of biographical and contextual information and aesthetic categories and concepts); (2) skill objectives (most prominent among them perceptual and critical-thinking skills); and (3) attitude and habit objectives (e.g., a welcoming attitude toward the subject and the habit of critical reflection). The original triad—intentional understanding, aesthetic understanding, and personal significance—correlates with the three focuses of the critical encounter: artist, work of art, and viewer.

How are Geahigan's goals and objectives to be achieved in the classroom? Generally speaking, through three sorts of activities: personal response activities, concept development activities, and student research activities. For Geahigan, personal response activities are of central importance, the starting point for and the validation of all subsequent art-critical learning. Solicitous attention to students' reactions is justified by the desired long-range outcomes of art education. It is not enough that students have the door to the art world opened for them; they should wish to take up residence in that world and continue to grow there. This will happen only when they gradually learn to value art for the significance and enlightenment it promises and for the pleasure of imaginatively exercising the intellectual faculties it affords. Simply put, personal response alone is able to motivate students and make their experiences with art meaningful. As Geahigan puts it, "Only if students achieve their own understandings and insights through observation and reflection will they gain access to the values to be derived from art."

A few additional remarks are apposite. Geahigan centers attention on perception as part of the mind's struggle to gain understanding; aesthetic gratification arises from the mental functioning characteristic of experience. Also noteworthy is Geahigan's tendency toward balance and moderation, although not at the expense of the primacy of the artwork or aesthetic concerns. Thus Geahigan appears to hold that a work of art may lend itself to several equally persuasive interpretations, but some can be rejected as clearly inapplicable, that is, not borne out by the work. Although students should be encouraged to respond freely to an artwork, they should also be required to support their conclusions with reference to features of, or facts about, the work (a point Wolff stresses when he says that a critical word in a critic's vocabulary should be "because"). Although personal responses are

indispensable in critical inquiry, they do not construct or constitute the work of art itself, thereby making the artistic artifact irrelevant. Geahigan further believes that although the selection of artwork for study may be influenced by a variety of considerations such as student interest or a wish to include work from other cultures, aesthetic merit should be the overriding criterion.

Finally, although Geahigan believes that art education serves students well only when it pursues aesthetic objectives (rather than political, ideological, or utilitarian ones), his approach could still contribute to certain salutary extra-aesthetic effects: The habit of critical reflection will stand people in good stead in many situations, the enrichment of the cognitive framework and the insights and understandings gained during critical inquiry will also enlarge and refine persons' dealings with the world around them, and the writing skills honed in personal response statements and essays as well as student research reports may help raise the level of general literacy. On these extra-aesthetic benefits of art criticism, Wolff and Geahigan are in complete accord.

What Wolff and Geahigan share is apparent and important for the unity of this volume. Yet some differences of accent and emphasis can be expected from a practicing art critic who is also a painter and an educational writer who has a theoretical as well as a practical interest in art criticism. Such differences, moreover, help to sharpen understanding of the slippery concept of criticism.

In contrast to certain views expressed in the literature of art education, Geahigan convincingly argues that although the criticism of contemporary is part of what constitutes art criticism, it cannot be the whole of it. Critical inquiry, which Geahigan takes to be the essence of art criticism, is applicable to any work of art, past or present, and his discussions of artwork from different historical periods amply demonstrates this point. Likewise, Wolff discusses not only contemporary but also traditional and modern art. Yet Wolff accents more strongly than Geahigan does the critic's responsibility to explain what contemporary artists are doing.

Geahigan's good understanding of contemporary theoretical work in the disciplines of art history and art criticism prompts him to see more overlap between these two disciplines than the separate volumes in this series might suggest. He is correct, for example, in stating that some contemporary historians of art write art criticism whereas some contemporary art critics discuss works of traditional art. Geahigan sees overlap not only between art history and art criticism but also between these two disciplines and the discipline of aesthet-

ics. There are strands of all three disciplines in much critical writing. The introductory volume in this series makes the same observation. A recognition of such overlap is also consistent with the principles of discipline-based art education itself, which posits interrelatedness among the disciplines of art making, art history, art criticism, and aesthetics. To restrict art criticism, or critical inquiry as Geahigan understands it, to inquiry into contemporary art would deny teachers and students access to rich accounts of works of art by critics who write about works of art from different historical periods.

With these observations in mind, any inconsistency that might seem to exist between Wolff's remarks and Geahigan's or between their remarks and the principles of discipline-based art education are more matters of accent and emphasis. Geahigan's understanding of art criticism is reasonable and practicable, and his chapters, along with Wolff's, make an important contribution to the literature of discipline-based art education.

Ralph A. Smith

Acknowledgments

Writers frequently bemoan the actions of their editors. I, on the other hand, feel nothing but gratitude for the actions Ralph Smith has taken on my behalf. Without his generous support and advice, a significant portion of what follows would not have seen the light of day.

T. F. W.

This project is the culmination of a long-standing interest of mine in art criticism and the problems of teaching criticism in the schools. I would like to thank the Getty Center for Education in the Arts for inviting me to undertake this project.

I am especially grateful to Ralph Smith, the general editor of this series. His astute guidance and unwavering encouragement and support throughout this project are deeply appreciated.

I would also like to thank students in my classes at Purdue University, from whom I have learned much over the years.

To my wife, Priscilla Cheng Geahigan, I dedicate the second half of this volume.

G. G.

The following have kindly provided permission to reproduce the photographs used in this volume (shorter citations are used in the text):

Figure 1. Beverly Pepper, *Hadrian's Wedge*. 1992–93. Cast Iron. 9'8" x 23" x 50". Fabricated at Fonderia d' Arte Salvadori, Pistoria, Italy. Exhibited at "Beverly Pepper: Altars and Sentinals" at the André Emmerich Gallery, New York, April 29–May 28, 1993. Reproduced in exhibition catalog. Photograph courtesy André Emmerich Gallery.
Figure 2. Joyce Treiman, *Rose IV.* 1985. Charcoal on paper. 30" x 22". Courtesy Schmidt • Bingham Gallery, New York.
Figure 3. Käthe Kollwitz, *Storming the Gate.* 1897. Etching on heavy

ivory wove paper. Private collection. Courtesy Galerie St. Eti-
enne, New York.

Figure 4. Anselm Kiefer, *Midgard*. 1980–85. Oil and emulsion on can-
vas. 142" x 237¾". Carnegie Museum of Art. Gift of Kaufmann's,
Women's Committee of the Museum of Art, and Fellows of the
Museum of Art. Photograph courtesy Richard Stoner.

Figure 5. Charles Sheeler, *Interior, Bucks County Barn*. 1932. Crayon on
paper. 15" x 18¾". Collection of the Whitney Museum of Amer-
ican Art, New York.

Figure 6. James Turrell, *Roden Crater Project*. Courtesy of the artist and
the Skystone Foundation.

Figure 7. Pablo Picasso, *Guernica*. 1937. Oil on canvas. 11'6" x 25'8".
Prado, Madrid. Giraudon/Art Resource, New York. Copyright
1996 Artists Rights Society (ARS), New York/SPADEM, Paris.

Figure 8. Jacob Lawrence, *Men Exist for the Sake of One Another. Teach
Them Then or Bear with Them*. 1984. Oil on masonite. 20¾" x 16¾".
National Museum of American Art, Smithsonian Institution,
Washington, D.C. Gift of the Container Corporation of America.

Figure 9. Frida Kahlo, *Two Fridas*. 1939. Oil on canvas. 69" x 69". Mu-
seo Nacional de Arte Moderno, Mexico City. Art Resource, New
York.

Figure 10. Parmigianino (Francesco Mazzola), *Madonna with the Long
Neck*. 1534–40. Oil on wood. 85" x 52". Palazzo Pitti, Florence. Ali-
nari/Art Resource, New York.

Figure 11. El Greco, *Portrait of a Cardinal* (probably Cardinal Don
Fernando Niño de Guevara [1541–1609]). 1541–1609. Oil on can-
vas. 67¼" x 42½". The Metropolitan Museum of Art, H. O. Have-
meyer Collection, Bequest of Mrs. H. O. Havemeyer, 1929.

Figure 12. Salvador Dali, *Apparition of Face and Fruit-Dish on a Beach*.
1938. Oil on canvas. 45" x 56.25". The Wadsworth Atheneum,
Hartford, Conn. The Ella Gallup Sumner and Mary Catlin Sum-
ner Collection Fund.

Figure 13. Édouard Manet, *A Bar at the Folies-Bergère*. 1881–82. Oil on
canvas. 37¾" x 51⅕". Courtald Institute Galleries, London, Great
Britain. Foto Marburg/Art Resource, New York.

Figure 14. Diego Velázquez, *Innocent X*. 1650. Oil on canvas. 55" x
47¼". Palazzo Doria Pamphili, Rome. Archivi Alinari/Art Re-
source, New York.

Figure 15. Georgia O' Keeffe, *Cow's Skull: Red, White, and Blue*. 1949.
Oil on canvas. 39⅞" x 35⅞". The Metropolitan Museum of Art.
Alfred Stieglitz Collection.

PART 1
Art Criticism and Its Uses

Introduction

For far too long, art criticism and art education didn't mix. Even today, some art critics insist that too great a discrepancy still exists between their discipline as they practice it and the way it is presented in elementary and secondary schools and institutions of higher learning. Such a view of art criticism is outdated and flawed. The theories and dynamics of art criticism have been studied in depth, and university and college art educators have extensively examined its potential for assimilation into a broadly based, multidiscipline approach known as discipline-based art education (DBAE). These developments have been dramatic and significant, and in the following pages I will demonstrate not only that art criticism has contributed substantially to the objectives of art education but also that it has much more to contribute.

I will try to bridge the gap that often separates critics and teachers by writing with a minimum of jargon, whether academic or professional, and a maximum of practical suggestions and advice. I've chosen to address myself primarily to those who bear the responsibility for bringing art criticism to the classroom. To these teachers and educators, I promise to be informal in approach, personal in voice, and as nonjudgmental as appropriate and possible in my conclusions. Discussions of art criticism will be open-ended and nontechnical. I will examine the distinctions between the various kinds of art criticism in the broadest possible manner and with the understanding that art-critical categories are never hard and fast; some of the best art critics are those who are able to adapt their critical strategies to the realities of the work examined.

What follows then is not an esoteric dissertation on art criticism but a practical discussion on why and in what ways that discipline can be of assistance to art education. Furthermore, my opinions are based on a belief that art criticism is as much about inducing others to realize their potentialities as it is about deciding which works of art are good, bad, or indifferent—and why. This is why I am so firmly, so emphatically convinced that art criticism's contributions to art education can be significant.

Although my remarks are intended for teachers who have the re-

sponsibility for developing an understanding of art, my perspective is that of a practicing art critic who also happens to be a painter. This fact influences the way I think of my responsibilities as a critic, as some of my examples of critical working will indicate. Because the term *criticism* has a number of associations and is subject to different definitions and accents, not all art critics share my values and beliefs. But what I do is not untypical. If my work has a special slant, it is that I think criticism has an inherently educative function and should take into account the needs and problems of both artists and the public. Such an approach to criticism is surely compatible with the idea of discipline-based art education.

In what follows, I will discuss the nature of art criticism and make recommendations for introducing art criticism into the classroom and provide some teaching tips, although the burden of this task falls to my coauthor, George Geahigan. His notion of critical inquiry, which also stresses an open, sympathetic approach to understanding works of art, is compatible with mine. One further note. At places in my discussion, I express the belief that art criticism can help young people become more imaginative and realize their creativeness. In saying this I do not intend that my remarks are directed primarily toward training young artists but rather toward students in a program of general education who are attempting to achieve a certain level of cultural literacy in making and appreciating works of art. I emphasize this point because some of my remarks about creativity might suggest that I have only studio exercises in mind. But that is not the case. The volume on art making in this series has the major responsibility for discussing the relevance of creative activities to understanding art, and readers may gain there a good impression of what art making can be like and the various traditions of teaching that enfold it. Before discussing some specific suggestions for introducing art criticism into the classroom, I'll discuss reasons for teaching art, basic types of art criticism, and the values and work of an art critic. This is the task of the next three chapters.

1

Art and Art Criticism

One of the most frequent complaints that teachers of the arts make is that the general public and the various media that report on art events don't understand the true nature of either the arts or arts education. These teachers point out that the prevailing media and public perception of the visual arts, music, dance, and theater is strictly limited to what is attractive, pleasurable, or entertaining. The arts are accepted as leisure-time activities that exist for diversion, amusement, relaxation, and occasionally—but only occasionally—for "inspiration." What that means is that the public ranks the arts very low on the list of subjects most valuable to children. It's all very well, as long as the budget remains stable, to teach youth how to paint pictures, learn what's good and bad in art, play musical instruments, and perform Shakespeare. But let the money begin to dry up, and chances are excellent that the first funds to be cut will be those for art education.

I bring this up not to bemoan a fact of life but to point out general opinion. Everyone advocates arts education to "enhance the quality of life"; there's never any doubt that arts education is "important," "vital," and "crucial to the future of our country's cultural life." No one argues, at least in public, against teaching the arts, and yet somehow, when the chips are down, support for the arts and for arts education is the first to go. The reasons for this vary, but at the heart of most of them lies either misunderstanding or indifference. It's the rare individual, even in the arts, who sees clearly beyond the ability of the arts to "inspire," "move," and "uplift." Everyone knows music, painting, drama, and the other arts can affect viewers and listeners in this manner. Should anyone doubt it, one need only display one of Rembrandt's late self-portraits, listen to a recording of Sir Laurence Olivier reading Shakespeare, or play Handel's "Hallelujah Chorus." Even very young children and unsophisticated adults can be deeply moved by these and similar works, and for those who love the arts they can create feelings that many describe as close to religious in depth and intensity.

When it comes to the question of why the arts can have such a profound impact, however, the public shows little interest and even less insight. The arts and their extraordinary capabilities are taken for granted or assumed to be too mysterious and ephemeral to be understood by any except a few dedicated specialists. Small wonder that the public is ambivalent about art education and that even a number of elementary- and secondary-level art teachers remains somewhat unclear about how—or why—art should be taught. If art is perceived as essentially ephemeral and mysterious and something that can neither be fully understood nor clearly defined, then what's the point of it except as a hobby and for the pleasure it can bring? Everyone knows how risky a career in the arts usually is and that one successful year by no means guarantees success the next. And most people are also aware that only a small fraction of those who choose one of the arts as a career can support themselves comfortably on the income from it.

No, there must be something else about the arts that makes them worth all the trouble and frustration they can cause, something that goes to the very heart of human existence and meaning and induces those who participate in their realities to feel not only that life is worthwhile because of the arts but also that it is profoundly meaningful and beautiful. Rudolf Arnheim suggests what this might be— and neatly pinpoints the importance of art education in the process— when he writes:

> I believe one can do no better than raise a question that is explicitly asked by a few persons but is implicitly faced by everybody sooner or later. It is the question of the ultimate goal of life. The practical objectives of a useful and gainful job, acting to the benefit of others, and entertaining oneself are readily defined and pursued. But there comes the time when all this seems temporary and one is faced with the revelation that the only sense there is to life is the fullest and purest experience of life itself. To perceive to the fullest what it means to truly love, to care, to understand, to create, to discover, to yearn, or to hope is, by itself, the supreme value of life. Once this becomes clear, it is equally evident that art is the evocation of life in all its completeness, purity and intensity. Art, therefore, is one of the most powerful instruments available to us for the fulfillment of life. To withhold this benefit from human beings is to deprive them indeed.[1]

I would go even further. I would say that art is humanity's deepest and most complex act of sharing. It gives shape and form to what moves and delights us most. The artist stands surrogate for us all. Artists create through who they are, and we respond through who we are. The work of art serves as an exchange and bridges the gap be-

tween individuals. To respond to art fully is to exist for a moment through the sensibilities of another.

The artist's sensibilities are the seeds of the world community. Their cultivation and growth guarantee the continued maintenance of civilization, of our ability and willingness to shape and share a better world. Without art, much of humanity would remain entombed within itself. The artist gives voice to common sources and experiences, creating a network of communication and respect. In a perfect world there would be no art, for it is the flawed and incomplete nature of individuals that calls it into being. Art is the imprint of life upon our consciousness and a facet of truth projected within a particular framework of comprehension. Every work of art is a clue to who we are, a reminder that we are always more than what we fear. The only defenses against art are arrogance and pride, the expressions of a smug and sterile self. Such a person hears no music, sees no painting, and reads no literature, for such things constitute a threat to the monuments they have made of themselves. Art is a state of grace before whose light we uncoil our secret selves and within which we receive promise of a greater whole. It asks nothing from us but our best.[2]

Such beliefs, written in 1979, still represent my feelings about art, although I would insert "and that we be ourselves" to the last sentence. If anything, I feel more strongly today about art's critical importance in daily affairs. I'm more convinced than ever that the quality of our lives, the depth and character of our values and ideals, and even the likelihood of our survival as a civilization depend to a significant degree on what art has to teach us about life, love, beauty, and, most of all, one another and ourselves.

I'm fully aware of the sensitive, even dangerous, ground I'm treading on here. To many of my peers, what I've written will sound like so much romantic nonsense. They will ask me to name one war that art has prevented, one catastrophe it has averted, and one tyrant it has blocked. And the more cynical among them will ask me to identify one individual I can prove became a better human being because of art. Of course, I can do none of that. I know of no war, no catastrophe, no tyrant that was stopped or thwarted by art, and I can present no positive proof—at least none that my colleagues would accept—that art, and art alone, was responsible for making anyone into a finer human being. Yet that no more undermines my conviction of art's profound and crucial importance in helping humanity achieve its highest goals than love's apparent failure to prevent wars and block tyrants causes me to think any the less of it as the greatest and most effective force for good.

I'm also aware that some believe it inappropriate for an art critic to voice such emotion-charged sentiments, especially in a book intended to advise teachers on how art criticism can help them teach art. My only possible response is that to write such a book without at least touching upon the significance and value of art would be to skim over the surface of the issue. It would be like painting a portrait and leaving out the eyes. It can be done, but there's not much point to it. Besides, why should the art critic remain detached and emotionally uninvolved? Is it even possible? Frankly, I doubt it. If anyone needs to be totally engaged in the realities and implications of art making and appreciation, to be immersed in the complex issues that lie at the root of art, it's the art critic. Without this engagement, this immersion, how can the critic enter deeply into the sources and dynamics of a work and its evolution from impulse or idea to final form? Or determine its true worth and quality?

By the same token, who is in a better position to help teachers gain a clearer insight into art's more complex and challenging realities? Or to help them understand the implications of not only the work of the great and famous but also of new, still untested paintings, videos, prints, photographs, and whatever floods the market at any one time? Art history can help them grasp the point and significance of art in the distant and recent past, aesthetics can help them confront fundamental questions about the nature and meaning of art, but only art criticism can take them to the art world's "front lines" and familiarize them with the ideas and issues that help fashion the more vital and adventurous art of the day.

One of art criticism's primary functions, then, is to identify, make comprehensible, and evaluate the newly created, no matter how strange, inartistic, or reactionary it might seem. To art critics, today's art must matter most; yesterday's art already belongs to art historians. To understand and feel comfortable with art produced five, ten, or twenty years ago is all very well and good, but at the same time, teachers or students who cannot come to grips with what is being fashioned now, at this very minute, will not have received the full benefit of what art criticism is uniquely qualified to provide.

Understanding Today's Art

But why, one might ask, is it so important to be concerned with the art of one's time? Isn't it enough to know and appreciate the art of recent years, the work of Picasso, Pollock, and Warhol as well as that of Cézanne and Van Gogh and of the Old Masters? What advantage

is there in involving oneself with today's confusing art world, with its conflicting passions and ideals and overproduction of work that may or may not be good—or even art?

The answer is simple. Like it or not, it is our art, the only art we have, and so it represents, for better or worse, our passions and ideals, our attitudes and values. If art is important to us, to ignore what is being produced by our most vital, imaginative, ambitious—and problematical—artists is to risk failing to understand something significant about ourselves. Good or bad, true or false—or somewhere in between—the very fact that some of it succeeds but most doesn't (and not necessarily for reasons of quality) tells us something about who we are, what we want, and the kind of society we see ourselves living within. In this context, an art critic is like a political analyst attempting to understand and clarify exactly what is going on in the world's trouble spots. It's all well and good, the analyst would argue, to know what happened in Rome or Berlin in the 1940s and 1950s, but it's much more important to know what's happening in those cities today.

Art teachers, because they work with young people who will be the consumers of tomorrow's art, need to be especially aware of the nature and content of the art of their time. They need not embrace it, but they had better understand it or they will be unable to guide students as they should. Familiarity with the art of the day gives teachers an additional frame of reference against which to view and discuss the work produced and studied in class. No matter how worthwhile and challenging the art of the recent past is, it no longer has the drama and tension associated with work still in the process of being conceived, shaped, and exhibited under highly pressured and critical gallery conditions.

It is this work in progress, in creative ferment, that often appeals to students. Their reaction to the provocative new work they see in art magazines, museums, and galleries is largely visceral and uncritical, similar to their response to rock music and other expressive aspects of their youthful culture.[3]

Getting Students to Examine New Art Critically

Getting students to examine new work with any degree of objectivity is invariably the responsibility of the teacher. No one else is in a position—or sufficiently interested or knowledgeable—to be of much help. If, however, the teacher is categorically opposed to, or unaware of, such work, a valuable opportunity to establish a vital

dialogue between student and teacher may very well be lost, or at least unnecessarily postponed.

Art criticism's involvement with art education should be a dynamic, ongoing process rather than an occasional and temporary infusion of critical insight and information. This sustained interaction becomes increasingly important once students begin to focus not on how something is done but on why they feel inspired or compelled to make or understand something one way and not another. That is a critical and challenging moment in the young student's life and almost certainly a difficult and challenging one for the teacher. It's at that point that individual self-awareness first makes itself known, and in a way and with an intensity that frequently cannot be denied. Unfortunately, it does so in a manner that is often as confusing as it is exciting. Dealing with this new dimension of awareness is seldom easy. It requires students to have faith and trust in their intuitions and abilities, and it requires of teachers unaccustomed depths of understanding, sensitivity, and tact.

Nurturing Imagination and Individuality

Nurturing imagination and individuality is an art; it means being sensitive to individual realities and knowing precisely when to be encouraging and supportive and when to be critical and firm. It is something that cannot be taught. Teachers are good at it because of a combination of skill, empathy, insight, and experience—with liberal doses of generosity of spirit and hard work thrown in for good measure. They have the knack of sensing what is individual and authentic—and the ability to draw it out. They neither dictate nor impose, but induce students to "discover" or to "become" themselves in whatever ways are most appropriate. In a discipline-based approach to art education, their ultimate objective is not to train professional artists but to educate well-rounded, fulfilled individuals, some of whom may find that art is the best way to give voice and form to their sense of self and what they might become.

To be sure, developing self-awareness is a slow, complicated, and, with some students, difficult process that needs and deserves all the help it can get. Not surprisingly, significant and quite specific support is available from art criticism, not so much from the aspect that categorizes and judges but from the side that approaches art making and appreciation with insight, sensitivity, and respectful attention and feels a genuine responsibility to stimulate and guide aesthetic growth. To those with particularly strong commitments to art criticism's more

supportive and generative side, the desire teachers have to touch and help activate what is most individual and special in students and see it emerge is understandable and familiar.

The Critic's Advantage

A critic's distinct advantage is the opportunity to examine and assess work that is considerably more advanced and sophisticated than student work. It may not all be of high professional caliber, but the character and objectives of most of it are clearly defined. Critics also generally have the background and experience—to say nothing of the time, skills, and opportunity—necessary for the kind of probing analysis that produces illuminating insights and significant evaluations. It seems only natural, given their common interests in discovering quality and activating individuality and imagination in others, that discerning, committed art teachers and art critics should understand each other and that the less professionally skilled of the two in matters of analysis and evaluation should find ways to accept and incorporate the insights and lessons the other can provide.

Art Criticism's Guidance and Support

Such help need be neither direct nor dramatic but can take the form of guidance or support: guidance in getting beneath the externals of art to its underlying meaning and worth and support for the belief that teaching young people to find fulfillment through art is both socially and personally worthwhile.

Confronted by a public that shows little understanding of what art and art education are about, art teachers can't be blamed for wondering occasionally if a lifetime commitment to helping children realize themselves through art is really worth the effort. At such moments they need only turn to art criticism, which, because of its generally rigorous and uncompromising insistence on quality and significance in art and its efforts to pinpoint and stimulate greater creative effort in emerging artists, can help them reaffirm their belief in the value of art and the efficacy of art education.

It can do so only if it is approached intelligently and with discernment and if its insights, methods, and examples are judiciously applied. The point, after all, is for art criticism to lend support, not to make things more problematical. Teachers have enough to worry about as it is. Teaching the young how to realize or fulfill themselves through art is not only the most estimable thing an art teacher can do

but also, in all probability, the most difficult and, by all accounts, the most challenging. And why not? Could anything be more challenging—or worthwhile—than getting children to realize what it means to be individuals, to feel, think, and express themselves as something other than shadows or extensions of others? To be independent and original? I think not—not even if one takes into account how vital a role art plays in this process of self-realization by being accessible to children of all ages and touching and activating them at their deepest, most generative levels of being.

The Teacher as Intermediary between Art and the Student

Art, after all, is impersonal. Even at its most provocative or seductive, it still requires—for younger children at least—a personal intermediary to explain or run interference for it. That's where the art teacher comes in—helped, to one degree or the other, by studio experience, aesthetics, art history, and, last but far from least, art criticism. Each of these disciplines has its own unique contribution to make even though it isn't always easy to determine precisely where the contribution of one ends and that of another begins. When it comes to alerting teachers on how best to detect and stimulate individuality and imagination, however, art criticism's contribution is unmistakable. It derives specifically from the discipline, and may have little or nothing to do with aesthetics or art history.

On its simplest, prejudgmental level, criticism is characterized by its insistence that a work of art—whether a child's or a mature artist's—be all of a piece and authentic, that it be structurally intact, and that it project the uniquely expressive voice of its creator in as direct, undiffused, and unambiguous a manner as possible. In the case of a young child of five or six, that seldom is a problem. Children, unabashed by the idea of creating art, permit their expressive energy to flow freely and unselfconsciously onto the paper or into the clay. In the case of someone older, however, say, twelve or fourteen, there frequently is a problem familiar to all teachers: how to discourage dishonesty of response in favor of authentic response, whether in learning to make works of art or in learning to understand them. That task should be less difficult since the art world has become more open to a range of artistic expression that formerly would not have been possible. More artists are being encouraged to find their own voices instead of being restrained by conventional standards, conformance to which risks inauthentic expression.

Students experience similar pressures to conform. This is where the dispositions and methods of critics can be helpful. Inasmuch as critics have comparable problems in their efforts to encourage young artists to search the fundamentals of their art and mode of expression, teachers can help students tap their inherently imaginative resources with the dispositions and methods of art critics. If anything is to be learned from the work of art critics, it is the challenge art criticism puts to artists to be authentic and not slaves to fashion. Art critics, for example, may try to induce young, emerging artists to peel away layers of artificial and false starts that had accumulated over the years and adversely affected creative growth. A judgment of an artist's later work may state that the individual had not realized certain potentialities that seemed inherent in earlier work but were never quite realized. Artists and writers alike often experience a falling off and inability to maintain a certain level of accomplishment.

In some respects, a teacher's challenge is more complex, as Henry Aiken has pointed out in an interesting discussion of the conditions for understanding, appreciating, and teaching art. A critic is not responsible for motivating the young in contexts that are often frustrating and inimical to learning. Yet in one major respect their task is fundamentally the same: to bring viewers closer to the distinctive being of works of art. Of the teacher of art, Aiken observes, "Making continent use of all these resources of understanding . . . his whole vocation is to bring his students to fuller awareness of the continuous evidences in works of art of the creative life which comprises one primary level of every man's own subjective being or actuality."[4] That says it precisely.

Granted that not all critics are concerned to call attention to individual strokes of genius, I agree with Aiken that the purpose of teaching art is to bring students to a greater understanding of how art reflects the creative life in all persons. I further agree with Aiken that teachers, in bringing to life the creative energy of works, convey through their presence, talk, and gestures "an awareness of what it is to look for true possibilities in a work of art, what it is to find a significant artistic form, and what it is to develop an authentic taste."[5] I assume that coming to appreciate the inherent creativity in human nature can be achieved through developing an understanding of both art making and appreciation. In such ways do students learn to differentiate between the genuine and the meretricious in art—and in themselves.

I have described the task of teachers in developing authentic learning in relation to the cultivation of self-awareness and self-realization

in connection with making and appreciating art. A concomitant development of such teaching and learning is the sharpening of reflective intelligence, a point emphasized in much of the literature on discipline-based art education. In such literature, art is understood as a special kind of knowing or exercise of intelligence. The strengthening of critical reflection through art is highlighted by D. N. Perkins, who provides excellent reasons for teaching art and describes how art criticism can develop reflective thinking. Works of art, he notes, are ideal for fostering critical thinking in several respects: They are inherently interesting and accessible, invite personal engagement and sustain attention, encourage puzzle-solving, appeal to various dimensions of human experience, stimulate a range of mental processes, and provide a model for interpretive efforts.[6]

Curiosity and Self-Criticism

It's important for students to learn to distinguish the genuine from the spurious in art and in their own making and understanding of art. Most artists, for example, have been their own best critics. Yet acquiring such critical insight is not a simple matter. It is a problem that besets older as well as younger students. It's never easy to be objective about one's own efforts, especially if the roots of those efforts remain at least partially buried and their reasons for being are only half understood. Young people, in order to achieve critical self-awareness of art, its making and products and of their own impulses and motivation and those of others, must develop a disposition to be curious. Some degree of curiosity is easy enough to provoke. It can be stimulated during individual studio critiques or less directly during classroom discussions in which provocative modern or contemporary works of art are analyzed in terms of structure, concept, and overall objectives. Here, art criticism can lend a helping hand, not only with specific examples of critical analysis directly related to the works under discussion but also with insights and techniques that have proven useful to critics in pointing out formal or thematic inconsistencies, or confused or apparently contradictory motivations, in artists of talent and promise.

These insights and techniques—the majority of which deal with ways to alert artists to the necessity of reexamining their creative premises and procedures—are demonstrated in the writings of several outstanding critics. The names of Hilton Kramer, Dore Ashton, Donald Kuspit, Robert Pincus-Witten, Thomas Lawson, Lucy Lippard, and Carter Ratcliff come to mind, as do those of Clement

Greenberg, Thomas Hess, and Harold Rosenberg from earlier decades. None of these critics feels—or felt—that art criticism necessarily bears a heavy educational responsibility and yet their writings have proven valuable in a variety of educational contexts. They are not the only critics with this ability, however. Most responsible art critics have the capacity to do much the same thing but with varying degrees of success. The majority deserve to be read and studied for what they can teach and warn against. Their writings and examples can be of considerable help to teachers wishing to develop greater insight into works of art and discover how best to help students develop critical self-awareness.

Translating Critical Insights into Educational Techniques

What is learned from critics must be translated into educational terms before it can be applied in the classroom. Here, art criticism can be of relatively little help, for it is the rare art critic who has taught in either an elementary or secondary school. Some of the best critics do teach, but only on a university or college level and then in specialized academic areas. Their focus is often on the discipline of art criticism itself. In fact, this makes what they teach and write of particular interest to teachers who do have the necessary experience and imagination to translate their ideas and suggestions into practical, everyday art-educational methods and techniques.

For art teachers, a critical theory or device is only as good as the art it helps students make or the insights and perceptions it engenders. Their experience has taught them to be wary. They know that imaginative accomplishment is an elusive force that can appear where least expected—and can disappear as unexpectedly. They also know that looks can be deceptive, that what seems to be art may be a sham, and what seems to be ugly may actually be art. But most of all, they are aware that whatever causes students to feel good or more alive while studying art is, in all probability, valuable and true.

These teachers customarily take a direct and practical-minded approach to art education. They suffer neither fools nor false authorities gladly, and they do their best to ignore rules and theories that inhibit learning and suppress curiosity. Their goals are clear if not always attainable: to challenge, incite, cajole, entice, persuade, or inspire students to the best possible understanding of which they are capable—and to cause them to become more sensitive, perceptive, and fully realized individuals in the process.

Fulfilling the Teacher's Educational Obligations

One cannot ask more of art teachers than what I've just suggested. By attempting and frequently succeeding in this task, they not only fulfill their professional obligations but also make it possible for art to do what it can best do for children: alert them to themselves as individuals capable of giving voice and form to whatever has meaning for them, both in the world around them and in their inner world. Teachers will probably not manage it all by themselves. At some time or other they may well receive assistance from art criticism. For a number of teachers, that assistance will be negligible—or so it will appear. For others, especially those who understand art criticism and know how to make it work for them, it may well be considerable. In addition, there will be times when its contributions are almost indistinguishable from those of aesthetics and even of art history. But that doesn't matter. What does matter is that the discipline is able to provide not only insights and methods dealing specifically with the art-critical process and with how it can be brought into the classroom but also guidance and support in the often very difficult process of helping young people develop self-understanding through art.

It will probably come as a surprise to many that art criticism, which appears so purely judgmental on the surface, is capable of providing this kind of support and guidance. Such assistance is possible because critics tend to keep their distance from the rest of the art world and avoid public discussions of their work and how they do it. Something else must also be considered, however. Artists and various other individuals often feel uncomfortable in the presence of critics and at times tend to attribute a certain coldness and lack of feeling—even a touch of cruelty—to them.

That is unfortunate and generally untrue. The majority of art critics are open and generous. Those who appear aloof and arrogant may only have adopted those attitudes to protect themselves from the many demands made upon them by artists, dealers, and curators who are in a position to benefit substantially from the critics' favorable opinion of what they do. It is not only the literature of art criticism that is accessible to art teachers; art critics themselves are frequently available for specialized advice and guidance. That should always be kept in mind when considering the ways in which art criticism can be of use to art educators and teachers. Reading and analyzing art criticism is certainly helpful, but direct contact with an art critic can, at times, be even more so.

In the following chapters I will offer suggestions for introducing

and teaching art criticism in the classroom, suggestions that stem not only from my experience as an art critic writing for newspapers and magazines but also from working with young people in various venues, including sessions sponsored by the Getty Center for Education in the Arts. I leave to my coauthor, George Geahigan, the spelling out of a systemic framework for defining and teaching critical inquiry in the classroom.

NOTES

1. Rudolf Arnheim, *Thoughts on Art Education* (Los Angeles: Getty Center for Education in the Arts, 1989), 26–27.

2. From *The Christian Science Monitor*, 25 January 1979, 20.

3. In *Criticizing Art: Understanding the Contemporary* (Mountain View, Calif.: Mayfield Publishing, 1994), Terry Barrett provides a discussion of contemporary art for an educational audience.

4. Henry Aiken, "Learning and Teaching in the Arts," *Journal of Aesthetic Education* 5 (October 1971): 59.

5. Aiken, "Learning and Teaching."

6. D. N. Perkins, *The Intelligent Eye: Learning to Think by Looking at Art* (Los Angeles: Getty Center for Education in the Arts, 1994), ch. 9.

2

Types of Art Criticism

More specifically, what is art criticism? What does it do? What kinds of art criticism exist today? And how is each kind of criticism distinctive? This chapter addresses these questions. First, however, one matter—the difference between art criticism and art reviewing—needs to be clarified, for it affects much of the discussion in this and subsequent chapters. An art review is a fairly straightforward description of the work on exhibit, often with little or no judgment or explanation, generally followed by a recommendation for or against seeing a show. Art criticism, on the other hand, is more concerned to assess a work's quality and significance on the basis of clearly established and identified critical criteria and then explain how it arrived at its conclusions. A critic's intellectual and aesthetic orientation plays a significant part in all this.

Good critics let readers know exactly where their commitment lies and the context within which they make judgments. Not surprisingly, considering the diversity of our art and the complexity of our culture, these contexts can vary dramatically. Their differences, in fact, form the basis for the various kinds of art criticism practiced in the United States today. Examining these varieties of criticism and the ways they affect a critic's approach and judgment can provide valuable insights into the range, flexibility, and seriousness of commitment to the study and evaluation of art in all its manifestations. Equally important, it can alert art educators to the rich resources available in the literature of art criticism.

Three Types of Art Criticism

In the very broadest sense, there are three basic types of art criticism: diaristic (also known as emotive, impressionistic, or autobiographical criticism), which features the subjective sensations and personal impressions of a critic; formalist (also known as internal, intrinsic, or aesthetically autonomous art criticism), which features the

properties and qualities of artwork; and contextualist (also known as art-historical, psychoanalytical, and ideological criticism), which stresses the factors or forces responsible for a work's assuming a particular shape or having a special meaning. When reading art criticism it is helpful to know whether a critic is talking about his or her personal feelings, in which case we may learn a great deal about the critic but not necessarily about the work under discussion; about the work of art itself, that is to say its sensuous, formal, expressive, and symbolic aspects; or about the conditions responsible for bringing a work into being, whether historical or psychological. In practice, these kinds of criticism are often not rigidly separated: No critic practices one or another exclusively, and even the most doctrinaire critic must, at times, incorporate elements from the others into a critique. Each type of criticism has historical precedents, but I will concentrate on examples from the nineteenth and twentieth centuries.

Diaristic Art Criticism

Diaristic criticism is the most common and the most informal kind and in many ways the most difficult to write. If not well done, it tends to be quite loose, overly personal, and even given to gossip. But when well managed it can read like a detailed entry in a diary or like a warm, perhaps impassioned, letter from one friend to another. A key to the character of diaristic criticism is the use of the personal pronoun *I* to establish identity and credibility and justify the highly subjective nature of this kind of writing. At its most casual, a diaristic critique may begin by saying, "I finally got out of my apartment and walked over to West Broadway to see what Mary Boone is showing in her gallery these days." Or, "I saw some mind-boggling canvases at the Guggenheim Museum this afternoon." Much art reviewing seldom rises above this level of writing. But in the hands of a sensitive critic, a personal, impressionistic approach can be both effective and rewarding, attracting readers to the deeper and more significant goals of art criticism.

Diaristic criticism arose in the nineteenth century as a reaction to criticism that concentrated too exclusively not only on the biography and personality of the artist and the social and historical conditions of art but also on a style of criticism that abided by the strict rules of the official artistic academics of the time. In contrast to official criticism, which any intelligent critic can apply once the rules are known, critics such as Oscar Wilde, Anatole France, and Walter Pater emphasized the subjectivity of criticism. Writing against standards of objec-

tivity in criticism in favor of emotive expression, Oscar Wilde observed that what critics require "is a certain kind of temperament, the power of being deeply moved by the presence of physical objects." Anatole France echoed a similar sentiment when he said that criticism consists of describing "the adventures of one's soul among masterpieces." And Walter Pater asked perhaps the central question of emotive criticism: "What is this song or picture, this engaging personality presented in life or in a book, to *me*? What effect does it really produce in me? Does it give me pleasure? And if so, what sort or degree of pleasure?" That diaristic criticism is a perennial and basic form of criticism is evident by the statements of a number of contemporary art critics. Donald Kuspit, for example, thinks a critic's task "is to try to articulate the effects that the work of art induces in us, these very complicated subjective states"; Robert Pincus-Witten stresses the need of critics for empathic identification with artists and believes that a critique of a work of art is as much a work of art as the work being criticized; and Joanna Freuh, a feminist critic, sets store by the importance of intuition and bodily sensations.[1]

The two examples of impressionist criticism that follow stand for many others; one is by Pater and another is by Pincus-Witten.

Pater was associated with the Pre-Raphaelite movement in Great Britain, a secret brotherhood that rebeled against the stereotypical medievalism and dry subject matter of the academic painting of the period. He became known as an apostle of aestheticism, a doctrine that places great importance on the enjoyment of aesthetic experience. This is evident in his discussion of Leonardo da Vinci's *Mona Lisa*.

> Hers is the head upon which all "the ends of the world are come," and the eyelids are a little weary. It is a beauty wrought out from within upon the flesh, the deposit, little cell by cell, of strange thoughts and fantastic reveries and exquisite passions. Set it for a moment beside one of those white Greek goddesses or beautiful women of antiquity, and how would they be troubled by this beauty, into which the soul with all its maladies has passed! All the thoughts and experience of the world have etched and molded there, in that which they have of power to refine and make expressive the outward form, the animalism of Greece, the lust of Rome, the mysticism of the middle age with its spiritual ambition and imaginative loves, the return of the Pagan world, the sins of the Borgias. She is older than the rocks among which she sits; like the vampire, she has been dead many times, and learned the secrets of the grave; and has been a diver in deep seas, and keeps their fallen day about her; and trafficked for strange webs with Eastern merchants: and, as Leda, was the mother of Helen of Troy, and, as Saint Anne, the mother of Mary; and all this has been to her but as the sound of lyres and

flutes, and lives only in the delicacy with which it has molded the changing lineaments, and tinged the eyelids and the hands. The fancy of a perpetual life, sweeping together ten thousand experiences, is an old one; and modern philosophy has conceived the idea of humanity as wrought upon by, and summing up in itself, all modes of thought and life. Certainly Lady Lisa might stand as the embodiment of the old fancy, the symbol of the modern idea.[2]

Art criticism has had no better aesthete than Walter Pater. But the diaristic tradition continues in the writing of Pincus-Witten. Especially noteworthy are the entries in his journal, selections from which appear in a volume representing twenty years of his criticism. Here is an entry dated October 10, 1982, about the painter Julian Schnabel.

Visiting the Mary Boone Gallery. Julian Schnabel has been painting there for a month now by way of opening the season. All mystery and exigency. The exhibition reflects all the pent-up anxieties attendant upon "the second novel." Since Julian had a family obligation in Boston that day, he left word that I might visit. I found the installation in the spattered all-white gallery—even the floor—a sensation. Like all romantic effort the exhibition needs pruning. When the works work, when Julian is painting at the height of his powers, the works are glacially perfect; conversely, depths are abysmal. Things will sort themselves out quickly though. Schnabel remains one of the very few interesting painters I know. And the heights are there.

The Raft is a huge plate painting, crockery silvered over to represent the shimmer of water. A cast bronze Christmas tree (and how complex was the gating for that pour?) stands as proportionately high off the surface as Duchamp's bottle cleaner from the background of his *Tu'm. The Raft* echoes with the violence of Géricault, as well as its realism, and the independent American-mindedness of Twain—Life on the Mississippi. Its single bronze tree invokes the three Christmas trees of Beuys's incarcerated Russian winters—as seen in *Snowfall,* the great work preserved in Basel.

The other relief painting is an untitled altar—a huge antlered bronze cross manacled to a painted backdrop. The work is too carbuncled. The imagery, such as it is, is indecipherable—intensifying the Carolingian book cover-like character of the work. Religious intention it has—what with a triptych-like composition and altarpiece organization. This is the part of Schnabel that exalts Michael Tracy: Schnabel as decorator. But sincerity is invisible.

Apart from these works, Schnabel is attempting a kind of feverdream painting of liberated unself-consciousness, dredging paint and image together. By moments he attempts to keep color fresh (often unsuccessfully), as fresh as his desire to ride out his heated jet of inspiration. Colors go murky owing to frenzied revision—painting under

fire—painting hovering just at the edge of respectability. It is a kind of dizzying aerial gymnastic, not so much as without a net below as wanting the very wire above—though this thread may be the disguised untrammeled verge-imagery itself.[3]

The combination of informality, gossip, pointed observation, apt association, and metaphor is characteristic of diaristic criticism. Although I do not always agree with Pincus-Witten's judgments (especially about Schnabel) and have misgivings about his belief that a critique is as much a work of art as the work that inspired it, I am sympathetic to his sentiment that critics should know artists and try to understand their concerns and intentions as much as possible. I prefer to leave gossip to the gossip columnists, however. To repeat, in the hands of accomplished writers who have clear insight into art, a knowledge of its history, and a flair for perceiving relations, diaristic criticism provides an alternative to art reviewing that merely skims the surface of the works and reveals little of the quality of a critic's experience of a work.

The chief drawback of diaristic criticism is its tendency to draw attention away from the artwork to the critic, whose literary account often upstages the work being discussed. Moreover, by eschewing principles of judgment and explanations of why given works are particularly meritorious, it opens the door to the expression of mere opinion. In doing this, diaristic criticism loses much of its educative value, that is, the disciplinary value inherent in coming to terms with the complexity of works of art. Granted that criticism has numerous functions, it is reasonable to expect that a critic will at least point out what is actually in a work to enjoy.

Formalist Art Criticism

It was because of their greater appreciation of art objects that formalist art critics gained increasing influence in discussions of modern art. Attempting to counteract excessive historicizing and psychologizing, critics such as Roger Fry and Clement Greenberg insisted that the form in which a work is conceived and realized is of utmost importance. Such conception and form determine artistic quality and significance, and art criticism that doesn't do justice to the formal quality of artwork is a failure. This is particularly true of writing about modernist works from roughly the mid-nineteenth century on, which heralded a dramatic change in artistic expression. Formalist critics maintain that modern art from Cézanne and Seurat to the cubists and

abstract expressionists and on to the geometric and reductive paint-
ers of the mid-twentieth century cannot be discussed properly with-
out a detailed analysis of form.

They also insist that structural analysis must lie at the heart of crit-
icizing not just work reflecting strict formalist ideas but work mirror-
ing the wildest excesses of the imagination. In fact, if a work resists
formal analysis, that in itself can be taken as proof that it certainly isn't
art. Compare a finger-painting by a chimpanzee with a superficially
similar abstract-expressionist canvas by Hans Hofmann and the
chimp's picture will rapidly prove to be structurally incoherent—
hence not art—whereas the Hofmann will reveal the presence of both
intention and method behind the apparently undisciplined wildness
of the artist's paint handling. Intention and method count most here.
The former, activated and given form by the latter, proves the exist-
ence in artists of a level of intelligence and concern dramatically high-
er than that evidenced by the chimpanzee. Form thus becomes the
prime clue to the nature and depth of artists' creative intentions and
to the vision, feeling, idea, or experience they wish to shape and com-
municate. To formalist art critics, therefore, Hofmann's formal meth-
od not only represents the artist's perceptions of the nature and mean-
ing of life but is also a personal, finely honed verdict on reality.

Small wonder then that formalist critics place so high a premium
on the ways artists "package" their ideas. And small wonder that
Roger Fry, the distinguished English art critic and writer who did so
much to explain modernism to a skeptical British and American pub-
lic during the early decades of this century, placed such great empha-
sis on "significant form" in his writings about modern artists. Form,
if it wasn't always everything, was close to it for writers such as Fry,
Clive Bell, Clement Greenberg, and Erle Loran, whose *Cézanne's Com-
position* (1943) caused an entire generation to rethink Cézanne in terms
of how he constructed his paintings.[4] Examples of the critical com-
mentary of Fry and Greenberg will convey the character of formalist
criticism.

Fry was the leading critic of the first third of the twentieth centu-
ry. His career included, in addition to critical writing, the study of
science, the holding of a museum directorship, and the editing of a
magazine. Kenneth Clark has said of Fry that insofar as the taste of
an era can be changed by any one man, it was changed by Roger Fry.[5]
At point here is Fry's discovery of the art of Cézanne, which persuad-
ed him that the defining features of visual art were its plastic and
formal qualities. Such qualities are highlighted in his description of
Cézanne's *Card Players*. Fry writes that Cézanne

seems to have carried the elimination of all but the essentials to the furthest point attainable. The simplicity of disposition is such as might even have made Giotto hesitate to adopt it. For not only is everything seen in strict parallelism to the picture plane, not only are the figures seen in almost as strict a profile as in an Egyptian relief, but they are symmetrically disposed about the central axis. And this again is, as it were willfully, emphasized by the bottle on the table. It is true that having once accepted this Cézanne employs every ruse to render it less crushing. The axis is very slightly displaced and the balance redressed by the slight inclination of the chair back and the gestures of the two men are slightly, but sufficiently varied. But it is above all by the constant variation of the movements of planes within the main volumes, the changing relief of the contours, the complexity of the color, in which Cézanne's bluish, purplish and greenish greys are played against oranges and coppery reds, and finally by the delightful freedom of the handwriting that he avoids all suggestion of rigidity and monotony. The feeling of life is no less intense than that of eternal stillness and repose. The hands for instance have the weight of matter because they are relaxed in complete repose, but they have the unmistakable potentiality of life.[6]

Fry further remarks that the gravity of *The Cardplayers* is reminiscent of some monument of antiquity or of the monumentality achieved in the paintings of the Renaissance master Giotto. And particularly relevant to our current situation in culture is that Fry's appreciation of the formal qualities of Cézanne and the Postimpressionists resulted in his developing a fondness for African and Asian art, a fact that multicultural critics of Fry's formalism usually fail to point out.

For another example of insightful formalist criticism consider the observations of Greenberg, a contemporary American critic whose influence in persuading others to see the qualities of modern and contemporary art rival Fry's accomplishment in educating viewers to the values of Postimpressionist painting. To dip into Greenberg's collected essays and criticism is to be reminded just how insightful and effective good art criticism can be and of how clearly and unpretentiously it can be written. Just as important, Greenberg shows us that it is possible to be both brief and to the point. His November 1942 account of a Morris Graves exhibition is exactly 154 words long, beginning with: "Gouaches. At the Willard Gallery. Graves's works almost exclusively in gouache on paper. He takes most of his motifs from zoölogy and embroiders them decoratively—birds, snakes, rodents and the like." And his last sentence sums up one attribute of this particular artist clearly and precisely: "He generates power out of lightness and fragility—that is, in his best work."[7]

Nothing could be simpler or shorter, and yet this brief essay says just about everything that could be said about Graves in 1942. Most of what we know of Graves today, especially his profound commitment to Eastern thought and religion, didn't become clear until later. Besides, Greenberg, a formalist art critic, would have paid little attention to Graves's metaphysical subject matter, no matter how important it was to Graves or to his collectors. Thematic content, Greenberg would have argued, has no real bearing in matters of artistic judgment. It is a purely subjective and irrelevant element and thus plays no significant role in art criticism, which must at all times remain objective and focused on formal matters.

Readers may have noticed, however, that this particular piece reads more like an art review than like a piece of art criticism. It is primarily descriptive, and although it does, elsewhere in the essay, predict a great future for Graves, it does so casually and without clearly defined critical justification. I selected this example, however, more for its brevity, simplicity, and straightforwardness than for its demonstration of a particular critical principle. Considering that Graves's work has always tempted critics into overwriting, Greenberg's cool and somewhat detached approach is especially noteworthy. Compared to the majority of his longer and more critically incisive writings—especially those on the abstract expressionist and color field painters—this is a very minor example. And yet it accomplishes precisely what it set out to do and in exactly the number of words needed—no more and no less.

One might argue that Greenberg's formalist approach is totally inappropriate for an analysis of Graves's profoundly subjective, even elusive, paintings and drawings. These, as I have written elsewhere, "seem more to have sprung spontaneously into being, or to record fragile evidence of the passing overhead (or within) of intangible but profoundly real and mysterious forces, than to have come about as the result of professional artistic concerns." If that is so, and if it is also not incorrect to say "Graves hunts and fishes for evidence of the divine," then how can a formalist art critic like Greenberg possibly understand or have anything worthwhile to say about an artist like Morris Graves?[8]

Greenberg can write perceptively about Graves because he probes beneath the surface drama or attractiveness of a work to what he considers its objective, definable core, its purely formal identity, and then examines it strictly in the light of how successfully impulse and idea were translated into expressive form. In Graves's case, Greenberg obviously realized that even that artist's most elusive and ephemer-

al paintings were grounded in sophisticated formal realities and that he was an artist of significant form as well as provocative themes.

A somewhat more formal analysis is found in Greenberg's critical essay on Piet Mondrian, which appeared on March 4, 1944:

> Mondrian's painting . . . takes its place beside the greatest art through virtues not involved in his metaphysics. His pictures, with their white grounds, straight black lines, and opposed rectangles of pure color, are no longer windows in the wall but islands radiating clarity, harmony, and grandeur—passion mastered and cooled, a difficult struggle resolved, unity imposed on diversity. Space outside them is transformed by their presence. Perhaps Mondrian will be reproached for the anonymity with which he strove for the ruled precision of the geometry and the machine in executing his paintings: their conceptions can be communicated by a set of specifications and dimensions, sight unseen, and realized by a draftsman. But so could the Parthenon. The artist's signature is not everything.[9]

Beautifully put—and so succinctly written. Whether or not one agrees with Greenberg's theoretical position—and his more recent writings have been come under severe attack since the 1970s—the main body of work still makes most other critics appear woolly and unclear. Even for those who cavil at his critical judgments, his place in mid-twentieth-century American art history is secure. More than any other writer, he has kept American art critics on their toes.

Although formalist criticism can be extremely helpful in discerning the structural qualities of works of art, its chief limitations are twofold. In slighting the subject matter of works of art, it fails to take into account what attracts many people to art in the first place and gives insufficient attention to the ways the interactions of medium, form, and subject matter contribute to the content and expressive power of a work. These limitations were the consequence of the formalist's project to return interest to the object, a project that was in effect a protest against types of criticism that showed more interest in contextual considerations than in aesthetic values. George Geahigan has more to say about the limitations of formalism in his chapters.

Contextualist Art Criticism

Contextualist art criticism goes by various names and tends to be associated with the interpretive perspectives of different disciplines, for example, art history, sociology, and psychoanalysis. I will discuss three kinds: art-historical criticism (or, more specifically, criticism

written by art historians), ideological (sociopolitical) criticism, and psychoanalytical criticism.

Art-Historical Criticism

The topic of art-historical criticism in the conventional sense has been well covered by Stephen Addiss and Mary Erickson.[10] Art historians, however, often function as art critics, and on such occasions their art-historical methodology is less in evidence. Because any good critic thinks and writes with a sense of art's history, one can expect that in their art-critical moments art historians will have something worthwhile to say about works of art as art. An illuminating example of an art historian addressing a work of contemporary art as a critic is Leo Steinberg's attempt to come to grips with the early work of the American painter Jasper Johns, in particular Johns's *Target with Four Faces* (1955). I have great sympathy with Steinberg's approach to criticism, for it exemplifies the honesty and openness to a work that George Geahigan and I share. It is an excellent example of art-critical inquiry.

In discussing the work of Johns, Steinberg reflects on the plight of anyone who is suddenly confronted with a new style that disturbs conventional habits of viewing. Steinberg himself, for example, experienced discomfort and uneasiness upon encountering Johns's work. Initially, he found it boring, depressing, and puzzling. After all, the paintings consisted essentially of numbers, letters, the American flag, and targets, and a wooden drawer extended from the canvas of one. He resented being forced to digest such ostensibly unrewarding content. In *Target with Four Faces*, for example, he could detect no artistic illusion, no metaphorphosis of subject, and no magic of medium. The target existed point blank and nothing else. Yet the art world had conferred artistic status on it by virtue of exhibiting it. Steinberg nonetheless resisted the Philistine tendency to dismiss new and different art out at hand, even though the work ostensibly rejected much that he cherished in art.

Prolonged scrutiny and probing of Johns's work eventually yielded a hypothesis about its character. Steinberg speculated that *Target with Four Faces* conveyed an air of mindless inhumanity and indifference; it seemed to obliterate normal human expression and relations. It was as if a feeling of desperate waiting pervaded the work that suggested a poignant absence from a humanly made environment. The human quest appeared bankrupt. Such an interpretation Steinberg hardly found inspiring. But what I want to point out is his questioning disposition.

What I have said—was it *found* in the pictures or read into them? Does it accord with the painter's intention? Does it tally with other people's experience, to reassure me that my feelings are sound? I don't know. I can see that these pictures don't necessarily look like art, which has been known to solve far more difficult problems. I don't know whether they are art at all, whether they are great, or good, or likely to go up in price. And whatever experience of painting I've had in the past seems as likely to hinder me as to help. I am challenged to estimate the aesthetic value of, say, a drawer stuck into a canvas. But nothing I've ever seen can teach me how this is to be done. I am alone with this thing, and it is up to me to evaluate it in the absence of available standards. The value which I shall put on this painting tests my personal courage. Here I can discover whether I am prepared to sustain the collision with a novel experience. Am I escaping it by being overly analytical? Have I been eavesdropping on conversations? Trying to formulate certain meanings seen in this art—are they designed to demonstrate something about myself or are they authentic experience?

They are without end, these questions, and their answers are nowhere in storage. It is a kind of self-analysis that a new image can throw you into and for which I am grateful. I am left in a state of anxious uncertainty by the painting, about painting, about myself. And I suspect that this is all right. In fact, I have little confidence in people who habitually, when exposed to new works of art, know what is great and what will last.[11]

What is significant in Steinberg's interpretation, apart from the fact that it illustrates the art historian's capacity for criticism of contemporary art, is not only his honesty but also his capacity for sympathetic understanding. He set aside personal bias and prejudice as much as possible in order to see Johns's work as it actually was. The educative value of such an approach is obvious. Steinberg's remark that a knowledge of art history was more of a hindrance than a help should not be taken too seriously; without such knowledge he would have been less able to perceive what was absent from Johns's work. Such knowledge also enabled him to anticipate the potential impact of Johns's work on future art. Art criticism by art historians then differs from conventional art-historical scholarship, which is more concerned to study works of art as they exist or evolve within a tradition.

Psychoanalytical Art Criticism

Another kind of contextualist art criticism directs attention less to the personal sensations expressed in the aesthetic experience of a work of art or to its social and historical antecedents. Rather, it speculates about the unconscious psychological motives of artists and the

Not anymore

hidden symbolic import of their works. A classic psychoanalytical study of art is Freud's interpretation of Leonardo da Vinci's work, but my illustration is Ellen Handler Spitz's psychoanalytical interpretation of the work of the Belgian surrealist René Magritte. In a survey of Magritte's life and work that highlights characteristic themes and interests, Spitz arrives at a consideration of *The Listening Chamber* (ca. 1944). The work, she says, seems to be a hallucination that consists of a giant apple in a crowded room barely able to contain it. Remarking the presence of apples in a number of Magritte's works, Spitz observes that normal relations of distance and scale are suspended once more.

> Claustrophobic sensations are evoked by the enormous fruit, and the relative scale suggests a tomb, an association strengthened by the title of a related painting, *The Tomb of the Wrestlers* (*Le Tombeau des lutteurs*) of 1960 and only weakly disavowed by the presence of an open window. Here, as always, *the apple fails to gratify*—this time not only because it is too close but because it has preempted all available space; there is simply no room for anyone or anything else. Again, the strangeness of this image betokens a return of the repressed, perhaps in the form of an infantile experience when the breast, the source of oral pleasure, appeared to have such mammoth proportions that it threatened to overwhelm and smother the baby, rather than to gratify. Panic, helpless rage, and the passivity of infancy mingle with the associations of the tomb—a convergence of beginnings and endings that has special personal meaning for Magritte and also a long tradition of linkage to Eve's tempting but dangerous apple. Here the title, *The Listening Chamber*, underscores the enforced passivity of infancy by focusing on hearing—sound being, more difficult to avoid than sight—and by adumbrating typical synaesthetic experiences of infancy, when oral, visual, spatial, and auditory sensations, both inner and outer, are conflated.[12]

Thus do ideas and sensations enter into the experience of Magritte's painting and yield unsuspected meanings. A sympathetic understanding of Magritte and his work and a knowledge of psychoanalysis combined to uncover hidden significance.

Steinberg might question, as he did in discussing Johns's *Target with Four Faces*, whether such interpretations are the result of overworked imaginations or of theory stretched too far. Are not works of art in danger of becoming mere counters in theoretical parlor games? What is worth noting in Spitz's writing is a good measure of Steinbergian openness to possible alternative interpretations. She believes that closure, the ultimate solving of a profound artistic puzzle, is not the goal. Criticism meanders in an intermediate space where the critic's eye

meets the artist's painted product; what will happen can never be foretold:

> One pictorial symbol attentively beheld will foreshadow new ones and gesture back to others, which then glide (or pop) into view and into new relations with them—like a mobile jigsaw puzzle or a kaleidoscope. Variations, modifications, combinations of motifs emerge to become focal and then recede. Tuba, bells, women, clouds—a thicket of forms surrounds us. . . . To wander through this maze of imagery may lead us now or in the future to hitherto unrealized moments with individual works of art, to a more finely tuned sense of the subjective experience of the given artist, above all to insight into our own psyches.[13]

Ultimately, the evidence of the work itself determines the credibility of an interpretation and whether it makes reasonable sense of the work and deepens our experience, understanding, and enjoyment of something important.

Ideological Art Criticism

Some would say that all thinking, and therefore all criticism, is ideological in the sense that it favors certain ideas and values and not others. And in a general sense this is true. What I have in mind is more specifically political, or sociopolitical, criticism. Such criticism typically assesses works in regard to the concern they show for certain ideas, values, or pressing social issues. This type of criticism may reflect the outlook of a national government, as it did in Stalinist Russia and Maoist China and still does in some places today. Or it may attempt to advance a variety of social and political interests within a democratic society, for example, feminist, multiculturalist, sexual, and religious. Or, as the case might be, in its advocacy such criticism may promote modern versus traditional art, regionalism versus cosmopolitanism, or postmodernism versus modernism.

The most prevalent type of ideological criticism of a sociopolitical nature in the twentieth century is Marxist-Leninist, usually referred to simply as Marxist criticism. Although there are varieties of Marxist criticism, its fundamental premise is that works of art cannot be politically neutral. Social attitudes and values in one way or another are inevitably conveyed by an artist's choice of medium, form, and content. Even nonrepresentational artwork can reflect social attitudes. Works of art thus have the capacity to affect the beliefs of people. It is not that aesthetic values are always irrelevant or that they shouldn't be enjoyed, only that criticism cannot stop with them. Judgments of political value or disvalue are a necessity.

The centrality of political considerations in Marxist criticism stems from Marx's conception of human nature. Berel Lang and Forest Williams have pointed out that for Marx the essence of human nature resides in social relations.

> Whatever the precise construction placed upon that phrase, which is currently a topic of philosophical controversy among Marxists, clearly social tendencies and structure are thereby stated to be integral to the very make-up of human experience and, *a fortiori*, of works of art. What anyone "perceives" as "objective" reality, quite apart from any didactic aim on his part, *already* embodies social theses. There can be no such thing as "pure art," in the sense of art without any aesthetically relevant social ingredients (so-called "abstract art" notwithstanding), if man's nature is irrevocably social. In a class-ridden society, moreover, a man's nature is not social *tout court*, but class-social. Even the sciences display such class-social determination. There it appears due to the critical importance of basic concepts and methods; not in experimental verifications and conclusions, which are a matter of simple logic and conscientiousness, but in the very posing of the questions, and once in a while in the interpreting of the results. The phenomenon is central, however, to the creation and appreciation of works of art, where it is a matter, as Leon Trotsky noted, of "feeling the world in images." That is why, Trotsky went on to observe, a man's thoughts may diverge, in their social determination, from his feelings, so that one may well "think as a revolutionary and feel as a Philistine." In one sense, then, a Marxist can (and Plekhanov did) endorse the trans-individual, disinterested, non-utilitarian character of the aesthetic that most theorists have deemed essential. But not in any sense that would deny the fundamentally social texture of man and man's works.[14]

Increasingly, ideological critics stress not just social relations and class as important determinants of human nature but also race and gender; indeed, race, class, and gender have become the principal concerns of ideological criticism. This kind of criticism can provide important perspectives on an understanding of art, but it often assumes what cannot be actually shown. "One of the problems with Marxism (and other sociologies of art)," observes Marcia M. Eaton, "is that it assumes a connection between art and social features that has yet been shown to exist."[15] Such connections, in other words, must be empirically verified. There is also the matter of counterexamples. Why, she asks, did Rembrandt continue to paint biblical scenes while Steen and Vermeer painted capitalistic possessions and leisure activities? Another concern of writers wary of ideological criticism is that such criticism denies there is anything special about art; everything is social. Aesthetic values are often considered inconsequential.[16] But

when aesthetic considerations are considered irrelevant to judgments of artistic merit, there is a question whether such criticism is properly called art criticism. Social or cultural criticism would seem to be more apt terms.

Ideological, or sociopolitical, criticism, however, need not spring from officially enforced criteria of value or from suppositions about race, class, and gender. It may also consist of arguments for a certain kind of style and artistic expression over another—the preference expressed for regionalism in American art, for example. Earlier in this century, the art critic Thomas Craven was a great champion of the American working class, whose rural and urban values he considered to be the most appropriate subjects for American art. Craven, an advocate of the well-known regionalist trio of Thomas Hart Benton, John Steuart Curry, and Grant Wood, began as a defender of modernism in 1919 while working as a writer on art for *The Dial*, one of that period's most influential magazines. By 1929, however, he had swung over to the opposition camp, and by the very early 1930s he was actively attacking modernism in all its forms as well as setting the stage for the emergence of Benton as The Great American Artist, the savior of American painting from the corrupting influences of European modernism.

His best-known books, *Men of Art* (1931) and *Modern Art: The Men, The Movements, The Meaning* (1934), were direct assaults on the modernist movement. Henri Matisse, whom he had praised extravagantly a decade before, came in for particularly vicious attacks, and from that time on no other modernist, European or American, could be considered safe from his acid pen. By the mid-1930s, Craven's passionate antimodernism, and equally passionate advocacy of what would soon be known as Regionalism, had been fused to form two sides of the same critical coin. In order to validate the Regionalists, he felt it necessary to vilify everything modern, especially if it was French, and call ever more loudly for an uncontaminated, indigenous American art.

He found such art—or so he claimed—in the largely rural paintings of Benton, Curry, and Wood and to a somewhat lesser degree in the works of urban realists such as John Sloan, William Gropper, and Reginald Marsh. For them he had nothing but praise; for the opposition modernists, nothing but contempt and acerbation:

> Let us take, for example, the amateur Communists and superannuated esthetes who have suddenly found it expedient to love their adopted country. These renegades, notorious in their contempt for anything

native, are now whooping it up for American art, and endorsing, for personal gain, every move made by the officials in Washington. Some of them have painted, at Federal expense, large mural eyesores in which the prescribed subject matter has compelled them to reveal their ignorance of American life, and their incapacity in all forms of art not concerned with the sorting of cubes and triangles. When they try to depict an American cow, they contrive an abstraction, or a bloodless, shapeless, milkless beast patterned on Picasso's plunderings of archaic wall decorations.[17]

Although as a writer Craven could be ruthless and irresponsible, he managed to become the most widely read art critic America has ever had. *Men of Art* was chosen by the Book-of-the-Month Club as one of its main selections and went on to become the best-selling art book of the 1930s. His other books were also remarkably successful, making him the first American writer on art to appeal to a popular audience on a truly grand scale.

If we compare the criticism of Greenberg, the explicator and defender of modernism, and Craven, its severe critic, we have two dramatically different art critics, both of whom exerted considerable, even at times great, influence—Greenberg during the 1940s, 1950s, and 1960s and Craven during the 1930s and early 1940s. Both had an impact on the art of their time, Greenberg by defining what characterized the Abstract Expressionist and Color Field painters and then championing them and Craven by attacking modernism tooth and nail while declaring the supremacy of regionalism and American scene painting. That, however, is where the parallels end. Greenberg and Craven are representatives of not only two different periods in American art but also of dissimilar approaches to art criticism. Greenberg is essentially an objective analyst. Whatever judgments he makes are determined by a purely logical process. Craven, on the other hand, was blatantly subjective. His judgments and arguments were generally predicated on how closely a work of art approximated his own vision of how good, solid, native American art should look. Greenberg is a formalist art critic. Craven, if he can be characterized at all, falls into the sociopolitical or ideological camp. (During his early promodernist days, Craven was also a formalist.) Craven's writing was much more passionately judgmental than Greenberg's. Art criticism was for Greenberg a coolly considered commitment to a particular way of viewing art; for Craven, it was nothing less than a moral crusade to rescue American art from the clutches of European modernism. Although they had totally different ideas about art and art criticism, both took art and their responsibilities toward it quite seriously.

Because of the influence of Greenberg and Craven, and because they so perfectly represent the extremes of American art criticism, it seems only fitting that anyone interested in the discipline of art criticism—especially those attempting to integrate some of its principles and practices into art education curricula—should take time to read what these men have written. To do so can only make them more aware of art criticism's range, effectiveness, and capacity to affect those who read it positively as well as negatively.

Observations

The types of criticism are never as clearly defined nor as precisely differentiated in real life as they have been in these pages. Only the most narrowly dogmatic or orthodox critics would insist that all art must be judged by one set of rules and standards.[18] Fortunately, such critics are extremely rare. Most practice an open, pragmatic approach toward the diverse and often complex thematic, formal, and technical aspects of art. Without in any way lowering their standards, they engage works of art with a broad range of critical criteria drawn from all categories of art criticism. Everything that helps illuminate the issues of a given work is grist to their critical mill. Only after the evidence is in and the analytical and shaping process begins do they reveal themselves by drawing conclusions that will identify them as primarily diaristic, formalistic, or contextualist. The resulting synthesized criticism may disappoint purists of various persuasions, but it is generally more insightful and informative and brings art to life on the printed page much more vividly than narrow doctrinaire and dogmatic criticism.

More open-minded and pragmatic critics, on the other hand, place as much emphasis on the richness and life-enhancing nature of art as on its precisely defined significance and worth. Their objective is as much to convey the dynamic, generative aspects of a work of art as it is to determine its merit as an art object or cultural icon. This willingness to approach art openly and without prejudice or predisposition, to examine it carefully and respectfully before deciding by which set of rules it shall be assessed, is a welcome indication that American art criticism is coming of age. It also suggests that art criticism is beginning to educate the public to a deeper understanding of the purposes and procedures of art. This is an encouraging development.

Pragmatic, eclectic art criticism is not easy to write. In addition to a broad and deep understanding of art, it requires a keen insight into the ideas and issues of the day, a thorough knowledge of the avail-

able kinds of art criticism, and the ability to distill complex thoughts and feelings into words and sentences that induce comprehension rather than confusion. As one writer has said, "If you could teach people to be critics, you could teach them to be human."[19] Difficult and challenging as this may be for the professional critic, it's obviously even more so for those who lack the necessary background and experience. Art teachers, although they have no interest in writing art criticism professionally, can usefully apply the insights and methods of the discipline in their classrooms.

NOTES

1. For a discussion of Impressionist criticism and references to Oscar Wilde, Anatole France, and Walter Pater, see Jerome Stolnitz, *Aesthetics and Philosophy of Art Criticism: A Critical Introduction* (Boston: Houghton Mifflin, 1960), 475–78. Donald Kuspit is quoted in Terry Barrett, *Criticizing Art: Understanding the Contemporary* (Mountain View, Calif.: Mayfield Publishing, 1994), 16.

2. Walter Pater, *The Renaissance* (London: Macmillan, 1924), 129–30; quoted in Harold Osborne, *The Art of Appreciation* (New York: Oxford University Press, 1970), 258. Appendix 3, "Reflection of Attitude and Interest in Critical Writing" in Osborne's book, contains a number of excerpts from art-critical writing.

3. Robert Pincus-Witten, *Eye to Eye: Twenty Years of Art Criticism* (Ann Arbor: UMI Research Press, 1984), 193–94; cf. Sun-Young Lee, "The Critical Writings of Robert Pincus-Witten," *Studies in Art Education* 36 (Winter 1995): 96–104.

4. Erle Loran, *Cézanne's Composition* (Berkeley: University of California Press, 1943). Loran's book, in fact, helped popularize the formalist approach to criticism, especially with art students, and upgraded Cézanne at the expense of the Impressionists.

5. See, for example, the dedication to Fry in Kenneth Clark's *Looking at Pictures* (New York: Holt, Rinehart and Winston, 1960).

6. Roger Fry, *Cézanne: A Study of His Development* (New York: Macmillan, 1927), 72–73, quoted in *Jacob Rosenberg, on Quality in Art: Criteria of Excellence, Past and Present* (Princeton: Princeton University Press, 1967), 110; cf. the discussion of Fry in A. W. Levi and R. A. Smith, *Art Education: A Critical Necessity* (Urbana: University of Illinois Press, 1991), 94–100.

7. Clement Greenberg, *The Collected Essays and Criticism*, ed. John O'Brian (Chicago: University of Chicago Press, 1988), 1:126.

8. Theodore F. Wolff, *The Many Masks of Modern Art* (Boston: Christian Science Monitor Books, 1989), 100.

9. Greenberg, "Obituary of Mondrian," *Collected Essays*, 1:126.

10. Stephen Addiss and Mary Erickson, *Art History and Education* (Urbana: University of Illinois Press, 1993); cf. Levi and Smith, *Art Education*, ch. 4.

11. Leo Steinberg, *Other Criteria: Confrontations with Twentieth-Century Art* (New York: Oxford University Press, 1972), 15; also quoted and discussed in Ralph A. Smith, *The Sense of Art: A Study in Aesthetic Education* (New York: Routledge, 1989), 78–83.

12. Ellen Handler Spitz, *Museums of the Mind: Magritte's Labyrinth and Other Essays in the Arts* (New Haven: Yale University Press, 1995), 49.

13. Spitz, *Museums of the Mind*, 55.

14. Berel Lang and Forest Williams, eds., *Marxism and Art* (New York: David McKay, 1972), 11.

15. Marcia M. Eaton, *Basic Issues in Aesthetics* (Belmont: Wadsworth, 1988), 86–88.

16. For an insightful discussion of this point, see Hilton Kramer, "T. J. Clark and the Marxist Critique of Modern Painting," *New Criterion* 3 (March 1985): 1–8.

17. Thomas Craven, *A Treasury of American Prints* (New York: Simon and Schuster, 1939), introduction.

18. For example, in *Out of the Whirlwind: Three Decades of Art Commentary* (Ann Arbor: UMI Research Press, 1987), Dore Ashton observes, "I don't have a critical method—common or otherwise. I am a fusion of many methods" (315).

19. Francis Sparshott, "Basic Film Aesthetics," in *The Philosophy of the Visual Arts*, ed. Philip Alperson (New York: Oxford University Press, 1992), 335.

3

The Values and Work of an Art Critic

Although I am known principally as an art critic and have spent an important part of my career writing for a newspaper, I am also a painter. This fact influences the way I understand my task as a critic, especially in my attitude toward artists and the responsibility of critics toward younger artists.

It is not unheard of for critics to be artists, or even art historians and philosophers for that matter. Critics engage in a range of activities and writing. As a newspaper critic I have reviewed exhibitions of traditional as well as modern and contemporary art, reflected on issues rocking the art world and joined in debate about them, written reflective essays about particular artists, served as a critic-in-residence at universities, and even juried high school exhibitions. I have also considered the nature of criticism and its pedagogical uses. Although it is possible to distinguish art criticism from art history and aesthetics and to know when one or the other is being done, there is considerable overlap among these disciplines, a point my coauthor George Geahigan also makes in his explanation of criticism as critical inquiry. Not all critics share the same backgrounds or premises about criticism, but my experience is not atypical. My emphasis on the educative function of criticism within the framework of discipline-based art education is perhaps distinctive, however.

The Values of an Art Critic

Critics should openly state their views about art, creativity, and the criteria of value they use in assessing works of art. As examples of such disclosure, I've written a number of columns that clearly reveal my values.[1] The first was an open letter to other critics that expressed my concern about the kind of writing one sometimes finds in many of today's journals and magazines, writing that undermines the contribution of artists and the creative process and celebrates instead critics, who often regard their critiques as works of art. I didn't dwell

on the negativism of such writing, but spelled out a few things that are too important to forget. What we must remember is that artists create and critics follow along, a little behind and to one side, and comment on what the artists do. Whatever else happens—no matter how helpful, destructive, regressive, or far-reaching—is secondary to the fundamental relationship between artist and critic.

A Dialogue between Critic and Artist

What I mean is really quite simple. Let artists paint, sculpt, draw, or whatever and let critics pay close attention to what results and what it signifies. Let there be a partnership of sorts, with critics fully aware that without artists they would be without a job and with artists willing to admit that an occasional word of advice from a critic with good insight might be a good thing. Beyond that, let them go their separate ways. An artist's primary impulse, after all, is to say "Yes," and a critic's to say "Maybe," "I don't think so," or even a firm "No!" A creator is impelled to overcome all obstacles and arguments, whereas a writer on art is more cautious and tries to see every side of an issue (or invent some that don't exist) and is more likely to tie Gordian knots than sever them. At other times both artist and critic function as opposing sides of a dialectical process designed to articulate and give credence to cultural ideals and values. What one presents the other confronts and examines—and then returns to the other for further clarification or elaboration. The result, as often as not, is art more truly representative of the full range and depth of a culture's attitudes and ideals than would be the case had it been a strictly individual effort. This process, this dialogue between artist and critic, can be of considerable value not only in lifting art above the merely idiosyncratic and self-expressive but also in challenging it to achieve importance, even greatness.

Greatness in Art

To achieve importance, however, both sides must be fully aware of the nature and limitations of their particular contributions—and in what greatness entails. The latter presents something of a problem. We know what was great in the past but often fail to understand what that word means in contemporary terms. We generally use it to identify whatever is most expensive or most applauded. We equate it with either size, speed, power, volume, and glory or maximum effectiveness and forget that it is also a matter of quality, discretion, ethics, and

morality. Art often falls victim to this misperception—witness the large number of paintings and sculptures straining to achieve greatness through sheer size, impact, or sensationalism. Such works are intended to stun and overwhelm and exist as the outward manifestations of human will, demanding power and control. Yet greatness in art cannot be forced; it can only be earned—and then only through its ability to move, challenge, or inspire viewers to see and experience more clearly and holistically than they could have before. All this critics may know as well as artists—or know even better. But knowledge and insight do not by themselves produce art. Something else is required—a quality that, for lack of a better term, we call genius or talent.

There can be no art without genius or talent—only doodles, dead renderings, or meaningless splashes of paint. Without genius, the most brilliant theories fall flat—as Kandinsky so often proved. On the other hand, genius by itself doesn't guarantee greatness, any more than does imagination, intelligence, courage, or persistence. These capacities and dispositions are merely the raw materials of greatness—essential but incapable by themselves of affecting us as truly great art can. Nonetheless, genius and talent are critical; they are the "spark plugs" that generate art and give it life. Regardless of their range or depth, these expansive life-impulses must be present if there is to be art.

The ability to transmit a sense of life through such things as color, form, and line is the most precious thing artists have. It is what establishes their creative identity. Everything else about art can be learned, but not that. For a critic to tamper with it, to attempt to intimidate an artist into curbing or diverting it for purely theoretic or nonaesthetic purposes, is very close to unforgivable. I can just imagine what Michelangelo or El Greco would have said had anyone told them that their art didn't address itself to the essential problems of their day, or how Rembrandt would have reacted had a critic suggested he modify his humanism to accommodate some new ideas from France. They would have roared their displeasure.

On Evaluation

I have also questioned another assumption of much art criticism—that its primary responsibility is evaluation, to assert that a work is successful or unsuccessful, good or bad. But a critic simply cannot be that final.[2] Critics can advise and recommend; they can and should alert readers to new talent, introduce them to new trends or ideas, and

point out exceptionally brilliant or tawdry painterly performances. Critics can suggest that greater attention be paid to certain artists and that others with overblown reputations be given short shrift. And they can see to it that readers get a reasonably accurate overview of a particular art season or of a particular movement or fashion. Beyond that, however, there isn't much critics can do—unless they forget themselves and act as though they were as much a part of the creative process as the artist. In that case critics will tell those who create in what style they should work and what formal ideals they should hold; they will set themselves up as exclusive judges of what is good and bad and do all they can to shape the art of their time according to personal ideas and prejudices. What such critics fail to understand is that the critical function begins after, and not before, artists finish their work. Although critics may encourage and advise talent, they cannot dictate to it without ending up fools.

Every individual manifestation of talent, creativity, the life force— call it what you will—has an identity and destiny of its own that cannot be fully perceived or anticipated by even the most astute outsider. Artists may have only the vaguest inkling of where their creativity is leading them and are at times as surprised as anyone else by what they have produced. At best, critics can help release creative energy; they cannot engender or control it. Faced with a flawed work of art or an artist blocked from working at full strength, they can point out inconsistencies, ambiguities, and unresolved contradictions or indicate where they feel an impediment to full creativity lies. Critics can say, "This works, and that doesn't," or "What you've done here is a dramatic step forward." They may ask why artists limit themselves to safe compositional devices or unimaginative color, create clumsy pastiches of other artists' works, repeat themselves endlessly, or depend too heavily on brilliant technique. But whatever they say or ask, their focus should always be on the release of creative energy, on growth and not on conformity to a particular style.

It can be argued that such advice and encouragement is the responsibility of teachers, not critics. The latter's only obligation is to alert readers to the good and the bad in today's art and recommend which exhibitions are worth seeing and which aren't. I disagree—but only to the extent that it is a critic's only obligation or that readers should be the only concern. A critic's function is subtle and complex and includes many activities that have little direct bearing on judgments between the good and the bad. Of these, the most important are attempts to broaden existing perceptions of art's significance and range and promote dialogue and confrontation between the critic and

younger artists designed to speed the latter on their uniquely individual ways.

Discouraging Prejudice

We have nobody to do this in AT

A critic also plays a critical role in dissolving prejudice. If he or she doesn't attempt to break down existing barriers between artistic attitudes and dogmas, who will? Just as important, critics, by virtue of a deep involvement with the art of the day and familiarity with the great art of the past, are in an ideal position to perceive the nature and quality of young artists' work and aid them at crucial moments by helping clarify intentions or by lending support when everything seems bleak.

There are those who insist that such intimate interactions between artist and critic do no good, that they only destroy the latter's critical objectivity. It is sometimes said that a critic should never know an artist. If art dealt only in absolutes, and if art criticism were an exact science with precise rules and regulations, I might agree. As it is, however, I do not. Art, especially when it is new, is dramatically open and volatile and cannot be approached as though it were a purely objective and definable thing. Creating art, after all, is a life-inducing activity that bears little resemblance to the manufacture of products on an assembly line. To know what it's about, critics must be aware of the entire process of creativity, not merely its end products. And to do that, they must be as willing to talk with and listen to both beginning and established artists as they are to look at their work. What we don't want is a critic with fragile sensibilities and prejudice against anything new or imperfectly formed. Such feelings of superiority might be tolerable if they didn't contaminate critical writing and drive an even deeper wedge than already exists between creator and critic.

YES!

AT look like this

I don't blame artists for having an ambivalent attitude toward critics. On the one hand, artists want good reviews; on the other, they are fully aware of being subject to the probings of someone who probably knows and cares much less about art but whose attitude toward it is patronizing and possibly even rude. What is needed is a clearer understanding—by artist, critic, and public alike—that art is an ongoing and ever-evolving process of actualization and realization, not a series of objects whose beauty and importance can be precisely determined. We also need to understand that although critics may occasionally play a minor—if vital—role in clarifying that process, they should by no means be seen as art's final judge and jury.

The Role of Tradition

My remarks about creating, talent, originality, and genius recall something I wrote earlier in which I stress the role of a living tradition in artistic creativeness.[3] I was reacting to an overemphasis on individuality and originality in art, on style and manner at the expense of substance. I wrote that eight days in the Netherlands and London looking at art, then three more days visiting roughly ninety galleries in New York, was exhausting but illuminating. It tended to put things into proper perspective and make me deeply appreciative of artistic quality. I found such quality in the explosive figurative paintings of the young Dutch artist Peter Wehrens in his exhibition at Amsterdam's Nieuw Perspectief gallery and in an exhibition of Canadian landscapes in London's Canada House Cultural Center. Back in New York, I also found it in Terence la Noue's vivid abstract paintings at Siegel Contemporary Art, Michael Lekakis's drawings at the Kouros Gallery, and Valentina Dubasky's paintings at Oscarsson Hood. But primarily I found it in Holland's and London's major museums, in their Leonardos, Rembrandts, Vermeers, della Francescas, Van Goghs, Mondrians, and numerous other older and more recent masterpieces. It's not surprising that I found artistic quality in great art, for it is particularly effective and memorable. But it's also very rare and represents only the tiniest fraction of the art produced by any culture. To compare a few towering masterpieces with the everyday art of another period is both naive and unfair. It makes no sense to compare the art of today with the best that was created during the seventeenth or nineteenth centuries.

Because of this emphasis on individuality, contemporary artists often feel that they have little choice but to opt for ludicrous extremes in their search for the "new." Because of a distorted view of tradition, they tend to view tradition as primarily restrictive and counterproductive. They've forgotten that great art can no more be merely willed into existence than a match can burst into flame in a vacuum. Art is the result of a dynamic process that has both private and collective significance. Art such as Michelangelo's encapsulates, advances, and caps a several-thousand-year tradition rooted in the art of the Greeks and Romans and enriched and modified by pre- and early-Renaissance formal and thematic ideas. To stand before a Michelangelo sculpture or fresco is to stand before history in dramatic and dynamic dialogue with one of the most profound geniuses of all time. Rembrandt, Rubens, Poussin, Cézanne, Picasso—the art of all of them is drenched with personal and cultural distillations of the great works

of the past.[4] Cézanne wanted nothing so much as to paint as grandly as Poussin; indeed, his canvases set beside those of Poussin reveal a profound similarity of structure and a remarkable sense of continuity. At the same time, great art often portends the art of the future.

One can stand totally absorbed before a Leonardo, a Rembrandt, or a Cézanne because so many dimensions and layers of meaning and suggestiveness lie beneath their surface images. We don't merely perceive a simple representation of an object, or a person, but find ourselves locked into a complex of ideas, forms, and emotions that seem endless in their implications. A Picasso painting that looks abstract may reverberate with echoes of Greek, African, and Etruscan forms and images. A Henry Moore sculpture may evoke vague memories of primal forms, of Stonehenge, or of ancient Near Eastern artifacts. That is what a true and living tradition is all about. And this tradition in no way restricts or cramps an artist's style; it enriches and ennobles it. Tradition is only destructive if older styles become the absolute ideals against which all new work is judged—if, for instance, the late paintings of Raphael or Matisse are adjudged perfect and then designated as the strict models for all future work. This sense of continuity and tradition has been violently disrupted in this century. Most artists are very much alone in their creative endeavors and must madly improvise or invent new forms or ideas in order to survive. This becomes increasingly true as one generation replaces the previous one and believes it must discredit its predecessor to achieve artistic validity. The movement is thus against tradition rather than toward it. As a result, an increasing number of younger artists has only two choices: to keep searching for ever more extreme and outrageous forms and devices so as to attract attention or to do just the opposite and copy nature as slavishly and mechanically as possible. That is where, to a large extent, we stand today.

The Question of Progress

Such reflection on the relation of creativity and tradition has prompted me to consider the question of progress in art. A reader once asked if we may speak of progress and, if we can, why is there so little great art produced today, compared to centuries past. Or is Paul Klee as good as Michelangelo? The answer depends on our definition of progress and greatness as they relate to art. If we insist that great art must be monumental, representational, humanistic, traditional, and technically brilliant, then recent art represents a decline from the past. And we could safely assume that progress is not intrinsic to art.

If, on the other hand, art is seen as exclusively representative of the culture that produced it, then it would no more make sense to compare the art of different cultures than to compare apples and oranges. Viewed this way, Rubens and Pollack would be merely painterly representatives of widely dissimilar social systems and in no way critically competitive. Progress, thus, could not exist.

Both positions are too simplistic. Art is much more than grandeur and brilliance, and art does occasionally rise above cultural limitations. The fact that Michelangelo was grander and more technically brilliant than Klee doesn't prove that Klee and his period show a decline from the days of the Renaissance. Michelangelo, after all, represented the flowering of a long and great tradition, and Klee a tentative step toward a new beginning. Michelangelo's art embodied the best ideas and forms of two thousand years; Klee's probed nuances of feeling never before explored through art. Michelangelo stands like a giant oak atop a mountain peak; Klee like a tiny seedling sending its roots into virgin territory. Both artists reflect different periods in the life-cycles of their cultures and can no more be compared critically than a grown man and a child or a flower and its seed. We can compare persons, including artists, on the basis of strictly defined qualities such as strength and brilliance and declare a person or artist stronger and more important than others on the basis of such qualities. But that's about as far as we can go. If I place Michelangelo and Rembrandt above all other artists, it's because they rate highest for me in certain important and clearly defined areas, not because they are the best in everything. I judge the greatness of artists on their overall achievements, on what they do with what they have rather than on special talents or sensibilities.

Twentieth-century modernism is a good case in point. In many ways it was an abrupt departure from tradition and constituted a revolutionary and dynamic approach to art. It cannot in any way be seen as a decline. If there was a decline in art, it occurred in the academic painting and sculpture of the latter half of the nineteenth century. Impressionism and Postimpressionism cleared the air, and with the advent of Fauvism, Expressionism, Cubism, and Constructivism a new era in art had begun. Modernism has been extraordinarily fertile and produced some excellent art. And yet it's quite likely that future generations will perceive it primarily as an experimental laboratory designed to probe the nature and the future of art. Unfortunately, some of these "experiments," rather than attempting to discover the full, rich nature of art, often resulted in work that was too purely formal. Even so, modernism has been one of the great periods

of art history. Art will never again be the same because of it. It has been responsible for the opening of dozens of doors through which art had never before ventured, and it helped establish at least as many new creative premises. That in itself should answer the question of progress in relation to contemporary art. Progress is found wherever there is creative fertility and dynamic growth. It's more important that art keep up with and advance beyond the cutting edge of its culture than that it end up beautifully framed in a museum. To accomplish this, it must commit itself to methods for which there often are no precedents and be willing to risk ridicule and censure. Taking risks has been true of the art of all periods. Never before modernism, however, has there been such insistence on originality and creative courage; modernism practically defined itself in terms of the dramatically new. In this it has been unique and has served an extremely valuable function.

Twentieth-Century Artists

Art critics write about different styles and periods in art and reflect philosophically on questions such as the value of originality and the role of tradition, the nature of progress in art, and other topics as well. But, as I've explained, critics are remiss if they don't discuss the work of modern and contemporary artists, the art of their own time, and not always the most experimental or innovative art. What follows is a discussion of several twentieth-century artists I've written about in newspaper reviews and reflective articles: Willem De Kooning, Julian Schnabel, Beverly Pepper, Joyce Trieman, Käthe Kollwitz, Anselm Kiefer, Andy Warhol, and a group of computer artists. De Kooning, Schnabel, Kollwitz, and Kiefer are in the Expressionist tradition; Pepper is a modernist abstract sculptor; Trieman is a more traditional representative artist; Warhol was an artist of popular images; and the computer artists combine artistic and scientific conventions.

Willem De Kooning

The occasion for a discussion of De Kooning's work was an exhibition that traced his evolution as a major figure of American Abstract Expressionism. Even though his work declined in quality during his later years, in the following critical piece I was more concerned to discuss his reputation, the quality of the exhibition in question, and reasons why people should attend the show.

> The De Kooning exhibition is small but excellent and wide-ranging in its selections, with paintings and works on paper dating from 1940

to 1984. It opens with a figurative oil, *Glazier,* and ends with two of his most recent, highly simplified, and controversial abstract canvases. Almost every aspect of his work is represented by at least one example. Most are of high quality and all are of art-historical interest. In short, anyone desiring a compact overview of De Kooning's stylistic evolution, quality as a draftsman-painter, and importance as a leading Abstract Expressionist, would do well to visit this show.

Several major museums and private collections, including the Metropolitan, Guggenheim, and Hirshhorn museums, lent their treasures to this exhibition. The Museum of Modern Art sent its *Woman II,* a 1952 oil, and *Seated Woman,* one of De Kooning's most successful studies in pastel and pencil. And we have the Rose Art Museum of Brandeis University to thank for entrusting the gallery with its 1961 *Untitled,* certainly one of the two or three most important paintings in the show. I've mentioned these museums for two reasons: to suggest the level of quality on view here, and to indicate how highly regarded De Kooning has been by museum directors over the years.

Museum officials are not unique in their respect for him, however. His fellow painters also hold him in high esteem, and have ever since his early days in New York in the thirties and early forties. Like most of the original Abstract Expressionists, his career developed slowly. He was twenty-two when he arrived in New York from Rotterdam in 1926, and a little over forty when his career began to take hold. From then on, however, things moved rapidly. By 1948 he was nationally known, and by 1950 an international celebrity. Fame temporarily became notoriety in the very early fifties when he shocked the art world with the first of his "Woman" paintings, a series of impassioned, highly ambiguous, single-figure studies of women that combined expressionistic intensity and violence with wild, painterly exuberance. No matter how shocked the art world might have been at first, however, by this violation of the near-sanctity of abstraction, the art world was soon paying serious attention to these dramatically distorted depictions of women. Indeed, it did more than that, for by 1954 a considerable portion of the art world had decided that De Kooning, even more than Jackson Pollock, was at the "cutting edge" of world art.

For many art professionals, that opinion still holds. In fact, were a poll to be taken today, it's my guess that a large number of critics and curators would rate De Kooning as the most significant painter of the fifties and his "Woman" series as the high-water mark of Abstract Expressionist art. Dissenting critics, on the other hand, might well prefer the abstract canvases that once again dominated his production from the late fifties on, most particularly such paintings as the Guggenheim Museum's 1955 *Composition* and the *Untitled* of 1961.

Except for brief flashes of his old power here and there—notably in his 1965 oil on paper *Woman* and his sparkling *Untitled* of 1975—the sixties mark the beginning of what I can only describe as his long down-

hill slide into banality. The seventies saw his work become increasing-
ly flaccid in form and excessively sweet in color, and the eighties saw
it deteriorate into mindless, stylized doodlings. The two large canvas-
es dated 1984 in the show are neither better nor worse than the dozen
or so I've seen that were executed shortly before or after that date. It
doesn't matter if they were painted by a child of twelve or a world fa-
mous artist of eighty, they're simply too trivial to be taken seriously as
art. I feel very strongly about this. It's one thing to honor De Kooning
for his genuine accomplishments. He deserves it. It's quite another to
demean him—as some observers tend to do—by failing to distinguish
between what really is special about his work and what is empty, or just
plain bad.[5]

Julian Schnabel

My discussion of the work of Julian Schnabel, on the other hand,
was less positive, an exception to my general disposition to be as
helpful as possible in my discussions of artists and works of art, es-
pecially in regard to the work of younger artists.

New York has seldom seen as overblown and self-serving an exhi-
bition as the twelve-year Julian Schnabel retrospective at the Whitney
Museum. As a demonstration of unbridled ambition, rampant exhibi-
tionism, and a trifling commitment to art, it tops any show in recent
years. True enough, it contains a few interesting paintings, including
three or four of the provocative pieces that led some critics between
1983 and '85—including me—to feel more positive than we had before
(or after) about his talents and aspirations. But taken altogether, espe-
cially in the light of Schnabel's international reputation and the fact that
this is a major retrospective, it ends up being exactly the sort of thing
that casts doubt on the integrity and seriousness of today's art world.

"Julian Schnabel" was organized by the Whitechapel Art Gallery,
London, in conjunction with the Musée National d'Art Moderne, Cen-
tre Georges Pompidou in Paris, and was then revised for its American
tour and installed at the Whitney by Lisa Phillips. Its thirty-seven works
survey Schnabel's career from 1975 to the present and include exam-
ples from most of his major periods. Almost everything on view is large,
and some of the canvases, in fact, are room-size. By now, everyone in-
terested in art must have heard of Julian Schnabel's spectacular leap to
fame and worldwide notoriety for his mammoth canvases. To these
canvases he attached broken crockery, animal hides, deer antlers, and
various other objects. He also used as painting surfaces black velvet and
full-size muslin landscape backdrops acquired from the Japanese Ka-
buki theater.

Both his success and his work jolted the art world shortly after 1980
as nothing had since the early days of Andy Warhol, and the lessons to
be learned from both were not lost on others hoping to succeed as dra-

matically. Glamour, big money, and instant superstardom, which had first
entered the gallery world on Warhol's coattails two decades before but
which had never totally caught on as legitimate or viable art-world goals,
were suddenly perceived as every young artist's birthright—as long as
he or she learned the rules and played the game. The result, as it must
now be obvious to everyone not overwhelmed by hype or double talk,
has been the increasing glorification of "promise" over accomplishment,
novelty and clever gamesmanship over substance, and the more or less
official sanctioning, by one museum after another, of a level and type of
art that is mildly interesting and provocative at best, and tawdry, trivial,
or just plain silly at worst. More specifically, it resulted in a veritable
explosion of large-scale and well-publicized museum retrospectives of the
sort currently honoring Schnabel. These were generally sponsored by
major corporations, accompanied by catalogs in which the artists were
lauded to the skies for their profound originality and creative courage,
and shipped from one major art center to another to guarantee maximum
market coverage. In effect, this amounted to nothing less than instant art-
world canonization of a few select individuals who may or may not have
deserved it, but who, having once received it, were guaranteed fame and
fortune for at least two or three decades to come.

No one has benefited more from this system than Schnabel, as this
Whitney show proves. With a few notable exceptions, it consists of lit-
tle more than a jumble of tentative and half-baked ideas and forms that
were more or less casually tossed off. They impress primarily because
of their sheer size (the largest is 16 by 28 feet) and awesome vacuity.
We are, in fact, intimidated by them and assume that anything that big
and empty and hanging in a major museum must be profoundly mean-
ingful and culturally significant. If not, why are they there? It's a good
question, and one I kept asking myself every time I went back to see
the show or reread the catalog essays. Compared with a genuinely
major artist such as a Joseph Beuys, perhaps, or a James Turrell, or
Anselm Kiefer, Schnabel comes across as uneven and generally skin-
deep. Perhaps because of that, his better pieces are all the more note-
worthy. *Part One* (1980), *The Mud in Mudanza* (1982), and *Muhammad Ali*
(1987) are actually quite powerful and effective. And *Jack the Bellboy, 'A
Season in Hell'* (1975) and *Hospital Patio—Baboon in Summer* (1979) project
a sensibility he would have done well not to have tossed overboard
once he made it really big.[6]

Beverly Pepper

My review of Pepper's work drew attention not only to the quali-
ties of her monumental sculptures but also to the problems museums
and galleries sometimes have properly exhibiting them.

It is obvious the moment one catches sight of it that something un-
usual was going on at the Brooklyn Museum these days. Standing tall

Figure 1. Beverly Pepper,
Hadrian's Wedge.

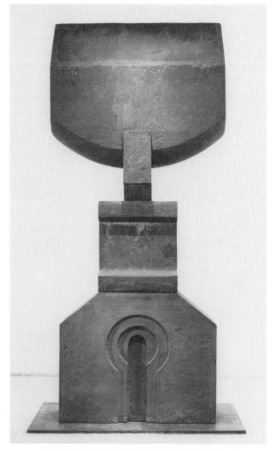

and straight before its main entrance, and looking vaguely totemic, are four monumental sculptures ranging from 28 to 36 feet in height and 5 to 8 tons in weight [figure 1]. They are there to add a touch of modernist class to the museum's nineteenth-century façade, and to announce to the world that their creator, Brooklyn-born Beverly Pepper, is the subject of a major twenty-year exhibition inside. The exhibition was organized by, and originally shown at, the Albright-Knox Art Gallery in Buffalo, New York. It consisted of more than sixty pieces, beginning with some of the artist's highly polished stainless steel sculptures of the 1960s and ending with several of her monolithic constructions of the early to mid-1980s. A number of photographs and models of site-specific works fashioned by Pepper in various parts of the United States and Europe are also included.

It is both an impressive and somewhat frustrating show, one that re-

inforces her reputation as one of America's better modernist sculptors, but that also subtly distorts her work's identity by presenting much of it within inappropriate or cramped quarters. The latter, of course, cannot altogether be helped. So much of her work is expansive and grandly monumental, and the museum's interior space, after all, is limited. Nevertheless, the problem should at least be identified, since it has led a few critics to hold the work itself entirely responsible for the critics' inability to respond favorably. It's an easy mistake to make, especially if one forgets that her sculptures are far from static and self-contained within their spaces, that they are, in fact, so dynamic and charged, so "alive," that almost every one energizes an area considerably beyond its own size. Thus, a relatively small and slim work seven feet high might need an additional fifteen or so feet of space within which to "breathe" and to establish its full identity. And a particularly large and aggressive form might require half a gallery all to itself in order to be accurately perceived and understood. In a museum environment such as this, with over sixty medium-size to huge sculptures occupying two galleries, and with only one room large enough to adequately contain even her moderately large iron or steel constructions, a considerable portion of each work's character and impact will inevitably become distorted or submerged. And so it has—at least in the case of many of the larger pieces (which seem uncomfortable, even alien, in the expansive rotunda gallery), as well as several of the clusters of smaller, slender vertical units. A few of the latter may be somewhat better served, but even they leave one with the impression that their wings have been clipped.

The viewer should be grateful, then, for the excellent color photographs of Pepper's various installations that are included and for the scale models that present miniature versions of several of her finest commissioned works within their architectural or natural settings. The same is true of the exhibition catalog, with its splendid photographs in color and black-and-white of finished pieces, works in progress, and installations. . . .

Taken altogether, it is difficult to see how anyone can fail to be impressed or even occasionally moved by what Beverly Pepper has produced over the past twenty years. The range is considerable, from the solid and chunky to the most elegantly elongated and purely vertical, from the most monumental to gently lyrical works as *Amphisculpture* of 1974–76 and *Sand Dunes* of 1985. The latter, in particular, designed specifically to relate to, and to be subtly modified by, the water and shifting sands of a Florida beach, indicates beyond a shadow of a doubt just how special and innovative her talents really are.[7]

Joyce Treiman

The work of Joyce Treiman evoked a different response.

Nothing is more welcome during a long day of gallery-viewing than

coming across work that is so genuinely moving or enchanting that it doesn't have to stand on its head or shout out its virtues to gain our attention. I can remember, as clearly as though it were yesterday, the time several years ago I encountered a small Giacometti painting of a chair in a gallery. It was so quietly self-assured, and represented such integrity, depth, and mastery, that it immediately erased from my memory the hundreds of good but often self-serving canvases I had just seen and turned what had promised to be a rather dreary day into an exhilarating one. I was affected by that painting much as I would have been a meeting with a very wise man willing to share whatever life had taught him, but who by no means insisted that I listen or even pay him any special attention. What he had to offer was there, but he was not pushing it. If I could recognize its worth and benefit from it, fine and good. If I could not, he had more important things to do than to try to convince me.

Fortunately, that quality, that "wisdom," is not limited to the work of important masters but can be found in as many places in art as truth, integrity, goodwill, and character can be found in mankind. I've come across it in the naive paintings of a farmer in Wisconsin; the carvings of a very old sculptor who works almost exclusively by touch; the pictures of excellent regional artists who have never seriously considered exhibiting in New York; and in modest pieces by otherwise overeager young painters. It means the most, of course, when found in the creative endeavors of someone who has devoted an entire lifetime to the furtherance of his or her art, and who had rich talent to begin with. Such an individual is certain to present us with quality as well as with character, and to add an element of poetry to what others might insist should be rendered in flat prose. Such artists are not as rare as one might think—given the art world's tendency to honor a few and to shove the rest under the rug, or to toss them a few tidbits now and again. I could, with ease and with little fear of meaningful contradiction, list the painters, sculptors, printmakers, photographers, and workers in other media who have either never received the attention they deserve or were unceremoniously dumped the moment their styles went out of fashion. But I won't. Instead, I will mention and discuss only one, Joyce Treiman, and even then, I'll focus on what some would consider a lesser aspect of her work.

Treiman's drawings are among the best being produced in America today. They prove that she is not only a superb painter but a first-rate draftsman as well. She has exhibited widely, has sold her pictures to some of our major museums, and has won several significant awards. For one reason or another, however, she has never quite made it beyond the fringes into the big time. Interestingly, her drawings have recently received somewhat greater attention than her paintings and, at this moment, seem more likely to gain official recognition than her larger and more "serious" works on canvas. This preference is meaningless, of course, for

everything she does is equally representative of her talent and commitment. It does, however, indicate that some of those who are unwilling to honor her more complex and "difficult" pieces are quite eager to lend their support to her smaller and simpler studies on paper.

The latter studies are filled with stylistic inconsistencies that, in lesser hands, would prove disastrous. Her style is both clinically exact and wildly extravagant. It zeroes in on a face, a foot, or a pair of hands with all the objective clarity of a Dürer, and then zooms back and kicks up its heels as though it had nothing better to do than have fun. Exquisite details rub shoulders with smudges and "doodles" barely recognizable as objects. And throughout it all, there is a delightfully free-spirited liveliness only occasionally dampened by highly charged, psychologically provocative images designed to remind us of the darker side of human reality. Treiman oversees and blends these various devices and themes with the aplomb of a brilliant symphony conductor pulling a widely disparate group of musicians into shape, and with the kind of mastery that dares take risks because it is secure in its ability somehow to pull everything off. It is in some of her figure and portrait drawings, however, that she is at her best and reminds us that in this wonderfully gifted and dedicated artist we have one of the most acute and versatile draftsmen of recent years.

That fact was brought dramatically home to me recently at the end of a particularly unrewarding gallery-visiting day. I was ready to call it quits but decided to stop in to see an exhibition of drawings by nine artists whose work especially interested me. Everything on view was very good, if not excellent, but two portrait studies by Joyce Treiman stole the show. They were more than merely good, excellent, or superb, they were alive—and they gave me much the same feeling I had received from the Giacometti painting of a chair several years before.[8]

In another review of Treiman's work three years later I reworked the autobiographical character of her work.

"Joyce Treiman: Friends and Strangers" was organized by Selma Holo, director of the Fisher Gallery. Its thirty paintings and thirty-three drawings were selected by Grant Holcomb, director of the Memorial Art Gallery, and UCLA professor emeritus Maurice Bloch. The paintings range in time from 1964 to 1987, and include such outstanding earlier works as *Yellow Lampshade* and *The Adventure;* a number of attributes to favorite artists executed between 1974 and 1982; three of her most powerful paintings of the mid-1980s; and several of her most recent pictures, most notably, *Friends and Strangers* of 1986 [figure 2].

It's difficult to know where to begin discussing Treiman's art. I wrote once that she could draw like an angel and paint like an Old Master—an opinion this exhibition more than substantiates. And it's also true that her work lies in the tradition of Rembrandt, Rubens, and Goya—with a tip of the hat to Bonnard and Lautrec—but without a trace of

mimicry or subservience. But most important, what she has, she has earned, and if, perhaps, she isn't as well known as others of less talent and fewer accomplishments, the blame cannot be laid at her feet, but at ours for failing to recognize true creativity in a form that is neither orthodox nor trendy. . . .

No other significant American painter today is as autobiographical as she. In fact, she would certainly be recognized by anyone who had seen as few as five or six of her canvases, and would be perceived as an old friend by the time that person had viewed this entire exhibition. But it is neither ego nor pride that causes her to include so many references to herself. Far from it. In actuality, it represents her desire to be a part of whatever is happening in the world she creates.

Thus in her series of large "homages" to favorite painters, she can always be found taking part in the festivities. In *Big Lautrec and Double Self-Portrait,* for instance, she is present both as herself and as Lautrec might have painted her. And she can be spotted, big as life, in tributes to Degas, Bonnard, Eakins, Sargent, Cassatt, Tiepolo, and Monet. Most significant, she appears seated beside, and with her arm around the shoulders of, a skeleton representing death in *Thanatopsis* (1983), one

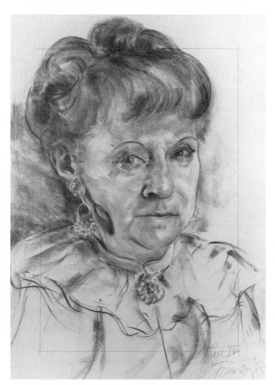

Figure 2. Joyce Tremain, *Rose IV.*

of the most moving and successful of all her works. The two are obviously on friendly terms, for there is nothing depressing about this painting. If anything, it is a haunting image of acceptance and resolution that resonates with much the same aching beauty and subtle hope one finds in Redon's finest floral pastels. It is in *The Parting*, however, and in *Hercules and Cerberus* (both from 1983), that her extraordinary ability to give form and expression to difficult and profound themes best reveals itself. In the former, the artist and her mother are separated by death and its questions and mysteries, and in the latter, the human and the bestial interact in a manner that is as psychologically astute as it is magnificently painted.[9]

Käthe Kollwitz

Another woman who has been the subject of a number of my reviews is the modern artist Käthe Kollwitz. Before discussing Kollwitz, and as a context, I recall some remarks I expressed in 1985 about the importance of a critic's love of quality and sympathy toward those who achieve it in a very special way. The piece sprang as much, if not more, from my experiences as a painter as from those as an art critic, and I made this point explicit in my remarks.

> I wish the words love, beauty, tact, and dignity were still part of the vocabulary of art; that criticism would concern itself more with the integrative and holistic aspects of creativity; and that every critic, curator, dealer, and collector should care as much about what constituted quality as about what caused a particular work to be perceived as "relevant," "significant, "original," or "new."
>
> If, however, my wishes were limited to one, I would ask that love's importance to art be made better known, not only because I know how crucial that relationship can be, but because that realization could help free us from the contaminating effects of an over-insistence on style, novelty, formalism, and fashion. But before that can happen we must reexamine our critical approaches to art, especially our belief that it can be analyzed on a strictly objective basis and without significant reference to such subjective factors as emotions or feelings. That it can, in short, be judged by standards that are clear, consistent, and absolute, and equally applicable to an ancient Egyptian fresco, a Renaissance sketch, and a Julian Schnabel panel made up of animal hides, broken crockery, and oil paint. Unfortunately, that is no more possible than judging oranges and carrots by a single standard, or deciding one novel is better than another because it was written in French.
>
> Obvious as that may seem, there are still too many art professionals who judge art that narrowly, who condemn one style by the standards derived from and applicable primarily or exclusively to another, and who reject an artist largely because his or her formal ideals differ from those

of the majority. There are even those who insist that art can only be made out of certain materials—that plastic and tin, for instance, will inevitably produce lesser works than marble or steel. And there are others who claim that anyone working in techniques traditionally reserved for the crafts will never produce genuine art. The trouble with such judgments is that they are based on external factors and procedures, failing to take into account the interior and subjective realities that motivate art and give it its energy and impact. Most particularly, they ignore the fact that art is a communicating device, a language, and that the means, the forms employed to get the artist's "message" across, cannot be perceived as ends in themselves—any more than my words on this page can be viewed merely as row upon row of little black specks.

Having spent several decades of my life as a painter, and somewhat less than one as a critic, it is perhaps only natural that my concern for what induces and impels creativity is at least as great as my interest in what it produces. I know, both from personal experience and from numerous conversations with artists, just how deep, inexorable, and life-transforming the creative urge can be. I am aware of how frustrating and heartbreaking it can be to feel something as huge as the ocean— and be able to transform only a few "drops" of that into art. And I've also experienced the rare and truly extraordinary moments of creative grace when everything falls into place without conscious effort or thought, and one can only look with awe at what "passed through" one's hands on its way to realization. Since I've been "on the other side of the fence," as it were, and have felt the powers that induce art, I am frequently frustrated at having to express myself as a critic in ways that have much more to do with the way art is "packaged" than with the forces that brought it into being. I feel similar unease at having to use an art-critical vocabulary carefully pruned of references to those emotions and feelings that are, more often than not, the heart and soul of the creative act.

Even taking into account that the making of art is a fashioning process, that even such explosive painters as Nolde and Pollock shaped their projected energies through controlled formal relationships, we must still contend with the raw emotional and visionary sources of art. Confronted by Kollwitz's 1932 drawing *Mother and Children*, do we really care about the style, technique, or medium the artist employed? I think not. What matters is the simplicity and directness of the artist's depiction of the mother's passionate, protective embrace of her children, the intense expression of her love for them. Kollwitz's draftsmanship and sensibilities were such that we feel our own muscles tighten in response to the mother's hug, and our hearts warm to the depth and genuineness of her love. Just as important, Kollwitz found the perfect format for her subject, and so produced an image in which feeling and form are and will always remain seamlessly fused and in perfect, effective balance.

It is this irrevocable fusion of content—be it emotional or intellec-
tual—and form that is crucial and that turns an impulse or an idea into
art, and a talented painter, sculptor, or whatever into an artist. It doesn't
matter if the work is by a New Guinea woodcarver, a twelfth-century
Chinese poet-painter, a contemporary African potter, or a young water-
colorist in New York's East Village. And neither does it matter if it is
"primitive," done on a scroll in ink, precisely realistic, serenely abstract,
or wildly expressionistic. If its motivating idea, experience, or emotion
is authentic, and its formal resolution is appropriate, then it could eas-
ily be a work of art. Not necessarily anything of great importance, or
even of particular interest, but something that can at least be identified
as such. That, of course, is only the beginning of the task of evaluating
art. But we cannot even get to that point if we insist on applying the
same critical criteria to everything we view and refuse to take into ac-
count that while certain artists may focus almost exclusively on the
architectonic aspects of painting and sculpture, others will prefer a more
informal and thematically dramatic approach, while still others will
devote their lives to giving voice and form to the simplest, deepest, and
most common human emotions. With that in mind, shouldn't our art-
critical vocabulary be expanded to permit us to identify the emotions
that are so crucial to the work of certain artists? Shouldn't we be able
to come right out and say, for instance, that it was love as much as
anything that inspired Van Gogh, Rouault, Kollwitz, and many others?
And without making more of that than is appropriate, would we there-
by at least help correct the current somewhat distorted emphasis on
these artists' expressive and formal means?[10]

My discussion of the work of Beverly Pepper, Joyce Trieman, and
Käthe Kollwitz, to mention but three women artists who have been
the subject of my criticism, prompted me to address the question of
stereotypes in art.

The art world still doesn't quite know what to make of women art-
ists. True enough, overt hostility and indifference toward them are on
the decline. And there is less and less talk about whether women are
capable of artistic greatness. In other areas, however, things remain
much as before. A patronizing attitude toward them and what they
produce, for instance, still prevails in certain quarters of the gallery and
museum world. It may be subtle and manifest itself as surprised de-
light at any evidence of genuine talent or accomplishment, or it can be
blatant and take the form of flattery or other exaggerated expression of
respect. It is most destructive, however, when it appears to champion
women artists and then proceeds to undermine their true strength, iden-
tity, or prestige by presenting them in a subtly distorted manner. When,
for instance, it represents them as "sensitive" and charming as opposed
to strong or significant. Or when it insists that their creativity lies al-

most exclusively in the direction of the intuitive and warm-hearted rather than in the intellectual and profound.

Inevitably, such stereotypes demean all those to whom they are applied. A large, beautifully mounted, and well-publicized exhibition of women artists, for instance, that stresses their lyricism and delicacy of touch at the expense of more solid and forceful traits, pays them no compliment, for it does little but perpetuate the myth of male supremacy in matters of depth and impact. The fact that women can paint or sculpt as "powerfully" as men—and without any "unnatural" straining on their part—still does not sit too well with many in the art community. Leave sensitivity and loveliness to the women and strength and importance to the men is their motto. Their argument ignores the fact that a number of the past century's most subtle and introspective artists have been men, and some of its most powerful and provocative have been women. Based on style alone, who could possibly identify the works of Redon, Whistler, Klimt, Morandi, Klee, Morris Graves, Mark Tobey, and Calder as by men? And who could identify those of Bonheur, Cassatt, Modersohn-Becker, Liubov Popova, Kollwitz, Neel, Joyce Treiman, Lee Krasner, and Nancy Graves—among many others—as the products of women? It simply cannot be done. The only possible giveaway would be subject matter—Cassatt's preference for young mothers with their children, for instance, or Kollwitz's numerous self-portraits. Outside of that, our best clues to the gender of these artists is a quick glance at their signatures, or better still, the labels that accompany their works.

To refer to Köllwitz once more. No one transcended sexual stereotyping more successfully than she did. Right from the start, from the time she was still in her teens, she confronted life squarely through her art and without the rose-colored glasses the male-dominated society of her time decreed were appropriate for women artists. By the time she was in her late twenties, she was deeply involved in a series of dramatic black-and-white prints that still stand among the most scathing attacks ever made against society's evils, particularly indifference to poverty and the suffering of others. A number of these, especially *Poverty Weavers on the March,* and *Riot* (all from 1897), are not only among the world's most powerful and uncompromising prints, but also among its best. She was, however, only warming up for what was to be a long and extraordinarily productive career that ultimately saw her achieve both worldwide fame as a graphic artist and professional degradation at the hands of Hitler. Her lifetime production was enormous. A 1980 catalog describes and illustrates 1,356 of her drawings, and she is known to have made 267 etchings, woodcuts, and lithographs—many of them in various states—as well as a few sculptures.

She was seldom without vigorous critical support, although, quite understandably, most writers focused on her provocative and occasionally disturbing subject matter and took her remarkable drawing and

printmaking skills pretty much for granted. And yet it is in her drafts-manship and in her ability to distill and compress profound and fre-quently overwhelming emotion into relatively small and compact black-and-white images that her true greatness as an artist lies. What others often failed to do in huge canvases or in murals, she consistently suc-ceeded in doing in prints that seldom exceeded the size of this page, and that often consisted of little more than a few bold strokes of a litho-graphic crayon. For sheer, concentrated emotional impact, no other draftsman of the twentieth century except Picasso could match her, and only a handful in the entire history of Western art could surpass her.[11]

In another column, I wrote:

If the twentieth century has produced one truly great woman artist, it almost certainly is Käthe Kollwitz (1867–1945). Two other artists who had the necessary talent and passion to match her, Paula Modersohn-Becker (1876–1907) and Lyubov Popova (1889–1924), died, unfortunate-ly, in their early and mid-30s. And Georgia O'Keeffe, for all her virtues and qualities, never quite made it onto Kollwitz's level. . . .

Even so, her reputation outside print circles has remained somewhat clouded. Critics, curators, and art historians have seldom paid her more than passing (if respectful) attention, and dealers, by and large, have ignored her in favor of artists whose works were provocatively mod-ern, colorful, and less starkly confrontational. One gallery that *has* con-sistently shown her prints and drawings, however, and in remarkable depth at that, is the Galerie St. Etienne. In its nearly fifty years on West 57th Street, it has mounted eighteen important exhibitions of her work and has served as a central clearinghouse for collectors, students, and scholars of her art.

In celebration of its newly renovated premises, the Galerie St. Eti-enne has just opened another major overview of Kollwitz's lifelong production, this time with particular emphasis on her use of printmak-ing as a vehicle to promote social change. The seventy-five prints and drawings in "Käthe Kollwitz: The Power of the Print" include many of her finest individual images, examples from all of her print cycles, rare proofs, rejected graphics, and a few significant preliminary studies. The overall effect, even for one who has known and admired her work for almost five decades, is overwhelming and deeply moving. From the early *Self-Portrait at the Table* and *Marching Weavers,* through such pas-sionate denunciations of human indifference and cruelty as *Storming the Gate* [figure 3], *The Survivors, The Volunteers,* and *The Mothers,* to such late graphic masterpieces as *Self-Portrait in Profile Facing Right* and *Seeds for Sowing Shall Not Be Milled!* the viewer is presented with one brilliant-ly distilled and focused human and expressive document after anoth-er. . . .

Although compassion was her primary response to life, she was also capable of venting her frustration and rage at war, poverty, political

murder, and any other form of inhumanity—and without recourse to the highly idiosyncratic or flamboyant distortions used by Otto Dix, George Grosz, or Picasso when they were most angry or passionate. Kollwitz, in fact, never deviated very far from direct physical description, from taking full advantage of the way people and things actually looked, and then using that information to fashion images that remained profoundly and specifically "human" even while serving as powerfully effective moral or social icons.

Her humanism, however, was never simplistic or sentimental, but was grounded in the very worst life had to offer. If anything, the subjects of many of her prints have survived and risen above levels of tragedy most of mankind never have had to endure. These individuals' courage, devotion, and sacrifice, their refusal to admit defeat or to fall victim to despair, represent, in fact, the dominant and most recurrent theme of Kollwitz's art. In her world, men and women may suffer, but their spirit, their will, and most especially their dignity remain intact. In this, Kollwitz comes closer to Rembrandt than any other twentieth-century artist. He, too, was interested more in tragedy's effect on the individual than on the group, and he, too, was capable of using the most ordinary of human acts to give form and expression to mankind's deep-

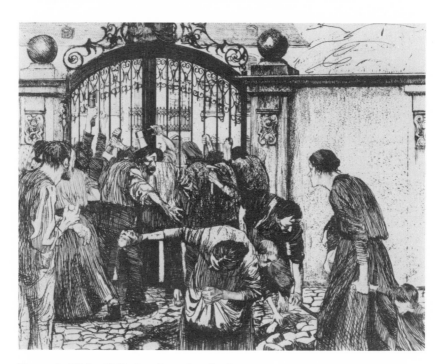

Figure 3. Käthe Kollwitz, *Storming the Gate*.

est, most ennobling, but also occasionally most painful truths and realities. Confronted by her soul-searching lithographs of the mid-1930s, one cannot help wondering how she would have responded as an artist to the Holocaust. As a passionate enemy of war and cruelty (she lost a son in World War I), an avowed anti-Nazi, and the wife of a physician who devoted his life to the poor, it is highly unlikely that she would have remained silent had she heard of what was taking place in Buchenwald and Dachau. Of course, she may have heard rumors but couldn't believe them. Or perhaps she simply didn't know how to cope with crimes against humanity on so huge a scale. But whatever the reason, the fact remains that her art stopped short of expressing that ultimate horror. And that may have been all to the good, since her love, her faith in the essential goodness of mankind, had been sufficiently tested by then.[12]

Anselm Kiefer

I wondered how Kollwitz might have responded to the events of the Holocaust, but she died before that was possible. But another German artist, the contemporary painter Anselm Kiefer, has responded not just to the Holocaust and humanity's inhumanity but to dark impulses generated by modern existence and the redemptive power of art.

It's entirely possible that West German artist Anselm Kiefer may be twentieth-century modernism's last major master. If so, he'll bring to a dramatic conclusion what such pioneers as Picasso, Matisse, Nolde, and Kandinsky set in motion eighty years ago. Just as important he may be the last artist sufficiently powerful, committed, and drenched in modernist ideals to respond to the dread cry of alienation, anxiety, and despair sent forth into this century by Edvard Munch's soul-searing 1895 lithograph, *The Cry*. That cry heralded mankind's rude awakening to an age of starker and more awesome dimensions of awareness than any it had known—dimensions that would lead either to greater spiritual enlightenment or, as would happen too often, the kind of despair that seeks refuge in sensationalism, totalitarianism, and oblivion [figure 4]. This soul-cry of the century was heard in no-man's-land during World War I, in Guernica, Dachau, Hiroshima, Vietnam, and Cambodia. It is heard in Harlem, Ethiopia, among the homeless on our cities' streets, in our prisons, hospitals, and mental institutions, and in political torture, drug addiction, and indifference to others. It found its way into art not only in the tragic, compassionate, or violent images of Rouault, Kollwitz, Picasso, and Beckmann, but even in the abstractions of purists like Mondrian and Brancusi, who responded to the nihilism and despair around them by fashioning icons of irreducible and unarguable perfection.

Formalist theory could neither diminish nor deflect the cry as Pol-

lock proved in his huge, labyrinthian canvases, and as other Abstract Expressionists like Kline, Rothko, and De Kooning, proved in theirs. Nor could Warhol's studied avoidance of its implications or the New Realists' insistence on its irrelevance suppress it. Despite everything, the cry persisted and was addressed, directly or indirectly, by almost every artist of note during the past two decades, from Joseph Beuys and the Neo-Expressionists to such recent "postmodernists" as Julian Schnabel, David Salle, and Eric Fischl. None of the latter, however, is quite capable of engaging it in depth. Compared with Munch's original print or Picasso's *Guernica,* their work appears flaccid and culturally two-dimensional. The passion and conviction simply are not there, to say nothing of the vision needed to engage so awesome and final a perception. Only Kiefer seems sufficiently prepared for the task, sufficiently blessed with the requisite vision, skills, imagination, and depth. But more important, he also projects a mystique or charisma that causes others to sit up and take notice. Some say that special quality is genius; others call it merely shrewdly packaged talent. (I'm inclined to think it's the former.) One thing is clear: It's extraordinarily impressive. It's so effective, in fact, that first-time viewers have been known to gasp as though physically assaulted when confronted by one of Kiefer's gargantuan efforts—and then to accept both the work and its implications without further ado.

That kind of response stems from the sheer size and aggressive physicality of many of his pieces. A canvas roughly 12 by 18 feet—covered with heavily encrusted mounds of paint, clumps of real straw, sheets of gouged lead, bits of porcelain, sections of copper wire, olive branches,

Figure 4. Anselm Kiefer, *Midgard.*

and huge, blown-up photographic images loosely overpainted—is
bound to have a powerful effect. Add to that the fact that Kiefer's paint-
ings project an aura of grave, almost mystical solemnity, and the depth
of character and seriousness of the artist come through. But that's only
the beginning. Because Kiefer's imagery is so provocative and he's so
wholeheartedly committed to his themes, he challenges us to decipher
the complex, multi-layered, and frequently disturbing symbols that
dominate and give meaning to, his art. This brings us to the heart of
the matter. Like Picasso, Beckmann, and Bacon, Kiefer communicates
and convinces through complexity and ambiguity rather than clarity.
He relies on a contrapuntal manipulation of symbols rather than a sim-
ple presentation of them. No matter how logically one attempts to "ex-
plain" his paintings, they always remain partly elusive and enigmatic.
One can go into the greatest detail about his primary themes—the per-
version of national identity; Nazi Germany's guilt and responsibility for
those it destroyed and brutalized; the saving grace of literature and art;
the value and significance of myth and religion; the importance of the
artist as cultural and national redeemer—and still not pinpoint what
he's all about. For that we must go to the work itself and experience it
in all its complexity, as a dynamic fusion of object, sensory device, sym-
bol, and metaphor. As art that makes its point by allusion rather than
exposition and that aims to be more redemptive than beautiful or en-
tertaining. Only then will we begin to understand what Kiefer has ac-
complished, and why he appears to be the only painter today capable
of responding to Munch's anguished cry of a century ago.[13]

Andy Warhol

After a discussion of the stature of a painter like Kiefer, it is difficult
to know what to make of the work of Andy Warhol, whose artistic
oeuvre can now be seen in a museum in Pittsburgh devoted exclusive-
ly to his work. I discussed his work in a magazine article and thus
was not limited by the limitation of newspaper reporting, where dead-
lines and restricted space place severe constraints on how much a
critic can say.

Andy Warhol has been called everything from a fraud to a great
artist, from an opportunist to one of the two or three most significant
creative figures of our time. Only Picasso, Dali, and Pollock stirred up
as much interest and debate in art, and only Elvis, the Beatles, and
Marilyn Monroe surpassed him in worldwide pop-culture acclaim.
[In 1990] London played host to what was hailed as "the most com-
prehensive display of Warholiana ever gathered together in one city"—
the Hayward Gallery's mammoth retrospective on tour from New
York's Museum of Modern Art, the Victoria and Albert Museum's pho-
tographs of Warhol's studio, and the Serpentine Gallery's exhibition of

work from his commercial-artist days, "Success Is a Job in New York." Now Warhol is joining the world's select company of artists with museums named after them and dedicated to their work. . . . And yet Warhol was a painter who seldom painted, a draftsman who traced as often as he drew, and a celebrated portrait artist who worked mainly from snapshots. To friends and critics he was frank and disarming. He said, "If you want to know all about Andy Warhol, just look at the surface of my paintings and films and me, and there I am. There's nothing behind it." And again, "All my films are artificial, but then everything is sort of artificial—I don't know where the artificial stops and the real begins."

Despite—or perhaps because of—what he said and did (or didn't do), he became world-famous and influential. Many critics, including Peter Schjeldahl and Carter Ratcliff, argue, in fact, that by erasing the distinctions between "fine" and "commercial" art and legitimizing consumer products and pop-culture heroes as subjects for paintings, Warhol was instrumental in redefining and redirecting a major portion of late twentieth-century art. Art history will probably decide that these critics were right. Warhol did, as Pop Art's dominant figure, help redefine art in the 1960s by raising common supermarket items (Campbell's soup cans, Brillo boxes) and color photographs of popular film and rock music stars (Elizabeth Taylor, Mick Jagger) to the status of important cultural icons. By that simple act, which he made even more revolutionary by painting these "icons" as unemotionally and banally as possible, Warhol helped art to "cool" down after its "hot" Abstract Expressionist period and to become more detached and ironic. Art history will probably also record Warhol's extraordinary influence on several generations of talented and ambitious younger artists around the world. To these youthful painters, photographers, and filmmakers, Warhol was the artist-magician who had made it BIG as no other American artist ever had, and who was, as a result, the person to study and emulate if one also wanted to become rich and famous.

Glamour, fame and wealth! Those were the things these youngsters associated with Warhol and what they obviously hoped would somehow rub off on them if they came into his orbit. No other artist of this century, except Picasso, elicited as much awe from young artists as Warhol. Merely to be in his presence was a great honor, and to be affiliated with him in any way was to be in on the ground floor of something that undoubtedly would affect the art of today and tomorrow. It's easy to understand such a reverential attitude in these budding artists. It's less easy to understand it in distinguished art professionals. But many felt that way, and because they did and weren't reticent about expressing their feelings, Warhol became one of the true "untouchables" of contemporary art, one of the very few recent artists (Joseph Beuys and John Cage are two others) considered almost beyond criticism by the pundits of the art establishment and their followers.

The emergence and flowering of Warhol-mania was fascinating to watch. It began in the early 1960s and reached its greatest height to date during and immediately after his recent Museum of Modern Art retrospective. The exhibition itself was a smashing success. Expressions of admiration and affection poured in from all directions. Nothing was too good for "Andy," and that included the catalog for the retrospective. It was huge (480 pages), profusely illustrated (460 plates—277 in color), and filled with everything one could possibly want to know about Warhol written in glowing prose contributed by distinguished critics and art historians as well as by numerous friends and acquaintances. It was a magnificent testimonial, especially since it was unanswerable. To have challenged its conclusions about Warhol's greatness would have turned one into a spoilsport. To have questioned its assertions about his goodness and modesty would have been ungracious and in poor taste.

It would also have been naive. One of the most fascinating things about Warhol is how studiously (and successfully) he worked at keeping his private life private. For instance, hardly anyone knew until after his death that, despite his hedonistic, even amoral image, he had never severed his ties with Roman Catholicism and that he was a regular participant, often with his mother, at mass. Neither was it generally known that Warhol had lent the prestige of his name to what is not only the most tradition-oriented art school in America but also the one least likely to proclaim his importance, the New York Academy of Art. This was both generous and an indication of his modesty in regard to his own abilities. Confronted by artistic brilliance—John Singer Sargent's paintings, for example, in his 1986 Whitney Museum retrospective—Warhol had no compunctions about discussing his own limitations as a painter and draftsman. These limitations had nothing to do with his art, however, which was predicated on the rejection of most of the skill and sensibilities traditionally associated with painting. His pictures were not "paintings" at all, in fact, but silk-screened transcriptions of photographic images with flat color overlays or, from roughly 1972 on, broadly executed brushwork modifications. Even more important, except for a few very recent pieces, his work totally lacked a personal touch, a sense that human feelings and emotions lay behind the images on his canvas.

That detached, impersonal look was intentional, of course, and central to Warhol's aesthetic. The last thing he wanted was to induce an empathetic or pleasurable response of the sort produced by the paintings of Rembrandt or Renoir. In that regard, he was closer in intention to a sign or billboard painter than to an artist who desires above all to express his or her feelings as directly as possible through the texture, color, and sheer physicality of paint. No wonder Warhol's paintings created such confusion in certain circles when they first appeared, and why he was dismissed as a "non-artist" (or, worse still, as a charlatan)

by those who put painterliness and the artist's personal touch above theory and devotion to the "new." It was bad enough that he slapped color photographs of dollar bills and rock stars onto canvas and became famous for it; it was adding insult to injury when a significant portion of that fame came about directly because he rejected those very qualities of expressiveness and sensitivity that traditionally separated the genuine work of art from an illustration or a piece of commercial art. It was as shocking and dismaying to these connoisseurs as it would have been to music lovers to be told that a singer was great because he or she sang off-key or had a thin and untrained voice.

Not surprisingly, considering their historical involvement with every kind of modernist theory, Europeans had less difficulty accepting Warhol as a serious artist than Americans had. West Germans, in particular, felt a kinship with him, probably because his posture of ironic detachment struck a sympathetic note at a time when they were still undecided as to their own artistic future. But even when they had committed themselves to Joseph Beuys's vision on the one hand and the Neo-Expressionists' passions on the other, Warhol remained a favorite. After Warhol's death in 1987, in fact, much was made in Europe of the Warhol/Beuys legacy to German art, a legacy that was celebrated in a highly successful exhibition, "Beuys and Warhol," held in the Darmstadt Landesmuseum in the spring of 1988. Even in France, Warhol was afforded that status of culture hero. One of the most fascinating testimonials to his fame, in fact, originated in Paris shortly after his death, when 2,500 counterfeit postage stamps bearing his picture, name, and dates, were privately printed, affixed to letters, and sent all over the world. Stranger still, they were honored by post offices throughout France. Japanese artists and collectors also responded enthusiastically to Warhol's work, partly because his pictorial strategy, the insistent two-dimensionality of his paintings and their dependence on flat, decorative color, was in accord with Japanese artistic tradition, but mainly because his images were so blatantly American and so obviously "progressive."

Such fame, of course, can easily create a backlash, and in Warhol's case it did. Not so much in Europe, where his reputation remained fairly steady, nor in Japan where it diminished slowly on its own accord, but certainly in the United States, most particularly in rural areas and smaller cities. America's art centers, however, especially Los Angeles and New York, remained largely faithful and enthusiastic. And understandably so, for Warhol was an urban artist to the core, and the devoted chronicler of that portion of urban society that celebrated glamour, status, wealth, and image above all else. It was there, in that hothouse mini-world within Big City America, that Warhol's art was born and brought to full bloom. And it was from there that word went out in the early 1960s of its importance.

But important to whom?

Certainly not to the many millions for whom art was an attractive pictorial record of a talented person's most beautiful or meaningful experiences. And certainly not to the thousands of painters for whom art was the most satisfying way of giving form and expression to whatever pleased or challenged them most. It was important to anyone for whom art was a profession or a business. To them, Warhol offered a most welcome opportunity to revive an art market bored by Abstract Expressionism and eagerly awaiting something lighter in mood and easier to understand. Warhol's paintings appeared made to order. What could be lighter in mood than pictures of Superman and Dick Tracy, or easier to understand than colored images of pretty flowers and Elsie the Cow?

Of course, there was always the question, "But is it art?" which the general public asked and which wasn't easy to answer because Warhol had done nothing "artistic" to the photographs he used except to jazz them up a bit with color. It was basically a matter of justification, of explaining why a blown-up, silk-screened picture of Elvis or Marilyn taken directly from a photograph and signed by Warhol was worth a few thousand dollars when the original photograph was worth twenty dollars at most. Or why a wooden box silkscreened by Warhol to exactly replicate a Brillo soap pads box sold for a small fortune when the box itself was tossed out with the garbage. The explanations weren't slow in coming and ranged from the dryly academic to the gushingly apologetic. All, however, stressed the importance of pop-culture images and mass-produced products in an increasingly consumer-oriented society, and the remarkable originality with which Warhol had addressed this issue and turned it into a new and legitimate subject for art. None, however, touched upon what would traditionally have been described as the art of his work, its quality, sensitivity, evidence of talent, even possibly (considering what was being claimed for it) its brilliance. None. Instead, the focus was entirely on the work's social importance, its value as a cultural document. And here everyone couldn't have been more enthusiastic.

In fact reading the catalog for his 1989 Museum of Modern Art retrospective, one is still struck today by two things: the need every writer obviously felt to proclaim Warhol's greatness and importance, and the passion and persistence with which these proclamations were made. But why? Picasso didn't get such protective treatment. Neither did Brancusi, Mondrian, Pollock, or many others who also had problems with the public. Perhaps it's because the work of an unusual, modestly talented, profoundly ambitious, and very shrewd artist was blown way out of proportion by a generation of art professionals, each of whom saw something in him he or she wanted or needed to see. Perhaps together, they created the myth of Andy Warhol the great artist whose only serious rival was Picasso. And perhaps, once their influence has waned, the world will be able to appreciate Warhol for what he

really was, an interesting decorative artist with an exceptional flair for color who forced art in the 1960s to get off its high horse and take a look at the world as it really was.[14]

Computer Art

In contrast to the Pop images of Warhol, the new images of computer art are different, something clearly brought out in an exhibition of such images from West Germany in 1986. It seemed to me that this bright new vocabulary offered new artistic possibilities.

If I were a young painter just starting out, I'd be very tempted by computer graphics. Not only does that field straddle science and art in a way that indicates these disciplines may not be as antithetical as we had thought, but it presents its user with both a provocatively expanded vocabulary of shapes, colors, and patterns and challenging new theoretical and experimental contexts within which to pursue his or her art.

One of the most fascinating of these contexts derives from fractal geometry, a mathematical study of forms recently developed by Benoit Mandelbrot to describe many of the irregular and fragmented patterns of nature. Since the most useful fractals involve chance, and both their regularities and their irregularities are statistical, their description and cataloging are particularly appropriate subjects for the computer. Complex mathematical theories and problems, and dynamics such as population growth and financial escalation, are fed into a computer and processed as images. Some resemble the psychedelic paintings of the 1960s, others, brilliantly colored sea horses, scorpions, paisley patterns, science-fiction illustrations, or new modes of abstraction. But whatever the resemblance, every one is the result of mathematical experimentation and demonstrates how unexpectedly varied the structures are that develop in the basis of the simplest laws.

To illustrate the beauty and complexity of these computer graphics, West Germany's Goethe Institute sent a group of the finest produced to date on a worldwide tour. I'm grateful it did, for the sight of eight of these images at Goethe House here not only convinced me, as nothing else has, of the artistic legitimacy of this new "art form," it presented me with as stimulating an aesthetic-intellectual experience as I've had in quite some time. It couldn't have been otherwise, considering their attractiveness and the issues they raise. My first reaction was disbelief that such vibrant pictures could have been computer-generated; my second, a powerful curiosity about how they were made, and what they signified for the art of the future. For answers, I turned to the exhibition catalog *Frontiers of Chaos*, with its excellent color illustrations and explanatory texts by five experts in the field. I was particularly intrigued by the use of the word "chaos" in relation to the production of works of such beauty.

Gert Eilenberger, in his essay on "Freedom, Science, and Aesthetics,"

ventured an explanation: "Why is it that the silhouette of a storm-bent, leafless tree against an evening sky in winter is perceived as beautiful, but the corresponding silhouette of any multi-purpose university build-ing is not . . . ? The answer seems to follow from the new insight into dynamic systems. Our feeling for beauty is inspired by the harmoni-ous arrangement of order and disorder as it occurs in natural objects—in clouds, trees, mountain ranges, or snow crystals That is part of the excitement surrounding these pictures: They demonstrate that out of research an inner connection, a bridge, can be made between ration-al scientific insight and emotional aesthetic appeal; these two modes of cognition . . . are beginning to concur in their estimation of what con-stitutes nature" And a little later, after discussing the manner in which the advent of powerful computers helped free scientists from some of their preconceptions about natural systems, he goes on to sug-gest that computers, rather than imposing order and discipline on ev-ery facet of life, are actually helping us to perceive the forms of a dif-ferent kind of order in what we had previously viewed as chaos or disorder. If he's right, and these computer graphics effectively argue his case, then we are indeed at the "frontiers of chaos," ready to "civilize" it by a clearer insight into the complexities of nature. And that, of course, is precisely where art will be found—eager as it always is to forge ahead into new and untamed territory. That, undoubtedly, is why these images are so engaging. There is both truth and an expansive sense of inquiry in them that challenges the viewer by alerting him or her to hitherto unsuspected possibilities. It's the way most genuinely new forms of art affect us, regardless of how strange or "inartistic" they may at first appear to be.

I am not, of course, suggesting that we discard our other modes of artistic expression and replace them with computer graphics. Far from it. I am only proposing that we add this new form to those we already have—much as we added photography a century and a half ago. We need all the help we can get in understanding the world—both seen and unseen—and every ounce of beauty we can find or help create. And since that's so, why shouldn't the computer, that ubiquitous medium of information and communication, also be called into service as an instrument of art?[15]

Summary

A major obligation pervading my work as a critic is the responsi-bility to be open and sympathetic toward artists and their work and to avoid superimposing a single critical perspective or type of criti-cism on all works. My writing contains elements of all three types of basic criticism—diaristic, formalist, and contextualist. Which type is stressed, or which combination, is a function of the demands of a

particular work or group of works. Once more, my experience as a painter is quite apparent and openly acknowledged. Although not all critics or readers will share my sympathies, judgments, and preferences, I try to state matters as clearly as possible in all my writing so others may share my perceptions or question them. I have distinguished art criticism from art reviewing, yet it should be apparent when, sometimes by necessity, my writing leans more toward one type of writing than another. Although criticism draws on theory and history, it is, strictly speaking, neither.

NOTES

1. All are from the *Christian Science Monitor:* "An Open Letter to Critics: Let Artists Soar," 23 July 1984, 21–22; "The Critic's Role: To Encourage Talent, Never to Dictate It," 24 December 1984, 21–22; "Art Calls for More Than Originality," 21 November 1983, 47; and "Progress in Art; or, Is Klee as Good as Michelangelo?" 8 March 1983, 19. My remarks are edited and slightly condensed versions of these columns.

2. Nelson Goodman, in *Languages of Art* (Indianapolis: Hackett, 1976), agrees: "To say that a work of art is good or even to say how good it is does not after all provide much information, does not tell us whether the work is evocative, robust, vibrant, or exquisitely designed, and still less what are its salient specific qualities of color, shape, or sound. Moreover, works of art are not race-horses, and picking a winner is not the primary goal" (261–62).

3. Theodore F. Wolff, "Art Calls for More Than Originality and Talent: It Builds on a Living Tradition." *Christian Science Monitor,* 21 November 1983, 47.

4. In *What Is a Masterpiece?* (New York: Thames and Hudson, 1979), Kenneth Clark refers to "two of the characteristics of a masterpiece: a confluence of memories and emotions forming a single idea, and a power of recreating traditional forms so that they become expressive of the artist's own epoch and yet keep a relationship with the past. This instinctive feeling of tradition is not the result of conservatism, but is due to the fact that, in Lethaby's familiar words, slightly adapted, a masterpiece should not be 'one man thick, but many men thick'" (10–11).

5. Theodore F. Wolff, "Modern Art's Father Figure," *Christian Science Monitor,* 5 October 1990, 12.

6. Theodore F. Wolff, "Making and Marketing Art Superstars," *Christian Science Monitor,* 7 December 1987, 23.

7. Theodore F. Wolff, "Artistic Creations That Push against Their Showcase," *Christian Science Monitor,* 6 July 1987, 25.

8. Theodore F. Wolff, "More Than Superb—Alive," *Christian Science Monitor,* 5 September 1985, 38.

9. Theodore F. Wolff, "Swimming against the Contemporary Tide," *Christian Science Monitor,* 31 May 1988, 21–22.

10. Theodore F. Wolff, "Love in Art," *Christian Science Monitor,* 29 July 1985, 21–22.

11. Theodore F. Wolff, "Undoing Stereotypes," *Christian Science Monitor,* 3 June 1987, 30.

12. Theodore F. Wolff, "Kollwitz Gave Modern Form to Humanity's Most Essential Questions," *Christian Science Monitor,* 14 December 1987, 21–22.

13. Theodore F. Wolff, "Kiefer: Bringing Down the Curtain on Modernism," *Christian Science Monitor,* 8 August 1988, 19.

14. Theodore F. Wolff, "Warhol: What Now?" *World Monitor* 3 (January 1990): 67–76.

15. Theodore F. Wolff, "Art by Computer," *Christian Science Monitor,* 29 September 1986, 23–24.

4

Art Criticism and Art Critics
in the Classroom

Why teach art criticism? Why bring it into the classroom at all? What is its value? Its significance? Its impact, either immediate or long-range? What is criticism uniquely qualified to do—and why is that important? Can it benefit a six-year-old as well as a teenager? Is it useful outside the classroom? In later life? If so, how? Simple, even obvious questions but critical to the point of this book and difficult to answer with any degree of finality. The difficulty stems from the fact that criticism is not as well established a discipline as are art history and aesthetics. It is still struggling to establish its identify and clarify its principles and procedures.

Why Art Criticism Should Be Taught

Despite being in its formative stage as a discipline, art criticism should be taught because, together with aesthetics, art history, and studio art production, it can help heighten student awareness of the qualities and significances of art. More specifically, it can help everyone, teachers and students alike, to learn to engage, discuss, evaluate, and write intelligently about works of art in all media and styles, regardless of how shocking, inartistic, or reactionary they might at first appear. That is what art criticism is uniquely qualified to do, and it is what differentiates it from other disciplines.

But why is that important? Quite simply, because being able to empathize with and respond intelligently to works of art goes to the very heart of what creative, responsive art experiences are all about. To be able to do that is to participate, at least peripherally, in the creative process; it is to share, if only slightly, in an artist's mysterious transformation of emotion, sensibility, and intuition into art. Not to be able to do so, on the other hand, is to be able to respond only to art already labeled, judged, and acclaimed. It is to recognize and know art primarily by its externals—its style or conformity to accepted

modes of expression—and to experience, at most, only second-hand indications of what the artist was able to convey. At its best, art is an act of intimacy between creator and viewer. To experience this intimacy, viewers must be willing and able to meet artists half-way. That is true of art in general; it is particularly true of art in its groping, formative phase while it is still searching for its most appropriate form and voice. That was true of Picasso's and Braque's early Cubist canvases, Pollock's and De Kooning's first tentative Abstract Expressionist paintings, and Eva Hesse's initial attempts at sculpture.

Sophisticated viewers now respond effortlessly to these works, but when they first appeared they presented profound and difficult challenges, as they still do to average gallery-goers. One of the great virtues of the "Pioneering Cubism" exhibit of Picasso and Braque at the Museum of Modern Art in New York in 1989 lay in the fact that viewers could trace the evolution and decline of Cubism from its first, still somewhat incoherent beginnings in 1907–8 to its highly polished, rather decorative endings in 1913–14.[1] With very little imagination, viewers felt transported back eighty years to the *bateau-lavoir* studios of Picasso and Braque to share some of the challenge and exhilaration they felt creating profoundly new and significant work. Although moments of such creative depth and daring are exceedingly rare in art, others equally valid if less important occur all the time in artists' studios around the world as well as in classrooms. In all of these, the quality and the nature of the achievement may vary; the principles remain the same.

The Uses of Art Criticism in the Classroom

It is precisely in sharpening perception that art criticism is best suited to help. Aesthetics can clarify concepts and assess the logic of arguments, art history can explain precedent and provide contextual information, and studio activity provides practical experience. Art criticism, however, is especially capable of sharpening critical and perceptual faculties and providing those who practice the discipline with the necessary skills to analyze, discuss, and evaluate specific works on the basis of their nature, quality, and importance. Fortunately, the insights and techniques of art criticism are available to everyone. They work best, however, when brought into play by open-minded individuals who disdain preconceptions and hasty judgments and are willing to respond simply and without prejudice to new forms of expression claiming legitimacy in the name of art.

On the other hand, if openness and a willingness to empathize with

the new are key factors in art criticism, they are also among the principal rewards teachers can expect from the discipline when it is brought intelligently into school systems. Classroom discussions that present art criticism as an investigative process demanding sensitivity and understanding as well as analysis and judgment will almost certainly result in greater openness on the part of students toward art's complex and often confusing realities. And with that as a beginning, it is not difficult to predict where further use of art criticism's example and teachings can lead.

Creativity and Art Criticism

Art criticism can provide ample evidence that creativity is a dynamic, life-seeking force that accepts no preset limits and whose future movements and appearances can almost never be accurately foreseen. By drawing attention to ill-advised judgments made during the past century and a quarter by critics dismayed by the startling novelty of the work of such artists as Monet, Cézanne, Van Gogh, Munch, and their like, students can learn the value of a cautiously respectful attitude toward difficult art. On the positive side, the literature and example of responsible art criticism can illuminate the dynamics of the creative process, particularly its insistence on finding its most appropriate form and mode of expression—or, if none exists, to invent it (witness the formal inventions of Brancusi, Calder, Miró, and Pollock). Most important, art criticism can lend critical support to a student's first tentative ventures into purely personal and original work by citing examples of others who risked derision and worse in order to give voice and form to what most demanded expression within them.

Now, some might object that citing risk-taking artists of the past is art history's function, not art criticism's. In a sense they'd be right, but only if discipline-based art education is understood as consisting of four unrelated disciplines and not, as it is perceived here, as a compound discipline contributing jointly to a common teaching objective.[2] Art history provides the historical continuity and knowledge, aesthetics the philosophical analysis, and art production the studio experience upon which students' understanding will partially depend; art criticism provides the verbal support that reinforces learning. Cooperation of this sort can only have a positive effect, for it draws together the principal attributes and procedures of each of the four disciplines and integrates them into an educational tool of considerable impact.

In such situations art criticism frequently takes the lead in the integrative process, not only because it is the most immediately accessible of the disciplines (everyone enjoys analyzing and criticizing) but also because it is, in many ways, the most adaptable. Art criticism bears somewhat the same relationship to aesthetics and art history as applied science does to pure science. The parallels might not be precise, but they're close enough to be instructive.

Art Criticism as a Practical Discipline

In bringing art criticism into the classroom, it is important to realize that it is a practical, working discipline designed to accomplish distinctive ends in specific ways. As such, it's less interested in formulating theory than in applying it to the realization of clearly defined goals. Unlike aesthetics it seldom asks general questions about the nature, meaning, and value of artistic expression, and unlike art history it doesn't normally concern itself with systematic relationships of the past to the present. Although every responsible art critic draws more or less explicitly on aesthetics and art history, these disciplines are not central to what art criticism does: analyze, describe, and evaluate specific works or types of art. It is precisely this practical side of art criticism that is of special value in the classroom, for it brings art down to a general level of discussion suitable for everyone, regardless of age, orientation, or background. Thanks to its literature and wide-ranging methods, criticism can induce students to investigate the issues of creativity and learn how to analyze and discuss any and all kinds of work, that by accomplished artists as well as kindergartners' finger-paintings and drawings by adolescents.

Acquiring a Sense of Familiarity toward Art

Casual but extended exposure to art criticism, then, even on its less sophisticated levels, can be helpful in inducing students to acquire a sense of familiarity toward art and artists. And that, in turn, will make it easier for them to view art as both a natural and valuable part of their lives. Although the purpose of discipline-based art education is not to prepare studio artists, art criticism, in that part of the program where studio exercises are undertaken, can provide students with a system of checks and balances that can discourage undisciplined expression. Students will further be helped to develop critical criteria that can be used not only to assess their own work but also that of others. Art criticism can also help students appreciate that creativity

requires freedom but only from externally improved restraints rather than standards and criteria derived from individually determined values and ideals.

Writing Art Criticism in the Classroom

Motivating students is a perennial problem of teaching. One of the most effective ways to encourage them to acquire a knack for criticism is by having them put their reactions to works of art into words as clearly as possible. Although often neglected, writing is, after all, an excellent way for students to learn how to marshal their critical arguments most effectively and organize and shape their thoughts, observations, and conclusions. Toward that end, all forms of written criticism, of music or literature as well as of art, can provide first-rate examples as models to study.[3]

Art criticism is exceptionally rich in examples of the way intuition, insight, and analysis, coupled with basic writing skills, can result in clear, understandable prose that describes the work at hand, defines its attributes, interprets its meaning, and expounds on its quality and significance. These examples, examined and discussed in class or studied individually by older students as working models and guides, can provide the format and outline for these students' first tentative attempts at writing art criticism. Results may not, at first, be very impressive, but they should help introduce a semblance of intelligence, order, and logic into these beginning attempts at writing art criticism. If nothing else, it will alert them to the thought and care that can go into what seems to be a simple piece of writing on art.

Initially, what matters most in this use of writing is not the product so much as the process, the lessons learned, and the disciplines that students acquire as they try to transform general, often vague, impressions and reactions into clear, convincing prose. Although improved writing skills should certainly result from such training, the principal objective is heightened self-awareness. As Harold Taylor so aptly remarks, "The purpose of engaging the student in the act of writing is the same as the purpose of engaging him in true reading— to reveal to himself what it is he really thinks, what he honestly feels."[4] Such writing can also be of the greatest importance in helping students realize their critical capacities. As Edmund Feldman points out:

> Very often . . . the difference between the great and mediocre artist is due to the fact that the great one is a great critic—not necessarily of

other people's work, but of his own. The person who has professional aspirations in art cannot get very far unless he has developed a high degree of insight into the meaning of what he himself has done. Where does he acquire that insight? Who is going to show him how to form the critical act on his own work? Many of us have encountered young-sters or university and art school students who have extraordinary tech-nical abilities but who seem not to know when they have failed. This is to say, they lack critical insight into their own work.[5]

Because this insight is so important, acquiring it must take top prior-ity. That's where writing comes in. Critical writing, whether practiced in conjunction with art making, studio critiques, or discussion about works past and present, can help induce this form of self-awareness. It won't work for everyone, but it should for a large enough number to make it worth the effort.

Some will object to an emphasis on art criticism and critical insight as having little or no bearing on youngsters under eight or nine—and hardly any more on those up to twelve or thirteen. The suggestion that very young students should be asked to write their own elementary form of art criticism will seem naïve and ill-advised at best—not to mention the suggestion that professional art criticism be studied in class to give students a means of looking at, evaluating, and discuss-ing works of art. These are sensible objections if it is assumed that all children in art classes, regardless of age or inclination, will be expect-ed to devote significant time to such writing and if they will, even at third- or fourth-grade level, be expected to benefit from reading the critical writings, say, of Hilton Kramer, Clement Greenberg, and Donald Kuspit. That would indeed be naïve and ill-advised, perhaps even complicating, and possibly even destructive. What would be appropriate and workable, however, would take into consideration such matters as a student's age and level of sophistication as well as a school's curriculum objectives.

Ideally, the process would be gradual, with critical ideas and con-cepts measured out as they can be assimilated. It would be a process of accrual, a progression from grade to grade, beginning with talking about art and then writing about it. That might seem to require a particular kind of mind and sensibility—to say nothing of a special way with words. On a professional level that may be so, but interest-ed students should be able to accomplish a considerable portion of what professional critics do.

We should try to neither encourage or discourage art criticism as a profession. It is important to remember that the goals of a discipline-based program are to help students develop their understanding of

art and guide them in the process of learning how to interpret what they see in terms of the larger issues of their society and time. Writing aids in that process. Jacques Barzun has brought out this point very well in observing that "the benefits of teaching art to the young will consist mainly in the pleasure that comes of being able to see and hear works of art more sharply and subtly, more consciously, to register that pleasure in words, and compare notes with other people similarly inclined."[6] In the most successful cases, the value of writing and discussing criticism can extend far beyond the field of art. In partly successful cases, it will have activated a greater awareness in students of the nature and value of critical inquiry in general, especially as it relates to a greater understanding and appreciation of difficult works of art.

Art Criticism and Playfulness

But there's more. Art criticism can lead students even further—into the realms of aesthetic enjoyment, for instance, or toward simpler and lighter-hearted pleasures in art. Most people assume that art criticism isn't playful and that it's too serious and solemn to tolerate irreverent treatment. It is true that criticism has a serious responsibility: to help art stay on track and remind it of its larger objectives. But art is much too alive and expansive to always be solemn and significant; it also needs to kick up its heels and have fun. There is a playful as well as a pious side to criticism. Too often the innocent, light-hearted aspects of art are perceived as irresponsible, superficial, and not worthy of the great traditions of art. Klee, Miró, and Calder, among others, were roundly condemned at the beginning of their careers as shallow and trivial, insignificant artists. Much the same criticisms greeted the first showings of Claes Oldenburg's gigantic lipstick and clothespin sculptures and Niki de Saint-Phalle's over-ripe naked women painted bright blue. In almost every case it was art critics who set things straight and art criticism that carried the word. The result was tolerance, acceptance, and finally enjoyment of the works. Calder's mobiles, hand-made toys, and other light-spirited, three-dimensional creations in particular have delighted and given pleasure to millions of art lovers around the world.

Art criticism made it clear that these works, although undoubtedly frisky and fun-filled, were art and so could be enjoyed as much as one might wish without fear of embarrassment. For that we should all be grateful. In general, however, the idea that something can be fun and still be art—and significant art at that—is still a revolution-

ary one for many Americans. Thanks to our tradition of hard work
and practicality, it's not always easy for us to accept work that isn't
"serious" or "important" or that shows little or no evidence of pro-
longed or highly skilled labor as "real" art—especially if such work
appears flippant or openly contemptuous of the skills or ideals gen-
erally associated with art at its finest and best. Naïveté and clumsi-
ness may be condoned, but insults to artistic ideals—or more point-
edly to a viewer's most cherished notions of truth and beauty—are
unforgivable for most people. Unfortunately, students often share in
these misperceptions and prejudices; even those who do not may feel
pressured to produce only work that conforms to limited communi-
ty understandings of genuine art.

Countering such pressure can be difficult for students, especially
if art has been too narrowly idealized in their experience or even ex-
cluded entirely from their lives. Getting them to realize the impor-
tance of art and appreciate its enormous range and richness has
stumped more than one well-intentioned teacher. But teachers can
always turn to art criticism for help. Abundant, excellent examples not
only justify light-hearted, delightfully iconoclastic creations but also
celebrate them on solid critical grounds. I doubt that there is any
nonconformist art—from the most irreverent to the most idiosyncrat-
ic—that doesn't have a champion somewhere whose critical writings
can provide a convenient point of departure for whatever open-end-
ed classroom approach a teacher may need or have in mind.

Critical Valuation of Nonconformist Art

Some of the most effective art criticism of the late 1970s and early 1980s
dealt with the issue of critical validation—in this instance the militantly
nonconformist work of a generation of young artists (Neo-Expression-
ists and New Imagists) whose work consciously violated many of the
most sacred principles of the preceding generations of American artists.
The "crime" of Jonathan Borofsky, Sandy Skoglund, William Wegman,
Jean-Michel Basquiat, Mark Tansey, and many others was exactly the
same as that perpetrated by students rebeling against established values
or authority. Examples of these artists' work and of the critical writing
that dealt with it can be found in any of the major art magazines of the
period. They are worth study because most of the critics (particularly
Donald Kuspit, Carter Ratcliff, Peter Schjeldahl, and Roberta Smith) con-
tinue to be deeply involved with art criticism.

The most powerful message art criticism can communicate is that
art is too rich and profound ever to be narrowed into only one style,

method, or approach. To make that clear is to accomplish a great deal. To go one step further and convince youngsters that anything they think, imagine, or experience strongly enough can legitimately be turned into art is to prove art criticism's worth as a significant part of the educational process. And yet, valuable and important as this validating process is, it represents only one aspect of art criticism's capacity to enhance the lives of students. Helping them overcome inhibitions must be balanced by helping them perceive and assess quality and significance, not only in their own work and that of established artists but also in their culture and time.

The Vision Implicit in Art Criticism

At the heart of every genuine piece of art criticism lies a vision, an ideal, of how things could be. At times, the discrepancy between that ideal and a particular work of art may be ruthlessly examined; at others, the discrepancy may be only hinted at or discussed in general terms. In the classroom, criticism is principally concerned to advance the growth of student understanding in their art making and appreciative efforts. Were that not the case, art criticism would have no place in the classroom. The last thing young people need is the heavy hand of professional authority setting up impossible standards and then condemning all who fail to meet them. Art criticism can, however, introduce an element of firmness and certainty into the teaching of art. It can also guide a clearer understanding of how the young can best develop abilities and interests and help induce greater awareness of art's noblest, most life-enhancing qualities and goals. Seen this way, it is not at all far-fetched to say that art criticism—or at least the art-critical process—can be the creative conscience of art education. Some might reject this idea as arrogant and self-serving, but I am sure reflection will prove that it's close to the mark.

Bringing art criticism into the classroom is a two-step process: Educators should acquire greater knowledge of art criticism's methods and objectives and translate that knowledge into educational methods and techniques appropriate for those to be taught. Although the first is the easier of the two steps, it's still more difficult than acquiring a satisfactory overview of the other three art disciplines. Studio production, aesthetics, and art history have systematic guides, a rich and informative literature, and clearly defined professional identities. Art criticism does not—or at least not to the degree the others have—although it does have a literature that consists of prime examples of its published works.

These examples are invaluable and should be examined with care, either as they appeared originally in newspapers and magazines or as they were recycled in book form. Major art magazines in particular, some exceptions notwithstanding, contain some of the best, most clearly focused art criticism now published. Newspaper art criticism, on the other hand, geared as it is to a broader, less specialized readership, tends to be more general in scope. And yet precisely because this form of writing is more general and less demanding, it can provide an excellent introduction to the discipline. Equally important, newspaper art criticism can be more immediately effective for educational purposes than other forms because it almost always appears while the art discussed is still on view. Those interested have the opportunity, when the art is accessible, to compare it with the written review and opinion. Most art magazine critiques or reviews appear two or three months after the exhibitions under discussion have closed and also cover only shows in the major art centers. Much of what these critics write, therefore, lacks the sense of direct involvement that can be found in good newspaper art coverage. With the advent of the Internet, it will now be possible for criticism to be more immediately available, and thus the time lag between criticism and response to it will be offset

Art Magazine Criticism

Overall, greater significance can usually be attached to the writing found in art magazines, which tends to be more reflective than newspaper pieces and generally concerned with broader issues. In a sense, newspaper art criticism, which involves tight deadlines, reports in some detail what is happening in the art world and attempts to indicate which exhibitions, and whose works of art, are or are not worth viewing.

Magazine art criticism, on the other hand, focuses more on art world issues and examines the work of selected artists in greater depth and within the context of defined critical criteria. America's best and most influential art criticism since the 1950s—from Clement Greenberg's powerful clarifications of abstract expressionist theory to Donald Kuspit's probing analysis of postmodernist developments—has usually appeared in magazines or journals. The relatively few art-critical dialogues—"conversations" in print between critics of opposing positions—have also appeared in magazines. And the first advance warnings of significantly new or trend-setting developments in the art world can be found more in the monthly and weekly forums than in the daily ones.

Both forms have their advantages, however, especially if they are read in tandem and with as objective an attitude as possible. An unbiased, thoughtful reading of art-critical literature representing the discipline's full range of attitudes and positions should give teachers a clearer idea of not just art criticism's diversity but of how best to introduce the discussion and evaluation of art into classrooms in a more challenging, fair-minded manner.

A Warning

A warning is in order. Teachers should be cautious of puffery and other self-serving forms of writing. After decades of being barely respectable, art now is both respectable and profitable. With more than six hundred art galleries in the Greater New York area alone and others mushrooming in cities throughout the United States, the competition for sales and attention is extraordinarily keen. Respectability and artistic legitimacy are highly sought art world prizes because they are immediately translatable into economic values. The situation has spawned a body of writing on art that is more closely related to public relations than to art criticism. At best it is uncritically supportive of particular artists, styles, and movements. At worst it is flagrantly partisan. Fortunately, such writing is fairly easy to detect because of its exaggerated, unsubstantiated claims and pompously academic, inflated, or merely fashionable prose style.

On the whole, however, most published writing on art—both straightforward art criticism and the more general kind of art reviewing practiced by some of the better art critics—is legitimate and substantive. Just as important, it's full of invaluable information, including some of the best art-educational resource material to be found anywhere.

Learning to use this material may be difficult at first for those unfamiliar with the methods of art critics or intimidated by their reputations. And yet it's simple as long as one remembers that art criticism is only informed opinion. No matter how wise or brilliant a critic's opinion may be, it is still only an opinion and not an infallible, scientifically established judgment. True, the opinion may seem irrefutable, and for the moment it may be so, but time and perceptions will soon change. The conclusions may remain the same, but the arguments presented to convince readers will almost certainly shift over the years as theories and concepts once considered inviolate are gradually (or dramatically) replaced by others.

What will most likely not change, however, is the value and im-

portance of responsible critical inquiry and critical dialogue. They will remain central to the issues and realities of art because the questions art raises are never answered in final or definitive form. They always remain open for further analysis and discussion. That is why it is advisable, when considering how art criticism can best serve art education, not to view criticism as the ultimate authority but as a dynamic, questioning process that probes and illuminates the overall issues of art as well as the quality and significance of individual work. The central issue is not whether someone is a good or great artist, but why that individual should or should not be considered an artist at all. Art criticism is uniquely qualified to answer such a question.

In order to answer this question in a manner that validates the artist and earns the writer the title of critic, a case must be built marshaling relevant pieces of information and insight and shaping them into the most authoritative, convincing argument possible. In the process, everything a critic knows, senses, believes in, and hopes for in relation to art comes into play to one degree or another. Because every piece of serious art criticism confronts, at least indirectly, the fundamental issues of creativity, critics must address the question of art's nature and identity every time a determination is made about whether or not a particular work is art and whether it is good, very good, or possibly great.

Once a critic makes a determination, the equally difficult task of shaping and presenting a valid, convincing argument about it begins. The successful resolution of that task is essential if what is written is to be taken seriously as art criticism or if it is to be of any real value in the classroom. Again, reading the writings of as many critics as possible can be particularly rewarding. If the insights and conclusions of one critic can be revealing, those of a dozen or so—especially if each represents a somewhat different point of view—can be profoundly illuminating.

Assimilating and Applying Critical Insights

How does one assimilate, consolidate, and apply the insights and the information garnered from art criticism, especially if they come from a variety of sources, and how does one adapt them to the classroom?

Primarily, one should remain alert and reflective. Analyze the literature of art criticism as thoroughly as art critics analyze art. Examine and weigh every piece with equal care and caution, no matter how distinguished the writer may be. The kinds of questions that one can ask of any piece of critical writing were set out in a useful question-

naire written by Thomas Munro in 1958 and are still relevant. Cautioning that not all the questions must be asked of every critique and that some require more effort to answer than others, Munro suggested the following fifteen, which I quote in entirety:

1. The *piece of criticism* to be analyzed: title or other identification of the text. (For example, a complete essay or excerpt from longer work, journalistic criticism, general theory, history, biography, advertising, propaganda. Date and place published; conditions and occasions for writing and publishing it.)

2. Its *author*; the *critic* or evaluator. (Significant facts about him and his predispositions; personality, education, special interests and attitudes as elsewhere shown. Social, cultural, intellectual, religious, philosophic background.)

3. *Artist* or artists whose work is criticized. (Significant facts such as their date, place, school or style of work; nature of their other works.)

4. *Work or works of art* criticized or evaluated: particular objects or performances; general types or styles of art discussed; periods, traits, specific details.

5. *Main evaluative or affective terms* applied to the text; to what or whom; in what specific ways. (What verdicts, judgments, attitudes, conclusions expressed? Mostly favorable or unfavorable? Extremely or moderately so? Uniformly or with some exceptions? Calmly and objectively or with emotion such as contempt, anger, sarcasm, rapturous or sentimental adulation?).

6. *Standards* used by the critic or implied in his evaluation; principles, theories of artistic or moral value. His tastes in art and in related matters. Explicitly stated or tacitly assumed? How defended? Criteria of excellence or improvement; reasons for praising or denouncing; concepts of desired or desirable qualities, effects, functions, purposes of this type of art. Rules for good art accepted by the critic. Cultural and ideological background of these standards (social, historical, religious, philosophical, political, etc.).

7. *Arguments and evidences* given by the critic to show how these standards apply to the present case. Defense of judgments expressed. Authorities invoked. Sources of evidence. References to the work of art itself, indicating how it exemplifies certain qualities regarded as especially good or bad, strong or weak, beautiful or ugly, great or trivial, original or imitative, etc.

8. Alleged *effects and consequences* of the work of art or some parts or aspects of it, on those who observe it. What kinds of *immediate experience* or psychological effect does it tend to produce, according to the critic? (For example, pleasant or unpleasant, interesting or boring, exciting, soothing, amusing, sad, terrifying, stimulating, elevating, depressing.) Does it tend (according to the critic) to arouse anger and resentment, religious devotion, pity and sympathy, or some emotional

attitude? Some disposition to a certain kind of action or attitude? What *deferred or indirect* effects, as on character, education, morality, religious faith, elevation or debasement of mind, mental health, citizenship, success in life? Are these effects considered important enough to determine the total value of disvalue of the work of art?

9. On *whom or what kinds of person* is the work of art said to have these effects? (For example, adults, children, men, women, soldiers, foreigners, invalids?) On people in general, without restriction? Under what *circumstances?* (For example, in school, church, evening entertainment? In foreign exhibition, performance or translation?)

10. Does the *critic himself* claim to have *experienced* such effects or *observed* them in others? When and how? What evidence does he give for believing them sure or probable in future? How conclusive is this evidence?

11. General modes of *thinking, feeling and verbal expression* exemplified in the criticism as a whole. How manifested; in what proportion and degree? (For example, polemic, interpretive, factual, explanatory, judicial, personal, impressionistic, autobiographical, scientific, hedonistic, art-for-art's-sake, moralistic, mystical, propagandistic.)

12. Special personal *motivations and influences* which may have affected the critic's attitude and judgment. (For example, friendship or enmity toward the artist; extreme prejudices; connection with political, religious, socioeconomic, or other groups which might tend to bias judgment; fear of or desire to please powerful authorities.) What evidence exists for this? To what extent, if at all, does it seem to invalidate the criticism?

13. *Strong and weak points of the criticism as an evaluation* of the artist or work of art. Do you find it convincing or not? Why? Is it enlightening, informative, helpful in perceiving, understanding, appreciating, or sympathizing with the work of art? Fair or unfair? Logical and adequately documented? Based on adequate personal experience and verifiable knowledge? Vague or clear? Thorough, profound, superficial, trivial, or perfunctory? Strongly individual and subjective or the opposite?

14. *Literary or other merits or demerits of the criticism.* (Aside from the question of its correctness as evaluation, or its factual truth as description and interpretation.) Does it read well as a literary composition in its own right? For what qualities? (For example, of style, imagery, colorful personality, etc.) What faults does it have as literature? Is it poetic, humorous, informative, enlightening? The expression of an attitude one can respect even though disagreeing?

15. *Summary estimate* of its nature and value. Which of the above questions and answers have been given most weight in reaching this estimate of the critical writing? Why?[7]

An excellent set of questions, but it leaves out one that I think is important, and why I think so no doubt derives from the fact that I

am an artist as well as a critic. Thus I would examine a critique not only for the information Munro discusses but also for its mention—or lack of it—of a discussion of an artist's creative identity, intentions, and development. Human creativeness is at the root of all art, and given certain tendencies in contemporary art theory and criticism an artist almost disappears from consideration, along with the work as a distinct kind of object. This opinion is consistent with the idea of discipline-based art education.

A number of art critics will insist that a concern for the educational potential of their discipline lies well beyond what they perceive as its only real objective: judging works of art. And perhaps, in the strictest sense, they are right. If, as others suggest and I believe, however, art critics are in some ways teachers at heart, then the educational concerns of a number of critics may well indicate that the parallels between the two disciplines are greater than has been traditionally assumed.

Parallels between Art Critics and Art Teachers

Both critics and teachers believe in perfectibility—not, perhaps, of the absolute kind but certainly of the sort that applies to works of art and young students. Both want the best for the objects of their attention—flawless formal relationships, masterful draftsmanship, and exquisite color harmonies for works of art and fully realized and integrated intellectual, creative, and social attributes and skills for students. And both, ideally, will do whatever is necessary to narrow the gap between what has been accomplished in creating and understanding art and what can still be accomplished.

For critics, that means a thorough analysis of the work in terms of its identity, character, coherence, purpose, and relevance; a cogent and detailed presentation that points out the discrepancies between what the work could be and what it actually is; and an evaluation of the work's overall quality and importance. For teachers, it means a subtler approach that takes into account a student's age, experience, talent, and general interests while also using a number of critical devices. So far as studio work is concerned, of prime importance is an analysis of a student's work in the light of its identity (What is it?), coherence (Is the composition successful?), effectiveness (Do the colors work well together?), and purpose (What was the student trying to do?). A discussion (in private or in class) of the degree to which the work fulfills the student's original intentions is also important. Judgment is relative, largely technical, and limited to the discrepancies

among a student's efforts, objectives, and performance and how those discrepancies might be removed.

These discrepancies are critical to art criticism and to art education alike and provide a substantive talking point for addressing what is wrong or lacking in a work of art or in a student's understanding. They also provide practical suggestions for improvement. Yet as important as technical considerations are, they only scratch the surface of our real concern: finding ways to raise the consciousness of students, not only imaginatively but also intellectually, spiritually, and possibly morally.

In the process of increasing awareness, art is used as focal point and guide—and with good reason. It is an end in itself and a springboard to other realities and dimensions of feeling and sensibility. For youths involved with art in the classroom, getting in touch with these other realities depends on their teachers. The broader and deeper the teachers' outlook on life, and the better equipped they are to share their insights and experiences, the more likely students are to realize their capacities more fully and understand the depth and grandeur of the cultural universe that lies beyond their homes and classrooms.

Every teacher, no matter how effective, can benefit occasionally from outside support. At times it can be direct and personal, involving a professional from another art discipline. It is extremely gratifying, for example, to receive letters from teachers detailing how particular critical essays of mine, duplicated and distributed in class, have led to lengthy discussions and some intriguing conclusions on topics that previously had been of little interest. On most occasions I have responded by mail; at other times I have been able to discuss the issues with students in person. Doing so is not unusual, and it would occur even more frequently if teachers would lay doubts aside and communicate directly with the professionals they feel would be of particular interest or value to their students. Every city or community of even moderate size has someone—perhaps the arts critic or reviewer for the local newspaper or a professor with experience as a critic from a nearby college or university—who could be asked to drop by and answer questions for an hour or so.

The Art Critic in the Classroom

I have almost always found classroom visits informative and challenging: informative because I have occasionally been presented with fresh, uncomplicated responses to questions I had assumed were all but resolved and challenging because there always were a few stu-

dents who took exception to something I had written or said and wanted to question me further or set me straight. Responding isn't always easy, for at best it means that I have to find a simpler, clearer, and more direct way of explaining my position. At worst, it means that I have to back off and admit that I might have been hasty or even wrong in my judgments.

I soon realized, however, that I couldn't have found a better way to communicate several basic truths about art and art criticism than by proving to students that the published opinions of a professional are not only not sacrosanct but also open to discussion and clarification and possibly in error. There is nothing embarrassing about that, and there could only have been if my attitude was arrogant and superior. But a critic, by my standard, can be neither, nor, I am sure, should a teacher. Both, if they are to be ultimately effective, must be subject to challenge and open discussion. They must be willing to explain why what they've written or said is true and worth taking seriously. In one case I encountered, a major classroom challenge dealt with the issue of whether there is a definable, qualitative difference between art and craft. Would it ever be possible for a quilt, for example, to be as great a work of art as a painting?

The issue had come up because I had written that such a question was too general to concern critics and that although it might interest me personally I would not address it professionally except in the unlikely event that I would be required to assess the relative merits and importance of a particular quilt and a particular painting. Such an event would bring the issue squarely into the realm of art criticism. Until then, however, it would be better addressed by an aesthetician.

The students, understandably, were a little confused by my position, but it gave me the opportunity to point out some of the distinctions between aesthetics and art criticism. The former asks and discusses large philosophical questions about the nature, meaning, and value of art; the latter applies them judgmentally to particular works. Although perhaps an oversimplification, it did help me make my point. To the students, though, my reasoning was hair-splitting and evasive, and so, despite my objections, we ended up after all discussing the merits of quilts as art.

It occurred to me while we were doing so that I was functioning as a teacher and not as a critic and that in the process I was drawing on the resources of aesthetics as well as art history. It turned out to be quite a discussion, ranging far and wide and touching upon such matters as the relationship of material to artistic quality (Can one

make great art out of fur?), the nature of greatness in art (Can great art be silly?), and the value and importance of artistic judgment.

I enjoyed the encounter, primarily because it gave me the opportunity to demonstrate the critical process rather than being forced to explain it in possibly dry and academic detail. But I wasn't the only one doing the demonstrating. Every time the teacher contributed information or pointed out something I had missed, she became a part of the process—and so did every one of the students.

I have had several other similar classroom experiences as well as a few that differed because I was asked to play the part of art critic for both judgmental and educational reasons. My function in one was to judge the entries in a local exhibition to which a large number of high school students had submitted work, and to do so in front of an audience consisting primarily of the young artists whose works were under consideration. As each painting or drawing was placed on an easel facing the audience, I commented on it, first in general terms and then in the light of its strengths and weaknesses. Finally, I indicated whether it was "in," "out," or "maybe"—the last signifying that I wanted to see it at least one more time—and then gave reasons for my decision.

It's important to note that I had seen none of the entries before they were placed on the easel and that although the time I had to examine each work was short I felt it was long enough to discuss everything fairly. What the students witnessed, therefore, was a fair approximation of how a critic views and evaluates the contents of a large exhibition consisting of many works by many artists. The reasons behind this novel approach to judging exhibitions were, I thought, good ones. Dozens of students were each given the benefit of an art critic's response to two or three examples of their work, and they and everybody else in the audience could observe a wide-ranging, open-ended demonstration of the critical process.

Of course, I took the students' level of experience into account. Apart from that, however, I approached each picture seriously and with respect. A two- to four-minute critique (more for those I asked to see again) is brief but at least it presented the students with clues to how the outside world responded to their work and perhaps some insights on how to improve the quality of that work. In a larger sense, they had the opportunity to see their work in relation to that of many other young artists and realize that a number of the creative and technical problems with which they had grappled also caused difficulties for others. Perhaps just as important, it allowed them to see that art, for all its complex formal and psychological ramifications, is also

something that can be analyzed and discussed objectively and logically. The main disadvantages of such a jurying system are that it works only with older students and that the sessions usually run from three to five hours. Otherwise, it's a challenging and effective program for everyone concerned.

Verbalize Clearly about Art

Another issue of central importance concerns the ability to verbalize about art clearly and effectively. Quite a number of teachers seem to be intimidated by the thought of discussing art openly and frankly. They prefer to be uncritical, even reverential, in the presence of works by such artists as Cézanne, Picasso, Miró, Pollock, and even Warhol and present them to students as cultural icons to be accepted without question and with as little critical discussion as possible. That's a big mistake, not only because it's still too early to deify most of those artists but also because such uncritical acceptance runs counter to the goals of art education.

Even the artistic "deities"—and certainly Cézanne is one of them—are valuable because of what we can learn from them by intensive probing. Uncritical acceptance is never a compliment to artists of stature. In fact, the greater the artist the more that individual's reputation will withstand and benefit from the most thorough analysis. A critic learns this lesson early, and it can easily be demonstrated in class with slides and color reproductions—or better still during a visit to the nearest art museum. Of particular importance in this context is the matter of communication and being able to "translate" an artist's intentions, qualities, and achievements into words that first get to the heart of the work and then induce insight and understanding in those who hear or read them. That is the real challenge, the "bottom line" for both teacher and critic and anyone else who wants to be understood and cause others to experience the excitement and pleasure that insight into another's creativity can produce.

Comparing Descriptive Writing on Art

But some will ask if the attitude just discussed is in line with a critic's professional responsibilities. Perhaps not, but it certainly is what some of the best and most successful art critics have done, and do, extremely well and in ways that can be of considerable help to teachers learning to do the same. One need only read some of the past century's best writings on art (for example, Walter Pater's famous

description of Leonardo's *Mona Lisa* quoted in chapter 2: "She is old-er than the rocks among which she sits; like the vampire, she has been dead many times, and she has learned the secrets of the grave"), to realize that even the most subtle undercurrents of art can be verbal-ized and conveyed by imaginative combination of words and imag-es. And one need only dip into the writings of some more recent art critics to be caught up by the logic of their arguments and their en-thusiastic discussions of the artist's attributes as well as their highly effective evocation of suggestive, remarkably precise images. As Clement Greenberg wrote of Paul Klee:

> Klee's feeling for design is what I would call ornamental. He worked in a small format, in the tradition of those who illuminated manuscripts and illustrated books. . . . Klee's *line* plays the all-important part in this. It is not a line along which the eye feels its way. . . . It seems never to enclose or describe a shape or contour very definitely. It hardly ever varies in its width along a single trajectory, it has little plastic feeling; we find it hard to say whether it is soft or sinuous, wiry or angular, and so forth. Adjectives do not fit the case, only verbs. Klee's line indicates, points out, directs, relates, connects.

And further on:

> I do not think that Klee's color has the range of his line. Its register is limited, relatively, to tints: light, tender, aqueous, thin. . . . It is color that intensifies and fades like light itself, translucent, vaporous, porous. . . . We see disembodied lines and flushes of color but whether of the real surface or in its fictive depths we cannot tell. Lines wander across areas of hues like melodies across their chords; surfaces palpi-tate, figures and signs appear and disappear. It is an atmosphere with-out dimensions.[8]

And toward the end of a piece on Mark Rothko I wrote that:

> A great colorist is a great dramatist, for he knows that the secret of color lies in manipulating the tensions existing between individual colors and in not giving them all equal weight or emphasis. Thus, a colorist such as Matisse will achieve his desired effect by decreasing the number of colors and maximizing the tensions between the ones he uses. In other words, were he working with numbers instead of colors, he would not state that $2 + 2 + 2 + 2 + 2 + 2 = 12$, but would, rather, say that $4 \times 3 = 12$, that $11\frac{1}{3} + \frac{8}{9} = 12$ or possibly even that $19 - 7 = 12$. He would, in short, try to create coloristic drama, and would leave flat, unimaginative laying-out of colors to beginning artists or to those with a poor color sense.[9]

Words can also be used negatively to attack rather than praise. Witness the derisive, destructive manner in which very new or revo-

lutionary work is often ridiculed—or, for that matter, the way conventional or traditional work is often attacked by proponents of the new. Recognizing such biased writing is essential for everyone, especially for teachers concerned that students receive a fair and accurate accounting of current art world ideas and events.

Defense against Biased Writing

The ability to analyze, discuss, and evaluate art is the best defense against biased or intentionally slanted art criticism. It is also important to know that art cannot be judged on style, technique, or subject matter alone and that so-called criticism that attempts to do this is highly suspect—to say the least. Being wary of the bad, however, is not as important as being receptive to the good—especially when it comes to evaluating and discussing art. Here again criticism can help by providing proof that spoken or written reactions to art are generally most effective when expressed simply and directly. It can also present evidence that excessive theorizing about art and an exaggerated concern for the opinion of others tend to becloud critical issues rather than clarify them. The more relaxed and casual the relationship between work of art and teacher the better. In art, familiarity breeds not contempt but respect, understanding, and, more often than not, genuine appreciation. Such familiarity cannot be achieved, however, as long as art is perceived primarily as something awesome, glamorous, or extraordinarily valuable—or as something that can be truly understood only by experts. Some works of art are difficult and obscure and do require some specialized knowledge, but they are in the minority and need not concern us here.

What does concern us is the identification and removal of anything that stands in the way of a direct and empathetic response to art—anything that inhibits or prevents substantive personal interaction between viewer and painting, sculpture, print, or other work. Whatever it is—insecurity, inexperience, lack of knowledge, feelings of intimidation, or anything else—if it blocks insight or understanding or prevents appreciation or enthusiasm for art in any form, it should be removed. Communication about art between teachers and students is challenging and difficult enough in the best of circumstances. To attempt it without significant personal involvement in, or enthusiasm for, the issues and qualities of art—either in general or as they apply to specific works—is to risk disinterest on the part of students. Art, after all, is a highly subjective form of communication and expression, especially for the young. To fail to appreciate that and attempt to teach what it is and what it signifies impersonally, with a heavy, perhaps

exclusive, emphasis on factual and visual information, is to fail to communicate the point of art and its value and worth.

Art's Positive, Affirmative Nature

Art's vitality—its positive, affirmative nature, generous spirit, and commitment to whatever is dynamic and life-enhancing—cannot be conveyed by words, videos, and color reproductions alone. Other factors must also be brought into play: the experiences of creating art of one's own and visits to museums and art galleries; the sense, transmitted by teachers, that art matters and is alive, dynamic, important, and even fun; and the idea that anyone who's interested can participate in its activities. Art criticism can play a significant role in these activities, just as it can contribute to the mood of challenge and excitement in the classroom that leads to better art and better understanding of art. All it takes is a willingness to accept what art criticism has to offer and sufficient sensitivity to its realities to apply them wisely and well.

Summary

By presenting students with ground rules for understanding and appreciating art, criticism and art critics can make them aware that all art is accessible. It can help students engage, evaluate, and discuss art more intelligently, especially for the sake of greater understanding and the analytical methods learned in the process. Furthermore, it can alert them to the fact that art doesn't exist in a vacuum. It is often extraordinarily complex and deeply embedded within vital, wide-ranging cultural contexts. Art criticism can lend support to youthful efforts to go beyond the artistically straight and narrow by providing evidence that creativity is a dynamic, forward-moving force that generally prefers risk-taking and originality to more conventional ways of making art.

Criticism can also provide a system of analytical checks and balances that helps students establish critical criteria; help justify the creation of playful or irreverent works of art to those preconditioned to view it as necessarily solemn and serious; help validate provocative works that might otherwise be condemned as too flippant or idiosyncratic; enable students to understand and respect worthy works of art they do not like or could not previously accept as art; and provide students with the stimulus and the precedents to write about art as a way of learning how to organize and present their observations

and conclusions clearly and cogently. Criticism can further help lay the groundwork for a deeper understanding of the importance of art in human affairs and of what it means in terms of integrity, commitment, and professional responsibility to be an artist of substance and stature. Most important, it can enrich and enhance the lives of students by alerting them to much of what is most vital, imaginative, and original in themselves.

In more practical terms, art criticism and art critics can help young people become familiar with the literature of art criticism, both past and present, by paying particular attention to the major art magazines as well as to national and local newspapers. It can encourage them to read as widely as possible in the field, making certain to include critics of all points of view, as well as scrutinize carefully how critics analyze, discuss, and assess different kinds and styles of art and take from each whatever seems useful or most appropriate. It can advise against accepting one critic or school of criticism as the final authority and encourage being alert for inflated rhetoric and intentionally slanted criticism. Students can learn to resist intimidation, either by works of art or by artists, and to discuss art simply and directly, feeling free to use colorful language. Along with this goes the avoidance of excessive theorizing or exaggerated concern for the stated or published opinions of others—no matter how important or influential they might be.

It is also important for students to be comfortable, relaxed, and familiar with art, remembering that art is human expression pertaining to human realities and that, at times, one can communicate its qualities and values through personal enthusiasm as well as (or even better than) straightforward factual and visual information. It is possible that something that looks ugly at first glance may be a new aspect of beauty and that a work that appears conventional and even drab may be making a highly original point. Also worth heeding is the occasional shifting of focus from judgment to encouragement for purposes of stimulating imagination and creativeness. Finally, teachers should take to heart the primary lesson of art criticism: Be objective, thorough, and clear in assessing art, whether it was created by a master or a child.

But AT fails @ this I have seen no point

NOTES

1. William Rubin, *Picasso and Braque: Pioneering Cubism* (New York: Little Brown, 1990).

2. This point is emphasized in Ralph A. Smith's remarks at the beginning of this volume.

3. For some examples of critical writing by students, see Terry Barrett, *Criticizing Art: Understanding the Contemporary* (Mountain View, Calif.: Mayfield Publishing, 1994), chap. 6.

4. Harold Taylor, *Art and Intellect* (New York: Museum of Modern Art, 1960), 16–17.

5. Edmund B. Feldman, "The Teacher as Critic," in *Research Readings for Discipline-Based Art Education,* ed. Stephen M. Dobbs (Reston: National Art Education Association, 1988), 63.

6. Jacques Barzun, "Art and Educational Inflation," *Journal of Aesthetic Education* 12 (October 1978): 20.

7. Thomas Munro, "The Criticism of Criticism," *College Art Journal* 7 (Winter 1958): 197–98; reprinted in *Aesthetics and Criticism in Art Education: Problems in Defining, Explaining, and Evaluating Art,* ed. Ralph A. Smith (Chicago: Rand McNally, 1966), 478–80.

8. Clement Greenberg, "Art Chronicle: On Paul Klee (1870–1940)," in *The Collected Essays and Criticism,* ed. John O'Brian (Chicago: University of Chicago Press, 1988), 1:68, 69–70.

9. Theodore Wolff, *The Many Masks of Modern Art* (Boston: Christian Science Monitor Books, 1989), 138–40.

5

The Lessons of Art Criticism

Thus far in these chapters I have discussed the nature of art criticism, the values and work of an art critic, and how criticism can be introduced into the classroom. The question now is how to get students to understand and assimilate what art criticism has to offer. As anyone who has taught art knows, encouraging young people to view and discuss art as art, not merely on its superficial and imitative aspects, can be a challenging assignment. It can be difficult enough to induce intelligent, well-educated adults to look beyond subject matter, style, or technique in examining works of art. To get youths aged seven, twelve, or even seventeen to do so can prove a formidable task.

The Issue of Perception: Looking versus Seeing

How does one get a young person to really look at a work of art, to get beyond its surface characteristics and configurations to its substance and meaning, perhaps even to its reason for being? And, having accomplished that, how does one then point the way for this young person to relate these new insights into the work's identity, structure, and meaning to the larger issues of artistic quality and cultural significance? My coauthor George Geahigan makes several worthwhile recommendations along these lines that reflect his understanding of pedagogical situations in the classroom. The following discussion is drawn from my experience as an art critic.

Perhaps we'd be wise to begin by asking exactly what we mean when we insist that youngsters look at art as art. On the simplest level, we mean that art is a unique and complex form of human expression, a special language and way of knowing that has numerous dialects but a common vocabulary and grammar that students must learn. On a deeper level, we mean that they should stop merely looking at art and really try to see it. But what does that mean? What is so special about "seeing"? How does it differ from looking? From viewing? From any other form of observation?

Seeing is noticing. It implies awareness, even a certain degree of understanding, of the object observed. Looking is more casual and random. To see is to comprehend if not the full significance of what is viewed then at least its identity and the context within which greater comprehension can be achieved. In art, to see is to perceive a work within a larger context or particular frame of reference. It implies knowledge, insight, understanding, the ability to relate to a particular painting, sculpture, print, or whatever to others like it and to its historical precedents. It suggests familiarity with art in general and with art's many forms, styles, methods, and functions. Depending on the discipline, seeing can lead to many things. For art critics, it can result in sharper perceptions, deeper insights, and even, quite possibly, a few valuable intuitions. It can also, if critics probe deeply enough and can communicate, result in the kind of evocative prose that makes works of art come alive on the printed page and causes art teachers to snip critical essays out of newspapers in order to read them in class. And why should anyone be surprised by that? What easier way is there to alert youths to what they can see in art if they know how and where to look? It's simple and doesn't require up-to-date information on art. Such essays can be found in old newspapers and art magazines, and finding them is something students can be assigned to do.

The Value of Evocative Descriptive Prose

Two kinds of descriptive writing are particularly effective in art criticism and can be equally effective in the classroom. The first creates as many dramatic, colorful, and evocative verbal images as are helpful and appropriate. The second painstakingly describes those aspects of a particular piece a critic feels best illustrate the quality and significance of the work. The first depends on intuition and empathy, on the ability to identify strongly with whatever is occurring on canvas or paper or in clay. The second is more purely descriptive and analytical. Its purpose is not to re-create art in verbal form but to examine and discuss everything about the work that contributes significantly to its strength and weakness.

A critical essay that I wrote on the Japanese-Brazilian abstract painter Manabu Mabe provides an example of the first kind of descriptive criticism.

> These paintings are as immediate and direct as anything produced by the Abstract Expressionists or the great Japanese masters of calligraphy. In fact, one could describe them as explosive, for they contain such

concentrated energy that they often seem "unleashed" rather than painted by hand.

Their visual impact is extraordinary and as immediate as a whiplash. A yellow slash of paint hurls itself across a black void to connect with a slender white arabesque that meanders elegantly over a magenta field. A smear of vivid colors thunders across a sky-blue background, stops short at the painting's edge, and somersaults lazily downward to end up as a smudge of brilliant pink. Or a black slab of paint twists around, transforms itself into a deep blue, and spews out light blue flecks of paint against a blue-green sky.[1]

Merely descriptive, true enough, but sufficiently evocative to help set the stage for the critical comments a few paragraphs further on. My second example of descriptive criticism is a portion of an essay on a Charles Sheeler drawing:

His goal was always to fashion a more "perfect" image, to come as close as possible to creating icons of everyday or industrial reality. . . . To this end, he used photographs for authenticity, the principles of design and dramatic contrast for impact. He hoped, by playing them against one another, to produce paintings and drawings that both universalized their subjects and defined them as very real objects and places in the here-and-now.

He succeeded particularly well in *Interior, Bucks County Barn* [figure 5] . . . Nothing looks more real and solid, for instance, than the buggy at the center. And yet, where is its right front wheel? All we have in its place is an ambiguous area of grays that could be almost anything. As we study it, however, we become aware of how cluttered this area would be had Sheeler included the wheel. And so he left it out, compensating for its absence with a series of visual devices. He strengthened the patches of sunlight on the wall immediately to the left of where the wheel should be, and darkened both the objects on the pegs and the short board rising above them. This carefully worked out illusion satisfies the eye's need for balance, removes a problem area in the composition, creates a more harmonious flow of texture and tone, and does so without sacrificing one iota of authenticity or "truth."

The entire composition is full of such subtle illusions and adjustments. How, for example, is the buggy's front left wheel attached? The answer is that it isn't, and yet our eyes "read" it as firmly attached. And where would anyone sit in the buggy? Or harness it and attach it to a horse?

The more we study this drawing, the more "abstract" and unreal— and the more exquisitely and shrewdly designed—it becomes. Forms are moved a bit to the right or left to create more interesting patterns, or to lead the eye in a particular direction. Note, for instance, how subtle and crucial the inward curve on the vertical plank at bottom right is,

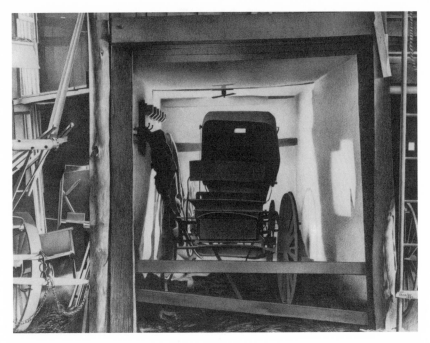

Figure 5. Charles Sheeler, *Interior, Bucks County Barn.*

and how essential the short, light, board above it is in diverting the eye
from the harsh dark angle of the doorway. Even the shading through-
out is delicately modulated to focus our attention, or to draw it away
to something more important.[2]

Although my strategies in these pieces differed, my objectives were
the same: to significantly heighten reader awareness of the qualities
and attributes of the works. Used in class, these and similar descrip-
tive paragraphs should help students become aware that art is more
than pleasant colors and accurate depictions. It is a unique, highly
sophisticated pictorial language with its own values, rules, and ob-
jectives that need to be understood and respected if art's secrets are
to be revealed.

New and Unusual Art

My task in discussing Mabe and Sheeler was made easier by the
fact that I didn't have to establish the artistic legitimacy of their works.
That would not have been the case had Mabe and Sheeler been con-
troversial newcomers or cutting-edge artists. But what if I had dis-

cussed something by such an artist, something so startlingly new and astonishing that it resembled nothing I had ever heard described as art before? How would I have handled that? My approach in addressing such work resembles that of Leo Steinberg (chapter 3). I tend to be more tentative and probing, and I rely on and trust my intuitions and sensibilities to a far greater extent than I did with the Mabe and the Sheeler. More important, I describe and discuss how and to what extent my intuitions and sensibilities affect and help shape my final determination of the work's quality and legitimacy as art. After all, if something as subjective as intuition is as critical to my judgment as logic and analysis, readers have every right to know about it.

Intuition and Sensibility in Art Criticism

Generally, however, intuition does not get the credit it deserves from art critics, who prefer to give the impression that art criticism is logical, judicious, and given to little doubt or hesitation. Although that may do wonders for art criticism's reputation, it projects a distorted picture to the world in general and to artists, art students, and young people studying art in elementary and secondary schools in particular. The fact of the matter is that art, because it is as much the product of feeling and emotion as of logic and reason, cannot be grasped fully without recourse to intuition and sensibility. To believe that one can truly comprehend art, particularly during its germinating phase, without their help is to be badly mistaken and blind to the profoundly subjective nature of art. The difficulty lies in communicating this fact to students. Critics, quite naturally, prefer to downplay these concessions to subjectivity and stress the perceptual skills and reasoning abilities that led to their critical conclusions.

I'm also concerned that students be encouraged to approach art as openly and empathetically, as intuitively, as they wish. If they are to receive the full benefit of art's great range and depth, it's essential that they learn how to sense art's hidden qualities as well as see those that are visible. It shouldn't be difficult, especially if they learn always to keep an open mind, trust their intuitions, and accept the fact that their most spontaneous reactions to art may well be their truest and best. In some ways, young children are wiser about such matters than adults. They frequently respond with delight to works that adults agonize over; adults often carry such an excessive amount of critical baggage that they cannot respond simply and directly to art created primarily for delight and enjoyment. I still hear people insist, for instance, that Alexander Calder's mobiles cannot possibly be art because

"art can't be that simple," and I have heard others reject Niki de Saint-Phalle's colorful sculptures and assemblages because they are "too much fun."

Those who feel this way are the victims of an inability to establish a sensible working balance between intuition and reason in approaching art. Or, quite possibly, they've been inculcated since childhood with the notion that "real" art is always either serious or monumental—or both. They don't realize—or can't accept—that art is incredibly complex and can be almost anything it wants to be. It can celebrate human greatness or express delight in the way a grasshopper sits on a blade of grass, or it can thunder, enchant, dignify, console, be silly, or poke fun. There are times when art should be accepted and enjoyed as simply and whole-heartedly as a bouquet of flowers and others when it is wise to temporarily suspend the question, "Yes, but is it art?"

Seeing Art Whole

Seeing this way is especially important when dealing with children. Before anything else, before getting to such matters as judgment and categorization, we should induce youngsters to try to see art whole, as a living, dynamic part of life and not merely as a series of valuable and important objects demanding unqualified attention and respect. When teachers do begin to alert students to the reasons for judgment in art, they must maintain a sense of proportion. Art, like most of what occurs in life, cannot be judged absolutely. It is multifaceted and elusive, and comparisons and categorizations can often be misleading and distorting. Teachers can cite, for example, the impossibility of determining which is truer, a circle or a square—or blue or yellow. They can ask whether a rosebush is more alive than a redwood—or a sparrow less real than a hawk. And in matters of art, whether a miniature watercolor by Paul Klee is intrinsically less worthy than a fresco by Michelangelo. The answer is obvious, and yet adults continue to admire not only size but also power and aggressive energy in art. Worse still, we convey these prejudiced attitudes to the young, making it almost inevitable that art still occasionally is judged, even in the lower grades, more on the basis of size, impact, and accuracy than on sensitivity and life-enhancing qualities.

Missing the Point of Creativity

We miss the point of artistic creativeness or fail to appreciate its sources and driving force if we fail to realize that art, before it is any-

thing else, is an impulse, an intuition, an insight, or possibly even an overwhelming feeling of love or joy demanding to be shared. Even when art is triggered by something seen or touched, there is generally a special response associated with that perceptual or tactile experience, a sense of wonder, perhaps, or possibly a feeling of delight. To say that art is motivated by love and fueled by exhilaration may sound simplistic or falsely romantic, but it's true more often than not. And even when it's not, a form of love still exists for the craft, the artistry through which an artist gives form and expression to perceptions, feelings, and ideas. George Grosz and Otto Dix, those most angry of early-twentieth-century artists, obviously loved the act of drawing or painting the pictures through which they projected their frustration and rage. And Picasso, deep into *Guernica*, must have been more positively affected by the passion and scope of his vision than angered or disturbed by his painting's tragic theme. Were that not the case, *Guernica* would not challenge and excite us as it still does today.

Art's Genesis and Fulfillment

Art, then, begins as an impulse, an urge, in one man, woman, or child and finds fulfillment as an aesthetic experience in another man, woman, or child. Invariably, no matter how complex or wide-ranging it might be, art makes its point strictly on a one-to-one basis. The process is of primary concern for art critic and teacher alike, although the former emphasizes judgment, distinguishing those who have mastered the process from those who haven't, and the latter focuses on getting the process to work in children of various ages. At issue is how the insights and methods of the former can best help the performance of the latter. Criticism can help teachers stimulate or motivate learning by involving the curiosity and imagination of students.

Stimulating Curiosity and Imagination

Imagination is best stimulated by encouraging students to tap their emotional, sensory, and intuitive resources; alerting them to the fun, challenge, and thrill of making and appreciating art; and presenting them with a glimpse of what they may be able to accomplish in terms of emotional and spiritual growth and better ways to communicate their feelings and ideas. Language is critical to this process, as is the ability to identify with the thoughts and emotions of the young. Although it's often true that the early stirrings of imagination in young

people manifest themselves as eagerness or excitement—or at least of heightened interest—that isn't always the case.

Some students, especially those conditioned to view studying art as silly, unproductive, or even counterproductive, may exhibit varying degrees of boredom, reluctance, and even of antagonism toward any form of art work. Art teachers must be wise and experienced enough to recognize such signs of resistance for what they are and deal with them constructively. The most obvious but still the best way is with words that kindle interest, stimulate curiosity, and generally lend support to the sensibilities of hesitant or defiant students. Such words, especially when presented in conjunction with color reproductions, slides, or actual works of art, can create a verbal bridge between the art students' views and their latent creativity. The aim is to help them respond to what has been created—the colors, shapes, textures, and subject matter that various artists have used to express feelings and give form to their ideas. Here teachers can function as art critics, first by describing the examples shown and indicating something of the context within which they were made and then by leading the class in a general discussion of the works' attributes and qualities.

Concentrating on Accessible Art

It's advisable in the early stages of cultivating awareness to concentrate on art that is relatively uncomplicated and accessible—works by the Impressionists, for example, or lively and colorful pieces by such artists as Odilon Redon, Henri Matisse, Joan Miró, Alexander Calder, and Paul Klee, or possibly Edward Hopper and Andrew Wyeth. But no matter what the selection the works shown should be fairly easy to grasp and identify with. The point is to stimulate interest and induce individual response—not to overwhelm students with brilliant virtuoso performances in paint or stone that may convince them that art can be produced only by geniuses.

Jackson Pollock's "drip" paintings offer many interesting challenges to young people, as do the three-dimensional works of Eva Hesse, Red Grooms, and Niki de Saint-Phalle. Pollock, in particular, is grist for the mill of any teacher in the role of art critic. Show even one of his paintings and ask, "Is this art?" or, "Why do people call this art?" and a lively discussion will almost certainly ensue. Follow that up with, "Can you do as well?" and the response will assuredly be loud and affirmative.

The advantage of showing and discussing the work of artists such as Pollock, Miró, Hesse, Grooms, and de Saint-Phalle lies in the fact

that their paintings and sculptures do not appear to present insurmountable technical obstacles to young people who may have few if any artistic skills. Anyone, even a six- or eight-year-old, can (it would seem) dribble paint on canvas like Pollock or cut out "silly" figures like Grooms.

These same youngsters, having once tried it and found it not so easy, are ideally positioned to discover for themselves why that is so and how they might do better the next time they try. It can, after all, be disappointing to attempt something that appears ridiculously easy only to discover that it's neither as simple not as easy as one had thought. I once spent a two-hour session with a group of high school students discussing their classroom attempts to produce Pollock-like drip paintings. All agreed that they hadn't done very well and that even their best efforts were too flat and decorative. But what a lesson they had learned. Just to have discovered that there is more to art than what appears on the surface—even something as "obvious" as a Pollock canvas—was a great step forward. And to have gained sufficient insight into what they had done to describe their best efforts as "too decorative" indicated that they had taken a significant step toward becoming constructively self-critical.

Of course, their teacher deserved much of the credit. She had activated the project, first by showing a dozen or so slides of Pollock's paintings, then by identifying and discussing his art-historical antecedents, and finally confronting the class with a series of questions. The first—"Is this art?"—drew a mixed response, so she went around the class and asked students to explain their answers and indicate, if they had said no, which contemporary of Pollock's had produced art and why they thought so. Among the artists mentioned were Picasso, Georgia O'Keeffe, Andrew Wyeth, and Andy Warhol, primarily because the work of each bore evidence of considerable skill and imagination and because they all "had something to say." Pollock, on the other hand, seemed to have nothing to say and showed no evidence of either skill or imagination. In fact, one student said, "Any kid can do what he did." The teacher continued the discussion with a series of questions: "What do you mean when you say that an artist has something—or nothing—to say?" "What is skill?" "Must a true work of art be skillfully done?" and "What makes you think that Pollock required no special ability?" She then questioned students who felt that Pollock's paintings were art: "Would you still feel that way if you hadn't been told that he is internationally famous and that many critics think he's an important artist?" "How would you answer someone who said that anyone can dribble paint but not everyone can

paint or draw realistically?" and "What is the main thing that con-
vinced you that Pollock is a real artist?"

What the teacher was doing is consistent with the idea of disci-
pline-based art education, although the teacher was probably not
conscious of it, so natural did her different kinds of questions and
activities seem to her. In placing the work of Pollock in historical
perspective she was calling on art history. In asking whether the
works of Pollock were actually art, she was asking a fundamental
question of aesthetics. The discussion of the works involved some
description and analysis of Pollock's works, which brought art criti-
cism into the picture, and the students' efforts to make "Pollocks"
called on methods, skills, and art making. This is what is meant when
it is said that discipline-based art education is an integrated com-
pound discipline. The more knowledgeable about the disciplines in
question and experience and adeptness in integrating them, the more
likely discipline-based art education can be an effective approach to
teaching art.

An Art Critic in a Classroom Discussion

My involvement with the class came after the students had com-
pleted their "Pollocks" and had already spent part of one session dis-
cussing what they had produced. I began with several questions:
"How important do you think it is that Pollock worked on huge can-
vases with oil and enamel paints and you worked on much smaller
sheets of paper with tempera paint?" "How do you think Pollock felt
while he was making his first 'drip' painting?" "Did he feel good, or
was he a little scared or worried about whether important people he
wanted to impress might laugh at these paintings?" "If he was scared
or worried, why do you think he kept right on dribbling paint?"
"What would you have done in his place, and why?" "If you felt deep
inside that you had something important to say with paint and color
but no way to say it 'by the rules' or in any style or technique you
had ever seen, what would you do?" I then asked them why they
thought their efforts had turned out to be—as they had all agreed—
too decorative when compared with what Pollock had done.

Their answers were varied, interesting, and to the point. One stu-
dent felt it was because they knew what their pictures were supposed
to look like, so everybody focused on effect rather than expression.
Another insisted it was because none of them had "gone crazy" the
way Pollock must have done when he really got "into" his painting.
A third wasn't sure but thought it might be because they were all

afraid to really splash away for fear of messing up their clothes. And a fourth felt it was because of a dislike for making messy pictures.

The young people learned that to really "do" a Pollock required considerably more passion and much greater commitment than they had put into their project. Even more important, judging from their answers to the previous questions, they were also beginning to sharpen their insights into the nature of creativity as well as gaining a better understanding of some of the risks and challenges that can confront artists, especially those determined to go their own way in the latter part of the twentieth century. The students were, at least momentarily, acting the part of art critics, both of Pollock's work and of their own. By the time the session ended we had covered much the same ground, raised many of the same questions, and come to a number of the same conclusions as had the professional critics who had written about Pollock and the other Abstract Expressionists during their heyday and immediately after.

Art criticism's objectives and methods were modified during the session in order to accommodate educational rather than critical goals. Pollock's art, style, and formal strategies were examined carefully, not to determine his stature as an artist or quality as a painter but to induce students to question their ideas and objectives. The process, however, is familiar to every art critic. Even so, I contributed little to the discussion that couldn't have been handled by the teacher. My role was supplemental: to pick up where the teacher left off with her questions and help students understand that the critical process is essentially the same in the professional art world as in the classroom. Contexts other than the making of "Pollocks" can also be used to describe how teachers functioning as art critics contribute to the goals of discipline-based art education.[3]

Familiarity with Today's Art

It's vitally important that students become aware not only of the art produced by artists of the distant and more recent past but also of that being created by some of the more probing and problematical contemporary artists. Alerting youngsters to the issues and implications of Pollock's art may—and does—serve a useful purpose, but in the long run it is only a preliminary step in the long-drawn-out process of teaching them how to interact dynamically and substantively with the art and culture of their own time. After all, a great deal has happened in art since Pollock's era. Some of it is of fairly high quality and vital to any real understanding of what has transpired in our

culture these past several decades and of where it might be heading. To deny insight into this work to students of any age (particularly those in junior and senior high school) because their teacher either doesn't understand it or feels uncomfortable with it is unacceptable. At the very least, it should be introduced and discussed. Here again, art criticism can be of service by providing information on what is happening in contemporary art and guidance in determining what is best and most significant. It can also provide clues about how to approach such work.

Conceptual art, primarily because it places ideas and concepts above objects in importance and is, at heart, didactic, can be especially effective in challenging students to look beyond the external and obvious and find deeper meanings and implications. The problem lies in finding examples that are sufficiently intelligible and provocative, visually and conceptually, to engage their attention. The work of Carl André, Sol LeWitt, and Robert Morris, for example, is too rarefied for youngsters (except possibly high school seniors), and even Joseph Beuys's varied and fascinating efforts are too esoteric. A possible solution lies in the work of a number of artists who have been able to personalize conceptual and environmental ideas and approaches in novel, provocative, and generally highly accessible ways. Christo, with his famous "wrapped objects," twenty-five-mile-long *Running Fence,* and bright pink plastic-covered Florida islands, would be a good and useful example. He also has the advantage of extraordinary exposure through his huge outdoor pieces (which are always extensively covered by the press) and the many articles and books about his work. The fact that he uses the services of dozens of individuals in his projects, thereby fusing the social with the aesthetic, also tends to make him more interesting to students. The work of Walter de Maria, Jenny Holzer, Niki de Saint-Phalle, Nam June Paik, Bruce Nauman, Jeff Koons, and Barbara Kruger would likewise provide challenging classroom discussions.[4] Their efforts raise varied and important questions about the critical process and its ways of determining the significance and worth of new works of art.

James Turrell's *Roden Crater Project*

A valuable artist for the purpose at hand is James Turrell, a difficult-to-categorize creative figure whose primary medium is light and who has been devoted to making an extinct volcano crater into a remarkably original and provocative work of art since the 1970s. Turrell's creative objective is clear and well defined: to fashion light

(natural as well as artificial) and places into environmental pieces of such challenging ambiguity and effectiveness that viewers are induced to respond, immediately or in time, with heightened levels of awareness. Viewers, caught off-guard by Turrell's subtle but extraordinary light and environmental effects, usually respond first by feeling something akin to awe; then they attempt to interpret the experience in terms of their backgrounds and inclinations. Some viewers perceive the experience as a moment of exhilarating expansiveness, others as an illuminating insight into perception, and others still as a quiet reflection on the mystery and wholeness of life. But whatever the interpretation, the work's effectiveness results from Turrell's ability to startle viewers into a state of total openness, stripped clean of convention, artifice, dogma, and any other conditioned or habitual response to the raw, stark stimuli of experience.

Roden Crater Project (figure 6) is a remarkably original conception. It is also an excellent subject for a classroom assignment in which the issues of artistic creation are examined in the light of art criticism's methods and ideas as they apply to new works of art. Some of Turrell's earlier pieces consisted of light projections employed within darkened interiors to create illusions of vibrant geometric configurations when in fact "nothing" was present, but the *Roden Crater Project* is an altogether different sort of thing. This as yet unfinished work

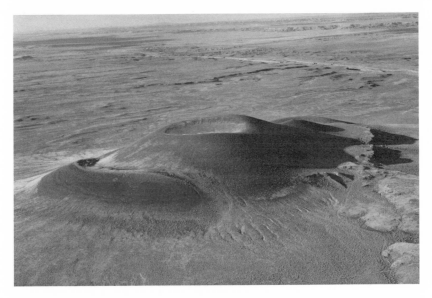

Figure 6. James Turrell, *Roden Crater Project.*

consists entirely of the crater of an extinct volcano on the edge of the Painted Desert not far from Flagstaff, Arizona. The crater, slightly wider than the island of Manhattan and a little taller than New York City's Chrysler Building, will function as a gigantic "viewing platform" from which people can confront the heavens in an exhilarating but carefully orchestrated manner.

To experience this piece, viewers approach from the west, enter a nine-foot-high tunnel that angles upward 1,035 feet into the crater, and emerge into an interior space rimmed by the crater top and dominated dramatically by the sky above. The best time to enter this space is at dusk while the drama of night in the desert is still unfolding and the stars are just beginning to appear. As that occurs, the night sky slowly becomes transparent, allowing viewers to see, with exceptional clarity, objects that are thousands, even millions, of light years away. The effect is spectacular and yet the very nature of the project and its novel approach to the creative act prompts a question: Is it art?

The most debatable aspect of Turrell's work is its impersonal nature. Light projections and an extinct crater are neutral entities that provide evidence of neither skill nor individuality. They just "are," and although it's clear that Turrell puts a great deal of time and effort into his work (the Roden Project may well take him a quarter of a century to complete), his creations lack the kind of individualized, even idiosyncratic, expression that makes the work of Van Gogh and Picasso so exciting. But that's just the point. Like a good teacher, Turrell would rather induce others to realize something significant through his art than enchant or impress them with his talent or skill. Throughout his career, his primary objective has been to activate the viewer's deepest, most fertile conceptual and creative resources and provide with new ways of gaining access and insight into their deeper dimensions of being. Looking back at the history of art, he concluded that too much attention had been paid to the object that embodied and conveyed its "life message": the beautifully executed painting or the superbly carved piece of sculpture. What would happen, Turrell asked, if the creative act bypassed all that demonstration of skill and focused almost exclusively on the life message itself—the insights, delights, exaltations, and feelings of awe and expansiveness that great art can induce? Wouldn't that serve the true purpose of art more effectively? Wouldn't that be truer to the nature and genius of art? And what, he asked when he had finally found the device that would best embody his ideas, was more appropriate to this vision than an extinct crater? It was much too big to be carved and impossible to reshape in any other way but perfect for what he had in mind: an environmental piece only negligibly altered

that would permit viewers to experience the full, dramatic impact of art's life message in its purest, least encumbered state.

The project's single greatest asset for my purposes is that no one else has ever attempted to transform a crater into a work of art. The shock and surprise value of such an action as a precipitating agent for lively classroom discussions is therefore almost limitless. Another factor in its favor is its largely untouched state. No matter how much Turrell adds to or modifies the crater, its immense size will make all such work appear insignificant. For all intents and purposes, therefore, Roden Crater is and will remain a "found object," much bigger but similar to the dramatically twisted and weatherbeaten pieces of driftwood or beautifully veined and proportioned stones artists find and let stand as art with few if any alterations. Indeed, it seems to many that despite Turrell's grand intentions and the staggering amount of physical and creative effort that has gone into it, the *Roden Crater Project* will always remain what it was when Turrell discovered it: a volcanic crater standing all by itself in the desert.

Roden Crater as a Teaching Aid

The issues are clearly drawn. On the one side are those who believe that the *Roden Crater Project* is an extraordinarily original and significant work of art that will be increasingly recognized as such. On the other side are those who believe that, despite Turrell's vision and good intentions, the Roden Project is, and will remain, nothing more than an extinct volcano crater. No other contemporary work of art better demonstrates the complex variety of issues that can exist in a major, late-twentieth-century artistic statement, and none raises more questions for art critics to examine and answer.

Fortunately, progress on the crater has been carefully documented, and even without a site examination one can still get a clear picture of what it is and what it's intended to do. A film of the work's evolution is in production, and slides are already available, providing background information on the crater's location, appearance from various angles (including from the air), and developments since its inception in 1972. For classroom use it might also be advisable to show slides of Turrell's other projects to demonstrate the evolution of his work and its adaptability. Turrell's own words on the Roden Project and on his overall objectives would also be helpful; they can be found in the catalog published in conjunction with his 1985 retrospective exhibition at the Museum of Contemporary Art in Los Angeles and from various other museum catalogs.[5]

It is important that the Roden Project be approached openly and with as few preconceptions as possible on the part of the teacher about what is and what is not a work of art. It is also critical that every effort be made to grasp it as a serious attempt to create art in a novel, hitherto untried, manner. There are any number of fascinating challenges, from the probable initial disagreement between the students and Turrell about what constitutes art to the fact that the crater cannot be analyzed in purely formal terms.[6]

Neither art history nor practical studio experience will help students or teachers understand works such as the Roden Project; only aesthetics can be called upon for significant support. Much contemporary art is often more concerned with raising questions about traditional assumptions than with creating aesthetically pleasing objects. The real value lies in its focus on idea and process and in its challenge to use extensive visual and verbal information about a huge, exotic natural object as the basis for classroom discussions on art's range, capabilities, and limitations. Students should be encouraged to discuss whether it is possible to transform such an object into a work of art and, if so, under what conditions. Does Turrell appear to be meeting these conditions in the *Roden Crater Project?*

Questions Raised by the *Roden Crater Project*

The almost endless questions raised by Turrell's project probe every aspect of human creativity, from the philosophical to the intensely practical. They deal with fundamentals: If a crater can be a work of art, how about a tree? Or a sandy beach? Or sunlight? They focus on process: Assuming that a crater can become art, how much and in what way does one have to modify it before it can become art? Or the questions can be more general: Could an engineer—or a farmer or a plumber—have conceived this project? If one of them did and built it as a private hideaway, would it also be considered art? If, after the project is completed, not one single person shows up to experience it, will it still be a work of art? And why couldn't one have just as profound and significant an experience out in the open under the stars far away from anything touched by human hands? Why do we need Turrell's project when nature, in all its awesome beauty, is everywhere around us?

Merely asking such questions isn't sufficient, however. The focus here is on art criticism not aesthetics, and therefore we must emphasize helping students marshal the insights and skills needed to discuss and weigh the merits and implications of the project as well as

its reasons for being and its qualifications as art. Turrell's crater is full of fascinating issues to explore. While deliberating on its qualities and attributes, consider the matter of style. Does it exist in this work? If it does, how does it manifest itself? How would a formalist critic go about analyzing and assessing the project? Or one whose critical orientation was essentially contextualist (art historical, sociopolitical, or psychoanalytical)? Is there one thing about the *Roden Crater Project* that all art critics, regardless of affiliation, could agree on? If so, what is it?

It won't be long before Turrell's project is completed, and visitors will begin driving out to see it and experience what it has to offer. But in the meantime, finished or not, the Roden Crater and the theories and light works that led up to and precipitated it are excellent stimulants for the kind of classroom discussions appropriate for the introduction of art criticism into art education. This provocative work explores areas of creativity other traditional or environmental works barely touch upon. It offers a wide variety of relevant, challenging issues and ideas for students learning to understand totally unfamiliar and unusual works of art. In addition, Turrell's project offers such an open, expansive vision of art's capacity to affect human actions for the good that any attempt to probe its purposes and realities—or its ability to activate a similar vision in others—cannot help but induce youngsters to take art a bit more seriously than they otherwise might.

However one views it, as an environmental oddity, a fascinating idea or a work of art, the *Roden Crater Project* is difficult to ignore. And because it might very well represent a kind of art that future generations will understand and respect more highly than ours does, it seems only appropriate that those who belong to the first of those future generations should be introduced to it as thoroughly as possible.

NOTES

1. Theodore F. Wolff, "Putting It on the Line," *Christian Science Monitor*, 1 September 1983, 20.

2. Theodore F. Wolff, "With a Special Lens," *Christian Science Monitor*, 28 July 1983, 20.

3. Kay Alexander and Mickey Day, *Discipline-Based Art Education: A Curriculum Sampler* (Los Angeles: Getty Center for Education in the Arts, 1991).

4. For further examples, see Terry Barrett, *Criticizing Art: Understanding the Contemporary* (Mountain View, Calif.: Mayfield Publishing, 1994), chap. 3.

5. Julia Brown, ed., *Occluded Front: James Turrell* (Los Angeles: Lapis Press, 1985), 13–46.

6. The *Roden Crater Project* presents puzzling philosophical questions, but

contemporary art is full of puzzles that young people can learn to cope with more effectively by using Margaret P. Battin et al., *Puzzles about Art: An Aesthetics Casebook* (New York: St. Martin's Press, 1989), written, compiled, and edited by four philosophers of art, and Ronald Moore, ed., *Aesthetics for Young People* (Reston: National Art Education Association, 1995), in which contributors discuss aesthetic puzzle-solving in a classroom context.

Exercising Critical Judgment

At various points in these chapters I have observed that criticism should be both nonjudgmental and judgmental, depending on the context and the task at hand. It is time now to probe more deeply into the issue of judgment as it relates to art and the classroom and examine more closely the ways teachers can use art-critical methods and techniques to clarify the judgmental process and set it in motion.

There are those for whom the word *judgment* is too harsh and final a term to use in conjunction with art, especially within an educational context. It is reported that some teachers cringe when they hear the word *judge.* In one sense I agree with them. Artistic judgment is difficult and not always important. At times one should accept and enjoy art simply and wholeheartedly, as if it were a bouquet of beautiful flowers. Furthermore, the critical process is often complicated by the fact that art, like almost everything else in life, cannot be judged absolutely. It's too complex and multifaceted, too subtle and elusive. At the same time, we live in a world in which comfort, success, and possibly even survival depend on the ability to exercise judgment wisely. Like it or not, judgment is a part of life, and we had best understand it.

Teaching Judgment

One of the easiest, nonthreatening ways to become acquainted with judgment is through art. Few other areas of human activity are as vital and far-ranging yet as close to the well-springs of human thought, intuition, and feeling. We are all touched by art in one way or another, and we respond with the full range of human emotions and often with a considerable degree of critical insight. Developing that insight—the ability to discern quality and assess importance in art, especially in the art of one's day—is not as difficult as it might seem. This is particularly true if one starts early in life, preferably during the first years of school, and retains an open, questioning mind.

Both an early start and an open mind are important. Starting early allows long years of practice; keeping an open mind helps guarantee a fair degree of objectivity in dealing with what, in later life, will seem to be an endless succession of new ideas, styles, forms, and fashions in art. The major problem is striking a proper balance between the generative and the judgmental, between learning how to express oneself freely and learning how to analyze and evaluate art. This is where art criticism can be of considerable help. The discipline's presence in the classroom has at least as much to do with stimulating the imagination of students and enhancing their lives as with teaching them how to make intelligent judgments in matters of art.

Well and good, but what exactly is judgment? Several dictionaries yield a composite definition: Judgment is the ability to form, or to come to an opinion, objectively and wisely. Three key words tell the story: *opinion, objectively,* and *wisely.* All three are important, but two stand out: *opinion* because all judgment, no matter how weighty or thoughtfully arrived at, is still opinion, and *objectively* because judgment must be impartial. It may be difficult at first for students—especially very young ones—to be objective or substantive in their critical evaluations and go beyond the level of "I like it because it makes me feel good," or "It's good because the colors are pretty." But once they are capable of "I think that's good because the colors are beautiful," or "I don't like that because the shapes look awful together" the initial phase of the battle will have been won.

Older students, especially adolescents, will probably have more substantive reasons for their opinions, but the idea that different kinds of art may require different sets of critical criteria might still surprise them. A discussion, therefore, of the various kinds of art criticism—diaristic, formalist, and contextual—would be in order. Going one step further, the students could be asked to write short critical essays illustrating the various ways critics of different persuasions evaluate art. Picasso's *Guernica,* for example, or one of Calder's mobiles, could be discussed and assessed, first as a formalist art critic might do it and then as the assignment might be handled by a critic who has pronounced ideological commitments.

As an example of ideological criticism, a class might examine the treatment of contemporary art in twentieth-century totalitarian regimes, especially Nazi Germany and Stalinist Russia. Hitler's condemnation of most modern art as degenerate and Stalin's obliteration of Russia's revolutionary constructivist movement in favor of conservative and totally predictable Socialist realist art are good examples of

artistic judgment predicated on clearly defined premises and attitudes considered unacceptable by most democratic societies.

The question of art's relationship to dogma or ideology—political, religious, social, or any other—is fascinating and important, especially because it places the matter of artistic judgment squarely at the center of some of society's most serious and challenging issues. Can the good of the state take precedence over aesthetic considerations when judging art? Does morality have a place in art? At what point does political art cease being art and become propaganda? In asking such questions, students will realize that art is much more than an isolated, pleasurable phenomenon with little relevance to the world.

Some issues will be over the heads of younger students, but even so they should be touched upon to indicate how much is—or can be— involved in the process of examining and evaluating art. Above all, it must be understood that art does not exist in a vacuum; it reflects and resonates with the qualities and realities of other aspects of culture and society. Even the period in which a work of art is created or first seen can affect its critical reception. Anyone over the age of thirty has witnessed subtle—and occasionally dramatic—alterations in taste or judgment in regard to certain artists or movements. What qualifies as significant art in one decade can be seriously questioned in the next. And yet the work itself remains exactly the same; only the way it is perceived has changed.

Changes in Critical Judgment

Students should learn to understand why such changes occur and what forces—social, cultural, and possibly even political—may be responsible for them. This is important not only for better insight into the issues involved but also for an understanding of the pressure critics—or others who act judgmentally—receive to alter their original opinion. At this point, art history becomes relevant to critical inquiry. A fine line exists between genuinely independent judgment and judgment affected by outside forces—including, at times, a subtle form of peer pressure. Independent judgment can be difficult, especially if the art involved is new and controversial. No one wants to be perceived as a fool, and standing alone against one's peers can be disconcerting—unless, of course, one is totally secure in one's opinion. The young, however, are seldom that secure, especially when confronted by something disconcertingly new. They tend to be hesitant, unsure of what they think of an unusual painting or piece of

sculpture, and, feeling insecure, are likely to permit a classmate's rash reaction—or a teacher's subtle (or unsubtle) hints—to momentarily lessen their chances of being able to make up their own minds.

Judgments Must Be One's Own

Judgments, in this context at least, are of little value unless they are one's own. One of the major reasons art criticism is brought into the classroom is to help students learn not only how to come to their own conclusions about art but also how to feel secure enough to defend them if challenged. This point has been well stated by the philosopher Frank Sibley, who, in a discussion of what is aesthetic and nonaesthetic, observes that

> persons have to see the grace or unity of a work, hear the plaintiveness or frenzy in the music, notice the gaudiness of a color scheme, feel the power of a novel, its mood, or its uncertainty of tone. Persons may be struck by these qualities at once, or they may come to perceive them only after repeated viewings, hearings, or readings, and with the help of critics. But unless they do perceive them for themselves, aesthetic enjoyment, appreciation, and judgment are beyond them. Merely to learn, on good authority, that the music is serene, the play moving, or the picture unbalanced is of little aesthetic value; the crucial thing is to see, hear, or feel.[1]

Unfortunately, independent judgment is not always highly regarded in today's art world. The pressure to conform, to adapt one's ideas and attitudes to the prevailing norm, is still considerable, although certainly not as great as it once was. When selecting examples of professional art criticism for classroom use, teachers should be careful to choose writings primarily from those critics whose work embodies the principles and methods of responsible art criticism discussed by Thomas Munro (chapter 4) and demonstrates independence of mind as well. Fortunately, these critics represent almost every point of the art criticism compass, from the most advanced to the most conservative—with a liberal sprinkling of moderates of every critical hue. It might also be advisable to select a few examples of so-called bad or irresponsible criticism, which usually has three things in common: a limited regard for research and analysis, an inability or unwillingness to be objective, and an unswerving conviction that truth in art is finite and that it is on the critic's side. Nor should there be any room for criticism that debunks or praises by name-calling.

What, for example, could be more helpful to the next generation of art lovers (and all future generations) than eliminating, once and

for all, the still fairly widely held notion that quality and significance in art depend on whether a work is modernist or postmodernist, abstract or representational, pre-Warholian or post-Warholian, Structuralist or Poststructuralist—or whatever other creative or critical alternatives artists are asked to choose between. For such individuals, art is primarily a matter of affiliation or appearance, of quality and significance determined almost exclusively on the basis of style, ideology, medium, technique, or subject matter. This is comparable to gauging the value of human beings according to the color of skin, religion, or country of origin—nonsensical. And yet some current judgments on art are predicated on assumptions and prejudices no more reasonable or relevant than those. Fortunately, such judgments are decreasing in number, and those that do still appear are less likely to be taken seriously than they would have been two or three decades ago. The reason is obvious. Art criticism is gradually becoming more responsible and professional, and the reading public is becoming more discerning, knowledgeable, and sophisticated. The education critics have done their work well.

Attributes of Sound Judgments in Art

The attributes and qualities common to good art critics—those that produce sound judgments in art—haven't changed, however, and it isn't likely that they will. They are determined as much by common sense as by the realities and objectives of the discipline. They apply equally well to anyone who attempts to assess art as to professional arts critics. The excellent description of these attributes and qualities compiled by Bernard C. Heyl in 1943 is unsurpassed for simplicity and inclusiveness. In contrast to Munro's questions, which can be asked of any critique, Heyl addresses the qualities of critics. He begins by suggesting that

> the more skillful the critic, the more completely will he possess and use the six following qualifications: 1) a natural sensitiveness to the aims of the artist and to the qualities of the works he is judging; (2) a trained observation resulting from wise and varied experience with the kinds of art he is considering; (3) sufficient cultural (i.e., historical, religious, social, political, iconographic and so forth) equipment to enable him to understand the objects of his criticism; (4) a reflective power which will allow him to detect and hence take into consideration personal eccentricities in his preferences, and by means of which he will analyze, weigh and balance the effects which artistic creations make upon him; (5) a degree of normality, as opposed to eccentricity, which will make

his range of experience sufficiently central to be available for partici-
pation by others; and (6) a critical system which will present a satisfac-
tory theoretical basis for artistic evaluations.[2]

No list could be more complete and to the point—or provide a better
set of guidelines for anyone (professional or student) wishing to
achieve at least some degree of critical objectivity. True, one might
wish for a seventh qualification—the ability to organize and present
the assembled material clearly and convincingly in written form—but
Heyl probably took that for granted. As it is, he's provided an excel-
lent blueprint for how to set about judging art in a manner enabling
an individual to transcend preferences and prejudices, avoid leaping
to conclusions on the basis of purely external or categorical evidence,
and arrive at the point of judgment with a sufficiently broad and deep
understanding of all the issues involved.

Heyl's first qualification, "a natural sensitiveness to the aims of the
artist," is often overlooked. I suspect this is because judgment is gen-
erally (mistakenly) perceived as a purely objective act that would be
compromised by including as subjective a factor as "sensitiveness."
Furthermore, the argument goes, it's difficult, if not impossible, to
know what an artist's aims really are. But that's exactly the point.
Heyl isn't suggesting that critics must know exactly what an artist's
intentions were for a particular work but only that they be aware of
the overall nature of the artist's aims and sensitive to the particular
qualities that determine the nature and purpose of individual works
of art. To put it another way, artistic judgment can ultimately depend
as much on feeling and understanding, on being able to identify, at
least to a degree, with an artist's way of seeing and doing things, as
on other, more purely reflective and analytical attributes. For Heyl,
this kind of empathetic response also extends to an artist's tools and
methods and a general comprehension of such things as how paint
is applied, why armatures are built, when clay should be fired, and
why purple can be a different color to use. Heyl doesn't require that
critics master the artist's tools and methods. He suggests only that a
sympathetic awareness of and respect for what they are and can do
will considerably enhance an individual's ability to evaluate art.

I don't see how anyone can disagree with that. At the very least, it
can do no harm to have some insight into what motivates artists and
how art is produced; at best, it can bring far greater clarity and cred-
ibility to the judgmental process and judgment itself. Because so much
of art's identity and effectiveness depends on the nature of the mate-
rial used and the way it is transformed from inert substance into art,

it makes sense that some insight into processes and materials will help anyone judging art. In this, studio art production can enormously benefit young students by exposing them to a broad range of techniques and media. Although aesthetics, art history, and art criticism enrich and deepen a student's understanding of art's larger realities and ramifications, only direct personal experience with manipulating materials can instill full awareness of what the expressive powers of materials can contribute to an understanding of arts. Even when methods and materials are peripheral to a given work, understanding them can provide individuals who judge with additional valuable information toward forming a final decision.

Heyl's second qualification, that a critic should possess a "trained observation resulting from wide and varied experience with the kinds of art he is considering," also seems self-evident. Yet, as alert readers of art criticism must know only too well, that often is not the case. Specialists in any field feel little or no compunction about exercising judgment in unfamiliar areas, and everyone has come upon at least one art review written by a novice who has a fine vocabulary but little knowledge and even less insight into the kind of art under consideration. The critical word in Heyl's second qualification is *experience,* and because he stresses "wide and varied" experience we can only assume that he expects a critic to be not only exceptionally well-rounded but also mature in years.

For students, "experience" has a much more limited meaning, varying considerably from youngsters in the lower grades to high school seniors. "Wide and varied" would have to be considered in context—not too limited and spotty, one would hope, but even if so that should not deter acquiring as much direct experience of art as possible by painting, sculpting, or studio experience, visiting local museums, galleries, and artists' studios, and traveling to view art in major art centers.

Acquiring such experience is only half the battle. Knowing how to use it is at least as important and generally more difficult. For that, other resources must be tapped to help put things into proper perspective and thereby provide students with the best possible critical contexts within which to develop conclusions and evaluations. Of these, art criticism is one of the most incisive and effective—and one of the most accessible. No matter where students live or go to school, art criticism is available, if not in the local newspaper then certainly in one of the several nationally circulated art magazines or in one of the handful of books—usually published by university presses—that deal specifically with art criticism.

Heyl's third qualification, that a critic should have "sufficient cultural equipment . . . to understand the objects of his criticism," also seems self-evident but is not always universally approved. Here, at least, a little more common sense prevails, possibly because this qualification applies more often to art-historical art criticism than to any other kind. The focus is on fairly evaluating art produced by individuals of different social, religious, political, philosophical, or aesthetic persuasions and taking those differences into account as well as criteria for artistic judgment. On a practical level, this requires enough background to be almost as knowledgeable and objective in judging the art of other people and places as in judging the art of one's own society, time, and place. Just as important (possibly even more so), it means being knowledgeable and open-minded about contemporary styles and modes of expression that aren't critically acclaimed or fashionable at the moment.

Few critics would disagree—at least in theory—and yet a surprisingly small number have the knowledge, interest, and critical objectivity to meet this qualification. Most young critics, especially those with university training in criticism, are primarily interested in art they perceive as "at the cutting edge" of the culture, still being shaped by the moment's most dynamic and significant idea. Therefore, they concentrate on identifying artists who represent this cutting edge—and then ranking them in the light of certain theories—rather than examining art in all its richness and diversity.

This either-or approach to judging art is the last thing to encourage in young students. Art is much too rich and dynamic to be reduced to an aesthetic intellectual game for specialists with the proper credentials or for those with "correct" insight into what constitutes "genuine" or "authentic" art. This trivializing influence can be defended on only one count: to get the full, rich story of art to young people as early and directly as possible. That won't make the critical process easier, and it certainly won't guarantee dramatic results, but it's probably the only way future generations will be able to see art in its best light, as an extraordinarily generative and vitalizing force for everyone it touches and not primarily as a source of pleasure, prestige, profit, or power.

"A reflective power which will allow him to detect and hence to take into consideration personal eccentricities in his preferences, and by means of what he will analyze, weigh and balance the effects which artistic creations make upon him," Heyl's fourth qualification, is an important but seldom discussed matter. It means that a critic

should be self-aware enough to know when and where strong personal likes and dislikes can cloud the ability to be objective and experienced enough to know how to make allowances for them. Everyone, art lover and art critic alike, shares the problem. The color purple may make one cringe; neat, deliberate brushwork may offend a disposition that favors a wilder, more passionate technique; even certain subjects—infants, sunsets, or clowns—may trigger uncritical delight or profound irritation. One needs to be alert to such bias and wary of its possible effect on fair judgment. There is nothing wrong with having a few preferences or prejudices in art—as long as one knows how to keep them in their place.

Heyl's fifth qualification is surprising. No one else has thought it important enough to mention, yet Heyl's emphasis on it is justifiable. He says that a degree of normality, as opposed to eccentricity, is important for an art critic "to make his range of experience sufficiently central to be available for participation by others." In other words, a critic should be commonsensical enough to keep from being too esoteric or idiosyncratic to the general public. Heyl's primary concerns are communication and the ability to organize and present a convincing case for or against particular kinds or works of art. To a purist, this is of relatively little consequence, but it is of central importance to practicing critics and certainly to art teachers. For them, criticism isn't complete until its insights and conclusions have been shared with others.

Who these "others" are and how they should be addressed in print is cause for considerable disagreement among critics and reviewers. The majority hold that a critic's primary responsibility is to the general public and that all critical writing should be as straightforward and nontechnical as possible. A minority believe that critics should not concern themselves with being understood by the public at large and that they should adopt whatever critical format is appropriate for what they have to say. Not surprisingly, the first group consists largely of newspaper and magazine critics and writers and the second of independent or university-affiliated scholar-critics with backgrounds in aesthetics, art history, anthropology, and possibly psychology. The groups often don't have much to do with each other, although the division is informal and generally nonhostile. Members of the second group would almost certainly reject Heyl's fifth qualification as being too populist. Yet that point is well taken, especially for newspaper and magazine art criticism. If widespread communication is desired, then some form of attitudinal common denominator is needed.

Art Criticism as an Art Form

Heyl emphasizes the necessity of intelligence and sensitivity on the part of a successful art critic—and, by extension, of anyone else who assesses art regularly and well. Training and discipline are important, but what matters most is the quality and good will, the clarity and openness of the mind, of the person who judges art. Heyl appears to be saying that art criticism is itself an art and that for all its perceptual and analytical demands and dimensions it remains an intuitive, largely indefinable process demanding nothing less than the fullest demonstration of a critic's finest feelings and best intentions.

This character of criticism is an important point to convey to students. Heyl's thesis may appear general, but it covers a great deal of territory and omits little of importance. If nothing else, it should effectively balance the almost purely analytical and philosophical approach to art criticism generally favored by writers on art and art critics who have recently turned their attention to art education. Without wishing in any way to detract from the value and importance of their contribution, it seems only fair and appropriate that this other, more general and open-ended approach to art criticism and artistic judgment be given some attention. Judgment in art, after all, is not scientifically demonstrable. Critics and others who assess art know that there are times when the final decision, the commitment to a particular judgment, is impulsive and that there are dangers and rewards implicit in such decisions. That is where the *art* of art criticism comes in. At its finest and best, art criticism is a risky business; but then so is the creative process—and so is art.

Broadening Insight

The objective is to give students the broadest possible insight into the art-critical process, what my coauthor calls critical inquiry, ignoring no aspect of the discipline, even those that seem subjective. It is hard to prove a critic's sensitivity to material, "good eye" for color or line, "innate" sense of order, or "way with words," but some individuals do have such attributes, which should not be dismissed merely because they are not readily subject to scientific verification. Sensitivity, for instance, plays a greater role in artistic judgment than we sometimes care to admit—connoisseurship especially comes to mind—and art criticism would be the poorer without intuition and imagination. We would be the worse off without the intuition of a Bernard Berenson or a Kenneth Clark. I see nothing elitist in using

such words as *elegant* or *refined* for thoughts, sensibilities, or ideas if the word is accurate. These terms may be out of fashion just now; nonetheless, they are useful in art criticism.

We should not dismiss or decrease the commitment to straightforward, objective art criticism but allow a little unscientific, unverifiable intuition and sensibility into critical reactions and judgments. They've been there all the time, whether consciously acknowledged or not. Allowing them in should not, however, be seen as an excuse for lowering standards or moderating critical obligations. An art critic's most important word is *because;* writing thousands of words, painting the most provocative word pictures, and emphatically praising or condemning the art at hand cannot qualify as art criticism without well-substantiated justification.[3] At the same time, we'd be wise to take a more holistic view of art and art criticism, especially as they relate to art education. I've limited my comments on the cutting-edge aspect of art criticism for two reasons: this kind of critical writing is invariably specialized and has little, if any, relevance for anyone except other art critics and a handful of scholars; and much of what is produced is so partisan that it has little value in the classroom as a model of responsible art criticism. Reading it, one cannot but wonder whether art has become not the focal point, the reason for being, of the critical process but merely a pretext for writers to exhibit finesse in winning intellectual games with other critics and make points in academic or ideological duels. Such intellectual performance is appropriate in its place, but that place is not in the classroom.

Yet some aspects of art criticism do belong in the classroom. High on the list are the methods and ideas that challenge students to see, engage, understand, discuss, and evaluate art; that help them realize their capacities as art makers and consumers of art; and that enhance the quality of their lives. Such methods and ideas are made available to students by art criticism but generally only with the help and cooperation of art teachers, without whose active participation the majority of students—including even those of high school age—could not benefit significantly. If art criticism is to have any effect on art education, the key word is *cooperation.* By that I mean not only the cooperation of teachers but also the cooperation of critics and, necessarily, the cooperation of art education. Teachers can no longer afford to assume that art criticism is an aloof, almost exclusively judgmental discipline with little or no relevance for day-to-day art education. And art critics can no longer claim immunity from their responsibility toward the young, who will soon become the artists, art lovers, collectors, and connoisseurs.

NOTES

1. Frank Sibley, "Aesthetic and Nonaesthetic," *Philosophical Review* 74 (April 1965): 136–37, quoted in Ralph A. Smith, *Excellence in Art Education: Ideas and Initiative* (Reston: National Art Education Association, 1987), 136.

2. Bernard C. Heyl, *New Bearings in Aesthetics and Art Criticism* (New Haven: Yale University Press, 1943), 92–93.

3. In this respect, I find quite congenial Monroe C. Beardsley's discussion of critical evaluation in *Aesthetics: Problems in the Philosophy of Criticism*, 2d ed. (Indianapolis: Hackett, 1981), chap. 10. Beardsley suggests that critical judgments can be put in the form of "X is good (or poor) because," with whatever follows "because" constituting reasons for saying that something is good or poor. He classifies reasons as being cognitive, moral, or aesthetic. I am indebted to Ralph A. Smith for pointing out this discussion.

Suggested Reading

The literature of art criticism is not well defined, but it is nonetheless possible to distinguish art-historical criticism and philosophical analysis of the concept of criticism from works devoted specifically to criticism of art. Fortunately, some bibliographic work has already been done on the topic. A convenient place to begin is with the chapters by W. Eugene Kleinbauer on art history and Howard Risatti on art criticism in *Discipline-Based Art Education: Origins, Meaning, Development*, ed. Ralph A. Smith (Urbana: University of Illinois Press, 1987). A brief monograph *History, Theory, and Practice of Art Criticism in Art Education* (Reston: National Art Education Association, 1990) by Jim Cromer indicates how, historically, criticism of art has been intertwined with art making, art history, and aesthetics. Yet he isolates works that are more distinctively art-historical in character and reviews some of the literature in art education that bears on teaching art criticism. Extensive references to both the philosophical literature on the concept of criticism and works devoted more specifically to modern and contemporary art criticism can be found in Albert William Levi and Ralph A. Smith, *Art Education: A Critical Necessity* (Urbana: University of Illnois Press, 1991), the introductory volume of the DBAE series. See especially the suggested readings for the chapters on aesthetics and criticism. Two philosophical works are also worth mentioning: Jerome Stolnitz, *Aesthetics and Philosophy of Art Criticism: A Critical Introduction* (Boston: Houghton Mifflin, 1960), which contains a chapter on the educative function of criticism, and Monroe C. Beardsley, *Aesthetics: Problems in the Philosophy of Criticism*, 2d ed. (Indianapolis: Hackett, 1981), especially the chapter on critical evaluation. Another work is George Dickie, *Evaluating Art* (Philadelphia: Temple University Press, 1988), which presupposes a good knowledge of philosophical aesthetics.

The most extensive publication program in the area of art criticism is the continuing series titled "Studies in the Fine Arts: Criticism" edited by Donald Kuspit. A widely read art critic is Hilton Kramer,

whose writings are collected in two volumes: *The Age of the Avant-Garde: An Art Chronicle of 1956–1972* (New York: Farrar, Strauss, and Giroux, 1973), and *The Revenge of the Philistines: Art and Culture, 1972–1984* (New York: Free Press, 1985). For examples of feminist criticism, see *Feminist Art Criticism: An Anthology,* ed. Arlene Raven, Cassandra Langer, and Joanna Frueh (Ann Arbor: UMI Research Press, 1988).

Discussions of criticism can also be found in Edmund B. Feldman, *Varieties of Visual Experience,* 3d ed. (New Jersey: Prentice-Hall, 1987); Ralph A. Smith, *The Sense of Art: A Study in Aesthetic Education* (New York: Routledge, 1987), central to which is a notion of aesthetic criticism; Terry Barrett, *Criticizing Art: Understanding the Contemporary* (Mountain View, Calif.: Mayfield Publishing, 1994); and D. N. Perkins, *The Intelligent Eye: Learning to Think by Looking at Art* (Los Angeles: Getty Center for Education in the Arts, 1994), which is compatible with the idea of criticism as critical inquiry. An earlier work is *Aesthetics and Criticism in Art Education: Problems in Defining, Explaining, and Evaluating Art,* ed. Ralph A. Smith (Chicago: Rand McNalley, 1966). Discussion of art criticism in more specifically pedagogical contexts can be found in George Geahigan's list of suggested readings.

PART 2
Art Criticism: From Theory to Practice

Introduction

The previous chapters of this book are intended to convey an understanding of the discipline of art criticism and its relevance for discipline-based art education. Theodore Wolff's chapters present an eloquent statement of the value of the visual arts in human life, a comprehensive overview of different critical approaches, insights into his values and working methods as an art critic, and perceptive suggestions for the use of criticism in the classroom.

In turning to the application of art criticism to instruction in discipline-based art education, I would direct readers to the many insightful suggestions that my coauthor has made. Although written from the perspective of a practicing critic and painter, I find his views about art criticism very much in keeping with my own. Readers will find many connecting themes between our contributions to this volume. In the chapters that follow, I will point out those similarities and make explicit references to the preceding chapters.

Perhaps the most important area of agreement between Wolff and myself lies in the way criticism is conceptualized. Unlike many traditional notions of art criticism in the educational literature, both of us view criticism not as a procedure for talking or writing about works of art but as a mode of inquiry centrally concerned with determining their meaning and value. We both subscribe to the idea that critics should adopt an eclectic and pragmatic approach to criticism. They need to go beyond scrutiny of the work of art alone (formalist criticism) to consider the artist and the cultural context in which a work of art was created (contextualist criticism) and the personal reactions and life world of viewers (diaristic criticism).

Art criticism cannot be reduced to a step-by-step formula; those who engage in critical inquiry must think and reflect about the meaning and value of works of art. Because works of art differ from one another in significant ways, they usually present problems of interpretation and judgment for critics. Meaning in a work of art is not something that can simply be "read off" from its perceptual features,

nor can the value of a work of art be determined simply by the straightforward application of clear-cut, universally accepted critical standards. Yet because works of art also grow out of a tradition of art making, they can be understood by recalling the historical context from which they emerge. In Wolff's examples of critical writing, we see critical reflection exemplified to a high degree. His interpretations and judgments are informed by a sophisticated background in traditional and contemporary art that provides a perspective for viewing, enabling him to recognize different kinds of artistic aims and aspirations and different forms of artistic value.

As Wolff's writings illustrate, critical reflection is a challenging endeavor. It is also a social enterprise. Readers will find an open-minded receptiveness to works of art coupled with tough-minded skepticism about the critical judgments of others, dispositions I believe should be cultivated in any program of instruction in art criticism. Wolff strives to avoid preconceptions and demonstrates a willingness to consider works of art with care and attention. At the same time, he insists that critics should write intelligibly and provide reasons for their interpretations and evaluations. In his writings one finds Wolff reflecting not only about the arguments advanced by other critics but also about the concepts they employ. His writings illustrate how critical reflection inevitably extends beyond the immediate practical concerns of a critic to involve theoretical and philosophical issues.

The Role of Art Criticism in Discipline-Based Art Education

In addressing the task of presenting a systematic set of recommendations for art criticism in the classroom, I begin by discussing what I take to be the role of art criticism in discipline-based art education. Central to the idea of discipline-based art education is the belief that methods and content derived from each of four disciplines—art criticism, art history, aesthetics, and studio—should inform classroom practice. In the case of art criticism, this has generally been understood to mean that methods of inquiry and content derived from the discipline of art criticism would be employed in order to increase student understanding and appreciation.

An underlying assumption of this approach to visual arts education is that the parent disciplines underlying discipline-based art education represent separate areas of inquiry, an assumption that has given rise to a number of mistaken attempts to distinguish among these disciplines. It has sometimes been maintained, for example, that

art criticism is concerned only with contemporary works, whereas art history is concerned with works of the past. Some have also maintained that aesthetics undertakes inquiry into the meaning of concepts, whereas critics merely employ these concepts in their writings. Having drawn these conclusions, educators then go on to argue that art criticism in the classroom should focus on contemporary works of art.[1] Some also argue that the practice of criticism should eschew inquiry into underlying concepts or the teaching of concepts and principles, supposedly the domain of philosophical aesthetics.

These distinctions need to be examined carefully, for if they were actually accepted by educators I believe they would have devastating consequences for the practice of criticism in the classroom. They oversimplify the relationships that actually exist between art criticism and these other disciplines. There is, first, a substantial overlap between art criticism, art history, and aesthetics. Although art critics are interested in contemporary works of art, for example, they are also concerned with traditional art as well.[2] Even leaving aside the genre of historical criticism, which in itself is a standing contradiction to the notion that criticism deals only with contemporary art (chapter 2), there are a large number of essays and books by some of the most distinguished critics that are in no sense art history but rather writings aimed at conveying an understanding and appreciation of traditional art to a larger public. One can find critical writings dealing with art from prehistoric times to the present.[3]

Critics also engage in conceptual analysis and in the process employ the same kinds of arguments and methods of analysis as aestheticians.[4] Indeed, it would be impossible to resolve many issues and disputes within the realm of art criticism without undertaking this sort of inquiry. As philosophers are well aware, making decisions about the truth or falsity of any critical claim presupposes that one has a clear understanding of the underlying concepts employed. Where these concepts are open to multiple interpretation (as they often are in critical disputes), it becomes necessary that critics examine their meaning to resolve the issue at hand. Analysis of concepts is an inevitable part of any kind of inquiry, and because of this such a "theoretical" activity is an inherent part of all disciplines, including the discipline of art criticism.

There are, then, complicated relationships between art criticism, art history, and aesthetics as intellectual disciplines. Not only do art critics engage in some of the same kinds of inquiry as practitioners of these other disciplines but they also use findings from these other disciplines. No responsible critic could function today without an exten-

sive knowledge of the history of art, and many have a great deal of philosophical sophistication as well. When adapting the methods and content of art criticism to instructional practice it is a mistake to try and erect some simple distinction between each discipline. Not only would such distinctions be completely arbitrary, but they would also cripple the practice of criticism in the classroom.

How does one adapt the methods and content of art criticism to classroom instruction? Adapting does not mean that students should mimic the professional behavior of critics, a point often misunderstood by educators. In designing instruction in art criticism, educators are not literally bound by what critics actually do. They are not required, for example, to conduct a survey of the current interests of practicing critics in order to determine what art forms elicit the most attention. Some works of art that educators may wish to have students study (certain kinds of folk art or articles of applied design, for example) may have no developed critical tradition. Others may excite the interest of many critics (Robert Mapplethorpe's disturbing homoerotic photographs, for example) but may be unsuitable for use in many public school classrooms.

Educators instead need to consider the methods of art criticism in relation to the goals of understanding and appreciation, the reason an appeal is made to the discipline in the first place. Educators who subscribe to such goals are interested in teaching an understanding and appreciation of many forms of art, not just contemporary art. To realize these goals, students need to study traditional as well as contemporary art, fine as well as applied art, and folk as well as high art. Educators, must translate the methods of art criticism into instructional practice. They must select and generalize from the practice of professional critics to arrive at instructional activities that help students understand and appreciate art. In doing this, they are bound by practical and ethical considerations; the activities must be suitable for students and usable in the classroom.[5]

Aside from methods of inquiry, art criticism as a discipline also offers educators a body of content that can be used to help students better understand and appreciate art. "Content" is ordinarily taken to mean certain types of knowledge: for example, that of concepts and principles. Yet, although learning concepts and principles is part of what is involved in learning the discipline of art criticism, it is not possible to give any general account of the concepts and principles that structure the discipline of art criticism. The reason for this is that criticism, unlike, say, mathematics or the hard sciences, is not a "compact" discipline.[6] Unlike physics or geology, for example, where all

researchers focus their efforts on a few outstanding problems, there are an immense number of problems that are of interest to critics. In part this is because works of art vary enormously. But it is also because critics have differing views of their discipline. They pursue different kinds of intellectual goals and employ different critical methods and approaches. Any attempt to specify all of the immense number of concepts and principles underlying the discipline of art criticism precisely—assuming that it could be done—is an enterprise well beyond my scope here.

The approach to art criticism that I will take in the following chapters differs from others in the educational literature. Many writers treat criticism as a form of discourse—talk or writing about works of art. And much of the theoretical discussion in the educational literature is given over to explication of different kinds of critical statements: description, interpretation, evaluation, and so forth. Having defined these statements, educators then formulate them into a step-by-step procedure for talking or writing about works of art. Such an approach has limited value. Able classroom teachers may pay lip service to such procedures, but after a few trial performances they quickly move on to other kinds of instructional activities.

In the approach adopted here criticism is treated not as a form of discourse but as a mode of inquiry. Inquiry implies that works of art present problems of meaning and value for viewers. It is, therefore, the task of teachers and curriculum designers to structure classroom situations so students become aware of the problematic nature of works of art and then to design instruction so they are more competently able to deal with these works. Students must be led to think and reflect about works of art. They must be taught certain kinds of concepts, skills, attitudes, and habits. And they must be given opportunities to acquire the background information that makes works of art meaningful. Doing so requires an approach to classroom instruction that embraces a number of kinds of instructional activities instead of a single procedure for talking or writing about works of art.

Because this view of criticism differs from some prevailing ideas about art criticism, something should also be said about the genesis of this approach to criticism in the classroom. My initial concerns with existing models of art criticism came from my reading of contemporary aesthetics, especially the writing of Richard Wollheim and Arthur Danto. Both philosophers have stressed the central role of artistic intentions and contextual knowledge in understanding works of art, and both criticize the formalist assumptions embodied in current models of art criticism in the educational literature.

In seeking to translate the practice of criticism into educational terms I have been greatly influenced by the ideas of John Dewey, the first to recognize the need to structure learning around different forms of inquiry and argue for the teaching reflective thinking in the classroom. His ideas continue to be an important influence on American education. They have informed the general curriculum reform movement of the 1950s and 1960s, the aesthetic education movement, the reader response movement in English literature, the philosophy for children movement, and the critical thinking movement. For this reason, proponents of such movements are likely to subscribe to many of the same ideas and teaching strategies. Inquiry and the teaching of reflective thinking are at the heart of all of these movements, and all rely upon class discussion, the teaching of concepts, and other forms of instruction that Dewey recommends in his classic *How We Think.*[7]

Because discipline-based art education grows out of the aesthetic education movement and through this to the general curriculum reforms of the 1950s and 1960s, talk about critical inquiry has been part of the rhetoric of visual arts education for many years. Educators, however, have yet to work out a systematic and effective plan for teaching critical inquiry. In 1989 I agreed to coauthor this volume because of my conviction that prevailing approaches to teaching art criticism were not effective in helping students develop an understanding and appreciation of art and that Dewey's ideas offered a more fruitful alternative. Since the completion of this manuscript in early 1994 I have begun to see other educators also question prevailing approaches to teaching criticism. Articles and papers have begun to appear about reflective thinking and problem solving in relation to works of art, about collaborative learning, about structuring class discussion, and about techniques of questioning, all topics I explore in succeeding chapters. Clearly, something of a trend is developing. Perhaps a new dialogue will ensue about applying art criticism to classroom instruction. Educators continue to have a stake in making the study of works of art a more richly rewarding experience.

NOTES

1. Only a minority of educators have drawn this conclusion. The most influential proponents for the use of art criticism in art education—Elliot Eisner, Edmund Feldman, and Ralph Smith, for example—believe that the methods of criticism are relevant to the study of work from all periods.

2. The theory that art critics alone are interested in contemporary art also

betrays a misunderstanding of the discipline of art history. Modernist historians also study contemporary works of art.

3. A small sample of such literature includes: John Ruskin, *Stones of Venice* (New York: Merril and Berber, 1851–53); Walter Pater, *Greek Studies: A Series of Essays* (London: Macmillan, 1922); Roger Fry, *French, Flemish, and British Art* (New York: Coward-McCann, 1951); Adrian Stokes, *Michelangelo: A Study in the Nature of Art* (New York: Philosophical Library, 1956); Michael Fried, *Realism, Writing, Disfiguration: On Thomas Eakins and Stephen Crane* (Chicago: University of Chicago Press, 1987); and Dore Ashton, *Fragonard in the Universe of Painting* (Washington: Smithsonian Institution Press, 1988). This list could be extended indefinitely. For other examples, see the critical writings of Theodore Wolff and other critics in previous chapters of this volume and also chapter 5 in Albert William Levi and Ralph Smith, *Art Education: A Critical Necessity* (Urbana: University of Illinois Press, 1991).

4. For an expression of the same point of view, see the comments by the philosopher and aesthetician Ronald Moore in *Education in Art: Future Building, Proceedings of a National Invitational Conference* (Los Angeles: Getty Center for Education in the Arts, 1989), 152, 153. For examples of critical analysis of concepts see chapter 17 in Morris Weitz, *Hamlet and the Philosophy of Art Criticism* (Chicago: University of Chicago Press, 1964). Weitz argues rightly that analysis of concepts is one of the central activities of criticism.

5. For examples of the sensitive translation of methods of inquiry into classroom instruction, see Michael J. Parsons and H. Gene Blocker, *Aesthetics and Education* (Urbana: University of Illinois Press, 1993), and Stephen Addiss and Mary Erickson, *Art History and Education* (Urbana: University of Illinois Press, 1993). The volume by Parsons and Blocker, for example, does not recommend the reading of difficult philosophical texts, part of the professional responsibilities of all aestheticians. Instead, it suggests that students undertake the analysis of concepts within the context of class discussions about the meaning and value of works of art. The volume by Addiss and Erickson is especially noteworthy for its departure from the ordinary practice of professional historians. The authors propose that students study greeting cards, soda bottles, and other ephemera, items well outside the professional interests of art historians.

6. For the distinction between compact and noncompact disciplines, see Stephen Toulmin, *Human Understanding* (Princeton: Princeton University Press, 1972).

7. John Dewey, *How We Think* (Boston: D. C. Heath, 1933).

7

Art Criticism and Art Education

Most educators involved with the visual arts have been profoundly affected by contact with paintings, sculpture, photographs, architecture, and other works of art. They remember occasions in which they viewed a painting, attended an exhibition, or visited some cathedral of extraordinary beauty as experiences of great intensity and personal significance. To say that art has "enriched" their existence scarcely does justice to its importance. Most identify strongly with one or more art forms, cherish images from the visual arts, and continue to seek out new opportunities for aesthetic experience. In reflecting upon the enjoyment, inspiration, insight, and enlightenment that art provides, many would concur that a proper mission of the schools is to make it accessible to the young. Understanding and appreciation of the visual arts are important goals of art education.

It is an optimistic sign that the art education profession has increasingly come to accept the fostering of such learning as a major responsibility. We do not live in a culture in which appreciation of the visual arts occurs as a normal part of socialization, and environmental forces may even be inimical to its development. The noted British aesthetician Harold Osborne has remarked that although appreciation of the arts requires no exceptional kinds of natural endowments, the attitudes and skills associated with appreciation diverge from the mainstream of practical life in an organized society; their development may be blunted by early educational influences, family circumstances, or a way of life in which a premium is placed upon strict utility. Osborne believes that if these attitudes and skills have not been learned at a youthful age it may be difficult to acquire them later in life.[1] Students are at an optimum age for fostering understanding and appreciation. If teachers abdicate responsibility for bringing such learning about, it is unlikely that the visual arts will play a significant role in their adult lives.

Given that understanding and appreciation are important goals of art education, how can they be realized? It is as an answer to this

question that art criticism assumes significance as an educational topic. One way of viewing art criticism is as an educational response to the problem of developing such learning in students. As understanding and appreciation have gained acceptance in educational circles, art criticism increasingly has come to be viewed as an important component of the curriculum.

In beginning any discussion it would be well to alleviate a common concern about art criticism, one that arises out of confusing two meanings of the word *criticism*.[2] Some educators have equated art criticism with having teachers and students make negative remarks about works of art. If this were actually what criticism is about, one could readily understand a reluctance to use it in the classroom. After all, what would be the point of teachers making—or having students make—disparaging comments about works of art? But such an idea is quite foreign to the concept of criticism that interests educators in the arts.

Art Criticism in Art Education:
Where Have We Been? Where Are We Now?

Picture Study and Art Appreciation

To understand the current interest in art criticism fully, it is helpful to review the genesis of this idea within the field of art education. A logical place to begin is with the "picture study" movement. Picture study was the first systematic attempt to teach art appreciation in public schools. The movement began in England in the late 1870s, moved to the United States during the 1880s, and was an established part of the school curriculum by the turn of the century. It began with the idea of using pictures and reproductions of art objects for schoolroom decoration and visual aids. Educators believed that displaying pictures and reproductions would create a more humane environment and facilitate instruction in other subjects in the curriculum. But they were also convinced that the study of works of art had educational value in its own right. Through the study of selected works of art, they argued, aesthetic sensitivity could be developed, values could be instilled, and the character of youths shaped.[3]

Proponents of picture study were in many respects true educational pioneers. Although they began with a set of educational aims and ideals, they had almost nothing to rely upon by way of established classroom methods. Consider for a moment how one might bring students to an understanding and appreciation of art. One strategy that quickly comes to mind is simply to expose them to works of art. Yet

contrary to the ever-popular dogma that appreciation of art is "caught rather than taught," educators quickly learned that merely display-ing works of art did little to cultivate either understanding or appre-ciation. They then turned toward more direct forms of instruction, and weekly or monthly lessons in art appreciation became the norm in many classrooms.[4]

When picture study began, teachers typically taught appreciation through lectures. A large monochrome reproduction of a work of art (or a group of small, postcard-sized reproductions) selected by the teacher would be set up in the classroom. The teacher would talk for a brief period about such things as the subject matter, the composi-tion, the artist, and the surrounding historical context of the picture. Students would listen to the lecture at their desks, after which a brief period of questioning might ensue. The lesson might close with some written or other assignment.[5]

Although the practice of picture study is often associated with this rigid approach to instruction, classroom practices evolved and changed as educators gained greater experience in working with chil-dren and responded to other educational forces of the period. One important development was a change in the content of picture study lectures. An early emphasis upon design and composition later shifted to a focus on what was represented within works of art. This was especially true in elementary schools.[6] It would be erroneous to con-clude that this merely reflected a predilection for the realism that dominated academic painting and sculpture of the time. A more plau-sible hypothesis is that it developed out of a growing conviction that young children did not comprehend the formal aspects of a work of art but responded instead to the representational content of the work.

Picture study proponents also began to rely more upon children's interests when selecting reproductions for study. At first, pictures were chosen on the basis of their moral or literary value, but as the movement evolved educators became more concerned about wheth-er the subject matter had intrinsic appeal for children. By the second decade of the twentieth century, picture study manuals tended to emphasize anecdotal pictures, those that represented a particular ac-tivity or event. Teachers were encouraged to use their lectures to tell a dramatic story, which the picture would then illustrate.

Finally, educators began to place greater reliance upon class discus-sion rather than upon lectures. Whereas earlier instructional manu-als appended a brief list of questions (often asking children merely to recall factual information that the teacher had presented), later manuals more often recommended that teachers elicit student reac-

tions to works of art. "The story of the picture may be drawn from the children rather than be told to them," one manual advised.[7]

Although instructional activities that evolved during the picture study period were not called art criticism, they nevertheless represent an initial attempt to deal with the problem of teaching an understanding and appreciation of art. As such, they can rightly be considered precedents to the instructional practices that most educators now associate with art criticism in the classroom. Interest in art criticism can, in fact, be viewed as an outgrowth of the ideals and practices that evolved during the picture study era.

Progressive Education and the Arts

As the romantic idealism that characterized educational thinking of the late nineteenth century gave way to the Progressive philosophies of the first half of the twentieth century, educational changes were afoot that would lead to the end of picture study. Some of the changes that Progressivism ushered in at first affected the teaching of art appreciation in a positive way. The Progressive concern with the developmental needs of children, for example, was undoubtedly responsible for sensitizing educators toward youngsters' preferences in works of art. And the Progressive view of students as active inquirers undoubtedly encouraged teachers to give them a more active role in art appreciation lessons.

Other changes in thinking brought about by Progressivism, however, gradually eroded the practice of picture study. During the 1930s and 1940s other educational ideals supplanted the goals of understanding and appreciation. One strand of Progressive thought, for example, emphasized citizenship and social reconstruction and undoubtedly accounted for the idea of fostering an understanding of different cultures through art appreciation lessons, an idea that emerged toward the latter part of the picture study period. That trend, in turn, was partially responsible for stimulating interest in the study of craft objects, articles of applied design, and the vernacular arts of different races and cultures. Over time, these art forms would come to replace many of the fine arts exemplars that had been studied previously.

The goals of personality development and life adjustment were predominant toward the end of the Progressive Era. For art educators of the period, these ideals were most closely linked with expressive studio activities. As a result, picture study largely disappeared from the school curriculum. What remained were sporadic lessons in art appreciation, an occasional course in art history or art appreciation in a few secondary schools, and a pervading belief that understand-

ing and appreciation of art were best cultivated indirectly, through studio work. During much of the period, teachers were actively discouraged from displaying works of art because it was believed that doing so would hinder students' creative expression.

The Emergence of Art Criticism: Aesthetic Education and Discipline-Based Art Education

The shift toward a serious reconsideration of the problems of teaching appreciation emerged during the 1940s and 1950s as part of a larger educational reform movement. Concerned about a lack of intellectual rigor in public schools, educators began to promote the idea of excellence through a reconsideration of the content of existing school curricula. Like their colleagues in other disciplines, educators in the arts were troubled by a lack of substance and sequence in their programs. In much of what passed for art education in the schools, little effort was directed toward cultivating enlightened student response toward works of art. More often than not, random experiences with art media, divorced from the aesthetic concerns that interest artists and others in the arts, were the norm. Efforts to remedy these deficiencies during the 1960s and 1970s came collectively to be known as the aesthetic education movement and continue in discipline-based approaches to art education.

Three figures can be identified with the resurgence of interest in teaching an understanding and appreciation of art: Thomas Munro, Harry Broudy, and Manuel Barkan. In "Adolescence and Art Education," first published in 1932, Munro, an aesthetician and educator, reflected upon the relevance of accepted art education practices to the developmental needs of students. Noting that the spontaneous impulse to manipulate art materials declines with age, he suggested that educators emphasize reflective thinking in the art curriculum. One strand of his proposal involved the "criticism of works of art, including those of old and modern masters, and also the efforts of the child and his fellow students." For Munro, criticism differed from customary ways of teaching both art appreciation and art history, both of which tended to rely upon rote memorization. It also differed from existing studio practices, which tended to focus on the narrow training of technical skills. Criticism involved "the process of explaining, analyzing, and appraising particular works of art" and "the training of critical powers."[8]

In a series of influential articles and books published during the 1950s and 1960s, Broudy, a philosopher, argued for a more substantive role for the arts in the school curriculum and for a reconceptu-

alization of arts instruction, especially at the secondary level.[9] For Broudy, the arts contributed to education in two important ways. Recalling the ideals of picture study, he argued that the arts played a vital role in shaping the character and values of youths and thus could make a fundamental contribution to value education. Broudy also considered the arts important as sources of aesthetic experience, reflecting an idea popularized by John Dewey. Aesthetic experience, for Broudy as for Dewey, was one of the things that characterized the good life. These rationales for the arts in education required a new form of instruction. Rejecting both the studio course and the survey course in art history, Broudy instead argued for an intensive study of a small number of exemplary works of art. Although his proposals did not specifically mention art criticism as such, other influential educators, such as Ralph A. Smith, were later to see in criticism a method of instruction for bringing about the kind of learning Broudy envisioned.

Barkan, an art educator at The Ohio State University, was one of the motivating figures behind the curriculum development efforts of the 1960s. Borrowing and adapting the ideas of Jerome Bruner, arguably the most influential educational figure of the period, Barkan was the first to enunciate major themes that have come to be associated with the discipline-based movement in art education: that the content of a subject is interrelated; that education should emphasize the structure of a discipline, that is, those fundamental concepts and principles that underlie a subject; that experts in a subject discipline should be called upon for guidance in constructing curricula; and that experts within a discipline provide models of inquiry that students in some fashion should emulate. It was Barkan who first identified the "disciplines" of art criticism, art history, aesthetics, and studio art as relevant to the curriculum. And in a number of influential articles he argued for a greater role for aesthetics and art criticism.[10]

With the writings of Munro, Broudy, and Barkan, many educators have come to once again accept understanding and appreciation of art as major goals of art education and to view art criticism as a critical adjunct in realizing this new vision of art in the schools. If art criticism was considered important in realizing such goals, however, the way it should be conceptualized was not immediately apparent. Educators of the 1960s sought to arrive at an understanding of the nature of criticism in different ways, one of which was to ask professional critics to reflect upon their practices.[11] Educators also either examined critical writings directly or generalized from their familiar-

ity with critical practice. By far the most important way of conceptualizing art criticism, however, was through an appeal to philosophical aesthetics and critical theory.

That philosophical aesthetics should be seen as a source of information about art criticism may seem initially surprising. But in the period between the two world wars, aesthetics, following a general trend in Anglo-American philosophy, turned away from philosophical speculation and metaphysical system-building toward a view of itself as a metadiscipline: one that sought an understanding of other, primary disciplines through close scrutiny of the language used by practitioners. At the same time, art history and literary studies became more firmly established as academic disciplines. Along with the growth of historical and critical studies, scholars began to write about the theoretical foundations of each of these disciplines. During this period, aestheticians sought to explicate the language that critics and historians used when they wrote and theorized about art.

Thus it was to aesthetics, as the philosophical study of the language of criticism, that educators looked during the 1960s and 1970s. Although it is sometimes difficult to identify the sources that individual educators used in formulating their models of criticism, it is likely that most relied upon such works as Harold Osborne's *Aesthetics and Criticism,* Monroe Beardsley's *Aesthetics,* Jerome Stolnitz's *Aesthetics and the Philosophy of Art Criticism,* and Morris Weitz's *Hamlet and the Philosophy of Literary Criticism,* all influential studies in the theory of criticism immediately after the war.[12]

As one might expect, each philosopher approached the task of explicating the discipline of art criticism differently. But had educators looked at a number of these studies, they would likely have been encouraged by a number of similarities. Each, for example, identifies and critiques different schools of criticism (biographical criticism, historical criticism, formalist criticism, Marxist criticism, sociological criticism, and so forth), simultaneously offering an encapsulated history of criticism and an appraisal of some of the underlying assumptions of working critics.[13]

Of more immediate interest to educators influenced by the rhetoric of Barkan and Bruner, each study explicates the concept of criticism in terms of a small number of basic "functions," "tasks," or "activities" held to be intrinsic to the discipline. Osborne writes variously about descriptive, evaluative (and sometimes interpretive) functions of art criticism. Beardsley explicates the activities of critics in terms of description (or analysis), interpretation, and evaluation. Stolnitz's

account focuses upon evaluation, analysis, and explanation (or inter-
pretation). And Weitz divides the activities of critics into description,
explanation, evaluation, and poetics. For educators attempting to
construct prescriptive models of criticism such activities would no
doubt have appeared to constitute the working methods of practic-
ing critics.

Since the mid-1960s a number of influential figures in art educa-
tion have proposed models of art criticism based upon these studies.
In these models, criticism is usually construed as an activity having
a number of stages or phases, usually identified with a particular kind
of critical statement. One of the earliest was Elliot Eisner's formula-
tion of criticism in terms of the activities of description, interpretation,
and evaluation.[14] Edmund B. Feldman's model of criticism—as de-
scription, analysis, interpretation, and evaluation—remains perhaps
the best known among art educators.[15] Ralph A. Smith offered another
model of art criticism employing the same classification scheme at
about the same time; also influential was an account of art criticism
as a form of phenomenological description by the philosopher and
aesthetician Eugene F. Kaelin.[16]

These early accounts of art criticism represent only the beginning
of what is now a sizable literature. The idea of art criticism contin-
ues to excite the interest of many educators, and additions to the lit-
erature have come as further applications of art criticism to art edu-
cation practice are suggested, as revisions to existing models of
criticism are proposed, and as new models of criticism are formulat-
ed. Noteworthy contributions have been made by Tom Anderson,
Terry Barrett, Laura Chapman, Robert Clements, David Ecker, Her-
mine Feinstein, Karen Hamblen, Louis Lankford, Sun-Young Lee,
Nancy MacGregor, Gene Mittler, and Brent Wilson, among others (see
Suggested Reading).

Educators now see in the practice of criticism the potential for
transforming art classrooms from places devoted solely to expressive
studio activities to places where students can become seriously en-
gaged in the study of works of art. Despite a growing constituency
urging its adoption, however, many teachers are still hesitant about
incorporating art criticism into programs of instruction. There are
undoubtedly many reasons for this. Certainly, one reason is that there
is still some uncertainty about what art criticism is. In initiating an
inquiry into art criticism and its role in art education, then, it would
be well to begin by considering what educators mean when they use
the term *art criticism*.

Art Criticism: Some Preliminary Distinctions

Art criticism means different things to educators in the visual arts. First, the term is used to denote a set of critical functions, tasks, or activities that critics perform: describing, analyzing, interpreting, explaining, evaluating, and judging. In formulating models of criticism for schools, educators translate these activities into tasks that students will perform in criticizing works of art. Educators also use "art criticism" to refer to a discipline or field of inquiry. Criticism as a discipline is an evolving social institution marked by certain intellectual aims or goals, traditional types of problems, methods of inquiry, and groups of investigators. Finally, educators use "art criticism" to refer to certain outcomes of instruction. They sometimes speak of fostering critical skills or critical dispositions, of teaching students how to criticize and to criticize works of art. These skills, attitudes, and habits are not things students do; they are more correctly thought of as states of mind or dispositions to do certain things.

Although the latter two meanings of the term are relatively unproblematic, there is often a troubling ambiguity in educators' attempts to explicate criticism as a set of instructional activities. Many conflate the idea of critical inquiry—criticism as a set of activities performed to enable critics to determine the meaning and value of works of art— and critical discourse, criticism as a set of speech acts (and the resultant product of such acts, critical statements).

This problem has its roots in the philosophical literature. Philosophers explicate criticism principally in terms of critical discourse, for they are primarily interested in such things as the nature and verification of critical statements and the types of the arguments critics use when they talk or write about works of art. Yet they often go beyond explications of critical statements and critical arguments to offer observations about such things as aesthetic perception, critical reflection, and the working methods of practicing critics, concerns that reveal a more encompassing interest in critical inquiry as a whole.

Within these texts it is often difficult to separate observations about perception and critical reflection from concerns with critical discourse. One reason for this is that words such as *describe, analyze, interpret, evaluate,* and *judge* are used ambiguously. They are used not only to refer to acts of speaking or writing but also to ways of thinking. Such shifts indicate a fundamental uncertainty about how the discipline of art criticism is to be explicated. A similar uncertainty can be found

within the philosophy of science, where philosophers have long been divided about whether their professional concerns rest solely with explicating science within a "context of justification" or whether they encompass a "context of search and discovery" as well. Clearly, observations about critical perception and reflection reflect a concern with search and discovery, whereas explication of speech acts, different kinds of critical statements, and their methods of verification, reflect a concern with justification.

In relying upon such accounts to inform their conceptions of criticism, educators imported a similar conflation of these two ideas into the models of criticism devised for classroom instruction. They are never separated clearly; instead, ideas about perception and critical reflection are embedded within an overall framework principally devoted to explicating certain types of critical statements. Words such as *description, analysis, interpretation,* and *evaluation* thus acquire two kinds of meanings. They are defined explicitly in terms of the performance of certain kinds of speech acts and are also used ambiguously to refer to perceptual or cognitive processes.

This unconscious conflation has had unfortunate consequences. Critical inquiry encompasses both a context of search and discovery and a context of justification. Yet because the activities of art criticism were defined explicitly in terms of the performance of certain kinds of speech acts, the larger concern was reduced to a more narrow focus upon certain types of critical statements and their verification or justification.

Translating Art Criticism into Instructional Practice

Despite some rhetoric about inquiry in the literature, the models of art criticism that educators developed are actually models of critical discourse rather than critical inquiry.[17] Nevertheless, because of the conflation of these two ideas, teachers and curriculum designers were inevitably led to identify inquiry into the meaning and value of works of art with a certain kind of structured discourse. Critical inquiry thus became equated with various procedures for talking or writing about art.

It is not hard to understand the appeal of such procedures for educators faced with the difficult task of designing classroom instruction. In presenting an account of what art criticism is, models of art criticism seemingly offer answers about how to structure teaching and learning. Yet some reflection will reveal that these models are not as promising as they might initially appear.

Despite frequent references to dialogue and discussion in the educational literature, for example, the models come nowhere near to being an adequate conceptualization of classroom discussion. One reason is that they fail to capture the enormous range of statements that one could reasonably expect to be made when students and teachers speak to one another about works of art, a fact that has begun to attract the attention of a number of educators. A few have noticed that teacher-student discussions, for example, will inevitably include questions or statements about personal reactions to a work of art. These types of statements, however, are typically not included in the models of criticism educators have proposed.[18] Another reason is that the models overlook the unpredictability and dynamism typical of class discussion. Dialogue or discussion does not proceed in a step-by-step fashion. To propose a rigid sequence of steps (describing, interpreting, evaluating, and so forth) for criticizing works of art would be to stifle meaningful discussion rather than promote it.

There is only one plausible way of interpreting these models: as a recommendation for another traditional method of instruction: student recitation. Unlike discussion, recitation is a structured form of talk or writing in which students proceed in a linear fashion through a series of discrete steps or stages. Whether educators intended their models of criticism to be construed in this way is an open question. Nevertheless, it has been the most common way of translating them into instruction. Most teachers believe the way art criticism is to be taught is to place students in front of a work of art and have them describe, analyze, interpret, and evaluate what they see.

If one construes art criticism in this fashion, the question of how to teach criticism seemingly does not arise because a workable method for criticizing works of art in the classroom appears to be readily at hand. Yet it is doubtful whether such a hope can be sustained. Educators have begun to question the practicality of the recitation format. Is it reasonable, for example, to have every student exhaustively describe a work of art when classmates are able to view it for themselves? Do teachers really want every student to go through exactly the same procedure for each and every work of art? That would be tedious and time-consuming. Some students will be bored with listening to other students talk, just as they might be with listening to a lecture. They almost certainly will grow tired of the same instructional activity being monotonously repeated. And do educators want students to acquire the habit of responding to works of art in some mechanical fashion?

Teachers are faced with not simply the problem of involving stu-

dents and structuring novelty and variety into their classes, although these are real concerns. They also have to consider the great range of students whom they hope to teach: students who differ in their ages and backgrounds, in their academic abilities and attitudes toward schooling, and in their life interests and career goals. It is unreasonable to expect that one and only one method of instruction will be effective with all students in all teaching situations. If recitation provides a possible answer about what to do in teaching art criticism, it also leaves teachers with the disquieting problem of how to retain student interest over the long term as well as how to meet individual needs.

The feasibility of recitation as a method for enabling students to understand and appreciate works of art can also be questioned. Some educators have begun to notice that there is a formalist bias in current models of criticism. Formalism is a view that treats the work of art as a self-sufficient entity and assumes that viewers can gain adequate understanding of a work of art through careful scrutiny alone without recourse to information about the artist or the context in which a work of art was produced. That there is such an assumption underlying many models of art criticism seems readily apparent, for classroom recitation, in and of itself, makes no provision for moving beyond the work to acquire information about its artist or cultural context.[19]

What is disturbing about a formalist approach is its unduly constricted notion of what actually constitutes meaning in a work of art. In attempting to deal with what can be confirmed only through study of the object itself, formalists have tended to limit the boundaries of critical relevance to directly perceptible properties. Formalists have traditionally given short shrift to the iconography and symbolism in a work of art, for example, surely an important dimension of appreciation. Formalists have also overlooked the personal reactions of viewers. For many theorists of criticism, these have come to be seen as unwarranted limitations. They would argue that art criticism needs to recognize a much broader range of human concerns.

Critical theorists have also come to dispute formalist assumptions about how viewers come to understand art. Historically, formalism developed as a reaction against biographical criticism and its preoccupation with information about the artist. In attempting to redirect critical attention to the art object itself, formalists argued that consideration of an artist's intentions had no relevance to a work of art's meaning. Many theorists now dispute this. Formalist strictures against consideration of artistic intentions, they contend, rest upon a basic

misconception of artistic intentions as purely private events in the mind of the artist. They argue that artistic intentions are something else entirely. Seeking to determine what an artist intended—a central concern of critics—is a fundamental way of coming to understand a work of art. In pointing this out, theorists have reaffirmed the relevance of biographical and contextual information to critical practice.

Critical theorists have also taken exception to formalist views about aesthetic perception, which they view not as passive reception of a work of art's properties but as an active effort at obtaining meaning and shaped by an observer's cognitive repertoire. That being the case, simply observing a work of art is no guarantee that a person will thereby gain a full understanding of what is seen. Viewers lacking the appropriate cognitive background are more likely to be puzzled or prone to misinterpreting the work. Formalists seem to be mistaken in believing that observation alone is sufficient for obtaining understanding.

Clearly, an impasse has been reached in thinking about how art criticism can be applied to educational practice. Models of criticism in the educational literature traditionally treat it as a form of discourse, a set of linguistic activities defined in terms of the making of characteristic kinds of critical statements. In applying these models to educational situations, many teachers are led to equate critical inquiry with student recitation. If recitation seems to have initial promise as an educational method, it also leaves educators with some troubling concerns. It seems to be impractical as a method for meeting the needs of different students in different classroom situations and over extended periods of time. It also commits educators to a formalist view of art criticism. Formalism, which in recent years has come in for a great deal of criticism, distorts the nature of aesthetic perception and critical meaning and fails to recognize the central role of background knowledge and contextual information. In relying upon a recitation as an instructional strategy, educators seem to be denying students the kind of learning they want them to attain.

Art Criticism as Critical Inquiry

The way out of this impasse lies in a reconsideration of the basic categories with which art criticism has been conceptualized. In the classroom, it is best construed not as a form of discourse but as a form of inquiry.[20] Critical inquiry can be identified with efforts to determine the meaning and value of works of art, the central goals of art criticism as a discipline. Critical inquiry may be defined, therefore, as the pursuit of meaning and value in works of art.

How should this search be undertaken in the classroom? Instead of advocating a single method or procedure for criticizing, educators should think in terms of three sets of instructional activities: personal response activities, concept and skill instruction, and student research activities. All emphasize determining the meaning of works of art rather than identifying value and other goals of professional critics.[21] This does not mean that critical inquiry in the classroom is to be restricted to this focus, however. The pursuit of meaning inevitably raises issues and concerns about the aesthetic and moral value of works of art, about the artist and the viewer, and about the contexts in which the work of art is created and appreciated. Nevertheless, determining the meaning of a work of art is the initial concern of any viewer, and for this reason it must be given priority in planning and implementing classroom instruction.[22]

Personal Response to Works of Art

Critical inquiry starts with the personal experience that students have with a work of art and with reflection upon the adequacy of that experience. Reflection, in turn, begins when students confront what John Dewey called a problematic situation. Works of art are potentially problematic because they can be understood and evaluated in different ways. The challenge to reflection often goes unrecognized, however. If students are sometimes puzzled by a work of art and realize that they lack relevant understanding, more often than not they believe that what they observe is the only way to see and understand that work. If merit can be assessed in many different ways, students typically base evaluations upon a narrow set of value criteria.

Critical reflection can be promoted in the classroom in three ways. First, teachers can have students exchange observations and opinions about a work of art. In doing this, they provide opportunities for students to test the validity of their reactions to works of art and to gain insights from the experiences of others. Second, teachers can have students compare and contrast related works of art and so provide opportunities for them to overcome the limitations of their preconceptions about works of art as simply imitations of reality. And third, teachers can confront students with provocative and controversial works of art. In doing this, they provide opportunities to experience works that challenge their own ideas and values.

All three strategies can help promote critical reflection. In using them teachers function both as facilitators and as collaborators, assisting and working with students to determine the meaning and value of works of art.

Concept and Skill Instruction

Personal response activities necessarily predominate in any curriculum devoted to critical inquiry, but they do not exhaust the kinds of instructional activities needed if students are to arrive at more adequate determinations of meaning and value. Teachers also need to plan for the acquisition of relevant aesthetic concepts and skills. Knowledge of aesthetic concepts enlarges and refines response, provides strategies for viewing works of art, and often increases enjoyment. Teaching concepts and skills requires a teacher to assume the role of an authority in providing knowledge rather than functioning as a facilitator or collaborator in the search for meaning and value.

Student Research

In addition to conceptual knowledge and skills, students also need to acquire biographical and contextual knowledge, which enhance a viewer's ability to find meaning in works of art. Sometimes it is appropriate for teachers to provide such knowledge through lectures or assigned readings. It is usually better, however, to have students acquire this knowledge through independent research projects. Topics for such projects can be derived from questions that arise from prior encounters with works of art. In student research activities teachers function as mentors and guides in helping students plan projects and assisting them in conducting library research.

These three types of instructional activities define the parameters of critical inquiry in the classroom. This approach to art criticism differs in fundamental ways from other proposals for criticism in the educational literature. First, it does not assume that students can adequately understand or judge a work of art through observation alone. Instead, it assumes that works of art present problems of meaning and value. Second, it does not rely simply upon exposure to the work of art for student comprehension. Instead, it recognizes that students may need to be taught concepts and skills and that they may need to go beyond the confines of a work of art in order to seek background information. And, third, it does not rely upon a single method of instruction but rather countenances the legitimacy of many kinds of instructional activities, including class discussion, lectures, and other modes of teaching and learning.

NOTES

1. Harold Osborne, *The Art of Appreciation* (London: Oxford University Press, 1970), 4.

2. This problem is discussed in George Geahigan, "Art Criticism: An Analysis of the Concept," *Visual Arts Research* 9 (Spring 1983): 10–22, in which I suggest that a major reason for the confusion over the word *criticism* is that criticism as a general activity of speaking (the sense intended by educators) is a technical meaning of the term, one that is limited to a particular sphere of professional discourse in education and the arts. Criticism as the activity of making a particular kind of statement (the negative, pejorative sense of criticism), on the other hand, is one that is encountered in common everyday speech.

3. For a discussion of the moral values of art in relation to art education, see Mary Ann Stankiewicz, "The Eye Is a Nobler Organ: Ruskin and American Art Education," *Journal of Aesthetic Education* 18 (Summer 1984): 51–64.

4. For a discussion of picture study in relation to the development of art education practice, see Frederick M. Logan, *Growth of Art in American Schools* (New York: Harper Brothers, 1955) and Arthur D. Efland, *A History of Art Education* (New York: Teachers College Press, 1990).

5. This format is suggested by the recommendations provided in many articles and teaching manuals of the period. These, of course, do not tell us what actually occurred in classrooms. Nor should one assume that there was strict uniformity in what passed for picture study.

6. To see this changing emphasis one only need compare editorials by Henry Turner Bailey in the *School Arts Book* (forerunner of the present *School Arts*) between 1905 and 1911.

7. Delia Kibbie, Jane Rehnstrand, and Maybell Bush, *Picture Study for Elementary Schools* (Eau Claire: Eau Claire Book and Stationery, 1928), vi.

8. Thomas Munro, "Adolescence and Art Education," *Bulletin of the Worcester Art Museum* 23 (July 1932): 61–80, reprinted in *Art Education: Its Philosophy and Psychology* (Indianapolis: Bobbs-Merrill, 1956).

9. See Harry S. Broudy, "Some Duties of a Theory of Educational Aesthetics," *Educational Theory* 1 (November 1951): 190–98; Harry S. Broudy, B. Othanel Smith, and Joe R. Burnett, *Democracy and Excellence in American Secondary Education* (Chicago: Rand McNally, 1964); and Harry S. Broudy, *Enlightened Cherishing: An Essay on Aesthetic Education* (1972, repr. Urbana: University of Illinois Press, 1994).

10. Manuel Barkan, "Transition in Art Education: Changing Conceptions of Curriculum Content and Teaching," *Art Education* 15 (October 1962): 12–27; and Manuel Barkan, "Curriculum Problems in Art Education," in *A Seminar for Research and Curriculum Development in Art Education*, ed. Edward L. Mattil, Cooperative Research Project V-002 (University Park: Pennsylvania State University, 1966).

11. For an example of this, see the contribution by Harold Rosenberg in *A Seminar for Research*, ed. Mattill, 60–70. This book, which pairs a professional critic and an art educator as coauthors, is, of course, another example.

12. Harold Osborne, *Aesthetics and Criticism* (London: Routledge and Kegan Paul, 1955); Monroe Beardsley, *Aesthetics: Problems in the Philosophy of Criticism* (New York: Harcourt Brace and World, 1958); Jerome Stolnitz, *Aesthet-*

ics and the Philosophy of Art Criticism: A Critical Introduction (Cambridge: Riverside Press, 1960); Morris Weitz, *Hamlet and the Philosophy of Literary Criticism* (Chicago: University of Chicago Press, 1964). Influential earlier studies include Bernard C. Heyl, *New Bearings in Esthetics and Art Criticism* (New Haven: Yale University Press, 1943); and Theodore Meyer Greene, *The Arts and the Art of Criticism* (Princeton: Princeton University Press, 1940).

13. A useful classification of different schools of criticism is given by Theodore Wolff in chapter 1.

14. Elliot Eisner, "Curriculum Ideas in Time of Crisis," *Art Education* 18 (October 1965): 7–12.

15. Edmund B. Feldman, *Art as Image and Idea* (Englewood Cliffs: Prentice-Hall, 1967); and Edmund B. Feldman, *Becoming Human through Art* (Englewood Cliffs: Prentice-Hall, 1970).

16. Ralph A. Smith, "Aesthetic Criticism: The Method of Aesthetic Education," *Studies in Art Education* 7 (Spring 1968): 20–32. A revision of this model of art criticism is presented in Ralph A. Smith, "Teaching Aesthetic Criticism in the Schools," *Journal of Aesthetic Education* 7 (January 1973): 38–49. In the later version, Smith proposes two broad divisions of critical activity: exploratory criticism and argumentative criticism. The former encompasses description, analysis, characterization, and interpretation, and the latter evaluation. See also Eugene F. Kaelin, "An Existential-Phenomenological Account of Aesthetic Education," *Penn State Papers in Art Education*, no. 4 (University Park: Pennsylvania State University, 1968).

17. For a discussion of this problem, see George Geahigan, "Conceptualizing Art Criticism for Effective Practice," *Journal of Aesthetic Education* 30 (Fall 1996): 23–42. What would a model of critical inquiry be like if actually constructed? I think it would have to be formulated along the lines of Dewey's well-known theory of reflective thinking. In Dewey's theory, reflection starts with the existence of a problem or felt difficulty. In the case of art criticism, this problem would bear upon questions about the meaning and value of a work of art. Following this phase is one in which the problem or felt difficulty is intellectualized into a problem to be solved. That phase, in turn, is followed by the formulation of a hypothesis to guide further observation. Following this, the thinker reasons about the consequences of the hypothesis. In the final phase of Dewey's model, the thinker tests the hypothesis through observation or imaginative action. See John Dewey, *How We Think* (Boston: D. C. Heath, 1933). I have chosen not to explicate art criticism in terms of such a model because educators historically have had a tendency to misinterpret Dewey's model as a procedure for acting.

18. The absence of statements such as these is but one indication of the oversimplified view of language reflected in current models of art criticism. Models of criticism in the educational literature reflect ideas about language that were prevalent during the 1940s and 1950s. During that period philosophers thought that ordinary discourse (hence critical discourse) could be adequately categorized into a few types of critical statements (description, interpretation, evaluation, and the like). Since that time, however, philoso-

phers have come to realize that ordinary discourse is immensely more complicated. Instead of a handful of critical statements, they now estimate that there may be upward of a thousand or so different types of statements in ordinary language, most of which can be expected to appear in critical discourse and in class discussions about works of art. See J. L. Austin, *How to Do Things with Words* (Oxford: Oxford University Press, 1962). A lack of awareness of the full complexity of ordinary language is one reason why educators have been prone to confuse student recitation with class discussion.

19. It is ironic that such an assumption runs counter to what many authors of current models of criticism may believe about art and aesthetic response.

20. This does not mean that critical discourse is irrelevant to the concerns of educators, however. Speaking and writing are some of the ways in which critical inquiry is undertaken, and they are the ways that the findings of critical inquiry are conveyed to others. Educators, therefore, are legitimately concerned with critical discourse when seeking to understand classroom interaction and evaluating student learning. Typologies of critical discourse, in and of themselves, cannot be used to structure instructional activities in the classroom, however.

21. The discipline of criticism embraces many goals quite apart from determining meaning and value. Critics, for example, are sometimes interested in social criticism and promoting the careers of certain artists. Determining the meaning of works of art, however, is a necessary prerequisite to achieving these larger goals.

22. Professional critics are paid to make value judgments about works they are criticizing. Students in the classroom, on the other hand, are under no such obligation. Although concerns about the merit of a work of art will frequently enter into the study of works of art, it is by no means necessary that students decide upon the value of a work of art while studying it. Determining the meaning of a work of art, however, is always a concern of viewers.

8

The Pursuit of Meaning:
Proximate Goals of Critical Inquiry

In the last chapter I noted that viewers try to make sense of what they observe when they confront a work of art. Finding meaning, therefore, is the initial preoccupation of viewers. This chapter discusses three types of meaning. First, viewers are concerned with what an artist is attempting to do in making a work of art, with achieving an intentional understanding of that work. Second, viewers go beyond trying to ascertain artistic intentions and attempt to organize their perceptions through what I shall call an aesthetic understanding of that work. Third, viewers often find meaning not only in understanding a work of art but also in relating that understanding to their lives—in gaining personal significance from the work. Determining these different types of meaning are proximate goals of critical inquiry.

Aesthetic Assumptions of Critical Inquiry

Focusing on the pursuit of meaning implies a different set of working assumptions than other approaches to art criticism in the educational literature. Many recommendations for criticism imply a formalist aesthetic, which assumes that a work of art is a self-contained entity capable of being understood through scrutiny alone. Works of art on this orientation are much like a rock or a stone in a landscape, having an independent status apart from both artists and viewers. For formalists, meaning resides in perceptible properties and their interrelations. Artists are regarded as individuals who act in isolation from viewers and the culture at large. Viewers are seen as individuals who apprehend what is visible to any person with normal eyesight and faculties. Works of art for formalists are correctly understood in only one way, and attaining such an understanding is assumed to require no special background knowledge or preparation.

Simple and appealing as a formalist orientation to art criticism is, it fundamentally misconceives both art objects and what occurs in the

making and viewing of works of art. Adopting such a viewpoint, as we have seen, has pernicious consequences for the practice of art criticism in the classroom. What assumptions underlie the present approach to art criticism?

In delineating these, we can start by recognizing that art in its most encompassing sense is a "form of life," a set of social institutions characterized by certain social roles and activities that are organized in order to satisfy human needs and interests. As institutions, the visual arts have evolved and developed; they are the outcomes of artistic traditions that vary from one culture to the next.[1] To understand art from this institutional perspective, one must recognize the work of art as well as the artist, the viewer, and the surrounding contexts in which art is made and appreciated.

From this perspective, artists are seen as participants in ongoing enterprises existing before them and continuing after them. In making a work of art, they enter into a tradition that has established ways of proceeding. Making art cannot be viewed as something that involves only an artist and an art object; artists seek to convey meaning to others. In order to do this, they must consider the perceptual and cognitive capacities of their audiences. They must believe that others possess capacities and tendencies to see, think, and reason just as they do; they must also assume a common body of knowledge and belief; and they must assume a similarity of interests between them and their audience. It is by exploiting all of these things that artists are able to manipulate the physical materials of their chosen medium and produce configurations that are comprehensible and interesting to others. In making art, artists adopt the role of viewer as well as creator. In making objects that have meaning for them, they make objects that are meaningful to others.[2]

Moving to the side of the viewer, scrutinizing art cannot be understood in terms of a passive "taking in" of the directly perceptible properties of an art object. Aesthetic perception is more properly construed as an active search for meaning. In scrutinizing a work of art, a viewer will assume that an artist has made something meaningful and will try to make sense of it. Viewers will be concerned with what an artist intended to do in making that work. They will also go beyond trying to decipher intended meaning in order to organize their perceptions in other ways. Finally, viewers will relate these newly discovered understandings to their lives and seek personal insights from works of art.

Looking at works of art is challenging because they can be understood in different ways and, for this reason, present puzzles and prob-

lems for viewers. A commonplace observation is that a work of art is never understood completely. If that is the case, why undertake the search for meaning in the first place? Theodore Wolff has provided an eloquent answer in his discussion of the joys and benefits to be had from interacting with works of art (chapter 1). Many people find viewing art to be an intrinsically rewarding experience.[3] And many believe that viewing art contributes to self-understanding and personal development. In looking at works of art, we confront the ideas, beliefs, and feelings of others, all of which reveal our own limitations. We accommodate different perspectives by reorganizing our cognitive framework to assimilate new points of view. As a result, we grow and develop as human beings.

Understanding Artistic Intentions

Making a work of art is an intentional activity—an artist tries to realize certain aims, goals, or purposes. Imagine an artist such as Pablo Picasso at work on *Guernica* (figure 7), for example. There are many things that he might have been trying to achieve in planning and executing the work. He was likely trying to cover a large canvas with paint, create a dramatic and unified composition, explore some of the aesthetic possibilities of Expressionism, Cubism, and Surrealism, represent the senseless bombing of the Spanish town of Guernica, and express outrage and anger at that atrocity.

Artists usually have many goals. Picasso might have had such personal goals as clarifying the meaning of the tragedy in his own mind, working through certain emotional conflicts about the tragedy,

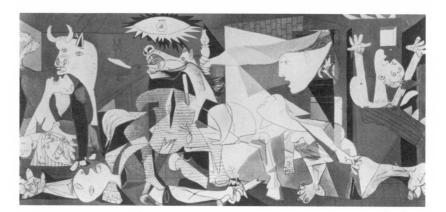

Figure 7. Pablo Picasso, *Guernica*.

broadening his skills as a painter, and promoting his artistic reputation. He might also have been trying to affect other people in certain ways, influence events, and bring about change. He might, for example, have been trying to arouse popular anger at the regime of General Francisco Franco (responsible for the bombing), to discredit his regime, and to remove it from power.

While many artistic goals are personal, others are shared. When artists make art, they join an ongoing enterprise in which certain aims or goals are already established. They can choose to reject some but cannot reject them all. Otherwise, what they would create would not be recognized as a work of art. Artists working in the same art form—painting, sculpture, and architecture, for example—will have a cluster of related goals. Some but not all will overlap those of artists who work in another art form. A painter or a sculptor, for example, will often attempt to represent objects or things, but this is rarely the aim of an architect. Yet painters and sculptors, as well as architects, attempt to create unified aesthetic objects.

Artists working in different artistic genres will also share certain goals. Painters of landscapes, for example, will typically have different (if overlapping) sets of goals from those who paint still lifes. The former might be concerned with the changing patterns of sunlight and the rendition of atmospheric effects, and the latter might exhibit a greater interest in rendering textural effects.

Different artistic goals are also inherent in an artist's style. Consider, for example, Expressionism, Cubism, and Surrealism, which all reject Impressionism. Each, however, does so in pursuit of a characteristically different set of artistic aims. Expressionist artists typically are interested in the depiction of personal emotions and feelings, subjective concerns that are often coupled with a protest against what is felt to be a hostile social milieu. Cubist artists, on the other hand, reject what is felt to be an Impressionist preoccupation with the mere rendering of evanescent effects of light and atmosphere. They strive to create pictorial alternatives to an optical conception of reality through abstracting the shapes of objects and arranging them on a flat plane. Surrealist artists, unlike Impressionists, are concerned with the unconscious aspects of the psyche. They seek to liberate the creative unconscious through the use of a-logical automatic procedures, startling juxtapositions of unrelated objects, dream imagery, and private symbolism.

Many of the goals that an artist has in making a work of art are related teleologically—there is a means-end relationship between and among them. Applying paint to canvas, for example, is a step Picas-

so took in order to realize the goal of producing a representation of the bombing of Guernica. Producing a representation of the bombing of Guernica, in turn, was a step taken in order to discredit the Franco regime. Having an end in view, however, does not mean that an artist must be constantly thinking about goals in the process of making a work of art. Picasso, for example, need not always have been thinking about representing the bombing of Guernica or discrediting the Franco regime during the extended period in which he worked on the painting. Nor does it imply that an artist's goals cannot be modified in the process of creating a work of art. Artists often do change their goals as they receive feedback from the work and as their ideas and feelings evolve.

Artists' goals are formulated on the basis of their ideas and beliefs about the world around them. In order for Picasso to portray the bombing of the Spanish town of Guernica, for example, he must have believed that Guernica exists and that the bombing of the town took place. He must have believed that the bombing was morally wrong. And he must almost certainly have believed that viewers would react in a certain way to his painting. Because artistic goals arise out of a particular society and culture, many are specific to a particular period. For example, Picasso could not have represented the bombing of Guernica before it actually took place. He could not have experimented with Expressionism, Surrealism, and Cubism before the twentieth century. And he could not have produced an oil painting had he lived in ancient Greece.

Understanding What an Artist Intended

An artist produces a work of art to convey meaning. Viewers who approach a work of art, therefore, do so on the assumption that it is meaningful. They will try to understand what has been produced. The first question to be asked concerns what the artist is doing or attempting to do in making the work. In asking such a question, the viewer is inquiring into the artist's goals. These constitute his or her intentions in making the work.

Many goals are readily recognized. Just by looking at *Guernica*, for example, most viewers can see that Picasso intended to represent a bull, a horse, a woman holding a dead child, and other figures and objects. They can see that he intended to produce a semi-abstract composition with sharp contrasts of light and dark. And they can see that he intended to depict a violent catastrophe of some sort. Because these things are recognized immediately, there is a tendency to overlook the role of one's cognitive background in making such understandings

possible. Yet the ability to understand what Picasso was doing or at-
tempting to do in painting *Guernica* quite literally depends upon the
knowledge, beliefs, and understandings that a person brings to bear
in scrutinizing his work. Viewers are able to understand much of what
Picasso intended through scrutiny alone because artists have tradi-
tionally considered the perceptual and intellectual capacities of their
audiences. Someone who truly intended to represent a horse, for ex-
ample, would not produce a configuration that would likely be read
as an image of a ship. Artistic intentions, then, are in some sense
public matters, but understanding the intentions of an artist requires
background information and knowledge.

If most works of art are comprehensible to some degree, circum-
stances often conspire to create estrangement between artist and view-
er. In early and less complicated societies artists made work for a re-
stricted audience that shared many of the same interests and beliefs.
As a consequence, almost everyone was able to understand the work
an artist produced. But as cultures expanded and grew more diverse,
artists have tended to work for specific social groups whose ideas and
values differed from others within the same community. The range of
art objects available to the viewer is also greater now than ever. In
earlier times someone's exposure to art would generally be limited to
the relatively few works that were near at hand. Travel was difficult,
museums were largely nonexistent, and books and reproductions
were scarce and inadequate. Now, art from the past as well as the
present, from other cultures as well as our own, is readily available
to anyone.[4]

But there is yet another reason why average people find it difficult
to understand works of art. As the making of art evolved from sim-
ple beginnings, it also grew more complex and reflexive. Artists were
no longer content to serve the interests of other members of the soci-
ety; they increasingly began to focus upon their own specialized in-
terests. Artists of the twentieth century have often made it a point to
stand apart from general society, and individual aesthetic and person-
al concerns have come to the fore. Fine arts throughout much of their
history reflected the values and concerns of the communities artists
served; now art tends to reflect the interests and concerns of a much
smaller segment of society.

If contemporary viewers are usually able to understand some of
what an artist is doing or attempting to do, other goals are likely to
remain elusive. Even a straightforwardly representational work such
as Kollwitz's *Storming the Gate*, for example, presents problems be-
cause most viewers would consider that they had only a partial un-

derstanding of that work unless they knew the particular incident being portrayed. And in turning from representational works such as Kollwitz's to examples of modern and contemporary art, the difficulties multiply. Viewers of Jacob Lawrence's *Men Exist for the Sake of One Another. Teach Them Then or Bear with Them* (figure 8) would likely be puzzled by the work's iconography and Lawrence's style of painting. Frida Kahlo's *Two Fridas* (figure 9) presents similar problems. Viewers would perhaps be at a loss to know precisely what each work represents, and many would be puzzled about the frequent departures from illusionistic representation.

Viewers are likely to be even more baffled by such recent works as Anselm Kiefer's *Midgard*, Beverly Pepper's *Hadrian's Wedge*, and James Turrell's *Roden Crater Project*. Kiefer's painting contains cryptic symbols, and the enormous size of the painting, its unorthodox combination of painting and photographic imagery, and its crude application of paint to a representational image are likely to overwhelm and confuse viewers. Pepper's sculpture does not represent anything directly and is likely to be puzzling for that reason. Even more bewildering, Turrell's reshaping of an extinct volcanic crater seems to depart completely from everyday ideas about what consti-

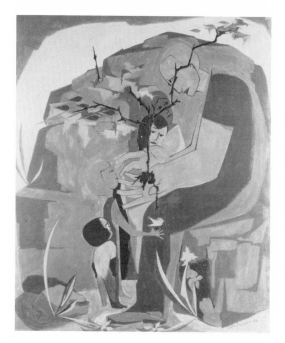

Figure 8. Jacob Lawrence, *Men Exist for the Sake of One Another. Teach Them Then or Bear with Them.*

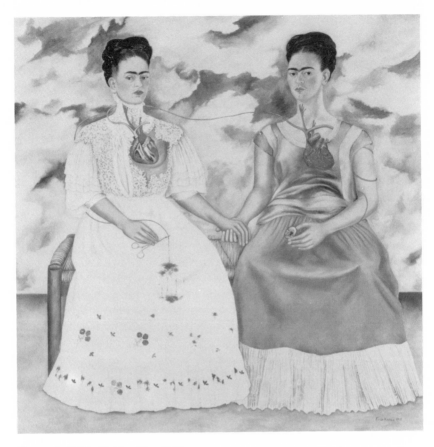

Figure 9. Frida Kahlo, *Two Fridas.*

tutes an art object. The "shock of the new," the estrangement and alienation that most people feel when viewing contemporary art, is a common phenomenon. Even sophisticated critics are often at a loss when encountering new works of art; consider, for example, Leo Steinberg's discussion of Jasper John's *Target with Two Faces* (chapter 2).

Thus, when looking at works of art, contemporary viewers are likely to be troubled by questions about what the artist was doing in making that work. In the case of Kollwitz's etching, for example, a viewer is likely to ask what particular incident is being portrayed. Why did Lawrence use flat, cut-out shapes and a collage style of painting? Why did he stylize the figures and distort the man's hands? Who is pictured in Kahlo's painting? Why is the same person repre-

sented twice? What meaning is to be attached to the strange symbolism of the cut vein and the two hearts? What does the Kiefer picture represent? What is the meaning of the snake and the broken palette? Why did the artist use a large photograph as the basis for his painting? Why did he obscure the imagery with a crude application of paint? What does the Pepper piece represent? And what is Turrell doing? Why is this a work of art?

In asking all of these questions a viewer is concerned with the intentions of the artist. What viewers seek is a structured set of goals that will enable them to make sense of the work of art.

Recovering Artistic Intentions

Works of art, then, are inherently problematic. Even though some of what artists intend to do is available through observation, full understanding is not automatically recoverable through scrutiny alone. Background knowledge is also necessary.

How is this acquired? One way is through the titles or other labels that artists employ, which provide a preliminary orientation and narrow the many possible ways in which works of art can be read. Take Pepper's *Hadrian's Wedge,* for example. Its title helps viewers see allusions to a classical subject. The title of the show in which it was exhibited, *Altars and Sentinals,* also suggests that the piece might be viewed as an object that has religious or ceremonial overtones. Even a work deliberately left untitled can be a revealing indicator of intentions, for it might indicate that an artist is not interested in representing a particular subject, something that might otherwise be read into it.

Artistic intentions can also be ascertained through interviews with the artist or through public statements in which the artist reveals his or her goals, either directly or through inference. Why, for example, did Lawrence use a Cubist collage style in *Men Exist for the Sake of One Another. Teach Them Then or Bear with Them?* Part of the answer can be found in the inherent rationalism of the Cubist style. In Lawrence's words, "Of all modernist concepts and styles, cubism has been the most influential. Because of its rationalism, its appeal has become universal. And because cubism seeks fundamental truths, it has enabled the artist to go beyond the superficial representation of nature to a more profound philosophical interpretation of the material world."[5]

What is Turrell doing or attempting to do in the *Roden Crater Project?* Part of the answer can be found in his interest in light and space and their impact upon viewers. In shaping the crater, Turrell is

attempting to create a neutral architectural backdrop so viewers can experience the light and space of the setting: "My work is about space and the light that inhabits it. It is about how you confront that space and plumb it. It is about your seeing. How you come to it is important. The qualities of the space must be seen, and the architecture of the form must not be dominant."[6]

Familiarity with the milieu in which an artist works can also assist viewers in understanding an artist's intentions. Part of this milieu is the physical setting in which an artist works. Kiefer's heroically sized paintings, for example, are not imaginary landscapes but actual representations of German landscape and recognizable to viewers who know that terrain. Knowledge of personal events in the life of an artist can also help viewers determine intent. *Two Fridas* was painted shortly after Kahlo's divorce from Diego Rivera and has been plausibly interpreted as a representation of grief and loss.

The social and cultural milieu in which artists work also shapes their goals and aspirations. Lawrence's art was strongly affected by the idealism and social activism of the Harlem Renaissance, and many of his paintings are intended to instill a sense of pride in African Americans. Kahlo's paintings are influenced by the Mexican revolution; her self-portraits in native Tehuana costume are in part expressions of solidarity with native Mexicans. And Kiefer's paintings are affected by a cultural crisis in a Germany struggling to come to terms with its military past. His *Midgard* deals with a Nordic myth and is, in one sense, an examination of the roots of German culture.

An important part of the surrounding culture is the artistic milieu in which an artist works. Knowledge of the artistic tradition that an artist inherits often allows viewers to infer artistic goals. Because Picasso made a painting instead of a sculpture of *Guernica,* for example, viewers are entitled to infer that, like other painters, he intended to produce an arrangement of shapes and colors on a flat surface, not a three-dimensional object to be viewed from multiple vantage points. Because he was painting a public mural instead of an intimate easel painting, viewers can infer that, like other muralists, he did not desire to produce an object that should be scrutinized for its subtle textural and painterly effects. Because he used elements of Expressionism, Cubism, and Surrealism, viewers can infer a cluster of artistic goals Picasso shared with other artists who worked in these same stylistic idioms. And because he combined these stylistic idioms, viewers can infer that his artistic intentions differed from those other artists.

To gain access to the artistic goals and aspirations of contemporary artists, many art critics make it a point to socialize with the artists, visit their studios, and familiarize themselves with the immediate social and cultural milieu in which they work, as in Robert Pincus-Witten's description of his visit to Julian Schnabel's studio (chapter 2). All of this is impossible when dealing with works of art from the distant past. To acquire biographical and contextual knowledge for them, critics must either undertake the same kind of investigation as art historians (historical criticism) or use the research findings of professional historians.

Without such background knowledge even sophisticated viewers are liable to misconstrue the intentions of artists. Consider the Mannerist painting *Madonna with the Long Neck* by Parmigianino (figure 10). John Sherman, an art historian, has described some common misinterpretations of such paintings by twentieth-century viewers.

> Since about 1920 it has become common to interpret Mannerist works of art in terms of "tension," "reaction," "irrationality," or "crisis," and to see in them an *intention* to shock in a discomforting way. There is much talk of anxiety (in the mind of the artist), spiritual malaise, conflict, and several more questionable psychoanalytical catchwords and concepts of the same kind. If the reader has dipped into modern literature on Mannerism he has, more likely than not, met this approach. . . . But if we stand back a little we should be able to see that "tension" and the rest already have an early twentieth-century flavor, and in fact the historian knows perfectly well that the expressionistic interpretation of Mannerism is an invention of the Expressionistic period.[7]

To ascertain the intentions of Mannerist artists, Shearman argues, a work of art needs to be thrown "back into the nest of ideas in which it was born." In doing so one finds that Mannerism was not a style "of tension or collective neurosis. It was, on the contrary, the confident assertion of the artist's right, . . . to make something that was first and last a work of art."[8] Mannerists reflected the culture of their period in placing expression of artistic qualities over other concerns. They sought to create a stylish elegance and refinement, often through the use of elongation and other distortions. They prized complexity over simplicity to the point where they crowded their pictures to demonstrate their fertility of invention. They attempted to create an air of profundity, sometimes deliberately obscuring the meaning of a work of art to do so. And they sought to demonstrate their artistic prowess through an effortless rendering of difficult figure poses. In recognizing these intentions, viewers arrive at a profoundly different understanding of Parmigianino's painting.

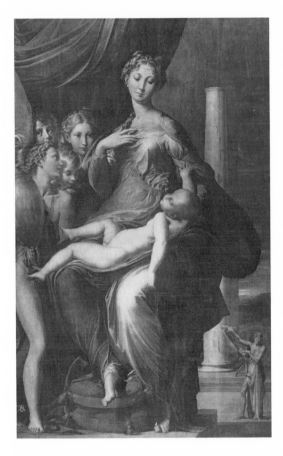

Figure 10. Parmigianino
(Francesco Mazzola),
*Madonna with the Long
Neck.*

The Intentionalist Fallacy

Focusing upon artistic intentions as a way of coming to understand
a work of art stands in sharp contrast to formalist conceptions of art
criticism. Formalist critics believe it is a mistake to appeal to an art-
ist's intentions, a mistake they label the "intentionalist fallacy."[9] For
the formalist, artistic intentions are private thoughts, mental events
that occur just before or during the process of artistic creation. They
argue that attempts to ascertain what these are send critics off on a
fruitless quest for biographical and contextual knowledge and away
from the work of art itself, the proper locus of critical concern. For
formalist critics such "external evidence" can only be an unreliable
indicator of meaning. They reason that such knowledge is often un-
available, either because artists are no longer living or because they
may not remember what their thoughts were. Then again, artists

sometimes lie or exaggerate when describing their intentions. Critics are thus faced with a dilemma, and, formalists argue, are better off seeking an understanding of a work of art through careful examination of its internal evidence.

A number of misconceptions underlie the anti-intentionalist thesis. One concerns the nature of artistic intentions themselves. First, contrary to what formalists believe, critics who seek to understand artistic intentions are not concerned with transitory thoughts that occur in the minds of artists but rather with the goals that artists seek to attain in creating works of art—with states of mind rather than with mental events. Second, the state of mind of the artist is not private but has a public character. Because making a work of art involves an attempt to convey meaning, many of these goals will be available to viewers directly. Furthermore, such goals, shaped by beliefs, can be inferred through investigation into the societies and cultures in which the artists live. Critics are not forced to rely solely upon what artists are willing to reveal. Third, formalist critics draw an arbitrary distinction between internal and external evidence. No viewer approaches a work of art with an innocent eye, but always with certain kinds of background knowledge that affects how the internal evidence of a work is perceived. Viewers who know more about an artist and the context in which works of art are created are able to see and understand more than viewers who lack such knowledge.

Aesthetic Understanding

Although viewers customarily seek to understand works of art in terms of artistic intentions, there is also another assumption underlying their interaction with works of art. Part of our contemporary concept of a work of art is that it is an artifact to be intellectually and imaginatively apprehended by viewers and thus function as a source of insight and enjoyment. This assumption might possibly be the result of social and cultural developments that have led over the past few centuries to contemporary ideas of the aesthetic. André Malraux has remarked that a "Romanesque crucifix was not regarded by its contemporaries as a work of sculpture; nor Cimabue's *Madonna* as a picture. Even Pheidias' *Pallas Athene* was not, primarily, a statue."[10] These artifacts are now understood in a different way than they were in the cultures of their origin.

Whether or not this is peculiarly modern concern, it is nonetheless a genuine assumption that contemporary viewers bring to bear in their approach to works of art.[11] With this assumption has come the

idea that meaning lies partly outside the intentions of an artist. There may be more (or less) in a work of art than its artist intended, and spectators have a legitimate role in uncovering what I shall call an aesthetic understanding of a work of art.

This concern arises for a number of reasons. One is that information about an artist or the culture in which the artist lived may be inadequate or unavailable. We know little about the culture that produced the cave paintings at Lascaux, France, and even less about the individual artists themselves. Even when information about a culture and artist is available, surviving records may be inadequate. There are, more often than not, large gaps in our knowledge about the cultures and artists of the past. When a viewer encounters a work of art produced in such circumstances, the best that can be done is to speculate about what an artist intended, recognizing that there may be no decisive solution to specific questions. Art historians, for example, are not completely certain that El Greco really did intend to portray Cardinal Fernando Niño de Guevara in the painting that bears his name (figure 11).

There are also situations in which an artist deliberately constructs a work that is indeterminate, ambiguous, or otherwise puzzling. Some Mannerist sculptors, for example, created figure compositions that could be understood in different ways and allowed patrons the privilege of titling them. Twentieth-century artists create perplexing images in order to provoke or mystify and thus stimulate further reflection. The symbolism in *Guernica,* for example, is purely personal; Picasso would not divulge its meaning even when asked. Kahlo's *Two Fridas* contains a startling juxtaposition of incompatible images. Although we may understand much of what each artist was attempting to do, we are not able to arrive at a determinate intentional understanding of just those particular aspects of each and so may come to value critics who can provide alternate ways of looking at these works.

Art critics may also seek to provide a form of understanding that goes beyond what an artist could have intended. Works of art, for example, may sometimes be viewed as symbols of cultural ideas or manifestations of underlying principles of which an artist was unaware. Thus a painting by Leonardo might come to be understood as a symbol of the Italian High Renaissance and a Gothic cathedral as a reflection of Scholastic thinking.[12] Historical, social, and cultural developments continually provide new ways of perceiving and understanding works of art in this way. In the twentieth century, psychoanalysis and Marxist economic theory have influenced critics. Works

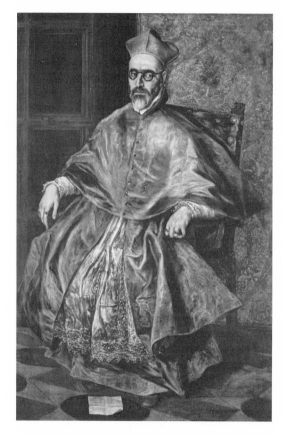

Figure 11. El Greco,
Portrait of a Cardinal.

of art have been understood as manifestations of latent drives or as expressions of bourgeois values, for example; issues of gender and race have also led critics to reexamine works. Some, for example, have uncovered sexual and racial stereotypes in otherwise exemplary work.

Artistic developments have also affected the way viewers have come to understand works of art. T. S. Eliot observed that works of art are not only influenced by the tradition from which they emanate, but they also modify that tradition.[13] What he meant is that later works of art create new and different possibilities for understanding earlier works. We have already seen how this could occur in considering contemporary critical responses to such Mannerist paintings as the *Madonna with the Long Neck.* Viewers who see tension, anxiety, and spiritual malaise certainly misread the intentions of Mannerist artists, for these readings are peculiarly products of a twentieth-century sensibility guided by assumptions about the value and importance of

Expressionist painting. But if such interpretations do not reflect the intentions of Mannerist artists, should we rule them out as irrelevant to the viewing of Mannerist art? Surely, having been educated to see in this way, we are able to discover these things in Parmigianino's painting. And having this sort of understanding of his painting makes our experience of his work all the richer and more rewarding.

All of these situations, then, underscore a particular attitude with which viewers approach works of art. If viewers assume that works of art are outcomes of intentional activity, they often assume that they are aesthetic objects as well. As such, they are looked upon as sources of the kind of intellectual enjoyment that comes about through the imaginative use of one's perceptual and cognitive faculties.

Aesthetic Response to Works of Art

The previous discussion of intentional and aesthetic understandings suggests that viewers have an active role in responding to works of art. Such an assumption is confirmed by the findings of psychologists and others concerned with visual perception. It is now common to observe that perception and conception are not isolated but rather conjoined in a viewer's response to a work of art. Perception of a work of art is best understood as an active effort aimed at obtaining understanding. As such, it parallels other kinds of efforts that people make in integrating experience into coherent wholes.[14] Philosophers, for example, have noted that aesthetic response possesses a structure similar to efforts aimed at establishing meaning in such disparate disciplines as science and the law.[15] Michael Polanyi characterizes all of these as species of "from-to" knowing. Aesthetic perception, like other modes of productive thinking, he argues, involves an imaginative synthesis of initially chaotic elements.[16] In perceiving a work of art, we call up our past experience, background theory and knowledge, bodily awareness, and present concerns. From these tacit elements we project an understanding based upon the clues presented in a work of art.

The imaginative element in aesthetic perception, as well as in scientific discovery, has aroused the attention of philosophers in recent years. Much has been made of line drawings of ambiguous figures to illustrate what occurs when viewers perceive a work of art. In observing a figure such as the famous duck-rabbit, for example, viewers first see the figure one way and then another. This shifting of aspects can be readily observed in Salvador Dali's *Apparition of Face and Fruit-Dish on a Beach* (figure 12). When observing the face, the objects in the background and the objects that form the eyes come into prominence.

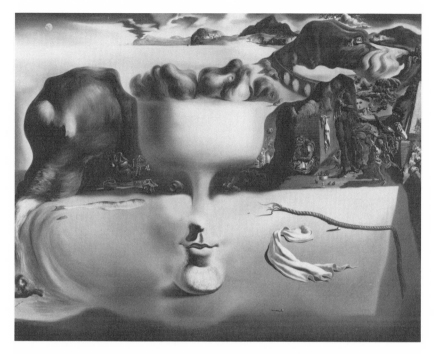

Figure 12. Salvador Dali, *Apparition of Face and Fruit-Dish on a Beach.*

Viewers focus their attention on the expression in the face. When observing the figure as a fruit dish, viewers' eyes travel to the pears at the top of the vase, and the eyes and mouth recede from attention. It is difficult to see both aspects, face and fruit dish, simultaneously. Not all features of a work of art, then, are present in consciousness at the same time. Some form a background to a viewer's focal awareness.

This change of appearance is but one characteristic of what has been called "seeing as" or "aspect perception."[17] It is worthwhile dwelling briefly upon some others. First, the seeing of the face or fruit dish goes beyond what viewers know literally is present in the work of art: a canvas covered with colored areas of paint. Second, aspect perception is not a mere thought or concept; viewers can see a face or a fruit dish in Dali's painting. Third, what viewers see depends upon features of the work itself. The ability to see both a face and a fruit dish in Dali's painting, for example, presupposes a work of art that is ambiguous and allows these sorts of readings. Fourth, a viewer's seeing can be more or less intense. Most people are aware of the face before they see the fruit dish; that is almost certainly due to the

importance of faces as opposed to fruit dishes in everyday life. Fifth, once having seen both aspects of a work of art, viewers can shift awareness from one to the other at will.[18]

In order to understand the importance of aspect perception as an account of a viewer's response to works of art, the example of the duck-rabbit should not be taken too literally. It is not simply a matter of seeing two different kinds of represented subjects in the same work. That is only one of numerous kinds of alternative readings a viewer might arrive at in confronting a work of art. It may be helpful to consider others. In doing so, some of the open-ended nature of visual response can be suggested.

Consider, once again, *Madonna with the Long Neck.* In it, viewers educated by twentieth-century expressionist painting see intensity, anxiety, and spiritual malaise. Mannerist artists themselves would likely have understood the painting as a virtuoso demonstration of skill and facility, a study in refinement and elegance. Note that with each reading we focus on different aspects of the work and literally see it in a different way. Twentieth-century viewers would likely focus upon the claustrophobic clustering of angels around the Virgin and child, the dislocation between foreground and background, the restless movement, the threatening atmosphere, and the strange figure in the distance. Mannerist artists, on the other hand, would likely have fastened upon the elegant gestures, the refined and graceful proportions of the figures, the sensuous modeling, the rhythmical curves, the skillful drawing, and the allusions to classical learning. The painting supports each of these understandings, and with each we see different aspects in the same work.

Aspect perception, then, is not limited to mere changes in our perception of the representational content of a work of art, as in the Dali painting. Instead, viewers can have many different kinds of focal understandings, and perception will change accordingly. They might, for example, come to recognize merit in a work of art. Perception is usually guided by an underlying conception of what good works of art are like. Coming to see a work of art as skillful (or unskillful), organized (or disorganized), or harmonious (or lacking in harmony) involves recognizing that a work of art possesses (or lacks) aesthetic value. It will not do to say that viewers first perceive a work of art in some neutral fashion and then go on to establish the value of that work through some independent process of calculation. It is more accurate to say that valuing is implicit in the perceptual response; viewers come to see skillfulness, disorganization, or harmony in a work of art as they observe it.[19]

Different ways of seeing and understanding a work of art are dependent upon both the efforts made in studying it and on viewers' background knowledge. Some kinds of understandings require little effort, and initial response to a work of art is likely to reflect nothing more than customary ways of observing. John Dewey described initial response to a work of art as a seizure, something that viewers simply have. Other kinds of seeing, however, require concentrated reflection and considerable background knowledge. To see a painting as a unified aesthetic whole, for example, presupposes a careful analysis of its component parts. And to see a painting as a reflection of Renaissance ideals requires a sophisticated background in cultural history. A casual glance at a work of art will almost never reveal all that it contains. Viewers invariably find that their perceptions change over time. Works of art are complex objects that require repeated exposure and concentrated study.

Critical Interpretations

A viewer's understanding, then, often goes beyond what is literally presented in a work of art. Critics convey such understandings in their interpretations of a work of art. Some interpretations attempt to establish the intentions of an artist in order to resolve puzzling aspects of a work of art. Others go beyond what an artist specifically intended in order to help viewers see the work in richer, more organized, and more rewarding ways. Sometimes a critic will present these latter interpretations as the central point, the main theme, or the essence of a work. Critical writing includes both intentional and aesthetic interpretations. The former often forms a stable foundation for the latter. Knowing that Picasso intended to portray the bombing of the Spanish town of Guernica, for example, is a basic understanding upon which critics then are able to offer hypotheses about the possible symbolic meaning of the horse, the bull, and the light bulb in the center of the painting. Even knowing that Mannerist artists sought to create an effect of stylish elegance, contemporary critics can still project further readings of conflict, tension, and spiritual malaise upon a painting such as the *Madonna with the Long Neck,* readings that reveal parallels between such works and Expressionist painting. There need be no conflict between intentional and aesthetic interpretations of the same work of art.

Because critical interpretations go beyond the evidence presented in a work of art, just how they are ultimately justified is one of the central problems of contemporary aesthetics. Most critics present in-

terpretations as tentative hypotheses about a work of art (see The-
odore Wolff's discussion of his critical practice in the first part of this
volume) and attempt to support them with critical reasons, some of
which at least will involve reference to the work of art itself. Critics
also provide background knowledge in order to help viewers see rel-
evant aspects of the work of art, aspects that may have gone unno-
ticed. Critical arguments are complex; no simple algorithm will allow
critics to decide upon the merit of a putative interpretation of a work
of art or discriminate among competing interpretations. Yet that they
can be justified, and that such justification must involve some refer-
ence to the work of art, are necessary assumptions underlying any
conception of critical practice as a rational enterprise.

Personal Significance

In this chapter, therefore, I disagree with theorists who argue that
understanding of a work of art is an independent creation of view-
ers and that there are only equally valid interpretations of a work of
art and no rational way of selecting one over another. If this idea must
be rejected, there is an important aspect of meaning, closely tied to
viewer response, that has not yet been discussed: personal signifi-
cance.[20] Works of art can be sources of personal insight. If such insight
cannot be equated with understanding, one must still recognize that
viewers, in coming to understand a work of art, encounter the ideas,
beliefs, attitudes, and values of others, all of which can lead to an
expansion of one's perceptual and cognitive horizons. In coming to
understand a work of art, viewers gain new principles for viewing
other works and the world around them.

Someone who comes to recognize different artistic intentions, for
example, has thereby gained access to other possible goals of artists.
To see elegance and refinement as an artistic goal, as in the *Madonna
with the Long Neck,* or to see *Storming the Gate* as a protest against
unjust social conditions, is to recognize these as possible artistic goals
in other works of art. Aesthetic understandings can also help view-
ers understand other work. Someone who first comes to realize that
Guernica contains symbols or that *Two Fridas* is an expression of sor-
row looks for symbolic meaning and personal expression of emotion
in other works of art as well. With each new understanding, viewers
gain a principle for viewing.

In coming to understand works of art, viewers also gain new prin-
ciples for looking at the world in general. The representation of ob-
jects or events in works of art, for example, might help people recog-

nize beauty or significance in something they had previously over-
looked. After viewing Edward Hopper's paintings of urban dwellings,
someone might come to see poetry in an empty tenement. After ex-
periencing *Roden Crater Project*, a person might later come to see the
changing drama of sunlight and shadow through an open window.
Looking at *Guernica* might prompt someone to recognize for the first
time the horror of civilian bombings during the Vietnam War. And
many viewers have learned to see blue and violet in shadows after
having viewed Impressionist paintings.

Works of art frequently affect viewers in more personal ways. In
prompting them to reflect upon their own life situations, art can con-
tribute to the development of a person's attitudes and personality.
One way in which this occurs is through a reading of the expressive-
ness of a work of art, an important indicator of an artist's attitude
toward a particular subject.[21] In recognizing this attitude, we come to
see new possibilities for feeling toward these same things in our own
lives. Looking at one of Édouard Vuillard's paintings, in which there
is a loving attention to the fussy interior of his home, for example,
might lead someone to reflect upon the warmth and affection within
their own domestic circle, something previously taken for granted.
The idealism expressed in *Men Exist for the Sake of One Another. Teach
Them Then or Bear with Them* might stimulate deeper sympathy for the
plight of African Americans. The nobility revealed in Rembrandt's
self-portraits as an old man might increase a viewer's resolve to con-
tinue in his or her chosen profession despite the onset of old age and
infirmity.

Gaining such insights is one of the major reasons why viewers look
at works of art. It follows, therefore, that the personal significance of
a work of art must be considered to be a legitimate concern of art
critics. Those who alert us to the possibility of such personal insights
perform a valuable service in educating viewers about one of the
values to be found in art. And in revealing their personal associations
and insights, critics help educate us about the potential complexities
and depths of visual aesthetic experience.

The Boundaries of Critical Relevance

I began this chapter by considering the formalist assumptions un-
derlying current educational models of art criticism. Formalists as-
sume that the work of art is a self-contained entity and that adequate
understanding can be gained through observation of the work of art
alone. Viewers can have only one kind of understanding, according

to the formalist. This understanding is available to anyone with normal faculties, for only directly perceptible properties of a work of art have critical relevance. For this reason, the formalist is unwilling to countenance critical concerns with biographical information, with the context surrounding the production of a work of art, or with the personal concerns of viewers.

If formalist assumptions are widely reflected in current models of art criticism, we have seen that they distort the nature of critical response. A more adequate view can be had by considering the making and viewing of art as transactional affairs. From this perspective an artist is seen as someone concerned with making an object that can be understood and a viewer as someone who seeks meaning in confronting a work of art. Contrary to what formalists assert:

1. *In observing a work of art, a viewer seeks to understand an artist's intentions in making that work.* Artistic intentions are aims, goals, or purposes that artists seek to realize in making a work of art. They can be personal or shared with other artists. They rest upon the beliefs that artists have. In seeking to ascertain the intentions of artists, viewers are interested in a structured set of goals that will help account for the puzzles and problems that a work of art poses.

2. *Works of art can be understood in ways that are different from what an artist specifically intended.* They can exemplify ideas and principles of which the artist was unaware. Aesthetic understanding differs from intentional understanding.

3. *There is no single correct understanding of a work of art.* There may be many valid understandings. Both intentional and aesthetic understandings are combined in critical practice, with intentional understandings often forming the stable foundation for aesthetic understandings of the same work.

4. *Biographical and contextual information are relevant to an understanding of works of art.* Artistic intentions are in some measure public matters that are recoverable by looking at the work of art itself. A fuller understanding of an artist's intentions, however, requires a suitably informed viewer who is familiar with the artist and the context in which the work was made.

5. *A viewer's perception and understanding is a function of that person's cognitive background.* An understanding of a work of art will vary from viewer to viewer and will change as a viewer becomes more knowledgeable and mature.

6. *A concern with the personal significance of a work of art is a legitimate part of critical practice.* Viewers seek personal insights from their encounters with works of art; the expansion of cognitive and percep-

tual powers constitutes a major source of value. Personal significance is different from an understanding of the work of art itself.

These assumptions lead to a different view of art criticism, one that recognizes the full complexity of critical response to works of art. To conceptualize the concerns of critics adequately, one must recognize not only the work of art itself but also the artist, the viewer, and the contexts in which works of art are created and appreciated.

NOTES

1. For the idea of art as a form of life, see Richard Wollheim, *Art and Its Objects* (Cambridge: Cambridge University Press, 1980). The idea of a form of life comes from the philosopher Ludwig Wittgenstein.

2. Richard Wollheim, *Painting as an Art* (Princeton: Princeton University Press, 1987), 39.

3. John Dewey, *Art as Experience* (New York: G. Putnam's Sons, 1934).

4. See André Malraux, *The Voices of Silence* (Garden City: Doubleday, 1953).

5. Jacob Lawrence quoted in Ellen Harkins Wheat, *Jacob Lawrence: American Painter* (Seattle: University of Washington Press, 1986), 17.

6. James Turrell quoted in *Occluded Front: James Turrell,* ed. Julia Brown (Los Angeles: Lapis Press, 1985), 25.

7. John Shearman, *Mannerism* (London: Penguin Books, 1990), 135.

8. Sherman, *Mannerism,* 171.

9. This is the view presented in the well-known essay by William K. Wimsatt and Monroe C. Beardsley, "The Intentional Fallacy," *Sewanee Review* 54 (Summer, 1946): 468–88.

10. See Malraux, *Voices of Silence,* 13.

11. See the comments by E. H. Gombrich on Malraux's assertions in *Meditations on a Hobby Horse* (Chicago: University of Chicago Press, 1963), 81–82.

12. See the discussion of iconology in Erwin Panofsky, *Meaning in the Visual Arts* (Garden City: Doubleday, 1955), 26–54.

13. T. S. Eliot, "Tradition and the Individual Talent," in *Selected Essays 1917–1932* (New York: Harcourt, Brace, 1932), 3–11.

14. This point is repeatedly emphasized by contemporary cognitive psychologists. Consider the statement: "The notion that perception is basically a constructive act rather than a receptive or analytic one is quite old. It goes back at least to Brentano's 'Act Psychology' and Bergson's 'Creative Synthesis,' and was eloquently advanced by William James. However it is not put forward here on the basis of its historical credentials . . . we shall see that the mechanisms of visual imagination are continuous with those of visual perception—a fact which strongly implies that all perceiving is a constructive process." Ulric Neisser, *Cognitive Psychology* (New York: Appleton-Century-Crofts, 1967), 94–95. There is some evidence for the active constructive nature of perception in our tendency to see new and different perceptual configurations in works of art merely as the result of prolonged exposure. See

Rudolf Arnheim, "Contemplation and Creativity," in *Toward a Psychology of Art* (Berkeley: University of California Press, 1966), 292–301.

15. See Norwood R. Hanson, *Patterns of Discovery* (New York: Cambridge University Press, 1972), and Michael Polanyi and Harry Prosch, *Meaning* (Chicago: University of Chicago Press, 1975). This is not to say that there is no difference between these different forms of inquiry. Aesthetic perception, for example, is not directed toward the establishment of empirical generalizations.

16. Polanyi and Prosch, *Meaning*, 46–65.

17. The concept of "seeing as" derives from the later philosophy of Ludwig Wittgenstein; see *Philosophical Investigations* (Oxford: Basil Blackwell, 1968), 193–204.

18. For discussions of Wittgenstein's notion of seeing as in aesthetic contexts see Roger Scruton, *Art and Imagination* (London: Routledge and Kegan Paul, 1974), 84–133, and Roger Scruton, *The Aesthetics of Architecture* (Princeton: Princeton University Press, 1979), 71–103.

19. Scruton, *Art and Imagination*, 134–47.

20. For the distinction between understanding and significance, see E. D. Hirsch, Jr., *Validity in Interpretation* (New Haven: Yale University Press, 1967), 8.

21. Wollheim, *Painting as an Art*, 98–100.

9

Initiating Critical Inquiry:
Personal Response to Works of Art

Personal experience with works of art is the beginning of critical inquiry; this experience is not passive but involves an active search for meaning. Teachers can assist students in this search by first eliciting spontaneous and genuine responses to works of art and then having a class reflect upon the adequacy of those responses. I label the instructional activities that enable teachers to do this "personal response to works of art."

In personal response activities, teachers have the responsibility of promoting critical reflection. How is this to be done? Reflection begins, as John Dewey reminds us, when students confront a problematic situation.[1] Works of art are almost always problematic because they ordinarily can be understood in different ways, but that challenge to reflection will often not be apparent. If students are sometimes puzzled by a work of art and realize they lack some relevant understanding, more often than not they are satisfied with their initial conception of the work. They can be led to an awareness of a problem, however, if confronted with alternative possibilities for thinking about that work.

This can be accomplished in three ways. First, teachers can have students compare their initial responses to works of art with those of other students (and at times with the responses of the teacher and professional critics). Teachers can also ask students to compare carefully selected works of art that are similar in subject, style, function, or theme. Finally, teachers can select provocative works for study, works that challenge what students customarily think, believe, or value. By exploiting all of these strategies, teachers can create the kind of unsettled situation that leads to further reflection about a work of art.

Critical reflection does not end with an imaginative response but requires that students also consider the grounds or support for what they and others say. By asking them to examine the evidence and reasons for their statements, they can be led to further reflect upon

their perceptions and understandings and consider the subjective basis for their responses: the ideas, attitudes, beliefs, and values they bring to bear in confronting works of art. This, however, can only occur in a classroom in which they feel free to exchange honest reactions to a work and disagree with the opinions of others. That in turn requires an accepting and supportive classroom atmosphere in which the emphasis is upon cooperation rather than competition.

In conducting personal response activities, then, teachers should attempt to lead students toward a more adequate understanding of works of art as well as toward personal insights based upon these understandings. Through personal response activities students should acquire confidence in responding to works of art and develop the habit of critically reflecting upon their initial reactions. Personal response activities set the stage for further inquiry; genuine involvement with a work of art inevitably arouses curiosity about its artist, other works of art, and the context in which it was made. Curiosity can be stimulated by encouraging students to ask questions as well as answer them—to engage in problem finding as well as problem solving.

Personal Experience and Aesthetic Value

For most people, interest in art develops imperceptibly out of an early and spontaneous interest in pictures, scenery, and natural spectacles, things they find interesting and exciting to behold. Young children enjoy looking at picture books and comic books and following a narrative through printed illustrations. They take spontaneous delight in such things as Fourth of July fireworks, vivid sunsets, autumn foliage, blazing bonfires, grand vistas, and large and splendid buildings as well as in beautiful objects: pieces of jewelry, feathers, shells, curious carvings, and colorful stones. We see this spontaneous delight in the collections of visual images children make: collections of postage stamps, Christmas cards, postcards, family photographs, trading cards, and the like.

Many of these things are not works of art. Some we would consider to be aesthetically insignificant, even if they were produced by talented people. Nevertheless, early experience with such things likely provides a foundation for later encounters with the more sophisticated and complex aesthetic objects encountered in galleries and museums. Some of the same human interests and concerns that lead most people to look at these things were perhaps also responsible for an early interest in works of fine art.

If our interests in art grew and developed, chances are it was be-
cause our personal experiences with art objects were rewarding. Aes-
thetic perception involves an imaginative response to an art object. We
find enjoyment and gratification in images that interest us: beautiful
scenery, exotic animals, fascinating people, and faraway places. Works
of art also provide vicarious experiences we would otherwise have
been denied: scenes from the past and images of the future, scenes
from literature and mythology, and dreams and fantasies. Through
art, we are able to see the world through the eyes of others. In allow-
ing us to see how other people, people with intelligence and sensi-
tivity, view the world, works of art provide us opportunities to en-
gage in reflection, to compare our ideas and attitudes with others, to
see objects and events in a new light, and, as a consequence, to gain
new insights. We grow and develop as the result of interactions with
art objects.

The rewards we found in our exchanges with art objects were per-
sonal. The enjoyment and enlightenment gained from works of art
motivated us to take up the challenges of more difficult and obscure
works. Many of us might recall that an interest in the formal aspects
of art objects, for example, developed rather late, only after many
prior experiences with works of art. What at first was a tacit compo-
nent of a larger total experience gradually assumed greater impor-
tance as we became acquainted with modern and contemporary
works of art. As we grew in maturity and sophistication, we came to
appreciate many works we had disliked previously and to view many
earlier enthusiasms in a new light. The fascination of some began to
pall; with others, we were able to discover new depths of meaning.

If our present interests in art developed out of a history of reward-
ing personal experiences, we can expect that any future interest in art
that students develop will come about in the same way. They will
continue their involvement with works of art only insofar as the trans-
actions they have are enjoyable and gratifying. Growth and develop-
ment in the visual arts cannot be separated from personal experience.

This brings us to an important principle of instruction. Teachers
must provide opportunities for active engagement with works of art
on whatever level of sophistication students are able to manage. It is
not their business to provide a preferred understanding, whether it
be their own or that of some professional critic. Only if students
achieve personal understandings and insights through observation
and reflection will they gain access to the values to be derived from
works of art.

A Plurality of Individual Responses

Personal experience is therefore the basis for critical inquiry. In confronting a work of art, each person brings to bear a particular constellation of knowledge, understandings, attitudes, and expectations based upon previous life experiences and experiences with art that determines how each will respond. Teachers can expect that the experience each student has with a work of art will be unique; they can also expect it to change as students mature and develop.

What are the implications of this for teaching and learning in the classroom? Consider how a class of high school students might react to Édouard Manet's *A Bar at the Folies-Bergère* (figure 13). Teachers are likely to be surprised by the enormous variation in response. Each student will likely react differently to the painting, and student reactions will likely differ from that of the teacher.

Many students, to be sure, will initially read the picture as a straightforward bit of reporting. They will take Manet's painting as a slice of life, a scene in a bar or nightclub, with people at a counter and a bustling crowd in the background. Yet the specific understanding that each

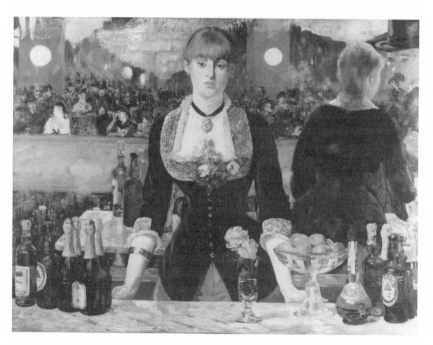

Figure 13. Édouard Manet, *A Bar at the Folies-Bergère.*

student has of the scene will vary. The interest of some will settle on the barmaid, others will be fascinated by the glittering atmosphere, and still others will focus on the details of fruit and bottles on the bar. Because their specific understandings of Manet's painting differ, their focal awareness of various aspects of it will also differ.

Students who study the work of art with care, in contrast to those who carelessly glance at the painting, are likely to notice details such as the legs of the trapeze artist in the background or the frame of a mirror. Some will see that the barmaid appears tired and at odds with her surroundings. A few will conceivably go beyond seeing the picture as a straightforward depiction and notice some of the visual ambiguities that have troubled critics from the time the work was first exhibited. It will occur to these students that the reflection in the mirror (if there is a mirror) cannot be accurate. Some will wonder whether there are one or two barmaids in the painting. A few might even notice the size discrepancies between the barmaid and the male patron, who is larger in the picture than he would be in real life.

As students continue to study the painting, the attention of some will also move from consideration of the things in the picture to what is happening, the events that are depicted. If some students will see a straightforward business transaction taking place, a few will notice the complex psychological relationship between the barmaid and the male patron. Adolescents are preoccupied with their own sexuality, with dating, and with relationships with members of the opposite sex. One or two students are likely to think that the patron is hitting on the barmaid.

The attention of some students will also move from the picture to a consideration of the place and time in which it was painted and the artist who created it. They will notice that people in the painting are dressed differently than they. Some will wonder about where the bar is, what kind of establishment it was, and when the events depicted could have occurred. Still others will wonder about who the artist was, what kind of personality he had, and why he painted that particular scene. Students who have noticed the visual discrepancies and puzzling ambiguities in the painting are likely to be troubled by what the artist was trying to do. Was the artist merely inept or was there some purpose behind these distortions?

Thinking about the painting is apt to lead some students to associate the scene in front of them with their own lives. Some young women, for example, might reflect upon the way they look in comparison to the barmaid. Students who have worked as cashiers or waited on tables will empathize readily with her boredom and fatigue. For a few, the contrast between fatigue and frivolity, between work

and pleasure, might be something they had not considered before. Others might notice the threatening presence of the male patron and wonder about the dangers inherent in meeting and dating strangers. A few students might even surmise that there is an element of sexual exploitation in the relationship between the patron and barmaid.

Depending upon their involvement with the work and the personal significance they find in it, students will have varied emotional reactions to the painting. Some will remain indifferent, others will enjoy the vivid rendition Manet gives us, and still others are likely to be offended by the liberties he takes in distorting space. Students who have made associations between the painting and their own lives might regard it as a profound commentary.

In suggesting some of the range of response to Manet's painting, my purpose is not to offer a catalog of all of the possible reactions. I have only touched upon some of the variations in response that might be encountered. It would be possible to expand indefinitely upon the ways that students might react. Differences in age, sex, social class, education, and economic standing will yield vastly different experiences with the same work of art. Younger students' responses will likely be less complex than those of older students, for example, because they will be able to bring to bear less background experience and knowledge of other works of art. They will likely not notice the complex psychological relationship between the barmaid and patron. Very young students might not even recognize the scene in the painting as a bar. Emotional reactions will also differ. Some students will simply note and enjoy the gaiety and the vivid realism of the picture, and others might simply be indifferent to the scene depicted because they lack the relevant experience.

Learning through an Exchange of Views

Any teacher who has worked with students recognizes the educational value of an exchange of views about a work of art. Speaking or writing about it pressures students to articulate half-formed ideas, thoughts, and impressions so these may be understood by others. Students also benefit by listening to or reading the responses of others. All of us approach a work of art on the basis of a unique background that limits our response; to see how others respond to the same thing can be both broadening and enlightening. We learn more about the particular work of art, and we also learn about the world and other works. Teachers and students alike learn about other people in the classroom and also about themselves.

Consider what students might learn from a discussion of Manet's painting. They first will reveal different understandings of it. Some are likely to read the painting as a documentation of a particular place and a particular time, a bit of factual reporting. Some might understand the painting as celebration of Parisian life. Others might read the painting as a subtle psychological study of the barmaid and the patron. One or two might believe that Manet intended the painting as a harsh social commentary. These differing understandings might be conveyed directly in interpretations or might be suggested by other remarks made during the course of some discussion.

When students articulate their understandings, aspects of the painting are revealed that had previously been overlooked. Certainly some will have not have seen such details as the frame of a mirror, the trapeze artist, or the figures enjoying the show in the background. Not all students will notice the boredom of the barmaid or the spatial ambiguities. Nor will all be aware of the dry paint quality or the contrast between the solid rendering of the barmaid and the impressionistic rendering of the background. Any understanding of a work of art is based on a selective focus upon certain aspects of it. As students discuss the various ways they understand the painting, different aspects of the work will be brought to light. An exchange of observations will reveal things that had previously gone unnoticed.

Any unrestricted conversation about Manet's painting is likely to range beyond the painting itself. A student who has worked as a cashier, for example, might tell classmates why she noticed the boredom and fatigue in the barmaid by recalling working late in a fast food restaurant. Others who have worked in restaurants might recall incidents in which they had encountered customers who were rude, insulting, or impatient. Their observations about the emotions they felt and the strategies they used in coping with such situations might be revealing to other students and give them perspective on a common social situation. Some might never have thought about what it is like for the person on the other side of the counter or of the difficulties of presenting an agreeable face to the public.

In a lively interchange about a work of art, students confront their own attitudes and values. Teachers, for example, will find that students invariably express emotional reactions to Manet's painting. They may react negatively or positively. Someone might object to Manet's painting as sexist, for example. This reaction will no doubt surprise others, who will want to know the basis for this negative judgment. Perhaps the student believes that the barmaid is being admired as a sexual object by the customer and that Manet approves

of this and has drawn attention to it in the painting. In a discussion about Manet's intentions, students might argue about whether he did approve of the use of beautiful women to entice male customers. Did he simply record what was common practice, or did he have a favorable reaction to what he saw? If he did approve of what he has shown in the painting, does that make the picture sexist? Some students might point out that these same business practices exist today, and the question might then arise about whether they are good or bad. Such a discussion exposes students to different points of view, giving them the opportunity to reflect on their attitudes and values on an important social issue.

The discussion could be extended to include other aspects of Manet's painting. Students, for example, might express curiosity about how he achieved some of his painterly effects, and discussion might come to focus on Manet's technique. Attention could also range beyond the work of art itself to include consideration of other periods of time or other cultures. Instead of illustrating such a discussion in more detail, however, consider how troubling such a conversation might be to formalist critics and to educators who espouse a formalist view of criticism. For many formalists, such a conversation would be largely irrelevant to the business of criticism because it goes beyond the work of art and does not focus on a "proper" understanding of Manet's painting. Educators who adopt a formalist view of criticism might argue that a free-wheeling conversation merely provides students with an excuse for indulging in personal reminiscences, free associations, and idle speculation. They might enjoy that sort of thing, but is it educational?

Such objections are not totally without point. It is possible for class discussion to degenerate into irrelevancy, and it is the teacher's responsibility to provide guidance and direction. But in this case such objections are ill-founded. Students are learning about the work of art through this exchange of ideas. It is true they might not be exposed to standard interpretations that inform a text on art history, but they are exposed to alternative interpretations of the same work, interpretations that have the power of illuminating it in various ways and, as a consequence, of leading students to recognize things in Manet's painting that had previously gone unobserved. If formalists are troubled by "digressions" that occur in conversation about a work of art, what is overlooked is the fact that what we see and understand is based upon our backgrounds.

What underlies the formalist's concern may be the erroneous assumption that there is only a single correct understanding of a work

of art, an understanding attained through scrutiny alone. Students must draw upon their background experience if they are to have an understanding of Manet's painting, so making such associations is not irrelevant but a vital part of coming to understand the work. Finally, formalists overlook the kinds of humanistic learning that is an important reason for looking at works of art: to understand the work itself and gain personal insight. Personal significance is one of the aims of critical inquiry. Teachers should encourage students to make connections among the work of art, their personal lives, and the world around them.

Promoting Student Reflection

A lively discussion about a work of art, in which students respond honestly and freely, is a goal of teaching. It is not something that will automatically transpire whenever students confront works of art. If students learn through an exchange of views, it is necessary to consider how such exchanges may be promoted.

Clearly, they might occur if students are interested in the work of art they are viewing. Yet teachers who watch students interacting with works of art are often dismayed by the casual nature of their response. Observation often stops with identification. After a hasty glance, barely sufficient to permit recognition of the subject matter or for taking in the work of art as a whole, students lose interest in what is before them. How are teachers to promote involvement?

The solution to this common problem comes in the realization that perception and conception are conjoined in viewing a work of art.[2] Contemplating is not simply a matter of staring; thinking is also involved. And thinking begins when students confront a problematic situation.[3] Only when they sense that there are alternative possibilities for responding to a work of art will their attention remain focused on it. There are three ways in which teachers can create the kinds of problematic situations that will encourage reflection.

Comparing Alternative Responses

Teachers can promote reflection about a work of art by drawing attention to differences in the way others have responded to the same work. Students will have different initial reactions to the same work, and teachers can encourage them to articulate these personal responses for others in the class. After students have responded, teachers can draw attention to these differences. Confronting them with alternative ways of considering the same work of art challenges students to think about the validity of their responses.

In articulating those responses, students will reveal different understandings of the same work, a direct challenge to others who understand it in a different way. Statements conveying understanding can be framed in different kinds of sentences. Sometimes students will reveal their understanding in what they say about themselves and sometimes in what they say about the artist of the work or the work itself. Often understandings are conveyed in the value judgments students make as well.

Take *A Bar at the Folies-Bergère,* for example. Students might say that they think the painting is a recording of a particular bar or nightclub or feel that it is a psychological study between the barmaid and the patron. They might speculate that the artist was celebrating a particular aspect of Parisian life or presenting a harsh social commentary. Or they might judge the painting to be a significant social document or a piece of pornography. Putting aside for a moment the question of whether these readings are correct or incorrect, they are all capable of provoking further thought and reflection.

What are some points of contrast to which teachers can draw attention when students respond to the same work of art?

1. *What is psychologically important for each student.* What is visually dominant in a work of art will differ from student to student. These differences in focal awareness are one indicator of different understandings. Someone whose attention is riveted upon the face of the barmaid and is acutely aware of her boredom and fatigue, for example, likely has a different understanding of the painting than someone whose attention is focused on its vivacious color and brilliantly painted textures. In pointing out these differences, teachers can lead others to the awareness that one person's understanding differs from another's.

2. *The associations the work of art calls forth.* The associations called up by a work of art have direct bearing on our understanding of it. As students seek to understand the work they will typically recall objects, people, and events in their lives. Some will be reminded of other works of art. Someone reminded of a Victorian novel when looking at Manet's painting, for example, will likely have a different understanding than someone who recalls past experiences working in a fast food restaurant.

3. *Curiosity and speculation about the artist or the context in which a work of art was produced.* As students view works of art, their attention will move from the art object to the artist and the context in which a work was produced. For example, they might wonder about the personality of the artist or about the period of time in which a work

was produced. What kind of person was Édouard Manet? Did he like to go to places like the Folies-Bergère? What kind of place was the Folies-Bergère? Such speculations are often indirect indications of some preliminary hypothesis about the intentions of an artist. By asking students to explain the reasons for their curiosity, teachers can uncover these alternative readings. Someone who thinks that the artist may have enjoyed going to the Folies-Bergère, for example, will have a different understanding of the painting than someone who believes the artist was indifferent toward such places.

4. *Differences in emotional response.* The reactions of students will vary from indifference to deep personal involvement. They will experience a variety of emotions when viewing a work of art: Boredom, pleasure, sadness, disgust, curiosity, delight, satisfaction, and alienation are all possibilities. Each reaction to Manet's painting will likely be based upon a different initial understanding of the work. By asking students to articulate the reasons for their emotional reaction, attention can be drawn to different aspects of the work of art and the underlying differences in understanding that account for their responses.

5. *Different evaluations.* Students will often spontaneously arrive at different value judgments about a work of art, finding it good, or bad, skillful or unskillful, profound or shallow, moral or immoral, truthful or false, sincere or insincere, and so forth. These contrasting value judgments also rest upon different understandings. A student who believes Manet's painting is immoral likely has a different understanding than one who thinks that it is sincere, and both will differ from a student who thinks the painting is a profound commentary on life. Teachers can elicit reasons for such value judgments as a way of arriving at different understandings of the work of art.

Controversy, then, is one key to promoting critical reflection. In eliciting and comparing different reactions, teachers have a powerful way of stimulating thinking about a work of art.

After students become comfortable with expressing their personal responses, teachers can from time to time introduce their own reactions to a work of art. Students will be interested in how the teacher reacts, just as they are interested in the reactions of other students. Teachers might consider the possibility of having older students read the comments of professional critics. Both activities require caution, however, so students do not feel inhibited in expressing what they think, believe, or feel. Teachers should first allow students to express personal reactions to a work of art, and they should encourage the view that many different ways of understanding are possible. When

introducing the writings of professional critics, teachers should try to choose selections that illustrate contrasting points of view (chapter 4).

Comparing Works of Art

Critical reflection can also be promoted by having students compare and contrast carefully selected works of art. The act of comparing and contrasting can challenge prior assumptions about the nature of art that foreclose thought and reflection.

When professional critics approach a work of art they are challenged by the many possibilities for understanding it. Their extensive knowledge of the history of various art forms, artistic genres, styles, and works within the oeuvre of a particular artist sets up expectations to draw upon. For example, *A Bar at the Folies-Bergère* is an oil painting, a genre painting, an example of nineteenth-century realism, and a late painting in Manet's development. All of these categories will suggest different artistic aims and intentions to a professional critic, who will likely consider whether or not they have been realized.

Students, however, will generally assume that what they see and understand in a work of art is the only way that it can be seen and understood. In confronting many paintings, drawings, and pieces of sculpture, they will often assume that an artist intended to copy whatever is depicted or portrayed. Given this assumption, it is not surprising that reflection stops with identification and deviations from familiar kinds of realism are seen as signs of ineptness and failure. In confronting nonrepresentational works, students are frequently baffled because they are unable to see in the work anything more than a physical object. In both instances they are not aware of the many goals and purposes underlying the production of works of art.

Background knowledge, therefore, is an aid to critical reflection because it suggests alternative possibilities for understanding a work of art. Yet teachers cannot hope to provide students with the extensive knowledge that professional critics have. By having students compare and contrast carefully selected works of art, however, they can challenge prior assumptions that foreclose thought and reflection. If criticism in the classroom will often focus on single works of art, teachers also need to provide opportunities to experience related works simultaneously. By presenting a number of works within some relevant aesthetic category, teachers can heighten sensitivity to differences that would usually go unnoticed. Such differences, in turn, will suggest that each work was produced with different kinds of artistic aims and intentions and thus can be understood in a different way.

Consider El Greco's *Cardinal Fernando Niño de Guevara*, for example, a painting many students might initially take as a reasonably accurate copy of the sitter. A comparison of this painting with Diego Velázquez's *Pope Innocent X* (figure 14), however, will dramatically reveal El Greco's painting as a powerful, expressive interpretation. Perception of the work's expressiveness will be revealed in what students say about the painting ("it's eerie"), in what they say about themselves ("it makes me uneasy"), in what they say about the artist ("Does he really see things that way?"), and in their evaluative remarks ("it's more of a cynical caricature than a truthful painting").

By asking them to explain their different reactions, students can be led to focus on features in the work that contributed to their initial readings. They will begin to notice the sideways glance, the contrast between the clenched and relaxed hand, the restlessly swirling drapery, and the uneasy perspective of the chair in relation to the floor, noticeable departures from what might be expected had El Greco been simply trying to copy what was before him. These deviations set the stage for a discussion of the artist's intentions: Why did El Greco depart from a literal depiction? Are these distortions the result of some handicap or of a difference in aims? Students are forced to reflect on such matters because their initial working assumptions about

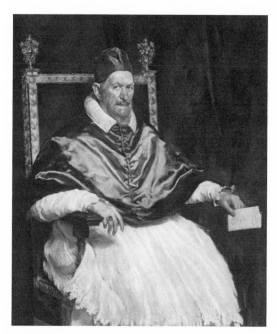

Figure 14. Diego Velázquez, *Innocent X.*

works of art, as transparent copies of reality, are seen to be inadequate. By inviting consideration of features responsible for their initial response, then, teachers can lead students to hypothesize about an artist's intentions.

Over time, and with exposure to other works with a similar subject, even a work in the mainstream of realistic European painting, such as *Pope Innocent X*, can be seen as expressive. Students will come to realize that an artist such as Velázquez was not interested solely in presenting a lifelike representation of a particular sitter but had other artistic intentions as well.

Comparing works of art is thus an important way of revealing different kinds of artistic intention. Teachers can facilitate this process by organizing instruction into thematic units in which closely related works of art are studied simultaneously. Students can compare:

1. *Works within the same genre.* Representational works of art have traditionally been categorized on the basis of their subject and nonrepresentational works on the basis of their function. There are traditional artistic genres that recognize these distinctions. For example, representational works of art have traditionally been sorted into portraits, landscapes, still lifes, historical paintings, and so forth; buildings are classified under the headings of ecclesiastical and domestic architecture. Comparing works by different artists within some traditional artistic genre is a good way of revealing similarities as well as differences in artistic intention. The more similar the works are to one another, generally, the more revealing. Works of art that show evidence of borrowing or artistic influence from one to another are especially fascinating.

2. *Earlier and later works by the same artist.* Individual artistic style grows and develops as the ideas and beliefs of an artist evolve and mature. Differences between earlier and later works can indicate differences in artistic intention as well. Once again, comparisons are more effective if the subject matter or function of the works compared is the same. Earlier studies and the final version of the same work can be especially revealing.

3. *Works of representational art and photographs of the subject.* Occasionally a teacher may come across photographs of the subjects that artists have used in creating paintings or sculpture. These make fascinating comparisons with the paintings themselves, dramatically revealing the alterations and distortions that occur as the artist shapes a vision of the world. Although difficult to find, these types of comparisons are especially intriguing.

Using Provocative Works of Art

Another way to encourage critical reflection is to present students with provocative art objects, works that challenge their expectations and assumptions. Critics, because of their extensive backgrounds, are challenged by works of art. They know that work was produced by artists from different time periods and cultures—people who have very different artistic aims and intentions. Such knowledge provides expectations about how other work might be understood.

A work of art can both meet and deviate from a critic's expectations. *A Bar at the Folies-Bergère,* for example, grows out of a tradition of Dutch genre painting concerned with the realistic depiction of contemporary life. Yet like all original works of art it also deviates from that tradition. If some of the aims and intentions evident in Manet's painting are shared with other works of art, some are unique to this painting alone. Unlike most Dutch genre paintings, for example, Manet's portrayal of the Folies-Bergère contains puzzling spatial ambiguities and an insistent emphasis upon the flatness of the picture plane. These violations of spatial logic constituted a challenge for critics who sense that the painting cannot be understood simply as an attempt to document a familiar scene. Once one considers the possibility that Manet intended to do more than simply portray the bar at the Folies-Bergère, the question then arises about how it is to be understood. It is this sort of question that forces critics to study a work of art with care and attention.

While art critics draw upon an extensive background, one can expect that most students will have had little knowledge of art. They will, however, possess some elementary aesthetic ideas as part of their general knowledge. In addition, they will bring to bear a complex background of other knowledge, understandings, and values that different works of art might challenge. Selecting works that deviate from what students customarily think, believe, assume, or value is another way of promoting critical reflection. What are some ways in which this can be done? Teachers can:

1. *Select works of art that challenge customary beliefs or ideas on some topic or issue of importance to students.* Works of art deal with fundamental human interests. They present ideas and illustrate attitudes about humanity, nature, religion, politics, love, and death. Teachers can select work that challenges what students customarily think about such topics, work that forces them to confront their personal attitudes and beliefs. Paintings by the contemporary artist Peter

Saul, for example, are often brutal indictments of militarism and the Vietnam War. Sculptures by George Segal often show the alienation sometimes found between couples in modern life. Sculptures by Duane Hanson show the banality of contemporary existence. Works by black artists such as Jacob Lawrence, or feminist artists such as Judy Chicago and Miriam Schapiro, articulate values and concerns that may be foreign to many students. Works of art often deal directly with the vital interests of students and because of this will often provoke thought and reflection. In choosing such works, however, wise teachers will take care to avoid indoctrinating one point of view but will attempt to show a variety of ways in which artists have treated a particular topic.

2. *Select works of art that challenge students' assumptions about the nature of some artistic genre.* Although students usually have less developed ideas about works of art than they do about general topics and themes, they usually do have some sense of the general categories customarily used to classify and sort art objects. They are aware that paintings can be grouped into landscapes, portraits, still lifes, and religious pictures, for example. They have a tacit awareness that buildings can be distinguished on the basis of their function and will approach a house with a different set of expectations than they will a church.

Selecting works of art that challenge these expectations can also promote reflection. A Surrealist painting such as that by Salvador Dali, for example, will often provoke thought precisely because it cannot be understood as a straightforward landscape. Philip Johnson's Glass House will often stimulate reflection because it violates expectations about the need for privacy in a domestic dwelling. Maya Lin's Vietnam War Memorial affronted many veterans and will likely challenge many students because it deviates from familiar conceptions of what a war monument should be like.

3. *Select works of art that challenge students' assumptions about the nature of some art form.* In addition to assumptions about the nature of artistic genres, students will also approach works of art with assumptions about what art (or good art) should be like. Typically, they will think about art in terms of traditional paintings, sculptures, works of architecture, craft objects, and the like. Many contemporary works do not fit easily into these preconceptions and for that reason will provoke critical reflection.[4]

Meret Oppenheim's *Luncheon in Fur* (a teacup, saucer, and spoon covered with fur), Marcel Duchamp's *Fountain* (a urinal), and wrappings by Christo are examples of modern and contemporary sculp-

ture that do not fit easily within traditional ideas about what sculpture should be like. Abstract Expressionist and Hard-Edge paintings fall beyond the pale of good art for many students. Performance art, installation pieces, and environmental works (Turrell's *Roden Crater Project*, for example) also challenge customary ideas. All confront students with questions about whether they actually are works of art and, if so, good works. If they are not acceptable as art, why do critics praise them? Such questions can be the stimulus for further research into the literature of art criticism.

A final word about selecting provocative work for the classroom: Teachers will find that art that has aroused debate and controversy in the popular press is a likely candidate for classroom study because it has challenged one or more of the common assumptions ordinary people bring to bear in their encounters with art. Making students aware of the nature of the controversy can add incentive to reflection.

Understanding and Misunderstanding

Up to this point I have been discussing different strategies for promoting student reflection. Having students compare their responses to a work of art with the responses of others, having them compare closely related works, and confronting them with provocative works of art creates the kind of problems that elicit a reconsideration of their initial understandings of a work of art. By leading them to an awareness of alternative ways of responding and by challenging underlying assumptions about the making of art, teachers can help students broaden and deepen their understanding. The educational value of this lies not only in what students learn about specific works of art but also in the insights they gain into themselves, the world, and other minds and cultures.

Inappropriate Responses

Although works of art are potentially capable of supporting many understandings, not every response that students have will be appropriate. Some will be based upon a misunderstanding of the work before them. Teachers must recognize that important learning occurs not only when students are exposed to alternative understandings but also when, through critical reflection, they come to reject a premature or inadequate conceptualization. Critical reflection does not stop with an imaginative response but should include considerations of evidence and logical consistency. Students should be encouraged to consider the grounds or support for statements they make. Doing so helps

cultivate habits of reflective thinking, one of the most important goals of general education.

Students frequently misunderstand the work before them because they have not scrutinized it with care and attention. A student who sees two barmaids in *A Bar at the Folies-Bergère,* for example, has not noticed or taken into consideration the frame of a mirror, something clearly present in the painting. At other times misunderstandings arise not because of carelessness or inattention but because of anxieties, prejudices, or personal preoccupations that lead students to respond to a work in an inappropriate way.

Consider someone who finds *A Bar at the Folies-Bergère* pornographic. Although most people can find an element of sensuality in Manet's painting, to call the work a piece of pornography is not justifiable. A student who makes such a harsh judgment is likely to be challenged by other students. Why does this person find the painting pornographic? Perhaps the student will remark that he or she finds the pose and dress of the barmaid provocative. Yet such an extreme reaction will no doubt surprise other students. The discussion that ensues might focus on whether the dress and pose are truly provocative. Someone might possibly point to the clothing that members of the class are wearing and observe that students usually dress to attract members of the opposite sex. As the discussion progresses, others might question whether clothing attractive to the opposite sex, in and of itself, makes something pornographic. As a consequence of seeing how other students react to the sensual element in Manet's painting, the student who originally objected to the work might well be led to see the inappropriateness of that initial response and perhaps even come to reconsider whatever underlying attitudes and beliefs about human sexuality that accounted for this initial reaction.

Understanding and Personal Significance

In promoting critical reflection, teachers provide opportunities for students to come together as a group in order to make sense of the work of art before them. In critically reflecting upon the work, however, students also have the opportunity to reconstruct their ideas. The resulting personal insights are an important outcome of critical inquiry but should not be confused with an understanding of the work itself. Interpretative claims of statements give rise to questions of evidence and logical consistency not raised by personal significance.

Critics routinely attempt to assess the adequacy of their own understanding of a work of art as well as that of other critics. When they challenge the merit of some interpretation in the professional litera-

ture, the issue frequently centers on whether it can be seen as a plausible representation of an artist's intentions. Take the interpretation of *A Bar at the Folies-Bergère* offered by T. J. Clark, a critic and historian. Manet's painting, Clark argues, can be understood as a representation of capitalist alienation.[5] That Manet intended his painting to be read in this way, however, seems doubtful. Research has shown that several of the figures shown enjoying themselves in the background at the Folies-Bergère are sketchy portraits of his friends. Given this, is it also plausible to hold Manet intended his painting as a harsh social commentary? Surely with this information Clark's interpretation loses much of its plausibility as an interpretation of what Manet was attempting to do. Yet if Clark's interpretation cannot be viewed as a reconstruction of what Manet intended, it nevertheless does provide a fascinating insight into the painting and helps viewers see it in a new light. The work can be understood as a symbol of capitalist alienation even if Manet did not intend it to be read in this way.

Teachers need to allow for the possibility of aesthetic as well as intentional understandings of a work of art. Students may offer a personal interpretation of a work of art or they may speculate about what its artist intended. If professional critical practice is often preoccupied with providing intentional interpretations, both aesthetic and intentional interpretations can illuminate a work of art and provide insight for viewers.

Professional critics are frequently able to offer intentional interpretations because they approach a work with considerable background knowledge of its artist and the context in which it was produced. Students, however, can frequently do little more than speculate about an artist's intentions, and many interpretations will not accurately represent what the artist was attempting to do. Teachers should not be overly preoccupied with what historical scholarship or critical commentary says about a work of art. When students undertake independent background research they will find that historical or critical interpretations differ from their own speculations. That does not necessarily mean that their interpretations are invalid, however. Like Clark's, such interpretations may also help them see the work in a new way. Teachers and students need to be aware of the distinction between intentional and aesthetic understandings and able to recognize the value of both.

The Need for a Supportive Classroom Environment

For critical reflection to occur, students must feel secure enough to not only communicate their personal reactions to a work of art but also to challenge the views of others. In the first part of this volume

Theodore Wolff comments on the importance of this for teaching and learning in the classroom. To create an environment in which students are able to convey their responses and honestly comment on the responses of others represents an achievement on the part of a teacher, one that requires tact and diplomacy. Teachers take a step forward in creating such an atmosphere when they recognize the legitimacy of many different ways of understanding works of art. It is a mistake to become preoccupied with a single correct reading. Doing so allows students to adopt strategies of error avoidance. They hesitate to express personal responses that deviate from the reactions of the teacher or influential students and become reluctant to challenge statements that others make.

Teachers need to create an informal classroom atmosphere, one that permits a friendly exchange of views. They should present disagreement and critical appraisal of the statements others make as part of the process of critical reflection itself. Students can be helped to become less inhibited by being encouraged to express tentative opinions and recognize that changing one's mind is an inevitable part of experiencing a work of art. They should not be penalized for "wrong" answers or for expressing contrary opinions. Nor is classroom debate, in which one person's views triumph over another's, an appropriate model for personal response. Instead, teachers should foster the idea that critical disagreement represents an opportunity to clarify and order one's thinking. Students need to look upon the process of coming to understand a work of art as a collaborative enterprise.

Inappropriate Teaching Practices

I have presented a picture of critical inquiry as a collaboration between students and teacher. Students engage in critical inquiry when they communicate their personal responses to a work of art and reflect together upon their adequacy. This view of teaching and learning in the critical domain stands in sharp contrast to other, inappropriate, teaching practices that have gained a measure of acceptance in art education. These teaching practices fall into two categories: those that attempt to impose some procedure for responding to works of art and those that try to shape students' initial responses so that they follow the interests and concerns of the teacher.

Teaching a Procedure for Responding

Art education is perhaps more familiar with the former error than the latter. Educators sometimes present a typology of critical state-

ments, which they translate into a set of activities that students are to follow in criticizing works of art. Models of art criticism that focus on such statements as description, interpretation, and evaluation fall into the category of teaching practices that attempt to impose a single procedure for response. Such models can only plausibly be interpreted as forms of student recitation.

Educators also attempt to organize critical talk by providing teachers with lists of questions to ask students. Sometimes these lists are given in published lessons prepared to accompany reproductions of works of art. Often the questions repeat the familiar description, interpretation, evaluation format found in many current models of art criticism. Students are asked first about various features of the work they are observing. Then they are asked questions about meaning. Finally they are asked about the merit or value of the work. Focusing on questions does have the virtue of recognizing that critical talk arises out of a context of need, something that recitation in and of itself tends to ignore. Yet even lists of questions can degenerate into a rigid procedure if teachers treat them as an agenda to be followed mechanically.

Seizing upon a single procedure for responding to works of art has a seductive appeal for many teachers because it seems to provide a way of structuring lessons on art criticism. Instead of an open-ended discussion that may fail to materialize or may wander off into uncharted territory, teachers have a way of filling class time and predicting the likely outcome of what might occur. They must recognize, however, that such teaching practices will have a negative impact.

First, imposing a procedure limits and shapes student response. Experiences with works of art are complex and not easily sorted into separate components; procedures for responding invariably ignore some aspect of experience, whether it be the emotions of the student, a concern with the intentions of the artist, an interest in the context in which a work of art was created, or some other aspect of a viewer's experience. Students need opportunities to grapple with their own individual responses, and teachers need to respect the totality of their experience.

To limit and shape responses is to ignore what is immediately relevant to students in their encounters with works of art. Individual concerns will vary, even when students confront the same work, to say nothing of the differences that will occur when they encounter different types of artwork. Requiring that they follow some fixed procedure in responding to works of art shunts aside students' immediate interests in favor of a topic dictated by some source outside of the

classroom. Teachers who have discussed works of art with students, for example, frequently find that their immediate preoccupations are not with what the work contains but rather with how other students have reacted to it. Yet most current models of criticism require that students initially focus on some aspect of the art object itself. In following some mechanical procedure, teachers are likely to find that the vital interests and concerns of students have been ignored.

Finally, teachers need to recognize that such procedures may foster attitudes and habits inimical to genuine involvement. When only one student is reciting, the attention of other students is likely to wander. The whole class should be involved in thinking about the work of art. Teachers may also become so preoccupied with the mechanics of some procedure for criticizing that attention is diverted from experience with the work. Yet it is the experience which is of foremost importance, not the manner in which one speaks or writes about it. Finally, teachers, in asking students to follow some procedure for responding to a work of art, may also be training them to focus only upon certain aspects that work, inadvertently fostering dogmatism and rigidity. Teachers should cultivate an openness to experience, a heightened attention, and a willingness to reflect upon initial impressions in order to promote future involvement.

Shaping Students' Initial Responses

Class discussion and other methods that permit a free exchange of views about a work of art are more effective in eliciting personal response and promoting critical reflection than are fixed procedures for criticizing art. But some forms of class discussion may stifle critical inquiry as well. Teachers can err when, through Socratic questioning or other kinds of discussion techniques, they attempt to shape students' initial responses to reflect their own interests and concerns. This is often done to lead students toward some preferred understanding of a work of art, either their own or that of some favored critic. Teachers who do so usually begin by trying to solicit some point of view and then challenge students to rethink their ideas and opinions by posing questions that will reveal inherent weaknesses in what they have said.

If teachers assume that their business is to lead students toward some preferred understanding of a work of art, considerable class time will be devoted to criticizing and correcting students. Although teachers cannot accurately predict what responses individual students will make, they can safely assume that students' understandings will not be the same as their own. Students will see the work differently. It will

arouse different associations and feelings, and, as a result, students will arrive at different judgments of meaning and value. Student response will differ substantially from that of professional critics as well. Indeed, how could we expect otherwise? Students lack the extensive experience and background in art of professional critics. They will typically know little, if anything, about specific artists and the culture in which works of art were produced. Nor will they be familiar with the special concerns and preoccupations of professional critics.

It is not hard to imagine the harmful effects that constant correction has on students, even if tactfully done. They will first quickly come to learn that it is not their personal response that matters but that of someone else. They will lose confidence in their ability to find meaning in a work of art and rely instead on a teacher or some other authority to provide them with an understanding, fostering passivity and dependency. Those who are insecure will likely become anxious about interacting with works of art. Such situations would perhaps put them at risk, because their response to a work will invariably differ from that of their teacher. Class time then becomes a guessing game as students try to find the answer that will please the teacher. Many are likely to be alienated because what is of interest and importance to them about a work of art will almost certainly go unrecognized.

All of this runs counter to what should happen in a classroom. A primary responsibility of the teacher is to cultivate attitudes and habits that underlie any serious involvement with the visual arts. Students, for example, should take pleasure in the experience of imaginatively apprehending it. They should gain confidence in the legitimacy of their personal reactions to art and enjoy the opportunities for social exchange that works of art offer. Yet they should also develop habits of critically reflecting upon their initial responses. If students leave the classroom without these dispositions, educators can have little hope that they will become seriously involved with the visual arts in later life. Teachers who have instilled such dispositions, on the other hand, have accomplished a great deal, for most people can enjoy and find meaning in works of art without extensive training in the visual arts.

Personal Response: Principles of Instruction

In this chapter, I have attempted to articulate the kind of teaching and learning activities that initiate critical inquiry in the classroom. The following principles underlie personal response activities:

1. *Focus on students.* The task of teachers is not to teach some understanding of a work of art but to provide opportunities for students to arrive at their own understandings. Personal significance, another aim of critical inquiry, cannot be taught. It can only result from a student's efforts at finding meaning in a work of art.

2. *Start with students' unique experiences with a work of art.* Students must be free to deal with personal reactions to a work of art, and teachers must respect what they see, think, feel, and remember.

3. *Provide opportunities for the exchange of honest reactions to a work of art.* Reflection begins when students confront a problematic situation. Sometimes they will sense a problem because they will be puzzled by some part of a work of art or the work of art as a whole. Whether or not this occurs, teachers can promote critical inquiry by drawing attention to differences in the way students have responded. These differences indicate alternative possibilities for understanding a work of art.

4. *Provide opportunities for students to compare works of art.* Students also encounter problematic situations when they realize that their working assumptions about art need to be revised. Teachers can challenge these assumptions by having students compare carefully selected works that are similar in subject, style, function, or theme. Comparisons reveal differences in artistic aims and intentions.

5. *Provide opportunities for students to confront provocative works of art.* Problematic situations are also created when students confront work that challenges what they customarily, believe, think, or value. Works of art can challenge beliefs or ideas about some issue or topic of relevance as well as familiar ideas and expectations about works of art.

6. *Provide opportunities for students to evaluate their responses and the responses of others critically.* Reflection does not stop with an imaginative response to a work of art; it should include considerations of evidence and consistency. Not every response is appropriate. Students learn habits of critical thinking when they consider the basis for claims others have made. Learning also occurs when students confront the subjective sources of their personal responses: the beliefs, biases, prejudices, and values that led to their particular reaction. Students should have time and opportunity to rethink their initial responses.

7. *Respect students' responses.* Teachers should avoid imposing some procedure for responding to a work of art. Instead, they should build upon the initial responses of students. They need to respect the totality of students' experiences and their immediate interests and concerns in responding to a work of art, something slighted when they impose a procedure for response. Teachers should also avoid class discussion

that leads students toward some preferred way of understanding a work of art. If they do this, they will inadvertently foster dependency, anxiety, and rigidity.

8. *Foster a sense of security.* Critical reflection can only occur when students feel free to express honest reactions and challenge other views. That cannot occur if students are penalized for wrong answers or if the class becomes a forum for debate. Cooperation, not competition, should be the norm.

NOTES

1. John Dewey, *How We Think* (Boston: D. C. Heath, 1933), 91–118.

2. In art education literature, one of the proposed ways of dealing with this problem is to have students exhaustively list all that they see in a work of art. But will students really become intellectually involved with a work by following this mechanical procedure? Surely they will be bored and frustrated rather than intellectually engaged.

3. In the terminology of contemporary psychologists, a problematic aspect of a situation as experienced by a person is sometimes termed "conceptual conflict," "cognitive dissonance, "or "conceptual incongruity." See D. E. Berlyne, *Structure and Direction in Thinking* (New York: John Wiley and Sons, 1965).

4. In the first part of this book, Theodore Wolff strongly advocates using controversial works of art in the classroom.

5. T. J. Clark, *The Painting of Modern Life: Paris in the Art of Manet and His Followers* (New York: Alfred A. Knopf, 1985), 253, 254.

10

Teaching Personal Response to Works of Art

Teachers can use systematic instructional methods to elicit personal response and encourage critical reflection: whole-class discussion, small-group discussion, informal writing assignments, structuring opportunities to choose works of art, and field trips and on-site visits.[1]

Whole-Class Discussion

One of the most important ways in which students can articulate personal responses to works of art and examine the adequacy of their responses is through whole-class discussion. The kind of discussion appropriate for personal response, however, is not the same as the formal discussion that transpires in most teaching situations. In most classrooms, teachers attempt to impart information, knowledge, or understanding. The kind of discussion that occurs, therefore, naturally lends itself to such an exchange. Typically, one finds teachers doing most of the talking, even as they attempt to solicit the participation of students. The contributions of students, in turn, arise as the result of specific promptings by the teacher. Class discussion moves back and forth from teacher to student rather than from student to student.

In attempting to elicit student participation, teachers typically use what have been called examination questions.[2] These are not genuine questions for which a teacher lacks answers but artificial requests meant to elicit a response so that the teacher can evaluate the learning that has occurred. Finally, one sees teachers rewarding correct answers with expressions of approval and in other ways shaping the behavior of students through the use of controlling language.

If this common kind of classroom discussion is inappropriate for eliciting personal response and fostering critical reflection, what kind of discussion should teachers seek to promote? Perhaps the best way of thinking about an appropriate form of class discussion is to recall conversations that occur among friends after they have seen a movie

or an art exhibit—discussions that are familiar to everyone. Such con-versations arise out of a need to make sense of one's prior experience with a work of art, the same need that motivates critical inquiry in the classroom. In such conversations, participants collaborate in the search for understanding and insight. These conversations are differ-ent from formal classroom discussions in the following ways:

1. *No single person dominates the discussion.* Instead of one person leading and monitoring others, it is assumed that everyone is on an equal footing as a contributor. This assumption gives the discussion a different character from that in most classrooms. Each participant is usually expected to contribute more or less equally, and speaking tends to be distributed evenly among participants.

2. *Discussions do not have the familiar question-answer pattern of much classroom talk.* Discussion does not move back and forth between one dominant person and other participants. Instead, discussion moves from person to person as each participant contributes and reacts to the ideas of others.

3. *One person does not continually prompt the responses of others.* Re-sponses, instead, are motivated by the initial interest of participants and their reactions to what others say. Initial ideas are modified and enlarged. Some topics are explored in depth as participants build upon the ideas of others. Other topics peter out as a consensus is reached or as the conversation develops in other directions.

4. *Conformity is not demanded.* Instead of participants conforming to the opinions of a single person, disagreement is accepted. Participants explore topics together and are permitted to challenge the views of others. Participants may or may not reach a consensus or even a con-clusion on the topics under discussion.

5. *There is a minimum use of controlling language.* There is no need for one person to reinforce the responses of others or tell them how to behave during the discussion. Speakers are rewarded by the atten-tion of others and interest in the topic at hand. Participants share re-sponsibility for keeping the conversation going.

Promoting this kind of conversation instead of the formal discus-sion that often occurs in a classroom is a challenge. Meeting it requires sensitivity and practice. Nevertheless, there are strategies for moving class discussions toward the kind of conversation that will facilitate personal response and foster critical reflection.

Eliciting Student Response

Teachers often attempt to start class discussions by displaying a work of art and asking questions about it. But class discussion may

be subverted at the very outset if teachers begin by asking the wrong kinds of questions. Some that a teacher might think would promote discussion will often have the opposite effect.

Take factual questions about the work of art, for example. Teachers sometimes think that asking questions about, say, the title of the work, the subject depicted in the work, or the sensory aspects of a work will encourage student participation. A teacher might reason that such questions would be a safe way of beginning a discussion because they ask for simple recall. But older students might be embarrassed by the simplicity of the questions and feel foolish mechanically pointing out what is obvious to their peers. Others will not be interested in what is being said because the information is already known. Factual questions, moreover, imply a single right answer. They are the kinds of artificial "examination" questions mentioned earlier. Students may come to see the discussion in terms of correct or incorrect answers being given and, thus, may be reluctant to express honest reactions to a work. Beginning a discussion with these questions will lead them to confuse the exploratory kind of conversation appropriate for critical reflection with the kind of formal class discussion described previously.

Perhaps the most serious objection to such questions is that they do not encourage the kind of involvement conducive to critical inquiry. Students are not asked to reflect about the work but rather to point out things obvious to those who only glance at it. Factual questions have their place in class discussion, but only when they support efforts to determine the meaning of a work of art. Focusing on these questions at the outset trivializes the discussion.

Personal Response Questions

What kinds of questions will encourage student involvement and reflection? These will not be factual questions that focus on the work of art but rather questions that focus on individual student reactions to the work—what each thinks, believes, or feels. Personal response questions, unlike factual questions, are open-ended. They do not call for a single correct answer but permit multiple acceptable answers. They are higher-order questions and require articulating personal involvement and reaction to the work of art. Those useful for initiating class discussion include:

1. *Nondirective questions.* These questions allow the widest variation in response. Asking them allows teachers to tap into the personal interests, preoccupations, and concerns of students because such questions shape the responses of students the least. Examples are:

What do you think is important to say about this work of art?
What is your first reaction to this work of art? Describe briefly.
How do you respond to this work of art? Emotionally? Intellectually? Sensually? Explain.
What does this picture make you think?
What details or features of the work of art mean the most to you? Why?

2. *Emotive questions.* These questions seek to ascertain the feelings or emotions that a work of art arouses. Examples are:

What emotions do you feel when you look at this work of art?
What feelings does this work of art arouse in you?
What interests or repels you about this work of art?
How does this work of art make you feel?
What part of this work of art intrigues you the most?

3. *Association questions.* These questions seek to elicit the associations or thoughts that a work of art raises. Examples are:

What does this work of art call to mind?
Who/what/where do you recall when you look at this work of art?
What idea or thought is suggested by this work of art?
Does this work of art remind you of any experiences you may have had? Explain.
Does this picture make you remember anything in your own life? Explain.
Does this work of art call to mind any other works of art you have seen?
How does this work of art differ from other works of art you have seen?

4. *Evaluative questions.* These questions ask students to examine the quality of their experience with a work of art. Examples are:

Do you like or dislike this work of art? Why?
Would you like to own this work of art? Why or why not?
What part of this work of art is the most appealing to you? What part is least appealing?
Would you change any part of this work of art if you could? What would you change? Why?

Which kind of question a teacher chooses to use will depend upon the work of art being studied and the specific class situation. Not ev-

ery category of question will be appropriate for all occasions. Notice, however, that all are unlike the factual questions that close discussion because they provide data the teacher requested. The preceding questions all leave the door open for further elaboration and development. Teachers can follow up on these questions with other questions and ask students to explain why they responded as they did.

Format Variations

Personal response questions can be presented in alternative formats. One can formulate them as interrogative statements, as in the examples above, or as any of the following:

1. *Sentence lead-ins.* These are unfinished sentences that students complete. They can be formulated for all categories of personal response questions. Examples are:

What I wonder most about this picture is. . . .
This work of art makes me feel. . . .
This picture reminds me of. . . .
I like/dislike this work of art because. . . .

2. *Check lists.* These are lists of descriptive adjectives that students can check or circle to characterize their feelings or the quality of their experience with works of art. A list of words such as *inspiring, uplifting, challenging,* and *stimulating* can be contrasted with other adjectives such as *boring, dull, dreary,* and *depressing.*

3. *Rating scales.* Some types of personal response questions can be presented in the form of rating scales. Likert-type scales ask students to agree or disagree with a statement. A Likert scale would list items such as the following:

This work of art is very appealing.
agree ___ ___ ___ ___ ___ disagree
This work is repulsive.
agree ___ ___ ___ ___ ___ disagree
This work of art is good.
agree ___ ___ ___ ___ ___ disagree

Another form of rating scale is the semantic differential, which lists pairs of bipolar adjectives. It might include items such as the following:

appealing ___ ___ ___ ___ ___ repulsive
friendly ___ ___ ___ ___ ___ hostile
good ___ ___ ___ ___ ___ bad

A final form of rating scale is to ask students to rank-order a number of works of art along some dimension. For example, they might be asked to rank-order work according to personal likes or dislikes, from those liked best (number one) to those liked least (number five).

5. *Tokens.* Personal response questions can also be presented in the form of paper tokens that students place underneath a work of art. The ubiquitous yellow happy face, for example, can be used to symbolize a student's regard for a work, a frowning face to symbolize dislike, and an expressionless face to symbolize a neutral reaction.[3]

Initiating Class Discussion

Teachers initiate class discussion by asking personal response questions. This can be done directly, for example, by asking students one or two questions after they have viewed a work of art. They can also be asked to respond verbally to one or more questions written on a blackboard, or prepared lists of questions can be handed out on assignment sheets. Perhaps the most effective way of beginning a class discussion, however, is to set aside five or ten minutes and give students a short writing assignment. They can be asked to respond to one or more questions in a couple of sentences or a short paragraph. This gives them the time necessary to reflect on their experience with a work of art and precludes mimicking the responses of the teacher or other students. Teachers can begin the discussion by having students read or paraphrase their answers to others in the class.

Most students respond readily to personal response questions and are eager to share their reactions. Occasionally, a teacher will encounter inhibited students or even a class that finds it difficult to express honest reactions to a work of art. It sometimes takes time to establish the trust and security that enables lively conversation and critical reflection. In some beginning classes the teacher may wish to preserve the anonymity of students by having them write brief answers to these questions on note cards, which the teacher can then read to the class. Another strategy is for the teacher to ask for the class's reaction to provocative comments of students in previous classes or to the comments of professional critics.

Facilitating Class Discussion

Personal response questions, then, are the starting point for class discussion. To maintain this discussion, teachers need to promote an attentive and open class atmosphere and obtain the widespread participation of students. This cannot be done if teachers respond to their comments in a judgmental way. While most teachers realize that

negative comments will intimidate and discourage students from speaking, some mistakenly believe that they can promote discussion by praising the contributions students make. Comments such as "that's very good," "I like what you have said," or "now you're thinking," however, do not invite deeper participation. They actually close off further thought and reflection and are perceived as attempts to shape and control the discussion at hand. When teachers make such comments, they once again become authority figures, and the discussion comes to be seen as the formal type of talk that dominates classroom life.

Teachers can best promote discussion by functioning as facilitators rather than judges. One facilitates class discussion by asking students to clarify what they have said. Because they are open-ended, personal response questions by their very nature invite requests for further clarification. Teachers can encourage students by asking them to explain their reactions to a work of art. Why was it "moving," "a turnoff," or "stimulating"? Such questions will need to be asked if others are to understand their initial reactions.

Clarification will also be needed because many times students will not clearly articulate what they are trying to say. It is often a challenge to put thoughts into words. For example, the language students use may be ambiguous, vague, or otherwise obscure. Comments such as "this work is racist," "it is dynamic," and "it is full of tension" invite misunderstanding because they are so easily misinterpreted. Value judgments (the work is "good," "bad," "trite," "profound," "ugly," or "grotesque") are typical examples of vague statements because value terms ordinarily have shifting criteria of application. What is "good" or "bad" for one person might not be so for another. For this reason it is often difficult to know precisely what is being stated.

The first task of a teacher as facilitator, then, is to ask for clarification so everyone will understand the remarks students make. Attempts at clarification can take a number of forms. Teachers can:

1. *Ask students to connect their responses with the work of art.* Do not let them simply express their reaction; insist that they tie it to the work of art. What in the work caused them to react as they did?

2. *Ask students to restate their ideas.* Students sometimes express fragments of thought, ideas that have not been articulated fully. If what a student says is baffling to others, ask that person to restate what they have just said.

3. *Ask for examples and contrary instances.* Abstract or technical terms can often be clarified if examples are provided. What does realism mean, for example? It can be explained by pointing to examples of

works of art that are realistic as opposed to those that are not. Teachers should ask students for examples and contrary instances of concepts they are using if they feel the meaning is unclear.

4. *Ask for underlying criteria.* Value terms that are unclear can be more readily understood when the criteria of application are made explicit. Teachers can ask why something is "good," "bad," "trite," or "ugly."

Promoting Critical Reflection

Besides clarifying class discussion, teachers should seek to promote critical reflection about the adequacy of initial responses to works of art. This can be done by drawing connections among the different responses of students and by having them compare their reactions with those of others. Judgments will be different, and some more defensible than others. Teachers can facilitate critical reflection by:

1. *Asking students to support their conclusions.* Teachers should encourage students to give reasons for their judgments or conclusions. Requests for additional reasons can also be made when the reasons themselves seem arbitrary. In general, students should back up their conclusions and make them understandable and convincing.

2. *Asking students for more data from the work of art.* Judgments and conclusions can be based upon one aspect of a work of art or upon many. Students can be asked to comment about a work in more detail. Consider someone who finds "dynamic conflict" in a painting. Why? Is it only because the work shows two boxers fighting, or do other aspects of the painting also make it appear dynamic? Are any aspects of the work of art overlooked that make it static rather than dynamic?

3. *Summarizing student comments from time to time.* Offering summaries of what has been said will keep the discussion on track and enable the rest of the class to follow the discussion more easily.

During the course of discussion, opportunities will arise for students to reflect on the subjective reasons for their particular responses. Teachers can encourage this by asking another type of personal response question: self-reflective questions. Examples are:

How does your perception differ from your classmates?
Why was your reaction different than the others?
Why do you suppose that you think that?
Why do you suppose that you feel as you do?
Why did that part of the work of art seem more important and significant to you than to others?

Questions such as these encourage students to reflect on the nature of their experience with a work of art. They also direct attention to the personal backgrounds of students that contribute to the uniqueness of their responses. Asked at the appropriate time, self-reflective questions can help students achieve self-understanding and personal insight.

From Personal Response to Artistic Intentions

An opportunity for further reflection arises when discussion shifts from the responses of students to the intentions of the artist who made the work of art: from what students think, feel, or believe to what an artist thinks, feels, or believes. This shift is important and should be duly noted by teachers.

One of the values of a thematic grouping of art objects is that it encourages students to see the work of art as a product of a human mind and the outcome of intentional activity. As students discuss different but related works of art, they will be constantly confronted with the fact that works with the same subjects, themes, functions, or styles are very different from one another. In attempting to account for these differences, students will be led to inquire into why they exist. "Why" questions of this type are really questions about artistic intentions because they focus on what an artist was trying to do.

By continuing to display works of art that have been discussed previously, teachers can draw attention to similarities among other works. A question such as, "Does this work remind you of others we have studied?" will encourage students to make comparisons between the work under discussion and other work the class has considered.

Even when students have not expressed an interest in the intentions of an artist, teachers can promote this shift in thinking by asking additional personal response questions. These can be called speculative questions because they ask students to conjecture about the artist and the context in which a work of art was made. Examples are:

What kind of person do you think made this work of art?
What kind of personality do you think the artist had?
What kind of person do you think might buy this work?
If you could visit the place where this work of art was made, would you like to go there?
If you could go back in time, would you like to visit the period when this work of art was made?
What effect do you think the artist's time had on this work of art?

These questions, like other personal response questions, invite further commentary. The discussion that ensues is an effective way of stimulating curiosity about the artist and the time and place in which a work of art was made.

Concluding Class Discussion

The conclusion of a class discussion offers further opportunities for students to reflect on what they have learned. Their understanding will normally have evolved and changed as the result of interactions with other students. Possibly they will have gained insights about themselves, about others, and the world. In concluding discussion, teachers should encourage the idea that an understanding of a work of art is never complete and that personal response ends with tentative conclusions rather than final answers. It is also a good time to help students consider what is not known or understood, thus laying the foundation for further inquiry through student research projects. Additional personal response questions can be used for both of these purposes. For example, the teacher might ask the following self-reflection questions:

Have your ideas about this work of art changed?
Have you learned anything about yourself or your classmates?
Do you look at the work of art in a different way? If so, how?
What is it you still do not understand about this work of art?
What questions do you still have about this work of art?
If you could ask the artist one question, what would it be?

An effective way of bringing class discussion to a close is to give another writing assignment. Teachers might have students take five minutes at the conclusion of a class discussion and write about how their original response to a work of art has changed, what they have learned, and what they still do not understand. Or, the assignment could take the form of a longer essay. Listing the questions that students have posed as the result of this sort of reflection can create an agenda for student research.

Discussions in the classroom will assume many different forms but will often proceed in the following way:

1. Students will first study one or more works of art.

2. Teachers will then have students respond to one or more questions, asking them to articulate their responses. These answers are used to initiate class discussion.

3. Teachers elicit critical reflection by drawing attention to differences in the way students have responded to the work of art and inviting them to comment on the reactions of others.

4. Teachers facilitate reflection by asking for clarification, by requesting supporting reasons for judgments or conclusions, by summarizing what has been said, and by asking further questions.

5. After students have examined their reactions to a work of art, teachers can stimulate curiosity about artistic intentions through additional response questions or through comparison with other works studied previously.

6. Discussion concludes with a reexamination of students' initial reactions to the work and with additional reflection on what has been learned in order to articulate remaining puzzles and gaps in understanding.

Small-Group Discussion

Whole-class discussion is one of the most important and useful ways of introducing critical inquiry. Yet for all of its usefulness this kind of discussion is a challenging undertaking in typical classes of twenty-five students or more. Twelve students is generally the ideal number that can participate fully. As class size grows beyond fifteen students, teachers will find it increasingly difficult to involve everyone. More vocal students will tend to dominate, and those who are shy or timid are likely to be overlooked. Small-group discussion is one way to ensure the participation of all students. By using it as well as regular class discussion, teachers have a more flexible set of options for promoting personal response and critical reflection.

Small-group discussion has other advantages aside from increased participation. A wider range of topics can be discussed, and by relinquishing direct control of the discussion teachers allow students to take more responsibility for their own learning. When students talk among themselves, they may also feel more free to address the topic in individual ways. Finally, teachers will find small-group discussion valuable as an effective way of providing feedback for written assignments.

Using Small-Group Discussion in the Classroom

Small-group discussion opens different instructional options and can be used in the following ways:

1. *As an alternative to whole-class discussion.* After students have viewed a work of art, the teacher may ask each to answer one or more personal response questions. After writing their responses, students come together in groups and discuss them. After the discussion, teachers can ask each group to reflect on what they have learned. Their findings and conclusions are then reported to other members of the class. A variation on this is to have students meet initially in small

groups of two or three to discuss their responses. After this discussion, each group meets with another group to identify one major idea or issue. At the conclusion of the second discussion students summarize their findings for other members of the class.

2. *As an alternative way of eliciting personal response.* Through small-group discussion teachers have two further options for eliciting responses. First, they can have students generate their own discussion questions. This can be done by asking each to list three or four questions that they believe should be the focus of class discussion about the work of art. After doing this, the teacher then divides the class into groups. Each group then ranks these questions in order of interest and importance in order to arrive at an agenda for class discussion.

A second strategy is to have students engage in stream-of-consciousness talk or writing. Students first break into groups of two or three. Each then speaks for three or four minutes, spontaneously describing their thoughts and feelings as they scrutinize a work of art. Those who listen take notes on what they find interesting. After taking turns comparing notes, students form larger groups to discuss their thoughts and feelings about the work. A variation of this is to assign a three-to-five-minute free-writing exercise. Students spontaneously write what they are thinking as they view a work of art. After writing, they share their thoughts with other members of the group. Doing that may again be followed by having them come together in larger groups to compare and contrast their thoughts and feelings.

3. *As an additional option for promoting critical reflection.* Teachers can pair students who have had radically different reactions to a work of art. Students first respond in writing; teachers then collect their responses and ask those with opposing views to discuss their responses with each other.

4. *As a way of having students discuss two or more works simultaneously.* Instead of having everyone respond to the same work of art, teachers may assign a different work to each group or allow groups to choose their own works. Teachers will find this a useful strategy when students assemble their own collections and visit museums or galleries.

5. *As a way of varying class routine.* Another useful variation on small-group discussion is to ask a group to conduct a panel discussion about a work of art. Class presentations can also be given by asking a group to interview one of its members. One person might volunteer to play the role of the artist of the work being discussed, for example. Others in the group interview the artist and ask about aims and intentions in producing a specific work.

Organizing Groups for Effective Discussion

Discussion groups can be structured in different ways. Groups may be formed from as few as two or as many as seven or eight students. Five is often ideal. Teachers can assign students to a group or allow groups to self-select. After each discussion, teachers can reassign students to groups or allow the groups to remain intact.

In using small-group discussion, teachers need to take steps to ensure that students function effectively within the groups. When teachers organize students into a number of groups, they give up direct control of the ensuing discussion. Simply placing students into groups does not guarantee that what is said will be worthwhile, however. Sometimes a teacher will find that only one or two in each group will participate while the rest merely observe. At other times, the progress of the discussion may be interrupted by clowning or irrelevant digressions. Sometimes students pair off within groups and several conversations occur simultaneously. Students also may not know how to follow up on comments that are made, so promising ideas and thoughts are never pursued. Participating in a small-group discussion is a skill that needs to be developed by teachers if discussion is not to degenerate into aimlessness. Teachers can help ensure productive discussion groups by:

1. *Establishing rules and procedures.* Establish rules for engaging in small-group discussion and teach them to students. They should be taught to listen to other students, wait their turn to speak, contribute to the discussion, and respond to what others are saying.

2. *Assigning a task for the group to accomplish.* Students need to understand why they are meeting in groups. If they are to discuss their initial reactions to a work of art or select interesting discussion questions, that needs to be made clear. Students should be held accountable for accomplishing these tasks.

3. *Having students write before they meet in groups.* Having students write their reactions to works of art or make a list of discussion questions before meeting in groups ensures that all will have something to contribute.

4. *Assigning roles for the participants.* Discussion will be more productive if students assume responsibility for the discussion. One person should assume the role of discussion leader (the person who keeps the discussion going), one person should function as a recorder (the person who takes notes), and one person should assume the responsibilities of the speaker (the person who presents the group results to the rest of the class). Group members may volunteer for these positions, or the teacher may select them.

5. *Asking for systematic discussion.* To ensure that everyone contributes, the group leader should ask each member to share responses and additional thoughts about the work of art. The recorder takes notes. After all of the group members have spoken, they may then respond, discuss, argue, vote, and select.

7. *Having students review the results of their discussion.* The recorder reads final notes on what has transpired to the rest of the group. Other members add comments so that the notes accurately represent the group's findings or conclusions.

8. *Recording each group's contribution.* Each group speaker presents the group's thoughts to the other members of the class. The teacher or some class member may wish to record each group's comments, either on the board or as a photocopied handout. Copies of the handout may be circulated during the next class meeting for further discussion.

Informal Writing

Informal writing assignments are yet another way of promoting personal response and critical reflection. These assignments differ from other kinds of writing often assigned in the classroom. They contrast with library research papers, for example, because they do not require students to look to outside sources for facts and information.[4] They also differ from textbook questions and book reports, which are typically assigned so teachers can determine whether learning has occurred.

Although personal response writing can be used as one part of an ongoing evaluative scheme, its primary purpose is to function as an aid in thinking. Any evaluative use it may have is secondary. Because of this, student writing will often have a different character. Instead of insisting upon polished prose and formally structured essays, teachers may wish to encourage students to articulate their thinking in a prose form that is comfortable and convenient. The product will often be rough (colloquial, fragmented, and ungrammatical) first-draft writing.

A distinction can be drawn between two kinds of informal writing assignments: personal response statements, which ask students to articulate their personal responses to a work of art within the confines of a paragraph, and personal response essays, which ask students to reflect upon their experiences in greater depth.

Personal Response Statements

Personal response statements are brief, usually five- or ten-minute writing assignments. Students first observe a work of art and then

write responses to it, either to questions the teacher poses or questions of their own devising. In addition to eliciting student reactions, brief writing assignments can be valuable in two additional ways: to stimulate interest in a topic before students have the opportunity to observe works of art and to facilitate thinking about some issue or concern that arises in the middle of class discussion.

Before studying a unit on landscape painting, for example, students might be asked to keep a daily diary in which they observe and comment on what they see on their way to and from school, recording whatever attracts and repels them. Do they enjoy looking at what they see? Why or why not? Do they see things in a different way at different times of the day? During different weather conditions? If they could alter their environment, what would they change? After writing about this topic for a week and discussing it in class, students will have a more developed awareness of some of the interests and concerns that motivate landscape artists.

Having students pause to write during the middle of a class discussion can also be a useful way of promoting reflection. Sometimes issues arise that are complex or unfamiliar, issues that require a brief pause for further reflection if students are to participate in an intelligent way. Consider the discussion described earlier in which a student characterized Manet's *A Bar at the Folies-Bergère* as pornographic. That is certainly a contentious claim and one most students would likely dispute. The question, however, is also likely to catch them off guard. Even if they have an intuitive sense of what pornography is, they are unlikely to have thought carefully about what makes something pornographic. The discussion that ensues might degenerate into a mere exchange of contrary opinions. Teachers can help facilitate intelligent participation by stopping the discussion for a few minutes and asking students to write briefly on what they think constitutes pornography. They will then be in a better position to give reasons for their opinions.

Using Journals in the Classroom

Different writing formats can be used to assist critical reflection and promote class discussion. For example, students can be asked to write their responses on note cards, which teachers then collect, or to fill out forms. Perhaps the most flexible and useful vehicle for student writing, however, is the class journal.[5]

Journals usually take the form of small looseleaf or spiral-bound notebooks that students are asked to buy. These can be divided into separate chapters. A teacher may ask students to set aside one chap-

ter for class writing assignments, for example, one for homework assignments and one for maintaining a dialogue with the teacher. The teacher may wish to have students decorate the cover of their journals or individualize them in some other way.

Teachers find journals valuable for a number of reasons. Journal writing can be structured into the daily routine of the classroom in an efficient manner. Teachers, for example, can have students write briefly in their journals at the beginning of class while attendance is being taken. That assignment can then be the springboard for whole-class or small-group discussion. Journal writing can be a convenient way of ending a lesson as well. Teachers can ask students to reflect on what they have learned during the course of a lesson and what they still do not understand. Journal assignments can also be given as homework, as a way of continuing the study of art beyond the confines of the classroom. Finally, journal writing is an excellent way of facilitating communication between student and teacher.

Journals are especially valuable because they are repositories of student thought. The most insightful entries can be developed at a later point into personal essays. Questions students raise can also be the genesis for library research projects. By asking them to review all of the entries in their journals at the end of a unit of instruction, teachers can help students better understand their changing reactions to works of art and their growth and development as viewers of art.

Teachers should emphasize the personal nature of journal writing; they may wish to remind students not to be overly concerned with spelling, grammar, and punctuation. Writing is to be viewed as an aid in thinking about works of art, not as finished prose. An effective way to teach students how to begin a journal is often to show them journal entries that the teacher has written or entries of former students. Entries should not be graded, but the effort made in keeping a journal should be counted, either by a point system or in some other way. Finally, at the end of a unit of instruction students should be asked to add page numbers, a contents page, and a conclusion in which they summarize and evaluate what they have written.

For journal writing to be effective, teachers must review and comment upon the entries from time to time. They usually skim most, but comments on entries of special interest or on those students circle specifically for this purpose can be effective ways to promote learning. Teachers may also wish to set aside some time to discuss each journal individually. A conference at the close of a unit of instruction provides a good opportunity to assist students in reviewing what they have learned.

Dialogue journals—letters between student and teacher—are especially useful ways of maintaining communication. Once a week (or more often if the student desires) a brief period is set aside for students to write a letter to their teacher and comment on ideas and concerns that have arisen during the previous week. The teacher collects them, writes a brief reply, and returns them during the next class period. Comments in dialogue journals are useful for various instructional purposes: New ideas or concepts can be introduced, further thinking can be encouraged, gentle pushes can be given to those students whose class performance can be improved, and, by modeling the kind of enthusiastic and informed intellectual discussion that stimulates involvement with art objects, teachers can initiate students into the joys of looking at works of art.

Personal Response Essays

Although personal response statements are a valuable way of starting critical inquiry, on some occasions teachers may wish students to engage in extended personal reflection about works of art. Having them write short essay papers permits this. In assigning these essays, teachers ask students to engage in a monologue about a work of art rather than in a dialogue with others. In contrast to personal response statements, which are purely instrumental aids to thinking and not intended for an audience, teachers may wish to use personal response essays to assist students toward more finished public statements of their views.

The essays may be as short as a page or two or can extend to four or five pages. They are typically assigned after students have had the chance to articulate and reflect upon their initial responses to a work of art. In other words, teachers will generally find them most useful as a way of extending thinking rather than initiating it. Some possible ways that personal response essays can be used in the classroom include:

1. *Asking students to consider some aspect of a work of art that has been overlooked in class discussion.* Class discussion will often develop in unpredictable ways. Teachers may find that important aspects of a work of art have not received attention or that important aspects of an experience with a work of art have been overlooked. For example, students might not have considered the possible personal significance of a work of art in discussing it in class. The teacher can ask students to consider this in a short one- or two-page essay.

2. *Asking students to trace the development of their thinking about one or more works of art.* At the conclusion of an extended discussion about

some work of art, a teacher might have students reflect on whether their initial response to it has changed. At the conclusion of a unit of study teachers can also ask students to summarize how their thinking about a topic has evolved since the unit was introduced.

3. *Asking students to reflect on what they do not know about a work of art.* At the conclusion of class discussion, the teacher might ask students to list any remaining questions that they have about a work of art and develop an essay around what they still find puzzling or perplexing. An assignment might be titled "If I Could Talk with This Artist, I Would Ask Him or Her ———."

4. *Asking students to develop some personal insight they have come upon in the process of writing their journals.* Teachers can have students review journal entries and circle the most insightful. They can then be asked to expand upon their original idea and develop it into a short essay for the rest of the class.

5. *Asking students to compare two or more works of art.* Comparing works of art is an important class activity. As students discuss different ones within some group of art objects that has been selected as the focus for study, teachers can have them examine two or more works in depth. Comparing and contrasting student reactions to two or more works can be a useful way of promoting awareness of different artistic intentions.

6. *Asking students to provide a personal overview and introduction to collections they assemble as class projects.* Assembling collections of art objects can be a useful way to introduce questions of aesthetic value into the classroom. Students can prepare short essays to describe their collections and give reasons for their choice of art objects.

7. *Asking students to write about some aesthetic concept or topic.* Written essays are a natural bridge between personal response and concept and skill development phases of instruction. Sometimes aesthetic topics will naturally arise during the course of class discussion or in journal entries. For example, students might wonder about the practical functions of some art object, or they might be puzzled about how a work of art came to be made. When such concerns arise, teachers can make provision for specific instruction on some aesthetic concept or topic and then ask the class to use personal essays to reflect on these in more detail.

Students typically find personal response essays a more challenging undertaking than personal response statements. In writing an essay, students need to organize their thinking and develop a coherent way of presenting their ideas. Writing an essay can sometimes generate anxiety if students are unsure how to proceed. Recognizing

this anxiety, teachers sometimes provide an outline of the topics to be covered. But that strategy is likely to prove counterproductive for the same reasons that classroom recitation is ineffective. It channels and restricts the thinking of students and teaches them to rely upon a formula for responding to works of art. It does not allow them to grapple with their own responses.

Two strategies can be used to assist students in their initial writing efforts. Teachers can introduce writing assignments by having students write brief essays that are extensions of personal response statements. After students become comfortable with shorter papers of perhaps a page in length, longer essay assignments can be given. Another effective strategy is to provide models of critical writing, either examples of writing done in previous classes or pieces of professional criticism. Before having students trace the development of their responses to a work of art, for example, a teacher might have them read one or more student compositions, such as:

> *The Return* by René Magritte is a simple composition made up of complex symbols. It is a surreal image of a geometric bird shape filled with clouds. The bird is descending into a nest with three eggs inside. The nest is perched on a window sill. These very bright images make up the foreground. The background, in contrast, is very dark. A tree-lined horizon stretches across the lower half of the work. The dark blue sky is dotted with points of light. It appears to be dusk. At first glance, one may have an idea of what Magritte was trying to convey to viewers. Further analysis of the work may, however, change the viewer's ideas.
>
> My first impression of *The Return* was quite different than the one I now have. I read the title and made a personal connection in my mind. I thought of returning to my parents' home after being away at school. The nest represented a family home to me. The bird in flight seemed to be a traveler. I first assumed that Magritte was making a statement about home and the return of a family member that had been gone. The discussion with my group dramatically changed this idea.
>
> Upon discussing my print with my group, my ideas took a turn towards a darker side. Someone said at the beginning of the discussion that she saw death in the picture. I hadn't thought of this. I believe that my thinking had been clouded by my own personal experience and I automatically connected what was occurring in the composition with my own life at the time. Discussing my print gave me a new outlook.
>
> The dark background and row of trees appears to be very ominous. It makes the bright bird figure of clouds stand out. The clouds represent heaven. The bird is descending down into the nest. It has been on a journey and is returning to its home. When analyzing the print at the very beginning, I had not noticed that the window sill is a very large

stone structure. It is the strong, solid type used in church. This gives the work a religious element. Also, the circular nest is a type of religious symbol. The circle is often used as a halo, or to represent the continuous cycle of life. The eggs inside the nest represent birth. They are white for purity.

The window sill frames the picture. It seems strange that there is light spilling onto the area where the outside world is dark. There are sharp shadows that run diagonally toward the center. Everything in the edge of the composition points inward toward the bird. It is the only abstract part of the work. All other elements involved are depicted realistically. The darkness of the background is very convincing as a night scene. The sky is dotted with light, as if stars are popping out of the sky. It is in sharp contrast to the light blue, daytime sky with white clouds that make up the bird shape.

Overall, *The Return* is a composition made up of contrasting elements that interact with each other; which is the way that life and death are. It is made up of bright images placed next to dark tones. The foreground images are light and seem heavenly. The dark, ominous background seems far away, hinting that the bird has left the real world. It has died and its spirit is returning to its home.

When the subject of death was mentioned at the beginning of the discussion, I did not agree that that was the theme of Magritte's painting. After analysis of the composition, I noticed elements of the work I had not seen before. I realized that my personal interpretation was not accurate. The discussion made me think about what is going on in the picture. I am convinced that it is about the whole life and death cycle. The dreamlike images of a Surrealist represent this process.[6]

Responding to Personal Essays

Personal response essays are typically assigned after students have articulated and discussed their initial views of works of art with other members of the class. Although the essays can be used as a way of providing closure, they do not necessarily signal the end of critical reflection. On the contrary, in responding to student essays teachers can provide opportunities for further dialogue and learning.

The most straightforward way of responding is to write comments on the papers themselves. For written comments to be effective, however, teachers must go beyond brief evaluative remarks and discuss the ideas and concerns that arise in the paper. This is often time-consuming, and many teachers find scheduling individual conferences with students to be a better way of providing feedback. They can ask them to clarify obscure passages and, together, model the kinds of verbal dialogue about works of art that should occur in the classroom. Even individual conferences can be time-consuming, however, if a teacher

has a large class and if several personal response essays are assigned during the course of a unit of instruction. An effective alternative is to have students discuss their papers with each other in small groups.

Structuring Opportunities to Choose Works of Art

If teachers can roughly surmise the kind of art that will interest many students, it is impossible to predict what all students will enjoy. In any class there will be individuals whose backgrounds lead them to choose one work of art over another despite what the majority of students might prefer. By pointing out differences in what interests and intrigues students, teachers have a powerful way of creating the kind of problematic situation that provokes critical inquiry. As students come to understand the bases for the value judgments of others, they enlarge their understanding and appreciation of works of art.

Aesthetic taste, then, is not static. It changes as students encounter alternative value judgments and as they reason together about the merits and deficiencies of works of art. Providing opportunities for students to make value judgments is an important way in which teachers can help them grow and develop in their understanding and appreciation of art. How is this to be done? Teachers sometimes assume that they can simply ask students to evaluate works of art as one part of a critical procedure, but these requests are artificial and ignore the context of need out of which value judgments arise.

Questions of value will arise spontaneously when students have opportunities to make choices about works of art. Teachers can create these kinds of situations in two ways: by asking students to participate in choosing the works of art they will study and by asking them to assemble personal collections of art reproductions. In making these choices, students will sense that their decisions have consequences. If they choose uninteresting works of art for the class to study, for example, they will have to live with their choices for the duration of an instructional unit. Students who assemble collections that others perceive as odd or uninteresting invite peer criticism. They are likely to consider the reasons and underlying criteria for their value decisions carefully.

Choosing Works of Art for Study

One way teachers can structure opportunities for choice is by asking students to participate in selecting works that they will study during the course of an instructional unit. The teacher first introduces the topic of the unit and then asks the class to look at and vote on

reproductions from a collection previously assembled. The works that receive the most votes become the focus for study. Where classes are smaller, the teacher might have each student individually select a work of art. The group could then study all of the selections that have been chosen. If there are gaps in the collection, or if important works have been overlooked, the teacher can simply add to the collection the students choose.

Sometimes it may not be feasible to have students participate in the selection of a focus group of art objects. A teacher might not have extra reproductions, for example, or there may be only a few examples of art or architecture from which to choose. Then too, allowing students to choose from a larger body of art objects requires that teachers have wider background preparation. In these instances they may feel more comfortable making the initial selection. Students, however, should be allowed to choose their work from within this group when they later undertake research projects.

In many instances teachers will ask students to choose works they like, those that interest and intrigue them the most. There are occasions, however, when asking students to choose what they dislike is an effective instructional strategy. In a unit on abstract art, for example, students may be offended by most of the works the teacher wishes them to study. In this instance, asking them to choose a "dirty dozen," a selection they think least worthy of being considered a work of art, can be an effective way of provoking thought and reflection. Why, they may wonder, do such works interest other people? Teachers can then ask students to choose the one work that they find most offensive, research what critics and others have said about that work, and defend it in a presentation to the class. There is often a marked change in the value judgments students make about such works after they have given their presentations.

A final way of structuring opportunities for choice is to ask students to recommend work for other classes to study. After a unit of study has been completed, they can list on notecards three works they found especially interesting and rewarding. Store the notecards after discussing reasons with the class. Teachers can use these recommendations when choosing works of art for future classes. They can also read them to future classes as a way of stimulating student interest in a unit of study.

Assembling Personal Collections

Teachers can also structure choice in the classroom by having students assemble personal collections of art objects. This might take the

form of a homework assignment extending over the course of a unit of study. Students are asked to collect anywhere from six to two dozen reproductions of works of art dealing with the unit topic being studied. These should be works that the student finds especially interesting or appealing. Reproductions can be clipped from periodicals, inexpensive reproductions can be purchased, or reproductions in books can be photocopied in color.[7] In preparing their collections, students label selections and write a brief introductory essay explaining the reasons for their choices. Collections can take the following forms:

1. *Gallery exhibits.* In a gallery exhibit, one student curates a show for other members of the class. In mounting the exhibit, students cement their reproductions on uniform series of white 9–by–12–inch pieces of white paper or mounting board. These are then displayed on a bulletin board, either in the classroom or in the hall. During the course of the exhibit the student whose works of art are being shown might be asked to give a brief "gallery talk" to others in the class, or a written "curators statement" or "catalog" of the show can be prepared and discussed with the rest of the class. A variation of this assignment is to have groups of students assemble shows or to have the class as a whole curate a show for other classes in the school. Having students curate gallery exhibits can be one avenue for further inquiry into the sociology of art and how the contemporary art world functions. Those who are not curators might be asked to role-play professional critics and write reviews of the show being displayed.

2. *Personal albums.* Collections can also take the form of an album of reproductions representing the personal tastes of students. In assembling their albums, students purchase either plastic page protectors for notebooks or photo albums with plastic sleeves. Reproductions are then inserted. Once again, the albums should be displayed, and written introductions can be prepared and discussed with other members of the class.

3. *Postcard collections.* A intriguing variation on personal collections is to have students send postcards to each other. Teachers randomly assign senders and recipients. The students then either buy postcard reproductions of works of art or clip small reproductions, paste them on postcard-sized tagboard, and address them to others in the class. In the space normally reserved for comments should be an explanation of why the sender thinks the recipient would enjoy that work of art. After the collections of postcards are assembled, recipients should discuss their reactions. Alternatively, teachers can ask them to write a short reaction, which can then be shared with the sender.

Field Trips and On-Site Visits

Teachers know that even the best reproduction is no substitute for the work of art itself. Because the impact of most works of art is severely diminished in reproduction, opportunities should be provided for students to view works of art through field trips or on-site visits whenever feasible.

Careful consideration should be given to community resources when designing units of instruction. If the nearby locality has outstanding works of architecture or distinguished pieces of sculpture, they might be selected as the focus for a unit of instruction. A teacher could take students on a visit as a way of initiating a unit, and slides can be taken for later reference in the classroom. At a later point in the unit, a follow-up visit might be scheduled. If students have access to these places on their own, teachers might consider having them make a personal visual photographic or videotaped essay. These would be shown to other members of the class, and each student could describe their personal response while doing so. A more ambitious assignment would be to have the students tape record a narration and a musical background to accompany the visuals.

Local museums and galleries are another valuable resource. If reproductions can be obtained of works from nearby collections, teachers should consider designing a unit of study around these. After students have studied the reproductions, they are usually thrilled to see the originals. Even if such reproductions are not available, students will be delighted to see works by the same artist, in the same style, or with a similar subject to those they have studied. A field trip toward the end of a unit of instruction is a festive occasion for students and a useful way of concluding the unit.

Experienced teachers know that field trips and on-site visits require careful planning if they are to be successful. Not all museums and galleries welcome visits by groups of students. Before scheduling a field trip, a teacher should always visit the place beforehand and ascertain its policy for student visitations. Students should also be instructed in the etiquette of museum visits.

Teachers will find on-site visits more rewarding as educational experiences if students have specific tasks to accomplish during the visits. For those visiting museums or galleries for the first time, initial curiosity about what is around the next corner is likely to prove overwhelming. It might be useful, therefore, to allow some time for the class to view the collection as a whole. After the overview, stu-

dents should be asked to complete some assignment calling for a personal response to one or more works.

Each can select, for example, one work of art they find especially interesting (dealing with the topic of a unit of instruction) and write a brief personal response statement, possibly in their journals. They then should discuss their response with a partner and select the most interesting of the two works. They then meet with another pair and repeat the procedure by writing response statements, discussing these two works, and again selecting the most interesting. Finally, the class meets as a whole to discuss the five or six most interesting works students have uncovered in the collection.

NOTES

1. Class discussion, small-group discussion, and writing assignments have been widely discussed in the educational literature as methods for promoting critical reflection. This chapter draws upon numerous sources in English, social studies, science, and other areas. I am especially indebted to John Dewey, *How We Think* (Boston: D. C. Heath, 1933); Robert E. Probst, *Response and Analysis: Teaching Literature in Junior and Senior High School* (Portsmouth: Boynton-Cook, 1988); and Richard Beach and James Marshall, *Teaching Literature in the Secondary School* (New York: Harcourt, Brace, Jovanovich, 1990).

2. John R. Searle, *Speech Acts* (Cambridge: Cambridge University Press, 1969).

3. Personal response tokens are available in the popular instructional game "Token Response," developed by Mary Erickson and Eldon Katter. The game is available from CRIZMAC Art and Cultural Education Materials in Tucson, Arizona.

4. Research papers do have a role in critical inquiry, however. In chapter 11 they are discussed as one of a number of possible options for student research projects.

5. Information on journal use in various subjects is given in Toby Fulwiler, ed., *The Journal Book* (Portsmouth: Boynton-Cook, 1987).

6. I wish to thank to Marcia Moore for providing this example.

7. University Prints in Winchester, Massachusetts, is one good source for small, inexpensive reproductions.

11

Extending the Framework for Response: Concept and Skill Instruction and Student Research

Personal experience and reflection upon that experience constitute the foundation for critical inquiry. Students learn through interacting with works of art and sharing their experiences with others. Yet there are limits to the kinds of understandings and personal insights that one can expect them to attain through observation and reflection alone. If students are able to see and understand much on the basis of their collective life experience, there are conventional ways of understanding the visual arts that are likely to remain closed to them unless they acquire certain kinds of knowledge and skills.

Among the most important are conceptual knowledge and perceptual skills. Acquiring the concepts and categories that critics and other sophisticated viewers use in viewing works of art allows students to make the kinds of discriminations that such people use in making sense of a work of art. Students also need to acquire biographical and contextual knowledge if they are to understand many of the aims and intentions of artists. Although there are times when it is appropriate for a teacher to provide background information through readings or lectures, in most instances it is best acquired by students through their own research efforts in order to answer questions that arise out of their encounters with works of art. Instruction in aesthetic concepts and background research play a subordinate role in critical inquiry. They should never be viewed as substitutes for personal response and critical reflection. It is, after all, not the purpose of public schools to produce professional scholars but students who find enjoyment and satisfaction in their encounters with works of art. Nevertheless, they are needed if students are to grow in their sophistication as viewers.

Background Knowledge and Aesthetic Response

Many students are unaware that a work of art may be viewed as something other than as a representation of some objects or event. Typically, they will focus only on what is depicted or portrayed and become baffled and frustrated when they encounter a work that is abstract.[1] Students who look at Georgia O'Keeffe's *Cow's Skull: Red, White, and Blue* (figure 15), for example, are likely see little more than a cow skull against a colored background.

Sophisticated viewers, on the other hand, are likely to have a much more complex response to O'Keeffe's painting. Their responses will likely encompass many different aspects of the work. For example, they will likely recognize a methodical application of paint over a carefully worked out drawing that was a characteristic part of O'Keeffe's oil painting technique. They will see that there has been a careful distribution of the colors into a symmetrical design. They will notice the rhythmical energy in the work and the contrast between the circular rhythms in the skull and the downward, V-shaped strokes of the blue background. They will see that the skull is skillfully integrated into the background by lines that parallel lines in the background and that the circular rhythms in the skull are echoed in the wavy lines of the red borders.

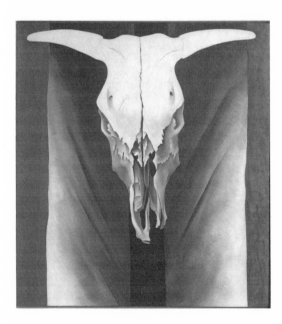

Figure 15. Georgia O' Keeffe, *Cow's Skull: Red, White, and Blue.*

These viewers will also recognize characteristic features of O'Keeffe's style and the influence of other artists. They will recognize that the picture uses a compositional scheme that O'Keeffe developed in earlier works and that her painting is a harbinger of other paintings using bones collected from the New Mexico desert. They might recognize elements of the modernist vocabulary in the simplified modeling, in the interest in two-dimensional patterning, and in the design of negative as well as positive shapes. Overtones of Surrealism might be detected in the strange juxtaposition of elements as well as in the disturbing imagery. And they will see in her interest in creating abstract designs from natural objects affinities with other works by painters and photographers in the circle around Alfred Stieglitz.

Sophisticated viewers will certainly respond to what is depicted within O'Keeffe's painting, but that response will not end with a bare recognition of the subject. For example, they will likely recognize potential symbolic meaning in the skull and the crosslike configuration. They will likely make associations with Navajo blankets and see references to the American flag in the red, white, and blue background. The modeling of the blue and white area on either side of the black band in the center will suggest not only a piece of woven material but also the sky. And in noticing the discrepancy between the modeling in this area and the flatly painted red stripes on either side, the thought might occur that the painting is not to be taken as an attempt to produce a literal depiction of a still life but rather as a metaphor for something else. All of this might lead them to surmise that the painting is supposed to have religious or patriotic significance.

In suggesting some of the complexities of O'Keeffe's painting, I do not mean to imply that these aspects will be perceived in isolation from one another. Noticing one aspect of a work of art may well come to alter an initial impression about some other; in this way experience may change and deepen. For example, the impression that some viewers first have of the expressiveness of a work of art might evolve as they reflect upon the artist's handling of the medium, the organization, or some other aspect of the work. What appears at first to be a clumsy representation of a drawn or painted figure or object, for example, might later come to be seen as a conscious distortion to create rhythms, emphasize the sensuous nature of the pigment, or arrive at a more elegant organization. Or, to return to O'Keeffe's painting, what seems at first to be a simple arrangement of objects may later come to be seen as a sophisticated compositional choice. Certainly, part of the expressiveness of her painting comes about because of the associations one brings to bear with earlier religious paintings hav-

ing the same kind of symmetrical composition. In realizing these things, viewers may come to have a different understanding of a work of art and appreciate it for the first time.

Differences between typical student response to a work of art such as *Cow's Skull: Red, White, and Blue* and the response of sophisticated viewers arise in large part from the kinds of background knowledge that each is able to bring to bear in scrutinizing that work. If that is the case, what kinds of knowledge do students need in order to respond to works of art adequately? Different forms of knowledge can be classified under the headings of "general knowledge," "aesthetic knowledge," and "biographical and contextual knowledge."

General Knowledge

Part of what sophisticated viewers bring to bear in confronting works of art is general background knowledge. Some of this is gained from life experience—from individual experiences as biological organisms and social beings. A viewer would need this sort of knowledge, for example, to recognize the representational content, grasp the allusions to the American flag, or see the patriotic overtones of the red, white, and blue color scheme in O'Keeffe's painting. At a deeper level, the viewer must draw upon this tacit knowledge to see the departures from photographic realism and sense the coordinated and resolved tensions, and the balance, that lend compositional stability to the work. An artist presupposes such knowledge in making a work of art. Because much of it is commonly held, theorists have sometimes been led to speak of a universal language of art.

Yet not all life experiences are the same. One source of the variability of response comes about because of differences in the cognitive background of viewers. People approach works of art not only with a common stock of experience but also with more specialized knowledge. Although much of this might seem irrelevant to critical response, it is difficult to rule out the potential usefulness of any knowledge. The nineteenth-century critic John Ruskin, for example, had an extensive background in meteorology and geology that he was able to use in fostering an appreciation of the landscapes of Turner. The twentieth-century critic Adrian Stokes had an extensive knowledge of psychoanalysis that he was able to use in explicating the motives underlying artistic creation and aesthetic response.

Should teachers attempt to provide students with this kind of specialized knowledge? Clearly, much of it cannot be taught directly but must be gained from life itself. Think of the joy and pain involved in romantic relationships or the dramatic effects of light and shadow on

a faraway vista, for example. Attaining such knowledge through vicarious experience is one reason why people seek out works of art. Still, the question needs to be considered, if only because occasionally one encounters proposals for teaching such subjects as psychology and sociology as foundations for literary criticism. It is not hard to imagine that similar kinds of proposals may one day be encountered in the visual arts.

There is no doubt that specialized knowledge of various kinds can occasionally be useful. The key question, of course, is, How useful? Could the time devoted to teaching such knowledge be better spent teaching something else? A proposal to teach certain principles of geology as a way of understanding landscape painting, for example, might appear initially sensible until a teacher realizes that students have more immediate needs. Unless background information has a direct bearing on understanding a work of art, it is probably preferable to use instructional time in some other way.

Aesthetic Knowledge

While general background knowledge plays an important role in critical response, there are also areas of knowledge conventionally associated with the visual arts that are of more immediate concern to teachers. When sophisticated viewers look at a work of art, they do so in terms of its utilitarian functions, medium and forming process, sensuous and formal qualities, representational content, expressiveness, metaphorical significance, style, and artistic development and influence. Most art teachers recognize that a work of art can be studied in terms of its practical uses, the materials and technique an artist uses, what is depicted or portrayed, the feeling tone of the work, the power of the work as a whole to symbolize other things in the world, and the development of, and influences upon, the style of the artist.

These different dimensions of critical response encompass many of the aims and intentions that motivate artists. An artist may intend, for example, to make an object that functions in certain ways, to explore a certain medium or technique, to represent some subject, or to express certain feelings about that subject. Because they embody different artistic aims, implicit within them are questions that sophisticated people ask about works of art and strategies for viewing.

These different dimensions of response, then, suggest an agenda for instruction in art criticism. Students should become familiar with these alternative ways of responding to a work of art. And because an understanding in one area can affect understanding in some oth-

er, students should also be led to consider the relationships between and among these different areas. Take, for example, a class that has not considered the possibility that a work was intended to serve some practical function. The teacher can introduce the concept of function, and the class can speculate about the possible functions of the work. After students have reached some tentative conclusions about the practical purposes for which the piece was designed, the teacher might then go on to introduce such other questions as:

> How has the function of this work affected the artist's choice of medium?
>
> How has the function of this work affected the artist's choice of lines, shapes, or colors?
>
> How has the function of this work affected the way the work was composed?
>
> How has the function of this work affected the artist's choice of subject?

These different dimensions of critical response provide a general overview of some of the kinds of aesthetic knowledge appropriately taught in programs of instruction in art criticism. More specific instructional concepts can usually be identified within them. Aestheticians and theorists, for example, have given considerable thought to organizing thinking about the sensuous and formal aspects of a work of art. Consequently, there exists a body of concepts, the so-called elements and principles of design, that can be taught in order to facilitate thinking and communication in that area. Teachers will recognize these as standard fare in many "foundation" texts and introductory art classes.

Other concepts usually receive much less attention in the classroom. Even though most students can recognize the objects depicted in *Cow's Skull: Red, White, and Blue,* many would undoubtedly overlook the symbolic overtones of the skull because of not being introduced to the concept of an artistic symbol. The capacity to recognize expressiveness is a natural human endowment, but explicit awareness of the movement, tension, and dynamism in O'Keeffe's painting is likely to be lacking unless these concepts are explicitly taught. Students are usually unaware that artists borrow from one another and are liable to overlook similarities between O'Keeffe's painting and other works of art unless different types of artistic influence have been pointed out.

What kinds of concepts should be taught in programs of art criticism? The task of identifying relevant aesthetic concepts belongs to

curriculum developers and individual teachers. Nevertheless, the undertaking can be facilitated by considering these dimensions of critical response in terms of categories that sophisticated viewers use to classify works of art.

When sophisticated viewers scrutinize a work of art, it is not considered in isolation but rather in relation to other works of art with which they are familiar. They identify them as specific kinds of art by sorting them into relevant categories. Some categories are quite broad, others are more specific. At the very broadest level, viewers look at works of art as examples of a specific art form: paintings, sculpture, photographs, or works of architecture. Within these very broad categories, sophisticated viewers will make further distinctions in the kind of genre. A painting will be seen as an example of a landscape, still-life, history painting, and so forth; a work of architecture might be seen as a church or a house. At still another level, viewers will look at works of art in terms of a historical or regional style. A landscape painting will be seen as an example of Impressionism or a product of the Barbizon school; a high-rise building will be seen as a work of the Chicago school or an example of the International style. Finally, sophisticated viewers will look at a work of art in terms of an individual artist's style. They will see that a painting is a typical Van Gogh or a building is one of Frank Lloyd Wright's prairie houses.

The categories that critics and other sophisticated viewers use to order works of art are seldom precise and often overlap. Many times they do not exhaustively classify some body of work; sometimes they have multiple criteria of application and so are interpretable in different ways. Frequently, they are personal and idiosyncratic. Such categories do map out a domain of experience, however, and allow sophisticated viewers to make sense of works of art.[2]

Consider the broad category of art forms, for example. Sophisticated viewers realize that the utilitarian functions of a work of architecture will often be different than a work of sculpture, the media and forming processes used will not be the same, and the organization of a piece of sculpture will involve different considerations. The same may be said for the other categories I have enumerated. Different artistic genres, such as landscape painting, portrait painting, and still-life painting, for example, will involve different sets of artistic considerations. Artists who choose to create in these genres will be involved with different subjects, different ways of composing and organizing a picture, and different ways of using artistic media. Sophisticated viewers know that works that differ in style are to be understood differently also. Landscapes in an Impressionist style will

differ from those in a Neoclassical style. Typically, they will exhibit differences in subject, differences in the handling of artistic media, differences in composition, and other differences as well.

If works in different categories are understood in varying ways, then teachers need to consider different ways of classifying works of art in selecting instructional concepts. Specific aesthetic concepts might not apply to all art forms, genres, or styles. Some concepts will be understood in a different way, depending upon the kind of art work selected for study. The concept of proportion has one meaning in figurative sculpture, for example, but quite another in architecture, and a more specific meaning in the architecture of Le Corbusier. A teacher or curriculum developer, then, will need to consider whether the works of art being studied are paintings, pieces of sculpture, or works of architecture. Consideration will need to be given to the kinds of genre divisions that can be made within the these works, the kinds of historical or regional styles represented, and the artists who produced them. All of these considerations will affect the choice of instructional concepts.

These different ways of classification are important not only as aids in identifying instructional concepts. Students should also be taught them. Knowledge of these categories will allow students to respond to newly encountered works of art in appropriate ways. One mark of a viewer's growing sophistication is the ability to map out the domain of art in ever more precise and detailed ways and, as a consequence, to understand the multiplicity of aims and intentions underlying works of art.

Because teachers are more familiar with some art forms than with others, some background research will often be required in designing a curriculum and planning instruction. Content for teaching about works of art can be gathered from:

- art appreciation textbooks and general introductions to the visual arts;
- textbooks in the foundations of art and design;
- books devoted to teaching an understanding and appreciation of a single art form such as painting, sculpture, architecture, or photography;
- introductory texts in philosophical aesthetics; and
- theoretical essays and manifestoes by artists and other practitioners of an art form.

The amount of aesthetic knowledge that underlies a sophisticated viewer's response to a work of art is enormous. Individual teachers

cannot hope to teach anything more than a small portion of the concepts that inform, say, a professional critic's response. Therefore, teachers should teach key concepts, only those that are most important in helping students understand the works of art being studied. Provision should also be made for them to encounter the same concepts over different years of schooling so their understanding can grow and develop. In selecting instructional content, teachers will also need to consider the background and intellectual capacities of students. Finally, some allowance should be made for the personal interests and expertise of individual teachers and for available instructional resources. For this reason, one can expect that the choice of instructional content will vary somewhat, even when teachers follow the same curriculum.

Biographical and Contextual Knowledge

A third kind of knowledge that sophisticated viewers bring to bear on their encounters with a work of art can be called biographical and contextual knowledge: knowledge concerning the artist and the physical and cultural setting in which a work was produced. Viewers rely upon these types of knowledge to recognize artistic aims and intentions and attain aesthetic understandings of works of art.

Consider how important biographical knowledge would be to understanding *Cow's Skull: Red, White, and Blue,* for example. A viewer who knows that O'Keeffe produced the painting after an extended visit to New Mexico is in a better position to recognize her allusion to a Navajo blanket, something that might otherwise be overlooked. To see her painting as a harbinger of other works based upon animal bones, a viewer would need know about other works in her oeuvre. And to see a stubborn and courageous aesthetic decision in her choice of a cow's skull for a subject, a viewer would need to be familiar with the subordinate role of women in the arts during O'Keeffe's time and O'Keeffe's struggle for independent recognition.

Biographical information includes what artists say about their work. If many viewers might recognize the patriotic overtones of *Cow's Skull: Red, White, and Blue,* for example, few are likely to see it as a satire on the efforts of Regionalist painters of the period unless they had specifically read O'Keeffe's comments on the genesis of the painting:

> There was a lot of talk in New York then—during the late twenties and early thirties—about the Great American Painting. It was like the Great American Novel. People wanted to "do" the American scene. I had gone back and forth across the country several times by then, and some of

the current ideas about the American scene struck me as pretty ridiculous. To them, the American scene was a dilapidated house with a broken-down buckboard out front and a horse that looked like a skeleton. I knew America was very rich, very lush.... For goodness' sake, I thought, the people who talk about the American scene don't know anything about it. So, in a way, the cow's skull was my joke on the American scene, and it gave me great pleasure to make it in red, white, and blue.[3]

As the passage shows, biographical knowledge cannot be sharply separated from contextual knowledge; the one shades imperceptibly into the other. O'Keeffe's painting, for example, reflects a number of aesthetic ideas that were current in the circle of artists and photographers who gathered around Alfred Stieglitz during the 1920s. To understand her painting as a reaction to Regionalist painters, to see the influence of Surrealism, or to see in her painting a reflection of a general aesthetic preoccupation with creating stylized abstractions from natural forms, it would be necessary to know about the artistic milieu in which she worked. Of course, to truly understand Regionalism, Surrealism, abstraction, and other manifestations of modernism one would need to know something about the social and cultural circumstances that gave birth to these artistic developments. The context surrounding the production of a work of art, then, properly extends beyond the immediate artistic milieu to include the society and the culture at large.

Student understanding of a work of art can thus be enhanced through biographical and contextual information. This can be gathered from a variety of sources:

- biographies of artists, autobiographies by artists, and correspondence and writing by artists;
- critical reviews of an artist's work;
- monographs and extended critical and historical studies of a single artist and that person's work;
- monographs and extended critical studies devoted to a particular art form, artistic genre, historical style, or regional style; and
- general works of history, sociology, and literature dealing with the society and culture in which a work of art was produced.

The amount of biographical and contextual information bearing upon a work of art is often staggering. Indeed, teachers and curriculum developers will find that much of the effort spent in designing curricula in art criticism will involve identifying sources of back-

ground information for the works of art being studied. Although time-consuming, this kind of background research can be rewarding for teachers. They usually find that their understanding and appreciation of works of art increases as they become familiar with the critical and historical literature; as a result, they become more confident about teaching criticism.

In searching the literature, teachers and curriculum developers must identify writing that not only illuminates the works of art being studied but also is intelligible and interesting to students. To locate suitable sources of information teachers will need to familiarize themselves with standard reference works in art and art history and with bibliographies of literature in the arts. The time needed to conduct library research has been greatly reduced through the introduction of computer literature searches that locate books and articles of potential use through databases.[4]

Developing a file of background information is an important part of planning a curriculum in art criticism. Teachers should familiarize themselves with the school library or media center to see what resources are available. More often than not, these will need to be supplemented. Librarians are often willing to use the library's budget to order books, films, and other materials needed for classes. Items can also be ordered through interlibrary loan, and information can be downloaded electronically. Relevant information can also be borrowed from other libraries and then photocopied and stored in a vertical file for easy access by students.

Teaching Concepts and Perceptual Skills

Aesthetic concepts and categories are generalizations based upon induction from experience. Although it is possible that students will acquire some of these simply through encounters with works of art, educators cannot leave the learning of concepts to chance and haphazard encounters. Teaching critical inquiry requires organizing student experience with works of art and actively intervening in teaching key concepts.

Instruction for teaching concepts and perceptual skills may be divided into three phases. First students have concrete experiences with works of art through the kinds of personal response activities described in earlier chapters; next a teacher introduces and explicitly defines aesthetic concepts; and, finally, students apply these concepts to the works of art they are studying.

Planning for the teaching of concepts begins with the organization

of the curriculum and the selection of works of art for study. Choosing an idea, topic, or organizing theme for a unit of instruction is a basic curriculum decision. After doing this, teachers are able to select specific works of art to be the focus of study. Aesthetic concepts are selected to assist students in understanding these works.

It is important to realize that the selection of a unit theme and a focus group of art objects can, in itself, facilitate the learning of concepts. The organizing theme for a unit of instruction can be a major aesthetic concept or category. It can, for example, be based upon a topic such as light; an artistic genre such as landscape painting; an artistic style such as Impressionism; or the work of a single artist such as Claude Monet. Even when a teacher chooses some other kind of organizing theme, he or she should select works of art related in meaningful ways that allow students to make connections among them.

Initial experience sets the stage for learning aesthetic concepts. As students engage in personal response activities they acquire the concrete experience needed for understanding concepts. By providing opportunities to compare and contrast works of art, teachers can help students find significant commonalities among works of art.

Teachers, however, will also want to pause at intervals to explicitly introduce aesthetic concepts to the class. During this second phase of instruction, a teacher provides definitions of the concepts through examples and demonstrations. Most aesthetic concepts are visual or iconic concepts. These are taught by showing examples of the concept—through the use of illustrations, works of art, diagrams, or other visual aids. Occasionally, for purposes of contrast, it may be useful to show negative instances of the concept, works of art or other illustrations that do not exemplify the concept being taught. Some artistic concepts are either "enactive" or have an enactive component; they are best learned through demonstration or engaging in some activity.[5] Teachers might find it helpful to teach a concept such as traditional tempera painting, for example, by demonstrating and having students engage in some brief activity in which they use the medium. Whether a concept is taught through examples or demonstration, teachers should always provide verbal labels to facilitate recall and communication.

In addition to teaching single concepts, it is sometimes helpful to introduce several concepts at the same time. For example, along with teaching students about the medium of tempera painting they might also be introduced to the concept of distortion to make the point that the appearance of images is often dictated in part by the media artists use. Understanding is enhanced when students are able to make

connections between one concept and another. Teaching aesthetic concepts, then, includes pointing out relationships between and among concepts students have learned.

The final phase in the teaching of aesthetic concepts is to apply the concepts to works being studied. Students in this phase return to the works of art that are the focus of a unit of instruction and apply their newly acquired knowledge through further discussion and writing assignments. Teachers use this phase to observe whether students have mastered the concepts and to review the definition of the concepts when needed.

From Personal Response to the Teaching of Aesthetic Concepts

The movement in teaching concepts is from actual experience with works of art to generalizations based upon these experiences and then back again to the works themselves. Teaching aesthetic concepts and perceptual skills should be integrated into ongoing instruction focusing on personal response to works of art. Students must first have concrete experiences with works of art before aesthetic concepts can meaningfully be introduced, and they must have opportunities to apply the concepts if they are to attain mastery.

If concept and skill development activities are interspersed throughout a unit of instruction devoted mainly to personal response activities, it is nevertheless important to distinguish between them. Unlike personal response activities, these instructional activities have a different focus. Students are expected to acquire knowledge and perceptual skills that will assist them in their search for meaning in works of art. A teacher's role is also different. Instead of functioning as a collaborator in the search for meaning, teachers assume their customary classroom role as purveyors of knowledge. Doing so lends a different character to the instruction and justifies using instructional methods that are inappropriate for eliciting personal response.

Although personal response and concept and skill instruction represent different phases of instruction, the boundary between them should not be drawn too rigidly. As students read professional pieces of criticism and interact with the teacher in discussing works of art (activities that are part of the personal response phase of instruction) they are inevitably exposed to the concepts and categories that structure the experience of these more sophisticated viewers. Much of the learning of aesthetic concepts and perceptual skills can be expected to occur in this informal manner.

Reading Professional Criticism

Consider the kinds of learning that might occur if students were to read Rudolf Arnheim's insightful analysis of *Guernica:*

> The picture is more than twice as long as it is high. . . . By selecting this format, Picasso waived the opportunity for a strong climax, to the extent to which a climax is expressed by height. The bull does dominate the scene, but he is only slightly higher than the other figures. More essentially, he is an integral part of the total composition, in which every element commands equal stress. Like the monochrome, the long format has an equalizing effect; it makes the picture tell an epic rather than a dramatic story.
>
> The long panel makes, furthermore, for a lack of compactness—that is, in the vertical the elements are closely related, but they can be far apart in the horizontal. The uniformity of color, shape, height, and spatial depth is counteracted by a panorama-like sprawling in the horizontal. Instead of tight cross-connections, there is a loose enumeration of separate happenings. The spectator's eyes, traveling along the canvas, inspect a sequence of themes rather than encounter a highly integrated structure, which would make the total content of the frame appear as one coherent although subdivided object. The world envisaged in *Guernica* is one in which much the same happens everywhere but without strong over-all organization.
>
> Picasso prevented the composition from falling to pieces by the symmetrical correspondence of the flanks—the bull at the left, the falling woman at the right—and the roughly equilateral triangle culminating in the oil lamp. The triangle is low, vaguely outlined, pierced by protruding shapes, and there is no tidy distinction between what is going on inside it and outside it. Many shapes, similar in size and character, strongly bent, jagged, narrow, cover the total surface of the canvas rather evenly. There are three areas of let-up, breathing spaces, on the left, on the right, and in the center. The foci of intricacy, the tight scramble of intertwined shapes, are all in the lower half of the picture and more intense on the left. This adds to the density of the chaos and weighs the scene down while leaving at the same time some freedom to the upper region of the lights, the flames, and the more significant heads.[6]

Arnheim's analysis helps us see Picasso's masterpiece in a new way by pointing out the complex relationships between the composition or formal organization of the painting and its expressiveness. For students who have not previously considered these dimensions of response to a work of art, reading such a piece of criticism can be a revelation. They will come to see that the composition of a work of art involves consideration of such things as its format, spatial relationships, and the relationships of components on the picture plane. Arn-

heim's analysis also introduces students to such concepts as focus, theme, climax, and symmetry. In using his analysis in the classroom, teachers could draw attention to these concepts, define them explicitly, and show how they apply to other works of art.

Modeling Critical Response

Few have the insights of Arnheim or of most professional critics, but students can also benefit from a teacher's observations about a work of art. One can hardly overestimate the importance of an individual teacher as a model for the behavior of students, who will carefully scrutinize and often emulate their teacher's reactions. A teacher's enthusiasm (or lack of enthusiasm) for a work of art, for example, will almost certainly affect student attitudes toward that work. Teachers can broaden student response to works of art by modeling the kind of response they think would be appropriate. A five-minute monologue in a more-less-stream of consciousness fashion can reveal the teacher's thinking, highlight aspects of a work of art that are unfamiliar to students, and introduce aesthetic concepts.

Imagine, for example, that a teacher sees that students are unable to achieve an imaginative entry into the subject depicted in a painting. Although they recognize what it is, they are unable to make inferences beyond what is seen literally: They are not able to respond to the "world within the work." The teacher can introduce this concept by pretending to take a journey within the painting. In the process of describing the imaginary journey, the teacher can point out what he or she hears, feels, smells, and surmises as well as what is revealed as he or she moves about within the painting. The students could then be invited to participate in a similar imaginary journey with other works of art.

Exposing students to the writings of professional critics and the observations of the teacher, then, can be an effective way of introducing aesthetic concepts. Both should be done, of course, only after students have revealed their reactions to a work of art. Reading critical writings or listening to the teacher discuss a work of art before they have expressed their own thoughts and feelings will intimidate students and discourage the kind of response needed to begin critical inquiry. Used appropriately, however, both can be important ways of developing visual sophistication.

Explicit Teaching of Aesthetic Concepts

If students learn aesthetic concepts from reading criticism and listening to their teacher, there are times when it is appropriate to shift

to a more direct form of instruction and explicitly introduce and define aesthetic concepts. This can be done by:

1. *Showing works of art.* Aesthetic concepts can be defined by pointing to exemplifications of the concepts in works of art, either works they have been studying or other works specifically selected for this purpose. What is selected should clearly exemplify the concept being taught. Teachers should show both a variety of works to give some sense of the extension of the concept and contrasting works of art to illustrate the boundaries of the concept.

2. *Using nontraditional art forms to illustrate concepts.* Many times teachers find it convenient to show standard works in the canon of Western art. Some consideration, however, should also be given to using works of art from other cultures and aesthetic traditions: South American, African, Asian, or other cultures; folk and vernacular arts; and examples of the popular arts such as magazine illustrations, comic books, commercial design, and architecture. Using nontraditional art forms allows teachers to suggest the full range of application of the concept being taught and can bring the teaching of aesthetic concepts closer to students' experience.

3. *Using poor works of art.* Many of the concepts underlying a sophisticated viewer's response to a work of art are value concepts or have value overtones. They are best brought out through contrast. Great efforts might be spent trying to teach such concepts as proportion, originality, balance, and unity, but unless students are exposed to works of art that are ill-proportioned, clichéd, unbalanced, and disunified a teacher is not likely to meet with much success. Showing genuinely bad works of art will usually intrigue students and will often inject humor into a teaching situation as well.

4. *Using diagrams and altered works of art.* Teachers can prepare diagrams or alter reproductions of works of art to better illustrate some aesthetic concepts. Many of the different kinds of formal relationships—line, shape, color, and texture relationships, for example—can be diagrammed to make detection easier. Teachers can also modify reproductions to make them more clearly illustrative. For example, a reproduction might be painted over to eliminate a critical element, thereby creating imbalance in the work, or a diagram of a piece of architecture might be changed and the building's proportions altered for the worse. Students could then compare the altered version with the original.

5. *Drawing analogies.* Aesthetic concepts can sometimes be illustrated through analogies between works of art and other things with which the student is more familiar. For example, it is often ef-

fective to teach about expressiveness in architecture by having students imagine the structure as a human body to better enable them to see the awkwardness, squatness, refinement, or grace of a particular building. They can be led to an awareness of the metaphorical significance in works of art by considering the morals and maxims to be found in parables or fables or the thematic meaning of poetry. Teaching about an artist's personal style might be done by talking about graphology and the study of personality through handwriting.

6. *Drawing attention to nature and man-made objects.* Finally, aesthetic concepts can be illustrated by pointing to other things in the students' environments—varieties of line, shape, color, texture, and other visual qualities in natural objects, for example. Teaching about artistic symbols can be done by drawing attention to the symbolic meaning found in such things as engagement rings and wedding dresses, flags and insignia, and commercial trademarks and corporate logos.

Definitions can be conveyed through different methods of instruction. Teachers can interject variety into a curriculum in critical inquiry through:

1. *Lectures.* Ten- or fifteen-minute lectures are the most direct way of teaching aesthetic concepts. Because the attention span of students is limited, teachers should keep lectures brief. In explaining a concept, they can either use commercial slides or reproductions or those made specifically for this purpose.

2. *Readings.* Teachers can introduce concepts through assigned readings. Art appreciation texts and texts devoted to the foundations of various art forms devote considerable space to the explanation of aesthetic concepts. Students can read sections of appropriate texts.

3. *Teacher-prepared handouts.* Teachers should consider preparing packets of readings when published material is not suitable or does not deal with key concepts.

4. *Films and videos.* Commercial films and videos that attempt to teach a basic understanding of the visual arts are useful. Teachers should familiarize themselves with what is available and use it when appropriate.

5. *Demonstrations.* Enactive concepts or visual concepts having an enactive component can be taught through demonstrations. Teachers, for example, can demonstrate various kinds of artistic media and forming processes.

Finally, students can learn aesthetic concepts through various kinds of hands-on activities that are assigned after the concepts have been introduced. Hands-on experiences can include:

1. *Brief studio experiences.* Students might learn about a particular artistic medium by working in that medium. They might be asked to emulate an artist's work to learn about that artist's style, or they might attempt to draw, paint, or sculpt the same subject in works of art they are studying to become more sensitive to the way that handling an artistic medium affects expressiveness.

2. *Diagramming and altering works of art.* Students also could be asked to diagram a work of art or alter a reproduction. For example, they might be asked to diagram a photograph of the facade of a building to study proportion or to diagram a picture to study the linear rhythms. They might be asked to improve or ruin a picture in order to develop a sense of the formal order in a work of art or to complete a picture in which a portion has been removed to develop a better sense of an artist's style.

3. *Classification and sorting exercises.* Students might be asked to sort through a collection of reproductions and group pictures according to a particular style, medium, technique, composition, function, or in some other way in order to demonstrate their understanding.

4. *Assembling collections.* Finally, teachers might have students assemble collections of pictures that exemplify various aesthetic concepts. They might collect examples of works of art that have similar subjects or compositions. They might assemble little-known works they think are exemplary, or works they think are clichéd or trite to learn about value concepts. Pictures collected can be displayed on a bulletin board and discussed with other members of the class.

Instruction concludes with the application of the newly learned concepts to works of art that form the focus of a unit. In this final phase of teaching students reexamine the same works to which they responded earlier. It is likely that their perceptions and understandings will have changed as the result of newly acquired knowledge. Teachers can provide opportunities to apply concepts through further class discussion and by assigning brief written essays. Asking students to compare two or more works of art in light of some aesthetic concept, for example, is an effective way of encouraging them to make further discoveries. During this last phase of instruction the teacher monitors the talk of students and scrutinizes written work for evidence that a concept has been learned. Additional explanation is provided when necessary.

Principles of Instruction

Concept and skill instruction differs fundamentally from the personal response activities discussed in earlier chapters. It might be helpful, therefore, to make explicit a teacher's role and responsibili-

ties in providing this kind of instruction.

1. *In teaching concepts and categories for viewing works of art a teacher must build upon concrete experiences with works of art.* Teaching concepts comes after students have had opportunities to engage in personal response activities.

2. *Concepts selected should be important.* They should help illuminate works of art that are the focus of a unit of instruction.

3. *Teachers should limit the number of concepts taught during a unit of instruction so students are not overwhelmed.* Teaching concepts occurs as part of a unit of instruction devoted principally to student response and critical reflection.

4. *Teaching is done through presenting examples and demonstration.* Teachers should present examples that clearly exemplify the concept, as well as contrasting examples when needed. The examples used should suggest some of the range of extension of a concept.

5. *Students should apply concepts to works of art they are studying.* After introducing and defining aesthetic concepts, teachers should provide opportunities for students to apply the concepts to works of art that are the focus of a unit of instruction.

6. *Teachers should reintroduce concepts periodically throughout the curriculum.* Students should have opportunities to expand and develop their understanding of these concepts.

Acquiring Biographical and Contextual Knowledge: Student Research Activities

In focusing on the teaching of biographical and contextual knowledge one moves outward from consideration of the work of art to consideration of the artist, the immediate artistic milieu, and, finally, to the general culture and setting in which a work of art was created. Each of these widening circles of interest opens vastly greater amounts of knowledge, all of which could potentially be included in a curriculum in art criticism.

In recognizing this, teachers are confronted with a dilemma. Any attempt to "cover" a significant portion of the information will likely end in frustration for both teacher and students. There is almost always too much material of potential relevance. Teachers quickly learn that it is impossible to present more than a small fraction of such material, even with the most strenuous efforts. Students, in turn, quickly become overwhelmed by what they perceive as masses of irrelevant information. Educators now realize that factual information, unless it is assimilated into a student's cognitive schema in some meaningful way, is soon forgotten. Only if students are able to use

such information in resolving a lack of understanding of some work of art is it likely to be retained.

How, then, can biographical and contextual knowledge be provided? As with the teaching of concepts and perceptual skills, student research can be divided into three phases. First, they experience works of art through the personal response activities described in chapters 9 and 10. Then teachers either assign background readings or have students undertake library research projects in order to illuminate works of art they are studying. And, finally, students share their newly acquired knowledge with other students.

Initial experience must precede background research because students will sense a need for biographical and contextual information only if they lack understanding of a work of art. Sometimes this need will arise spontaneously if students, for example, are unable to identify what is represented. At other times they will sense a need for further information only after extended discussion and reflection. After they have considered questions about the artist and the context in which a work of art was created, and after they have identified gaps in their understanding, they are ready to make the effort to secure background information.

Biographical and contextual knowledge may be acquired in two ways. Sometimes it is appropriate for a teacher to supply this information through lectures or assigned readings. In many more situations, however, the information is best acquired by students themselves through independent research projects. Of course, there are times when teachers may find it appropriate to assign both readings and research projects during the course of a unit of instruction.

Assigned Readings

With some works of art, the lack of specific kinds of background knowledge may preclude all but the most rudimentary understanding. Studying art that has historical, religious, or mythological content, for example, is likely to prove frustrating unless students can identify the subjects depicted. Here assigned readings might well be the most appropriate method of instruction. A teacher might well have the class as a whole read selections from historical sources, the Bible, or books on mythology.

Student Research Projects

In many more teaching situations, however, the questions students have about the works of art they study will be too varied or the material they will need to consult will be too extensive to be easily encap-

sulated within a set of readings. It is then better to have them acquire biographical and contextual information through an independent research project. The most appropriate topics for such projects are questions that arise out of prior reflection upon a work of art. Personal response activities inevitably lead to questions about such things as the background that shaped the artist's attitudes, other works the artist has created, the time and place depicted in a work of art, the critical reception that greeted the artist's work, and the cultural setting in which a work of art was created. Questions that cannot be answered through observation alone provide possible topics for student research.

Research projects can assume different forms. Teachers might consider assigning:

1. *Scholarly critical papers.* One possible kind of assignment combines research into what critics or authorities think about some work of art with what students think. Here, students function much like critics, reviewing and synthesizing the professional literature and contributing personal insights.

2. *Library research papers.* A library research project that acquaints students with biographical details of an artist's life or about the artistic and cultural setting in which a work of art was produced is still another possible kind of assignment. Teachers should emphasize that the search for information is undertaken to help clarify understanding of a particular work of art and that the project should help illuminate some of an artist's intentions in making that work.

3. *Research symposia.* The efforts of students can also be coordinated so that each student contributes a research paper on some aspect of a topic that a group has chosen. For example, if a group of students selects a particular artist as a research topic, one might research the life of the artist, another the artistic influences upon the artist's work, still another the historical surroundings in which the artist worked, and so forth.

4. *Oral reports.* After undertaking background research, students can briefly report on the particular work of art they have chosen, reinterpreting it in light of the information they have acquired. More elaborate projects might involve students preparing a slide lecture in which they show other works by the same artist, other works of art which influenced the artist, or photographs of the artist and the setting in which the work was created.

Guiding Student Research Projects

Helping students acquire biographical and contextual information can be done more effectively if teachers consider the steps to be taken in coordinating research projects. In student research projects:

- To arrive at a suitable topic, the teacher talks individually with each student about puzzling aspects of a work of art or about interests that have evolved out of class work.
- The teacher suggests appropriate projects with regard to available library resources and the individual's capabilities.
- The student writes out a plan of research and includes a tentative bibliography.
- The teacher discusses the plan and gives each student further suggestions.
- The student submits a final plan.
- The teacher keeps informal contact with students as plans are carried out.
- Students present the results of their research to other members of the class.

Principles of Instruction

Teachers should consider the following in providing this kind of instruction:

1. *Student research is undertaken only after students have had opportunities to engage in personal response activities.* The need for biographical and contextual information comes only after students realize they lack a full or complete understanding of a work of art.

2. *Biographical and contextual knowledge is taught through assigned readings and student research projects.* Sometimes the former is appropriate, especially when students lack a basic understanding of a work of art. Usually, student research projects are a more effective way of securing background information because they can be tailored to the questions and interests of individual students.

3. *In assisting students in their research efforts, teachers function as mentors and guides.* Teachers consult with students to help them decide on a research topic and offer suggestions at intervals during the course of a project.

4. *Students should be asked to apply the results of their research to a particular work of art.* Background research is typically undertaken to illuminate an artist's intentions in making a work of art, not for the information itself.

5. *Teachers should provide opportunities for students to share the results of their research.* Insights obtained through background readings and research should be shared with the class.

NOTES

1. Michael Parsons, *How We Understand Art* (Cambridge: Cambridge University Press, 1987).

2. Practicing critics often devote considerable thought to ways of classifying new works of art. Sometimes a critic's contributions are seen to lie as much in the concepts they devise for dealing with new work as in the specific judgments they make. Consider Harold Rosenberg's well-known discussion of action painting, "The American Action Painters," in *The Tradition of the New* (New York: Da Capo Press, 1994), 23–39.

3. Georgia O'Keeffe quoted in Lisa Mintz Messinger, *Georgia O'Keeffe* (New York: Thames and Hudson, 1988), 76.

4. An older but still relevant introduction to computer-based literature searching for art teachers is given in George Geahigan and Priscilla Geahigan, "Guidelines for Computer Literature Searching in Art Education," *Studies in Art Education* 23 (Spring 1982): 48–60, an explanation of how to conduct literature searches and a description of bibliographic databases in the arts.

5. For a discussion of iconic and enactive concepts see Jerome S. Bruner, *Toward a Theory of Instruction* (New York: W. W. Norton, 1966).

6. Rudolf Arnheim, *The Genesis of a Painting* (Berkeley: University of California Press, 1962), 26.

12

Planning Curricula in Art Criticism

Having a large repertoire of instructional activities for conducting critical inquiry is clearly important for teachers, but these activities, in and of themselves, will not ensure success in the classroom. Teachers also need to select activities on the basis of suitability for students and then structure these in a coherent fashion. Making such decisions takes one into the realm of curriculum planning.

Instructional Goals

As with any subject, instruction in art criticism is concerned with bringing about certain kinds of learning outcomes. These goals of instruction both justify and direct the actions of teachers and students. They indicate why certain kinds of instruction are important and suggest possible classroom activities. Different learning outcomes have been mentioned in describing educational concerns with art criticism, different conceptions of critical meaning, and appropriate kinds of instructional activities. In turning to the challenge of planning workable curricula in art criticism, it will be helpful to consider these outcomes in a more systematic way.

Art criticism as an educational subject encompasses both long- and short-term learning. Short-term objectives are usually viewed as a prerequisite to the attainment of longer-term learning. Although short-term objectives are often of immediate concern in the classroom, teachers should not lose sight of the long-term goals that justify teaching art criticism. In planning instruction, one considers some learning to be not only desirable in its own right but also the means for achieving other, more significant, educational outcomes.

What types of learning are involved in art criticism? One can begin with those far-reaching goals that define the ultimate purposes of art criticism and then proceed to a consideration of the short-term objectives that support these outcomes.

Personal and Social Development

John Dewey argued that no single kind of learning is the final outcome of education. He held that education is but the preparation for further learning.[1] In keeping with Dewey, I find that the ultimate goal of art criticism in schools is to develop students who can learn and continue to grow through effective interactions with their environments.

If philosophers and psychologists are still seeking a more precise understanding of what this means, there is growing consensus that education properly addresses several dimensions of a developing personality.[2] One is the aesthetic. In developing students' abilities to find meaning and value in the visual arts, they learn to experience things aesthetically. Many philosophers believe that aesthetic experience is intrinsically valuable and one of the good things in life. To neglect this dimension of a developing personality is to deprive students of one of the sources of human happiness.

Although critical inquiry has a major role in developing the aesthetic dimension of human personality, educators take an unnecessarily restricted view of its educational potential if they fail to recognize how else it might contribute to human development. A comprehensive account of these presents a large and complex task.[3] Some illustration of these contributions can be given, however, by considering self-understanding and social understanding as educational goals.

Many educators believe that for students to function effectively as adults they must come to some awareness of their attitudes, beliefs, and values. They must also be able to adopt the perspective of others and understand their motives and intentions. Such learning lays the foundation for the development of self-esteem, tolerance, respect for other people, and other valued educational outcomes. Critical inquiry provides opportunities for developing self- and social understanding. Works of art, by their very nature, confront students with the ideas, beliefs, attitudes, and values of others and in so doing challenge them to consider the adequacy and validity of their own. By sharing and reflecting on responses to works of art and seeking background information about artists and the cultures in which the art was created, students are able to define their personalities, acquire keener understanding of others, and come to a deeper awareness of the world.

Appreciation of Art

Another important outcome of critical inquiry is appreciation of art. Appreciation is a kind of valuing, one that arises out of direct expe-

rience. Students come to appreciate a work of art when they find their experience with that work worthwhile. Out of this experience they develop criteria for judging other works of art; what is worthwhile in their present experience becomes a standard for judging works of art in the future. In coming to appreciate a work of art, students do not merely develop a positive attitude toward that work but also the ability to give reasons why they believe it to be good or bad.

Appreciation cannot be brought about simply by telling students that a work of art is good or even why it is good. They must experience this value directly. This requires that they have opportunities to articulate, share, and reflect upon their personal responses to works of art. In planning a curriculum in art criticism, teachers should also provide opportunities for students to experience a continually expanding range of art objects and engage in activities that lead to deeper, more complex, and more satisfying experiences with works being studied.

Understanding and Personal Significance

Another important outcome of critical inquiry is understanding of art. As a learning goal, understanding is neither a capacity nor a disposition but an attainment. In coming to understand a work of art, students do not gain some new bit of knowledge about it but rather a new way of conceiving it. They come to understand something when they are able to assimilate it into a larger framework of ideas, beliefs, concepts, and categories. But understanding also implies a reorganization of that framework. In coming to understand a work of art, students not only gain insight into a specific work but also new principles for viewing other works as well.

There are two types of understanding: intentional and aesthetic. The first involves understanding a work of art in terms of what an artist was doing or attempting to do; the second involves understanding it as a reflection of some larger idea, concept, or principle of which the artist was unaware. By acquiring both kinds of understandings students will be able to view works of art in new and different ways.

In recent years, educators have come to recognize that understanding of art is a developmental phenomenon. The research of Michael Parsons has been especially useful in mapping different levels of aesthetic development.[4] Through clinical interviews with subjects of different ages, Parsons was able to identify five stages of aesthetic understanding. In the first stage, children take an intuitive delight in paintings, responding principally to the representational content and the color. Yet they do not sharply distinguish between subjective and

objective components of their experience. In the second stage, they focus principally upon the subject matter and judge paintings on the basis of realism and the beauty of things depicted. In the third stage, viewers become more aware of the expressiveness of an art object. In the fourth, they link expressiveness to the public features of the art object and come to see the work of art as part of an ongoing tradition. In the final stage of development, reached by only the most mature viewers, they become critically aware of this tradition and come to consider questions about its ultimate value.

If Parsons's theory is correct, one would expect most students in public schools to be in the second and third stages of development. That is, they will be preoccupied with the representational content of a work of art and, at a later point, with a work's expressiveness. The instructional strategies presented in earlier chapters can help students see the limitations of their understanding at each of these stages and encourage them to move toward more advanced stages of aesthetic development.

Closely related to understanding art is the personal significance gained from works of art. Coming to understand a work of art creates the potential for personal kinds of insights. This occurs when works of art reveal limitations in a viewer's conceptual scheme. Sometimes this will happen when a work surprises or disturbs students, challenging their ideas, beliefs, attitudes, or values. But it will also happen when students are confronted by the views of others in the class. When reflection results in a reconceptualization of assumptions, students gain new insights into their personalities, other people, and the world. Even though such insights do not bear directly on works of art being studied, they are legitimate and valuable outcomes of critical inquiry.

Attitudes and Habits

Attitudes and habits constitute another type of learning outcome. They are dispositions and imply active tendencies to behave in certain ways. Some of the most important attitudes teachers should consider are those students develop toward their classroom experiences. How students view their teachers, classmates, and classroom environment will largely determine their willingness to learn and their future involvement with works of art. Only when they feel comfortable and secure as members of the class will they be willing to risk exposing their thoughts to others, question and challenge the views of other students, and reflect critically on their ideas and feelings about a work of art. Of course, teachers should strive to make their classes enjoy-

able as well. There are many ways in which this can be done. Selecting works of art that interest students, structuring variety into the way lessons are conducted, and using humor are some of the strategies experienced teachers use.

Some attitudes are needed if students are to develop habits of critical reflection. Four of these are especially important. The first is a receptiveness toward works of art.[5] Many times students will be inclined to dismiss something they do not immediately understand or enjoy. Teachers should try to foster an openness to new experience and encourage students to study all works of art with care and attention.

Critical reflection also presupposes tolerance for ambiguity. Works of art have a plurality of meanings, and students differ in their need for closure. Some will be impatient with the idea that there is no one correct response to a work of art; teachers should encourage them to avoid premature judgments and search for different kinds of meaning.

Tolerance for divergent points of view is still another important attitude. Classes in critical inquiry often challenge the beliefs, attitudes, and values of students. Not only do works of art express ideas and feelings that have the potential to make students feel uncomfortable, but students also may disagree in their opinions and judgments about the work. Teachers should encourage open-mindedness.

Finally, critical reflection presupposes a skeptical attitude toward the claims that others make. Teachers should encourage students to consider the truthfulness or plausibility of statements that are made, and to judge their merits on the basis of evidence and logical consistency.

Skills

Skills are capacities or abilities that are acquired through training. Skills imply different levels of mastery that are developed over time through application and practice.

Art criticism as an educational subject encompasses many different kinds of skills. Some are general in nature and encompass other abilities; others are more specific. Some are applicable to many areas of life, whereas others belong exclusively to the domain of art. For this reason, no brief catalog can hope to be exhaustive. Curriculum planners may wish to expand this list or offer more detailed analyses of those described.

What are some skills teachers need to consider in planning curricula? One important group is involved in a viewer's perceptual response. Perceptual skills involve abilities to notice or discern different aspects of a work of art. Looking at a work of art ordinarily

involves scrutinizing it in different ways for the sake of the experience itself. There are a number of dimensions of critical response: the practical functions of a work of art and its medium and forming process, sensory and formal qualities, representational content, expressiveness, metaphorical significance, and place within an artist's stylistic development and an evolving artistic tradition (chapter 11). Students will differ in their ability to respond to all these dimensions. When they are unable to respond fully, it is appropriate for teachers to call attention to each aspect and provide practice in dealing with it through specific assignments.

Another cluster of abilities also enters into successful inquiry. These can be grouped under the heading of critical thinking skills, for they deal with the ability to identify and solve problems that arise in attempting to understand a work of art. One such skill is the ability to identify gaps in their understanding and identify problems or puzzles posed by works of art. This is an important skill because the problems and puzzles that students uncover set the stage for further inquiry. Students will also differ in their ability to generate hypotheses that could resolve puzzling features of a work of art. Some will be able to generate many hypotheses, others few. Some will generate reasonable hypotheses that will illuminate the work, whereas others will be able to offer only fanciful speculations. Another skill is the ability to judge the adequacy of statements about a work of art. Students' abilities to evaluate the truthfulness or plausibility of value judgments, interpretations, and other statements in light of the evidence at hand will differ. So will their ability to evaluate the consistency of conclusions and supporting reasons. Finally, students will differ in their abilities to apply conclusions reached through critical inquiry. It is sometimes difficult for them to apply their understandings to uncover personal significance in works of art.[6]

Critical thinking abilities such as these develop as students participate in critical inquiry in the classroom. Yet successful classroom participation also requires interpersonal and research skills. Although interpersonal skills enter into all phases of critical inquiry, they are especially important during the first phase of instruction when, through whole class discussion, small-group discussion, and informal writing assignments, students articulate and share responses to works of art. Doing so requires working cooperatively with others, contributing effectively to class discussion, and assuming leadership and supporting roles in group situations. Research skills are needed for independent research projects, which involve identifying and using library resourc-

es, planning and preparing research papers, and giving class presentations. It may be necessary for teachers to provide instruction in each of these areas when performance is unsatisfactory.

Knowledge

Observation and understanding of a work of art are functions of a viewer's cognitive repertoire. If students are able to respond to works of art on the basis of their general knowledge, that knowledge is limited and will generally need to be augmented. Three types of knowledge are especially important.

First, students will need to be taught aesthetic concepts and categories. These are tools that make it possible to organize experience with art in meaningful ways. They allow students to perceive and discriminate different features of a work of art that would otherwise go unobserved, to see relationships among disparate works, and to infer artistic intentions.

Next, students need biographical and contextual knowledge. Personalities and life experiences of artists are reflected in their art, as are the ideas, beliefs, attitudes, and values of the surrounding culture in which an artist works. Information about the artist and the context of artistic creation allows for inferences about intentions and understanding of the work as a reflection of larger ideas and principles.

Finally, students might need to be taught procedural knowledge, rules or principles of conduct in the classroom. This includes knowledge of class routines, appropriate comportment in classroom settings, different ways of interacting with other students, and procedures for securing information and presenting research findings.

Planning Curricula in Art Criticism

The learning outcomes just described, taken in conjunction with the instructional activities outlined in previous chapters, constitute the goals and methods of critical inquiry. In planning curricula in art criticism, teachers consider how this subject is to be adapted to specific educational situations.

The key to successful adaptation is careful planning and ongoing experimentation. Teachers need to deliberate about how the goals of art criticism might best be achieved for a specific student population given the circumstances and resources at hand. This involves considering such things as the needs of students, the time available for instruction, the skills and interests of teachers, the available instructional materials, and the facilities in which teaching will occur. Such delib-

erations result in the formulation of a plan of action—the projection of a sequence of instructional activities extending over a period of time.

Ideally, the plan will be presented in a written document. When undertaking curriculum planning, teachers usually find it more rewarding to work with a group of interested colleagues who may be able to contribute ideas and suggestions. Parents, students, administrators, and other faculty colleagues will also need to be consulted if curriculum planners wish their support. By putting a plan of action into written form, teachers can more easily communicate with those who have a legitimate interest in the planning process.

Teachers also need a written plan in order to function intelligently in the classroom. Having one allows them to coordinate their actions with one another, reminds them of future events, and helps them prepare for instruction. A written plan also constitutes a record of what has transpired, helping teachers reflect on what has been accomplished.

No plan of action can ever precisely predict what will occur in the classroom, however. Education is not yet a science, and educators do not have the knowledge to be able to predict the effects of instruction accurately. Teachers will invariably find that some aspect of instruction will not be successful; even the most carefully worked out plan of action will need revisions. After a number of trials in the classroom, a workable curriculum will finally emerge.

No curriculum is ever truly finished. Dedicated teachers regard curriculum planning and classroom experimentation as ongoing responsibilities. A written plan can never exhaustively catalog the actions of teachers and students. Nor can it foresee every contingency that might arise. There are always occasions when it is appropriate to deviate from what was planned, either to capitalize upon the immediate interests of students or for some other reason. A curriculum document is a working plan for a future course of action; it is not something that must be slavishly followed. One must always keep in mind the distinction between the written curriculum, a plan for acting, and the actual curriculum, the events that transpire in some classroom setting.

Planning Units of Instruction

A curriculum, then, is the projection of a sequence of instructional activities extending over a period of time. The basic element of a curriculum is an instructional activity. In planning a curriculum in art criticism, teachers organize activities into increasingly greater seg-

ments of school time: lessons, units of instruction, courses, and programs of study. A lesson is a single classroom episode containing one or more instructional activities. A unit is a series of related lessons. A course encompasses a number of units. And a program is the sum total of a number of courses.

Because little learning can be accomplished within the confines of a single lesson, teachers usually find it more rewarding to focus initially on units of instruction. A unit of instruction provides perspective, allowing teachers and students to see daily lessons in relation to the past and future. Units have no fixed length. They can encompass as few as four or five lessons or extend over two or three months of schooling. In planning units of instruction, teachers:

- identify unit themes;
- select appropriate works of art;
- examine works of art and define the goals of instruction;
- sequence instructional activities; and
- locate and prepare instructional materials.

Identifying Unit Themes

A unit of instruction must have a particular unifying focus or theme that will lend coherence to a series of lessons. This allows teachers to select related works of art for study, identify relevant aesthetic concepts, and organize lessons into a logical sequence. Units with a coherent focus permit students to move beyond a single work of art and see relationships among different works.

Different kinds of themes can unify focus. Ideally, themes should be neither too broad nor too narrow. Using an art form such as painting, photography, or architecture as unit theme will usually not provide enough focus. Using a single work of art, on the other hand, will not permit students to see relationships among works of art. There are five types of unit themes that avoid both of these extremes and offer fruitful possibilities for planning: topics or issues, aesthetic concepts, artistic genres, historical or regional styles, and individual artists.

Topic or issue units are organized around students' interests and concerns. Topics can range from concrete subjects to more abstract ideas. Those for younger students might include specific subjects such as animals, people at work, or the Old West. Older students are capable of dealing with more abstract topics such as alienation, politics and art, or the black experience. An issue differs from a topic in that it contrasts two opposing ideas. In organizing units on the basis of issues, teachers select those that students would feel comfortable dis-

cussing, for example, beauty and ugliness, man and the machine, and individuality and conformity.

Aesthetic concept units focus on specific aspects of works of art and how they come to shape viewer response. Concepts can be drawn from any of the categories for critical response listed in chapter 11. Examples include distortion in art, proportion in architecture, and the study of light.

Units on specific artistic genres are organized around a significant category within some art form, such as landscapes, self-portraits, or contemporary houses.

Lessons based on a historical or regional style might, for example, concern Neo-Expressionist painting, Pop Art, or Surrealism.

A fifth and final way of planning a unit is to center lessons around the work of individual artists. Such important figures as Rembrandt, Michelangelo, David, Manet, Matisse, Picasso, Frank Lloyd Wright, Le Corbusier, and De Kooning often seem to encapsulate the aesthetic concerns of an entire generation in their art. In examining the work of single artists, teachers can focus on the artist's life and individual development. By enlarging this focus during the course of a unit to include the study of an artist's predecessors and contemporaries they can also introduce issues of stylistic influence and deal with the major aesthetic issues of specific periods.

Selecting Appropriate Works of Art

The second step in planning a unit of instruction is to select works of art that exemplify the ideas or topics embodied in some unit theme. The number of art works needed will vary with the particular class situation; teachers might wish to select as few as three or four or as many as two dozen. These works become the immediate focus of critical inquiry.

During the course of a unit students will typically study other works of art as well. In teaching aesthetic concepts and perceptual skills, for example, a teacher may wish to show other works of art as illustrations and exemplars. When they undertake research, students will also encounter other works by the same artists and works by other artists as well. These will also be studied as students present their findings to the class. Although students will typically study a wide range of art, the original selection of work constitutes a reference point for later phases of critical inquiry. Teachers provide instruction, and students conduct research so these particular works of art may be better understood.

Many works of art are potentially suitable as the focus of study.

Several principles enter into choosing among them. The first is aesthetic merit. Other things being equal, teachers should select works of art that are good because these are likely to provide more worthwhile experiences for students.[7] One important (but certainly not the only) indicator of aesthetic merit is the fame or repute of a work of art. Something that has commanded the interest of critics, historians, and artists is more likely to prove more interesting than one that is largely unknown.

Even reputable works of art, however, may not be appropriate choices for a unit of study. Suitability is also important. The art must be capable of arousing the interest of students of different ages and personalities. This does not mean that only those works of art that are immediately appealing to students should be selected. Many works of art might be initially distasteful to students but come to interest and intrigue them if presented in an appropriate context by a skillful teacher. Classroom experimentation is needed in this vitally important but currently neglected area of curriculum development.

A third principle in selecting works of art is balance, a matter that constitutes one of the more divisive and enduring controversies in the field of art education. On one side of the controversy are educators who emphasize the teaching of exemplary works of art drawn from the mainstream European fine arts tradition. On the other side are educators who believe that the art of non-European cultures, art by women and minorities, functional as well as fine art, and folk and popular art also deserve a place in the curriculum. Ongoing debates among these educators have been a fixture of the art education literature for many years. The debate is not merely a parochial concern of educators in the visual arts but rather is part of a more general intellectual debate between what has sometimes been called modernist and postmodernist views of culture.[8] It seems to me that both sides have merit. It is doubtful that educators in the arts would have contested the issue so vigorously and for so long had that not been the case.

Some of the points that traditionalists make grow out of a recognition that works of art develop out of traditions of artistic practice and that to understand and appreciate works of art one must understand the traditions from which they emerge. These traditions embody the aims and intentions of artists, and masterworks within the traditions exemplify the criteria by which works of art are judged. Traditionalists also recognize that no curriculum can be all-inclusive. There is simply not enough time for students to study all of the many artistic traditions that exist within the confines of any one curriculum.

Teachers must, therefore, choose if there is to be some coherence in what is being taught. Because U.S. culture is largely an outgrowth of the European fine arts tradition, traditionalists argue that it is reasonable to focus on that.

Opponents of this view argue that this is an intolerable restriction. These educators point out that the study of works of art outside of the mainstream European tradition can be educational. Indeed, the study of alternative art forms can lead to many desirable educational goals that would be difficult to achieve through the study of the traditional fine arts. Studying non-European art, for example, can foster understanding of other cultures. And studying the art of ethnic and women artists can lead to greater self-esteem among minority and female students. A case can even be made that the study of alternative artistic traditions and art forms will help students to better understand works of art in the mainstream European tradition by providing a point of contrast.

If opponents in this debate seem divided, their positions are actually closer than one might initially surmise. It is doubtful that any reasonable educator—on either side of the debate—would argue that one, and only one, artistic tradition deserves a place in the curriculum. Yet this point has sometimes been lost in the heat of argument. When traditionalists argue that emphasis should be placed upon mainstream European art, for example, they do not mean that all other traditions are to be excluded. Educators of this persuasion have stated repeatedly that the study of major works in the European tradition can be supplemented by the study of other works of art. And when their opponents claim a place for other art forms and traditions in the curriculum, they usually argue that these ought to augment what otherwise would be studied as a matter of course.

There are, however, differences of emphasis. In large part these reflect divergent points of view about the ultimate goals and purposes of art education. Educators disagree, for example, about the emphasis that should be placed upon developing the aesthetic, as opposed to the nonaesthetic, dimensions of human personality. Such differences in philosophy have always characterized education, and there is likely never to be complete agreement about which works of art should be selected for study.

I think that no single canon, no definitive list of artwork, must be taught to all students. Nevertheless, developing the aesthetic dimension of personality is a proper concern of art education. To focus mainly on developing the nonaesthetic dimensions of personality is to risk losing sight of the unique mission of art in the schools. If stu-

dents are to develop some understanding and appreciation of the visual arts of their culture, they need to study the major artistic tradition from which it emerged. To enable that to happen, educators should select works of art that balance the traditional with the nontraditional. The balance need not be reflected in every unit of instruction, but it should appear within the curriculum as a whole.

A final consideration concerns the problem of availability. This in itself raises a number of issues, one of which concerns the merits of original works of art versus reproductions. Most teachers would agree that having students experience original works of art is desirable. They realize that reproductions distort the original work and thus diminish its impact. This is especially true for three-dimensional works of art, which lose a great deal when photographed. Sculptural and craft objects, for example, are meant to be experienced in the round, and a great deal of the enjoyment of architecture comes about through the viewer's participation in a changing spatial environment. Reproductions have been successfully used in classrooms for many years, however, and there is often no other practical alternative. Original art is usually not available for classroom use; even when it is available, teachers are likely to find their choices severely limited.

One partial solution to the problem is to arrange for periodic visits to museums, galleries, and the like where original works of art can be seen. Organizing instruction into thematic units can help students make sense of these visits. They find it exciting to see works of art they have studied, and reproductions can be selected on that basis. Even when it is not possible for students to view the same works of art they have been studying, they will enjoy seeing works produced by the same artist or works that deal with the same theme as other works in a unit of instruction. Teachers can also structure thematic units around works of art in the local community. Many communities have interesting examples of sculpture or architecture that are well worth studying.

A related issue concerns the kind of reproductions that teachers select. Developments in computer imaging suggest that this promising technology will become widely available soon. As a practical matter, however, teachers will most often choose either printed reproductions or color slides.

There are advantages and disadvantages to both. Many teachers find that large printed reproductions are more conducive to class discussion because teachers and students can more easily retain eye contact in a lighted room. Printed reproductions are also easily grouped into different arrangements that facilitate comparison. The chief dis-

advantage of printed reproductions is the limited selection that is available. One inexpensive way in which teachers can extend their collections is to search for outdated calendars and secondhand books that can be cut up for their pictures. Color slides, by way of contrast, can be found for almost any work of art that a teacher would care to choose. But comparing slides is often difficult because teachers must either have two projectors and a large screen or must shift back and forth between one slide and another.

Perhaps the best method of resolution is to employ both printed reproductions and color slides. A teacher might rely upon printed reproductions in selecting works of art to be the major focus of a unit of instruction because they will be the center of a great deal of class discussion. These works can be augmented by establishing a collection of slides that can also be used to teach aesthetic concepts and for student research projects.

Studying Works of Art and Defining Instructional Goals

The next step in planning is to study the works of art that have been selected and define the instructional goals and objectives of the unit.

Studying works of art means examining them with care and attention to uncover their less obvious aspects, looking for relationships among different works of art, and considering the possible reactions of students. Through this examination, teachers become aware of the limitations of their understanding—and perhaps of their need to do some background research in order to plan a unit adequately.

Acquiring knowledge about an artist, the context in which a work of art was created, and what critics or historians have said about the work provides some perspective on how to respond to the art. Doing so will suggest alternative ways of understanding, and the aspects and relationships that are uncovered will suggest aesthetic concepts and perceptual skills that might be taught during the course of the unit.

Teachers are better able to define instructional goals after undertaking such research. Defining goals involves stipulating the kinds of student learning to be taught within the time frame of the unit. Personal and social development and appreciation and understanding of art, although important outcomes of critical inquiry, will likely require longer periods of instruction and are best viewed as outcomes of courses and programs of study. Understanding and appreciation of specific works of art, however, probably are reasonable goals for a

unit. In planning a unit, it is generally wise to focus on a small number of knowledge, skill, and attitude objectives instead of attempting to list everything that might be taught. By concentrating on a few important topics, the most pressing needs of students can be targeted for instruction.

Sequencing Instructional Activities

Having defined instructional goals, the next step in planning is to outline the lessons to be taught during the course of a unit. Individual lessons are developed by grouping one or more instructional activities into class periods. In doing this, teachers need to consider the attention span of students. For young children, this may be as short as ten or fifteen minutes. By planning for more than one instructional activity during a single lesson, some variety can be structured into each period. Teachers should also have a backup activity if the first activity does not fill the time allotted. All units of instruction should have one or more lessons that introduce and attempt to arouse interest in the theme of a unit, lessons in which students respond to and study works of art, and culminating lessons that provide a sense of closure.

When planning the introduction for a unit, teachers might wish to include activities in which students reflect upon the topic at hand before inquiring into works of art. For example, to introduce a unit on Dadaism, students could read a short selection on the disintegration of European culture after World War I and speculate about what kind of art would be produced during such a period. In introducing a unit on Surrealism, the teacher might show examples of current rock videos and, through class discussion, bring out some of the aesthetic concerns that motivate Surrealist artists. An introduction to a unit on landscape might begin by having students make lists of beautiful and ugly things in their immediate environment.

In structuring the main body of the unit, teachers should generally begin with personal response activities because concrete experiences with works of art are needed before concepts and skills can be meaningfully taught. Personal response activities also precede attempts to secure biographical and contextual knowledge because the need for such knowledge will arise only as students sense the limitations of their understanding of a work of art. Students first respond to individual works and then to clusters of works from within the group of artworks selected for study. As they proceed through a unit of instruction, their responses will likely change and develop, and teachers should provide opportunities for students to revisit works studied earlier.

In general, teachers will find that instruction in aesthetic concepts and skills is best provided at those moments when students, themselves, recognize the need for help. Concepts and skills are not taught as ends in themselves but as specific competencies that aid in understanding and appreciation. Although concepts and skills can be taught in separate lessons, sometimes it is appropriate to teach them within a lesson devoted principally to personal responses to works of art or to student research. Lessons that focus primarily on personal response, for example, might also contain a brief activity that teaches a relevant aesthetic concept.

Students will usually undertake research projects during the latter part of a unit of instruction. Reports on research findings are a useful way of culminating a unit. After students have presented biographical and contextual information and formulated alternative interpretations of the works of art being studied, a teacher can provide opportunities to reexamine work studied earlier, giving students the opportunity to see whether their original responses have changed.

Personal response, concept and skill instruction, and student research phases of critical inquiry thus provide a general structure for sequencing lessons in art criticism. In planning a curriculum, this structure is adapted to meet the requirements of a particular teaching situation. Although the personal response phase of instruction will generally precede the teaching of concepts and skills or student research, it may sometimes be advantageous to modify the order in which these types of lessons are introduced. Where it is possible to correlate art classes with social studies or English, for example, teachers might well plan for the teaching of contextual information in one class while students respond to works of art in another.

There are also situations in which it may not be feasible to introduce all three types of instructional activities into a unit of instruction. Time constraints, the lack of relevant teaching materials, or other practical considerations may create circumstances in which it is not possible for teachers to extend critical inquiry much beyond personal response to works of art. In planning units in art criticism it is helpful to remember that an understanding of a work of art is never complete. Teachers and curriculum planners must judge for themselves how far the search for meaning can be extended.

Locating and Preparing Instructional Materials

The final step in planning a unit is to locate and prepare instructional materials. Different types of materials will be needed for personal response, concept and skill instruction, and student research. In

order to conduct personal response lessons, for example, reproductions and slides of artwork are necessary and, possibly, selections of critical writings. In teaching concepts and perceptual skills teachers will need to locate visual exemplars of aesthetic concepts. And in helping students undertake background research teachers will need to identify and locate relevant library resources.

Each phase of instruction will usually require some preparation of instructional materials as well. At the beginning of a unit, a written introduction that describes objectives and grading policies is useful. Class handouts that provide information and describe the steps to be taken in completing assignments are helpful. Teachers, as a matter of course, should provide a schedule of assignments and dates when projects are due.

Planning Courses in Art Criticism

Units of instruction represent an important level of curriculum planning. Yet teachers need to also look beyond the confines of unit planning if many of the goals and objectives of art criticism are to be attained. Any single unit necessarily encompasses a limited amount of instructional time and, hence, can address only a limited number of instructional goals. By structuring units into courses of study, teachers can plan for wider range as well as cumulative growth of learning.

Courses in art criticism are structured by grouping different units of instruction. A course can extend over a semester or over a school year and contain anywhere from two to six or more units. Each should be designed to extend the scope of the material studied as well as to expand and deepen learning. Course planning, therefore, requires that teachers stipulate different kinds of learning outcomes for each unit. It also requires that they plan for the reintroduction of key concepts and the gradual development of skills and attitudes, learning acquired over extended periods. Finally, in planning courses, teachers need to consider personal and social development and understanding and appreciation of art as goals of instruction. These types of learning are not attainable within the confines of a single unit and are best regarded as long-term outcomes of critical inquiry.

Integrating Art Criticism into Existing Programs of Instruction

The existing curriculum presents a number of stubborn challenges for educators who believe that developing an enlightened response

to the visual arts is a major responsibility of the schools. Instruction in the visual arts is not a major component of most school curricula. Although art instruction is available to most elementary school students, the time devoted to instruction is generally limited to an hour or less a week. At junior high schools, art is a required subject for nearly all students but is typically confined to a single course during the seventh or the eighth grade. At the senior high school level, art is an elective subject taken by fewer than 20 percent of students.[9]

Advocates of art criticism also recognize that the study of works of art is not yet a significant part of most school art programs. Most are devoted almost entirely to studio instruction. How well a studio curriculum serves the needs of students continues to be a subject of debate. Among thoughtful educators there is consensus that at the secondary level such a curriculum is seriously deficient. A curriculum that balances studio instruction with the study of works of art is necessary not only as a curriculum alternative to serve the majority of students who at present do not elect to take art but also to introduce a more reflective stance into studio instruction. Opinion is more divided about the value of art criticism at the elementary level. Although some educators have advocated its introduction as early as kindergarten, others argue strongly that studio activities fill a needed role throughout the elementary school years as an alternative to linguistically based forms of school learning.

Introducing art criticism into the elementary school raises questions about the readiness of students for critical inquiry. Answers to such questions will determine the balance between art criticism and studio activities and the way in which art criticism is to be presented. Unfortunately, little specific research exists to guide teachers on this important topic. What there is suggests that during the preschool and early elementary years children's perceptual, cognitive, and social development will likely preclude much of the kind of critical reflection that I have proposed. Children in the primary grades, as opposed to children in the upper elementary grades,

- are more stimulus bound and less responsive to the abstract features of their environment;
- are less able to differentiate complex parts within perceptual wholes;
- are less able to engage in hypothetical reasoning;
- are less able to generalize beyond a particular context;
- have a shorter attention span and a lower tolerance for frustration in solving problems;

- are unable to focus on more than one aspect of a problem at a time;
- are less able to communicate the workings of their thought processes;
- are less aware of the thoughts and feelings of others and less able to adopt the viewpoints of others; and
- are less able to effect a genuine exchange of ideas through discussion.[10]

These developmental characteristics suggest a more limited role for art criticism in the early grades.

In kindergarten through grade 3, therefore, art criticism is best viewed as an adjunct to studio practice. Instruction at this level might begin by having students briefly talk about their own artwork to other students at the finish of a lesson, something that is widely advocated in the literature but often neglected in practice. At the conclusion of an art lesson, teachers might also conduct brief discussions with children about works of art by having them compare their own artistic interpretations of some subject with those found in works of art. Many of the personal response questions given in chapter 4 can assist teachers in encouraging student response. Because many educators practice a more disciplined approach to the teaching of studio art, the teaching of aesthetic concepts can be expected to occur as an ongoing part of art instruction. At this age it is generally not appropriate for children to undertake biographical or contextual research, although teachers might well mention something about the artist and the background of a work of art when discussing it with children.

In the upper elementary grades (4 through 6), art criticism can assume a more prominent role in the art curriculum. Students at this age will often become dissatisfied with their artwork as their cognitive development outstrips their artistic skills. Although they will not have reached an adult level of perceptual, cognitive, and social development, many will be able to participate in the kinds of instructional activities described in previous chapters. Students in the fourth through sixth grades will have developed language skills to the point where they are capable of undertaking brief writing assignments, and it is appropriate for teachers to think in terms of lessons devoted entirely to critical inquiry, making due allowances for youthfulness.

In planning instruction for students at this age, teachers should also think in terms of coordinated units of instruction that intersperse lessons devoted to the study of works of art with art making lessons. For example, a unit on the city might contain lessons in which students

interpret cities in paintings and drawings and lessons in which they study cityscapes produced by professional artists. Teachers should also think of correlating art with other subjects in the curriculum. Topics for unit themes might be suggested by ongoing work in language arts or social studies, for example. Background knowledge gained from other subjects can provide some of the context for understanding works of art, although brief research projects are also appropriate.

Coordinated units of instruction can continue into junior high school, where it is also possible to develop units devoted entirely to critical inquiry. Junior high school students are approaching an adult level of development, and most are capable of undertaking sustained study of works of art and participating in all three phases of critical inquiry.

Art criticism in senior high schools provides an alternative to studio instruction. Teachers can use existing studio courses to incorporate units devoted to critical inquiry and so help students become more reflective about art making. Teachers should also consider the design of specific courses in art criticism to address the needs of the majority of students, individuals who no longer desire to make art but who can participate in the visual arts as enlightened viewers.

NOTES

1. John Dewey, *Democracy and Education* (New York: Macmillan, 1961), 100.

2. For a discussion of personality development as a goal of education, see John Snarey, Lawrence Kohlberg, and Gil Noam "Ego Development and Education: A Structural Perspective," in *Child Psychology and Childhood Education*, ed. Lawrence Kohlberg (New York: Longman, 1987), 329–84.

3. For a thoughtful and persuasive rationale for art education that recognizes both the aesthetic and extra-aesthetic dimensions of learning in art, see Ralph A. Smith, *Excellence in Art Education* (Reston: National Art Education Association, 1986).

4. Michael Parsons, *How We Understand Art* (Cambridge: Cambridge University Press, 1987). See also Howard Gardner, *The Arts and Human Development* (New York: John Wiley, 1973); Howard Gardner, *Art, Mind, and Brain* (New York: Basic Books, 1982); and Abigail Housen, "The Eye of the Beholder: Measuring Aesthetic Development," Ph.D. diss., Harvard University, 1983.

5. For a discussion of attitudes and habits of reflection in looking at works of art, see David N. Perkins, *The Intelligent Eye: Learning to Think by Looking at Works of Art*, Occasional Paper 4 (Santa Monica: Getty Center for Education in the Arts, 1994).

6. This is only a perfunctory account of critical thinking abilities. For an

attempt to delineate the component skills of critical thinking exhaustively, see Robert H. Ennis, "A Taxonomy of Critical Thinking Dispositions and Abilities," in *Teaching Thinking Skills: Theory and Practice,* ed. Joan Boykoff Baron and Robert J. Sternberg (New York: W. H. Freeman, 1987). Many of the skills Ennis identifies also underlie critical inquiry in the classroom.

7. Poor works of art might be used when teaching aesthetic concepts and skills (chapter 11). Contrasting poor works of art with those that constitute the focus of a unit of instruction is a means of developing sensitivity to aesthetic merit. Appealing to the principle of aesthetic merit raises the issue of whether aesthetic judgments can be justified or verified. Although they do not have the objectivity of value judgments in technical or scientific spheres of activity, aesthetic judgments are not arbitrary judgments of personal preference. They can be justified rationally.

8. The modernist-postmodernist debate raises even more fundamental issues, such as the nature of knowledge and the objectivity of value judgments in the arts. For an illuminating discussion of this debate in relation to art education, see Ralph A. Smith, *The Sense of Art: A Study in Aesthetic Education* (New York: Routledge, 1989).

9. Laura H. Chapman, *Instant Art, Instant Culture: The Unspoken Policy for American Schools* (New York: Teachers College Press, 1982).

10. David P. Ausubel, Edmund V. Sullivan, and S. William Ives, *Theory and Problems of Child Development* (New York: Grune and Stratton, 1980).

Suggested Reading

The Emergence of Art Criticism
in the Educational Literature

The literature on art criticism is large and growing. The following readings provide some background on the emergence of art criticism as an educational concept. The first specific mention of art criticism can be found in Thomas Munro, "Adolescence and Art Education," *Bulletin of the Worcester Art Museum* 23 (July, 1932): 61–80, reprinted in *Art Education: Its Philosophy and Psychology* (Indianapolis: Bobbs-Merrill, 1956). An initial call for the development of courses and teaching materials in art criticism can be found in Manuel Barkan, "Transition in Art Education: Changing Conceptions of Curriculum Content and Teaching," *Art Education* 15 (October 1962): 12–27; and Manuel Barkan, "Curriculum Problems in Art Education," in *A Seminar for Research and Curriculum Development in Art Education*, ed. Edward L. Mattil, Research Project V-002 (University Park: Pennsylvania State University, 1966). See also Elliot Eisner, "Curriculum Ideas in Time of Crisis," *Art Education* 18 (October 1965): 7–12. A good reflection of thinking about art criticism during the mid-1960s can be found in essays collected in *Improving the Teaching of Art Appreciation*, ed. David Ecker, Research Project V-006 (Columbus: Ohio State University Foundation, 1966). Ralph A. Smith, ed., *Aesthetics and Criticism in Art Education* (Chicago: Rand McNally, 1966) is an anthology of readings that introduced many in the field of art education to major topics in the philosophy of criticism.

Classic Models of Art Criticism and
Their Application in Art Education

A number of models of criticism have become classics in the sense that they have exerted an early and enduring influence in shaping educators' ideas about art criticism. Perhaps the most influential has been that proposed by Edmund B. Feldman in *Art as Image and Idea*

(Englewood Cliffs: Prentice-Hall, 1967) and *Becoming Human through Art* (Englewood Cliffs: Prentice-Hall, 1970). Feldman's model divides the critical act into four phases: description, analysis, interpretation, and evaluation. A revised version is presented in Edmund B. Feldman, *Practical Art Criticism* (Englewood Cliffs: Prentice-Hall, 1993).

Another influential model of criticism using a similar set of categories was proposed by Ralph A. Smith in "Aesthetic Criticism: The Method of Aesthetic Education," *Studies in Art Education* 7 (Spring 1968): 20–32. A revision of this model is presented in his "Teaching Aesthetic Criticism in the Schools," *Journal of Aesthetic Education* 7 (January 1973): 38–49. In this later version Smith divides critical activity into what he calls "exploratory criticism" and "argumentative criticism." The former encompasses description, analysis, characterization, and interpretation; the latter, evaluation.

A model of criticism based upon phenomenological description that has exerted considerable influence was presented by Eugene F. Kaelin in "An Existential-phenomenological Account of Aesthetic Education," *Penn State Papers in Art Education*, no. 4 (University Park: Pennsylvania State University, 1968).

A model of criticism based upon "aesthetic scanning" of the sensory, formal, and technical properties of works of art has been widely used in discipline-based programs of art education. The model is based upon writings by Harry Broudy; see *Enlightened Cherishing: An Essay in Aesthetic Education* (Urbana: University of Illinois Press, 1972) and the *Getty Institute for Educators on the Visual Arts Aesthetic Scanning Chart* (Los Angeles: Getty Institute for Education in the Arts, 1986).

Alternative Models of Art Criticism

Much of the literature on art criticism has been devoted to proposing revisions to existing models or new alternative models of art criticism. Use of the Feldman model of criticism in conjunction with biographical and contextual research is recommended by Gene A. Mittler in "Learning to Look/Looking to Learn: A Proposed Approach to Art Appreciation at the Secondary Level," *Art Education* 33 (February, 1973): 16–21. Inductive, deductive, empathic, and interactive approaches to art criticism are described in Laura Chapman, *Approaches to Art in Education* (New York: Harcourt, Brace, Jovanovich, 1978), 64–91. A discovery method based upon the teaching practice of the art historian James Ackerman is presented in Al Hurwitz and Stanley S. Madeja, *The Joyous Vision* (Englewood Cliffs: Prentice-Hall,

1970); and in Al Hurwitz and Michael Day, *Children and Their Art* (Orlando: Harcourt Brace, 1995). A revision of the Feldman model with an emphasis upon metaphoric interpretation of works of art is presented in Hermine Feinstein, "The Therapeutic Trap in Metaphoric Interpretation," *Art Education* 36 (July 1983): 30–33; and Hermine Feinstein, "The Art Response Guide: How to Read Art for Meaning, a Primer for Art Criticism," *Art Education* 43 (May 1989): 43–53. A model of criticism based upon the scientific method is given in Robert D. Clements, "The Inductive Method of Teaching Visual Art Criticism," *Journal of Aesthetic Education* 13 (July 1979): 67–78. A model of art criticism with suggestions for units of study is presented in Jim Cromer, *History, Theory, and Practice of Art Criticism in Art Education* (Reston: National Art Education Association, 1990). A curriculum unit on art criticism is illustrated in *Discipline-Based Art Education: A Curriculum Sampler,* ed. Kay Alexander and Michael Day (Los Angeles: Getty Center for Education in the Arts, 1991). For some specific applications of art criticism within educational settings, see *Lessons for Teaching Art Criticism,* ed. Terry Barrett (Bloomington: ERIC: ART, 1995).

Different approaches to art criticism, derived from the writings of aestheticians and other theorists, have been offered by a number of writers. Three possible approaches to criticism based upon the writings of aestheticians are described in Nancy MacGregor, "Concepts of Criticism: Implications for Art Education," *Studies in Art Education* 11 (Winter 1970): 27–33. Other proposals for criticism derived from aesthetic and/or psychological theories are presented in Per Johansen, "An Art Appreciation Teaching Model for Visual Aesthetic Education," *Studies in Art Education* 20 (Spring 1979): 4–14; and Per Johansen, "Teaching Aesthetic Discerning through Dialog," *Studies in Art Education* 23 (Winter 1982): 4–14; Rachel Mason, "Paul Ricouer's Theory of Interpretation: Some Implications for Critical Inquiry in Art Education," *Journal of Aesthetic Education* 16 (Winter 1982): 71–79; E. Louis Lankford, "A Phenomenological Methodology for Art Criticism," *Studies in Art Education* 25 (Spring 1984): 151–58; Tom Anderson, "A Structure for Pedagogical Art Criticism," *Studies in Art Education* 30 (Spring 1988): 28–38; Tom Anderson, "Defining and Structuring Criticism for Education," *Studies in Art Education* 34 (Spring 1993): 199–208; and Tom Anderson, "Attaining Critical Appreciation through Art," *Studies in Art Education* 31 (Spring 1990): 132–40.

Some models of criticism have been developed for use with specific art forms or with specific populations of students. For an approach to art criticism at the college level, see David Ecker, "Teaching Art

Criticism as Aesthetic Inquiry," *New York University Education* 3 (Summer 1972): 20–26. For the use of art criticism with pre-service teachers, see Gene Mittler, "Experiences in Critical Inquiry: Approaches for the Art Methods Class," *Art Education* 26 (February 1973): 16–21. A model of criticism that divides critical activity into description, interpretation, evaluation, and theory is presented by Terry Barrett in two influential texts for college-level students: *Criticizing Photographs: An Introduction to Understanding Images* (Mountain View, Calif.: Mayfield Publishing, 1990) and *Criticizing Art: Understanding the Contemporary* (Mountain View, Calif.: Mayfield Publishing, 1994). For the application of Barrett's model in the elementary classroom, see his "Criticizing Art with Children" in *Art Education: Elementary*, ed. Andra Johnson (Reston: National Art Education Association, 1992), 115–29. Barrett also discusses photography criticism in "Teaching about Photography: Selectivity, Instantaneity, and Credibility," *Art Education* 39 (May 1986): 12–15, "Teaching about Photography: Photographs and Contexts," *Art Education* 39 (July 1986): 33–36, and "Teaching about Photography: Types of Photographs," *Art Education* 39 (September 1986): 41–44. See also Terry Barrett and Kathleen Desmond, "Bright Discussions about Photographs," *Art Education* 38 (May 1985): 42, 43. For the application of art criticism to the study of architecture, see Wayne Attoe, *Architecture and Critical Imagination* (New York: John Wiley and Sons, 1978). This model is cited in Heta Kauppinen, "Teaching about Architecture," *Art Education* 40 (January 1987): 44–49; see also Ron Kellett, "Criticism in Architecture," *Controversies in Art and Culture* 3, no. 1 (1990): 44–52. A model of art criticism for older adults with a focus upon interpretation of meaning is developed by Heta Kauppinen in "Discussing Art with Older Adults," *Art Education* 41 (November 1988): 15–19.

Several models of art criticism have been presented in texts designed for public school students. See Gene Mittler, *Art in Focus* (Encino: Bennett and McKnight, 1986), a text designed for secondary students. Art criticism for middle-school students is presented in Ernest Goldstein et al., *Understanding and Creating Art* (Dallas: Garrard Publishing, 1986). For an application of the Feldman model within a junior high school art program, see Rosalind Ragans, *Arttalk* (Mission Hills: Glencoe Publishing, 1988). Gene Mittler and Rosalind Ragans also incorporate art criticism in their junior high school texts *Exploring Art* and *Understanding Art* (Mission Hills: Glencoe Publishing, 1992). A model of criticism developed for use with high school students is given in Elizabeth L. Katz, E. Louis Lankford, and Jan D. Plank, *Themes and Foundations of Art* (St. Paul: West Publishing, 1995).

Critiques of Existing Approaches and Theoretical Discussions of Art Criticism

Much of the literature has been devoted to critiquing existing conceptions of criticism and to metacritical investigations into its nature. The need for an expanded view of critical discourse is argued by David Ecker in "Analyzing Children's Talk about Art," *Journal of Aesthetic Education* 7 (January 1973): 58–73. Some limitations of the model of evaluation embodied in Feldman's approach to criticism are pointed out in George Geahigan, "Feldman on Evaluation," *Journal of Aesthetic Education* 9 (October 1975): 29–42. Objections to the formulation of art criticism as a rigid instructional procedure are given in Robert D. Clements, "The Inductive Method of Teaching Visual Art Criticism," *Journal of Aesthetic Education* 13 (July 1979): 67–78. See especially his criticism of description as an initial stage of such a procedure. A critique of discipline-based approaches to art criticism is given in Karen A. Hamblen, "An Examination of Discipline-Based Art Education Issues," *Studies in Art Education* 28 (Winter 1987): 68–78. Some theoretical areas of concern are identified by Karen A. Hamblen in "Three Areas of Concern for Art Criticism Instruction: Theoretical and Research Foundations, Sociological Relationships, and Teaching Methodologies," *Studies in Art Education* 27 (Summer 1986): 163–73; and in Karen A. Hamblen, "In the Quest for Art Criticism Equity: A Tentative Model," *Visual Arts Research* 17 (Spring 1991): 12–23. See also Linda Ettinger, "Critique of Art Criticism: Problemizing Practice in Art Education," *Controversies in Art and Culture* 3, no. 1 (1990): 30–41. E. Louis Lankford proposes a number of guidelines for critical discussions in "Principles of Critical Dialogue," *Journal of Aesthetic Education* 20 (Summer 1986): 59–65. A proposal for a greater focus on writing criticism and the use of examples of critical writing as instructional models is given in Brent Wilson, "Art Criticism as Writing as Well as Talking," in *Research Readings for Discipline-Based Art Education,* ed. Stephen Dobbs (Reston: National Art Education Association, 1988), 134–46.

A number of writers have objected to the formalist approaches embodied in many models of art criticism. Arguments for the need for biographical and contextual knowledge are made by Anne G. Wolcott, "Whose Shoes Are They Anyway?" *Art Education* 46 (September 1994): 14–20; and in Dennis Fehr, "From Theory to Practice: Applying the Historical Context of Art Criticism," *Art Education* 46 (September 1994): 53–58.

Some writers have also argued for a greater emphasis upon multi-

culturalism and social goals. In "Critique and Intervention: Implications of Social Theory for Art Education," *Studies in Art Education* 26 (Fall 1984): 20–26, Dan Nadaner contends that "socially constructed" meaning and ethical judgments should have a greater role in the practice of art criticism. In "Responding to the Image World: A Proposal for Art Curricula," *Art Education* 38 (January 1985): 9–12, he proposes using criticism to study alternative kinds of visual images in addition to traditional art exemplars. Terry Barrett argues for an interactive and socially engaged form of criticism in "Fewer Pinch Pots and More Talk: Art Criticism, Schools, and the Future," *Canadian Review of Art Education Research* 17, no. 2 (1990): 91–102. In "Multi-Cultural Approaches to Art Criticism," *Studies in Art Education* 30 (Spring 1983): 176–84, and "The Meaning and Use of Folk Speech in Art Criticism," *Studies in Art Education* 27 (Spring 1986): 140–48, Kristin G. Congdon argues for a greater acceptance of folk speech and alternative models of art criticism in classroom instruction.

Feminist approaches to art criticism are discussed in Elizabeth Garber, "Implications of Feminist Art Criticism for Art Education," *Studies in Art Education* 32 (Fall 1990): 17–26; Sally Hagaman, "Feminist Inquiry in Art History, Art Criticism, and Aesthetics: An Overview for Art Education," *Studies in Art Education* 32 (Fall 1990): 17–26; Laura Alpert, "Feminist Art Criticism: Issues, Assumptions, and Lived Experience," *Controversies in Art and Culture* 3, no. 1 (1990): 1–12; and Laurie E. Hicks, "The Construction of Meaning: Feminist Criticism," *Art Education* 45 (March 1992): 23–31. Examples of socially engaged approaches are gathered in *Pluralistic Approaches to Art Criticism*, ed. Doug Blandy and Kristin G. Congdon (Bowling Green: Bowling Green University Popular Press, 1991).

Some of the literature has also focused on theoretical discussions of the nature of art criticism. An account of how evaluations of works of art are supported is presented in David Ecker, "Justifying Aesthetic Judgments," *Art Education* 20 (May 1967): 5–8. A discussion of art criticism as an educational subject is contained in Gilbert A. Clark and Enid Zimmerman, "A Walk in the Right Direction: A Model for Visual Arts Education," *Studies in Art Education* 19 (Winter 1978): 34–49. Some ambiguities in the meaning of "art criticism," along with educational confusions that arise out of these ambiguities, are pointed out in George Geahigan, "Art Criticism: An Analysis of the Concept," *Visual Arts Research* 9 (Spring 1983): 10–22. For a discussion of the problems involved in defining such terms as *description, interpretation,* and *evaluation,* see George Geahigan, "Metacritical Inquiry in Arts Education," *Studies in Art Education* 21 (Spring 1980): 54–66. A discussion of criti-

cism as a social institution is given in Terry Barrett, "Critics on Criticism," *Journal of Aesthetic Education* 28 (Summer 1984): 71–82; and Terry Barrett, "A Consideration of Criticism," *Journal of Aesthetic Education* 23 (Winter 1989): 23–35. Barrett contends that contextual information is needed in interpreting photographs in "Photographs and Contexts," *Journal of Aesthetic Education* 19 (Fall 1985): 50–64. He proposes a category system for interpreting photographs in "A Theoretical Construct for Interpreting Photographs," *Studies in Art Education* 27 (Winter 1986): 52–60, and in "A Conceptual Framework for Understanding Photographs," *Visual Arts Research* 12 (Spring 1986): 68–77. Principles underlying interpretation are delineated in Terry Barrett, "Principles for Interpreting," *Art Education* 47 (September 1994): 8–13. Metacritical studies of professional criticism are reported in Terry Barrett, "Description in Professional Art Criticism," *Studies in Art Education* 32 (Winter 1991): 83–93; Sun-Young Lee, "The Critical Writings of Lawrence Alloway," *Studies in Art Education* 32 (Spring 1991): 83–93; and Sun-Young Lee, "The Critical Writings of Robert Pincus-Witten," *Studies in Art Education* 36 (Winter 1995): 96–103. For insightful comments about the discipline of art criticism and its relation to instructional practice, see Sherwin Simmons, "Art History and Art Criticism: Changing Voice(s) of Authority," *Controversies in Art and Culture* 3, no. 1 (1990): 54–63; and John A. Stinespring, "Discipline-Based Art Education and Art Criticism," *Journal of Aesthetic Education* 26 (Fall 1992): 106–12.

Critical Inquiry, Reflection, and Problem Solving

Although most writers focus on criticism as a form of discourse, sporadic references to critical inquiry, reflective thinking, and problem solving have been part of the art criticism literature since its inception. See Thomas Munro, "Adolescence and Art Education," *Bulletin of the Worcester Art Museum* 23 (July 1932): 61–80, reprinted in *Art Education: Its Philosophy and Psychology* (Indianapolis: Bobbs-Merrill, 1956). For some other references, see David Ecker, "Teaching Art Criticism as Aesthetic Inquiry," *New York University Education* 3 (Summer 1972): 20–26; Gene Mittler, "Experiences in Critical Inquiry: Approaches for the Art Methods Class," *Art Education* 26 (February 1973): 16–21; Karen A. Hamblen, "An Art Criticism Questioning Strategy within the Framework of Bloom's Taxonomy," *Studies in Art Education* 26 (Fall 1984): 132–40; Tom Anderson, "Attaining Critical Appreciation through Art," *Studies in Art Education* 31 (Spring 1990): 132–40; and Candace Jesse Stout, "Emphasis upon Expressive Outcomes in Teaching Art Appreciation," *Art Education* 43 (September 1990): 57–65.

For discussions of criticism that are in sympathy with the general approach advocated herein, see David N. Perkins, *The Intelligent Eye: Learning to Think by Looking at Art*, Occasional Paper 4 (Santa Monica: Getty Center for Education in the Arts, 1994); Richard Hickman, "A Student Centered Approach for Understanding Art," *Art Education* 47 (September 1994): 47–51; and Candace Jesse Stout, "Critical Conversations about Art: A Description of Higher-Order Thinking Generated through the Study of Art Criticism," *Studies in Art Education* 36 (Spring 1995): 170–88.

Personal Response to Works of Art

Critical inquiry begins with the recognition of a problem. Three general strategies for creating problematic situations are recommended: comparing student responses, comparing works of art, and confronting students with problematic works. Having students read different critical evaluations of the same work of art is suggested as an instructional strategy in Sun-Young Lee, "Professional Criticism in the Secondary Classroom: Opposing Judgments of Contemporary Art Enhance the Teaching of Art Criticism," *Art Education* 46 (May 1993): 42–51. See also her "Criticizing Criticism: Competing Judgments of Leon Golub's Paintings," in *Lessons for Teaching Art Criticism*, ed. Terry Barrett (Bloomington: ERIC: ART, 1995), 97–101. Comparing works of art as a strategy for eliciting student inquiry is illustrated in Joshua Taylor, *Learning to Look* (Chicago: University of Chicago Press, 1957). For further illustrations of comparison as a strategy, see Al Hurwitz and Michael Day, *Children and Their Art* (Orlando: Harcourt Brace, 1995), 318–24; and Terry Barrett and Kathleen Desmond, "Bright Discussions about Photographs," *Art Education* 38 (May 1985): 42, 43. A discussion of the problematic status of contemporary and foreign works of art, and a recommendation for including them in the art curriculum, is made in David Perkins, "New Art and the Abominable Snowman," *Art Education* 30 (January 1977): 13–16. See also Terry Barrett, "Fewer Pinch Pots and More Talk: Art Criticism, Schools, and the Future," *Canadian Review of Art Education Research* 17, no. 2 (1990): 91–102.

Art criticism has long been associated with classroom discussion. Karen A. Hamblen links class discussion with critical inquiry and recommends a taxonomy of questions for eliciting higher-order thinking in "An Art Criticism Questioning Strategy within the Framework of Bloom's Taxonomy," *Studies in Art Education* 26 (Fall 1984): 132–40. For specific examples of questions, see her "A Potpourri of Questions for Criticizing Realistic Paintings," in *Lessons for Teaching Art Criticism*, ed.

Terry Barrett (Bloomington: ERIC: ART, 1995). Suggestions for creating a classroom climate to foster class discussion are given in Sandra Kay Mims, "Creating a Climate for Art Talk," *Arts and Activities* 112 (January 1993): 6–9, 57, reprinted in *Lessons for Teaching Art Criticism*, ed. Terry Barrett (Bloomington: ERIC: ART, 1995). See also Herb Parr, "Collaborative Art Criticism: Not Mine, Not His, Not Hers—but Our Critique," in *Lessons for Teaching Art Criticism*, ed. Terry Barrett (Bloomington: ERIC: ART, 1995). Strategies for promoting class discussion with younger children are given in Martha Taunton, "Questioning Strategies to Encourage Younger Children to Talk about Art," *Art Education* 36 (July 1983): 40–43; and Margaret H. Johnson, "Beginning to Talk about Art," *School Arts* 90 (November 1990): 38–51. Modeling critical response to works of art is discussed in Edmund B. Feldman, "The Teacher as Model Critic," *Journal of Aesthetic Education* 7 (January 1973): 50–57. A recommendation for an "organic" form of class discussion is given in Candace Jesse Stout, "Critical Conversations about Art: A Description of Higher Order Thinking Generated through the Study of Art Criticism," *Studies in Art Education* 36 (Spring 1995): 170–88.

In recent years there has been increasing focus on writing criticism as an instructional strategy. For a proposal to use examples of professional criticism as models for student writing, see Brent Wilson, "Art Criticism as Writing as Well as Talking," in *Research Readings for Discipline-Based Art Education*, ed. Stephen Dobbs (Reston: National Art Education Association, 1988), 134–46. For suggestions about personal response writing see Richard Hickman, "A Student-Centered Approach for Understanding Art," *Art Education* 47 (September 1994): 47–51. Some writing assignments for the elementary grades are described in Terry Barrett, "Criticizing Art with Children" in *Art Education: Elementary*, ed. Andra Johnson (Reston: National Art Education Association, 1992), 115–29. For some specific strategies to assist students in writing about works of art see Candace Jesse Stout, "Critical Thinking and Micro-Writing in Art Appreciation," *Visual Arts Research* 18 (Spring 1992): 57–71. The use of journals is discussed in Kathryn L. Price, "The Aesthetic Journal: A Creative Tool in Art Education," *School Arts* 90 (November 1990): 24–26; and in Candace Jesse Stout, "The Dialogue Journal: A Forum for Critical Consideration," *Studies in Art Education* 35 (Fall 1993): 5–21.

Concept and Skill Development

The teaching of concepts and skills has long been associated directly or indirectly with art criticism in the classroom. A discussion of

some relevant concepts for assisting student perception of a work of art can be found in Ralph A. Smith, "Aesthetic Criticism: The Method of Aesthetic Education," *Studies in Art Education* 7 (Spring 1968): 20–32. Many other writers discuss appropriate content for art criticism instruction as well. For some examples, see Gene Mittler, "Structuring Instruction in Art Fundamentals for the Elementary School," *Art Education* 29 (October 1976): 12–17; Gene Mittler, "Toward a More Complete Introduction to Art in the High School," *Art Education* 39 (November 1986): 12–17; and Hermine Feinstein, "The Art Response Guide: How to Read Art for Meaning, a Primer for Art Criticism," *Art Education* 43 (May 1989): 43–53. For a discussion of the teaching of specific concepts and skills as part of art criticism instruction, see Ralph A. Smith, "From Aesthetic Criticism to Humanistic Understanding: A Practical Illustration," *Studies in Art Education* 25 (Summer 1985): 238–44; and Ralph A. Smith, *The Sense of Art: A Study of Aesthetic Education* (New York: Routledge, 1989), 219–52. David N. Perkins emphasizes instruction in concepts and skills as part of the teaching of critical thinking dispositions in *The Intelligent Eye: Learning to Think by Looking at Art*, Occasional Paper 4 (Santa Monica: Getty Center for Education in the Arts, 1994).

Biographical and Contextual Research

Discussions of the need for biographical and contextual knowledge now appear more frequently in the literature. For examples see Gene A. Mittler, "Learning to Look/Looking to Learn: A Proposed Approach to Art Appreciation at the Secondary Level," *Art Education* 33 (February 1973): 16–21; Anne G. Wolcott, "Whose Shoes Are They Anyway?" *Art Education* 46 (September 1994): 14–20; and Dennis Fehr, "From Theory to Practice: Applying the Historical Context of Art Criticism," *Art Education* 46 (September 1994): 53–58. A recommendation that students undertake library research can be found in Terry Barrett, *Criticizing Art: Understanding the Contemporary* (Mountain View, Calif.: Mayfield Publishing, 1994).

Index

THEODORE F. WOLFF received degrees in art and art history from the University of Wisconsin and was an exhibiting painter in San Francisco and New York before becoming an art critic for the *Christian Science Monitor*. His awards for art criticism include the National Headliners Award, the Art World/Manufacturers Hanover Trust Award for Distinguished Art Criticism, and the Award for Arts Criticism from the American Association of Sunday and Feature Editors. Many of his *Monitor* essays have been published in *The Many Masks of Modern Art*. Although he has returned to his first love, painting, he continues to work, lecture, and judge exhibitions. He is also the author of *Morris Graves: Flower Paintings, Enrico Donati: Surrealism and Beyond,* and a monograph on the American painter Joyce Treiman.

GEORGE GEAHIGAN is associate professor of art and design and coordinator of art education at Purdue University. He is the author of numerous articles on art criticism and is a frequent contributor to journals in art education. He is the recipient of several awards, including the Outstanding Dissertation Award from *Visual Arts Research*, the Mary Rouse Award from the Women's Caucus of the National Art Education Association, and the Outstanding Art Educator of the Year Award from the Art Education Association of Indiana. He holds a master of arts degree from the University of Illinois and a Ph.D. from The Ohio State University.